INGRID BERGMAN

A LIFE IN PICTURES

Ingrid Bergman, New York, 1946.
Photo: Irving Penn for *Vogue*
Copyright © 1947 (Renewed 1975)
Condé Nast Publications Inc.

ISABELLA ROSSELLINI / LOTHAR SCHIRMER (ED.)

INGRID BERGMAN

A LIFE IN PICTURES

1915—1982

STOCKHOLM, BERLIN, HOLLYWOOD, ROME,

NEW YORK, PARIS, LONDON

Introduction by Liv Ullmann

Interview with Ingrid Bergman by John Kobal

Texts by Ingrid Bergman, Robert Capa, Irene Mayer Selznick,
John Updike, Curd Jürgens, Martha Gellhorn and others

385 photographs from the Ingrid Bergman Collection at Wesleyan Cinema
Archives, Wesleyan University in Middletown, CT and many other public
and private collections

A visual biography authorized by Ingrid Bergman's children Pia Lindström
and Roberto, Isabella and Isotta-Ingrid Rossellini

CHRONICLE BOOKS

SAN FRANCISCO

Boca Raton Public Library

ACKNOWLEDGMENTS

First and foremost, I wish to express my sincere thanks to Isabella Rossellini who proposed this book and twice provided me access to the treasury of photographs from the Ingrid Bergman Collection housed at the Wesleyan Cinema Archives in Middletown, Connecticut, the caretakers of Ingrid Bergman's personal estate, from which most of the photographs in this book were taken. I am also indebted to her for the three days we spent working together in Munich in an attempt to shorten the picture section, which had meanwhile grown to 480 pages, by a third. Although we succeeded in exchanging about a third of the pictures for better ones, we were unable to reduce the total number of pages—on the contrary, their number increased. Rarely has such an economically sound plan been so magnificently dashed to pieces on the rocks of aesthetic reality. From this we learned: Ingrid could be improved, but not diminished.

I also wish to thank Jeanine Basinger, professor of film studies and curator of the cinema archives at Wesleyan University, for generously agreeing to place a major portion of her photographic treasures at our disposal so that they might be published for the first time. The pictures from the Ingrid Bergman Collection housed at the Wesleyan Cinema Archives are, so to speak, the visual backbone of our book. Thanks also to Joan Miller, head archivist of the Wesleyan Cinema Archive, for her never-ending willingness to quickly and precisely fulfill all our wishes and for carrying out all the work they entailed. She was, and is, the good fairy of this book.

Liv Ullmann, the sole surviving grand dame of cinema who worked with Ingrid, was so kind as to commit her personal memories of Ingrid to paper and make them available for this book. Our sincere thanks go out to her. We also wish to thank Simon Crocker, John Kobal's estate manager. By allowing us to print the wonderful interview between Ingrid Bergman and John Kobal conducted in 1972, the unmistakable melody of Ingrid Bergman's speech rings in our ears, if not the actual sound of her voice.

Thanks are also due to Ingrid Bergman's other children: Pia Lindström, Isotta-Ingrid Rossellini, and, above all, Roberto Rossellini Jr. for the faith and confidence they displayed in entrusting me and my staff with their mother's artistic œuvre.

Roberto Rossellini Jr. very kindly allowed me to view the Rossellini family's private photo album, which he keeps in Paris. He was extremely generous in loaning out his cherished photos which give the two Rossellini chapters a quite intimate flair. He also placed the handwritten note at our disposal with which Robert Capa invited Ingrid to their first rendezvous at the Paris Ritz in 1945, so that it might be published for the first time.

Our thanks also go out to all the photographers and cinematographers, the big and famous as well as the unknowns, whose pictures appear in this book.

Ingrid Bergman's and Roberto Rossellini's personal relationship with the founders of Magnum Photos is a unique "book within a book" at the crossroads of photo and cinematic history during the late forties. Ingrid Bergman was a friend of Robert Capa and David "Chim" Seymour; Roberto Rossellini was a close friend of Henri Cartier-Bresson. This is hardly surprising given that the aesthetic goals of filmmaker Rossellini and the early Magnum photographers were quite similar: both wanted to create a new image of social reality in post-war Europe. And they cast a spell over Ingrid Bergman and drew her away from Hollywood for a time. My thanks to Margot Klingsporn, whose photo and press agency Focus represents Magnum in Germany, and to Cynthia Young, who manages the estates of Robert Capa and David Seymour at the ICP in New York, for recognizing the significance of these personal friendships and for their energetic support. Thanks also to all the staff members of the many other agencies located in many countries all over the world.

And last but not least: thanks to cellist Anja Lechner, pianist François Couturier, and music producer Manfred Eicher for the spontaneous enthusiasm with which they embraced and implemented my idea of recording the song "As Time Goes By" from *Casablanca* as an acoustic leitmotif for *Ingrid Bergman – A Life in Pictures*.

Thanks also to the many unnamed helpers and staff members whose work contributed to the completion of this book.

Lothar Schirmer, Munich, July 2013

HER PHOTOGRAPHERS

Barbro Alving	Bob Landry
Eve Arnold	Philippe Le Tellier
Ernest Bachrach	Petter Lindström
Bruno Barbey	Manuel Litran
Cecil Beaton	Gaston Longet
Justus Bergman	Lars Looschen
Yul Brynner	Ivo Meldolesi
Clarence Sinclair Bull	Georges Ménager
René Burri	Inge Morath
Robert Capa	Lennart Nilsson
Arne Carlsson	Gordon Parks
Gene Cook	Irving Penn
Loomis Dean	Jim Pringle
Burt Glinn	Bill Ray
Carl Goodwin	Roger-Viollet
K. W. Gullers	Walter Sanders
Philippe Halsman	Ugo Sarto
Bert Hardy	Arne Schweitz
Jacob Harris	Olle Seijbold
H. Harsjon	David "Chim" Seymour
Dave Hogan	Lord Snowdon
Horst P. Horst	Peter Stackpole
Kurt Hutton	Mario Torrisi
George Konig	Michelangelo Vizzini
Jenö Kovacs	Raymond Voinquel
Madison Lacy	Laszlo Willinger

Jack Woods

HER FILMS

Munkbrogreven (1934)
Bränningar (1935)
Swedenhielms (1935)
Valborgmässoafton (1935)
På Solsidan (1936)
Intermezzo (1936)
Dollar (1938)
En kvinnas ansikte (1938)
Die vier Gesellen (1938)
En enda natt (1939)
Intermezzo: A Love Story (1939)
Juninatten (1940)
Adam Had Four Sons (1941)
Rage in Heaven (1941)
Dr. Jekyll and Mr. Hyde (1941)
Casablanca (1942)
Swedes in America (1943)
For Whom the Bell Tolls (1943)
Saratoga Trunk (1943)
Gaslight (1944)
The Bells of St. Mary's (1945)
Spellbound (1945)
Notorious (1946)
Arch of Triumph (1948)

Joan of Arc (1948)
Under Capricorn (1949)
Stromboli (1950)
Europa '51 (1951)
Siamo Donne (1953)
Viaggio in Italia (1954)
Giovanna d'Arco al rogo (1954)
La paura / Angst (1955)
Elena et les Hommes (1956)
Anastasia (1956)
Indiscreet (1958)
The Inn of the Sixth Happiness (1958)
Goodbye Again (1961)
The Visit (1964)
The Yellow Rolls-Royce (1965)
Stimulantia (1967)
Cactus Flower (1969)
A Walk in the Spring Rain (1970)
*From the Mixed-up Files of
Mrs Basil E. Frankweiler* (1973)
Murder on the Orient Express (1974)
A Matter of Time (1976)
Höstsonaten (1978)
A Woman Called Golda (1982)

HER OSCARS

1945 *Gaslight* (Best Leading Actress)
1957 *Anastasia* (Best Leading Actress)
1975 *Murder on the Orient Express*
(Best Supporting Actress)

HER DIRECTORS

Edvin Adolphson	Sidney Lumet
Anthony Asquith	Leo McCarey
Ingmar Bergman	Lewis Milestone
Fielder Cook	Vincente Minnelli
George Cukor	Gustaf Molander
Michael Curtiz	Silvio Narizzano
Stanley Donen	José Quintero
Gustaf Edgren	Gregory Ratoff
Victor Fleming	Jean Renoir
John Frankenheimer	Mark Robson
Carl Froelich	Roberto Rossellini
Alan Gibson	Gene Saks
Guy Green	Alex Segal
Alfred Hitchcock	Gunnar Skoglund
Ivar Johansson	Robert Stevenson
Ted Kotcheff	W. S. Van Dyke
Irving Lerner	Sigurd Wallén
Per Lindberg	Bernhard Wicki
Anatole Litvak	Sam Wood

HER LEADING MEN

Edvin Adolphson	Alexander Knox
Warner Baxter	Sten Lindgren
Ned Beatty	Walter Matthau
Humphrey Bogart	Robert Montgomery
Charles Boyer	Yves Montand
Yul Brynner	Hayward Morse
Eddi Cantor	Gregory Peck
Gary Cooper	Anthony Perkins
Joseph Cotten	Anthony Quinn
Bing Crosby	Michael Redgrave
Gösta Ekman	Georg Rydeberg
José Ferrer	George Sanders
Mel Ferrer	Omar Sharif
Albert Finney	Gunnar Sjöberg
Cary Grant	Hans Söhnker
Lars Hanson	Rip Torn
Leslie Howard	Spencer Tracy
Curd Jürgens	Mario Vitale

Mathias Wieman

Special Appearances by

Raphael
Auguste Renoir
Salvador Dalí
Andy Warhol

INTRODUCTION

by Liv Ullmann

She used to phone us during her last three years of life. Ingrid and I had worked together on a film Ingmar Bergman wrote and directed called *Autumn Sonata*. While filming, I invited Ingrid to join a girl's night comprised of Norwegian actresses and directors who regularly met to discuss the cinema, theater and our personal lives. There were seven of us, and I was the youngest. "You are our first guest, you mean so much to us," we told her, and sat down to a wonderful meal with wine and conversation. Ingrid was in good spirits and seemed to be enjoying herself that evening. At one point she stood up and proposed a toast.

"I have had so much in life," she said. "Maybe you think you never had as much. But I tell you, I never, never had such girl-friends who meet regularly as you do—all being women and sharing. I think it's wonderful! Let us drink to life-long friend-ships."

She made only one more film after her Academy Award nominated role in *Autumn Sonata*. It was a TV biography of Golda Meir, *A Woman Called Golda*, for which she won an Emmy and a Golden Globe.

I think she never forgot that feeling of closeness we'd shared at the girl's only night, because even as she was in the last stages of cancer she would call us to talk for a moment.

People often surrounded her, but I recognized in her an inner aloneness. Ingmar saw it, too. In the early days of rehearsal Ingrid and Ingmar did not get along. He was the unquestioned master of his soundstage, and she could be feisty to the point of abrasiveness. She nearly brought him to tears. "No more films. I can't go on," he told me. "I don't know what to do. Is the script so bad? I don't know how I can continue." But of course he did

continue. The tension on the set gradually improved, as he describes in Ingrid's autobiography, *My Story*:

Slowly I began to understand that Ingrid's need for security, tenderness, and contact is enormous. And she didn't feel at home with me; she didn't trust me one hundred percent, so I just had to demonstrate how I really felt toward her. That was fantastic because I had the feeling I had not to be polite any more, or strategic, or diplomatic, or search for the right words. So I revealed myself. I got furious when I felt furious. I was occasionally brutal; sometimes I was very tough with her, but at the same time I showed her how much I loved her.

It all began so badly. Even though Ingrid and Ingmar admired each other's work, and for at least ten years had discussed working together, when Ingmar finished the script we were going to do, Ingrid hated it. She was to play a renowned pianist and a mother who hadn't seen her daughter (my role) in seven years. It was too boring, she felt, too depressing. "What mother would go so long without seeing her daughter?"

Of all people, Ingrid knew the devastation of losing contact with her daughter.

Ingrid's own mother had died when she was three years old. Her father, a photographer, raised her with love and dreamed of her becoming an opera star until his early death. She was thirteen when he died and she was sent off to live with relatives. One of her aunts supposedly told her that her mother might have been part Jewish and that Ingrid should be careful in the coming years because anti-Semitism was growing in Europe. At the time, Ingrid wasn't worried about Germany or much of anything else besides acting. She trusted that the good German people would surely quell any problems arising from the Nazis. By the time she was 17 her Swedish film career had already begun.

She married Petter Lindstrom when she was 21 and gave birth to her first daughter, Pia. The family emigrated to the USA—where she went on to become the international star we adore and remember so well.

Her life suddenly changed in 1949. She went to Italy and fell in love with her *Stromboli* director, Roberto Rossellini. Their affair and her pregnancy created such a scandal in America that she was ostracized from Hollywood and stayed in Italy with Rossellini. They married in 1950. The resulting custody battle and public outcry denied her the right to see her baby daughter Pia.

So Ingrid was being true to her belief when she told Ingmar that no mother would deliberately go seven years without seeing her daughter.

In the early rehearsals of *Autumn Sonata* there were many extra "discussions" between Ingrid and Ingmar. He was used to working with people he knew very well. We all had a kind of dialogue without words. We understood him without questioning. But Ingrid, in her very direct way, started to question the script at our first reading: "Listen, we can't talk so much. We have to take away a lot of this talking. Do you really mean that this woman is going to say all this? I'm not going to say all this." And by the end of the reading, well, we all knew Ingmar, the whole crew knew Ingmar, and we were nearly under the table with fear. We thought that was the first and last day of the entire movie. I remember I went into another room and I cried because I was sure it wouldn't work. Ingmar was not used to that kind of criticism, and Ingrid, if she was that direct and wanted certain answers, wouldn't be happy either.

I was worried for both of them but, of course, mostly for Ingmar at the time—I knew how vulnerable he was about what he'd written. And how often he thought: Oh, this is perhaps silly? And then if someone told him it is silly, he was shattered.

Fortunately for the film, they eventually found their way back to each other.

There is a midnight confrontation in *Autumn Sonata* where the mother, Ingrid, has to listen to her daughter's long tirade against her. Any mother would be utterly destroyed by the daughter's terrifying anger. According to Ingmar's script, however, Ingrid had to show defeat and plead with her daughter to forgive her by saying, "I can't take any more. Help me. Touch me. Can't you love me? Can't you try to understand?" Ingrid absolutely refused to say those words. She said that in reality she'd

slap the daughter and walk out of the room. Silently, I agreed with her.

In *My Story* Ingrid wrote:

I remember that flare-up very well. I came out and shouted at Ingmar, "I can't do this scene. You have not given me a reason." Liv was sitting next to him, and she got up and left very quickly, and then just as quickly came back again with a little smile on her face. She was going to observe how far I could get with him.

He jumped out of his seat and marched right at me. He was furious but instinctively I knew he recognized my predicament. And he said the right words: "If you had been in a concentration camp, you'd say ANYTHING *for help!"*

At once I understood him, the hopelessness and depths of my defeat and despair. Yes, in a concentration camp—it must have been like that. I could play the scene now.

During the filming, Ingrid showed us her true stamina. We didn't know from the beginning that she was struggling with cancer. She never talked about it to anyone. She never complained. She was the first one to come to makeup. She always knew her lines. She was the last one, almost, to leave the studio at night.

Each evening after shooting she and some of us girls would sit together. We would have drinks and laugh, talking about the day. Not a word from her about her misery. One day Ingmar asked her to lie on the floor and talk about her past, and she stretched her arms out behind her head. I later heard that when you've had the kind of surgery she'd had, you cannot reach like that without pain. But Ingrid did it.

Late in the filming she learned that the cancer had returned to the other side of her body. The two of us went out for dinner, and she talked about her illness and her past. She said, "Oh, you know, I've been through difficult things before." She talked about the time she left the United States and couldn't see her daughter Pia for several years. She talked about her children with Rossellini, and how much she loved them and missed Pia. She talked about how she'd been attacked in the Senate, and for many years couldn't return to America. As she talked, I was looking for the victim. I was looking for tears, and I was looking for what would be natural—some self-pity. Never. She was telling the whole story with a little laughter, with some hesitant smiles, as if to say, such is life. "Ah, maybe I should have said this, maybe I should have done that. But you know, I was in love and com-

pletely alone. I can be impulsive and there was no one I could turn to for good advice."

That evening, I saw the tremendous strength of a woman who felt she was alone in life and ultimately had to make her own choices and live with the consequences without seeking approval. I saw her determination to go on, to have a full and worthy life as long as she possibly could.

Each Wednesday when we were shooting, Ingmar's tradition was to show a movie. He'd select the movie, and we all went. Sometimes we liked the movie and sometimes we didn't, but they were his favorites. He said, "Ingrid, we'll have a drink first, and then we're all going to see the movie." So, we go to the movie and then, after five minutes, Ingrid gets up and says, "I don't have time for this," and she leaves. I don't remember what the movie was anymore because I was so shocked. No one had dared to do that before. I don't think it was a great movie, and Ingrid was certainly right.

In my heart I admire a woman like Ingrid. I learned a lot from her about being a woman. I used to sit in the studio and watch her, feeling very proud to be a woman. That was because of the way she treated the people around her, the way she listened, the way she wanted to do what was asked from her, but at the same time doing what she felt was right for her.

Ingrid and I had shared similar life experiences. We'd both fallen in love with world famous directors and then bore a child out of wedlock. Our Nordic culture was so different from what we later found in Hollywood. We were tied to our Scandinavian roots, but found success in a foreign language. We discussed that late one night, and she confided to me that it was much easier for her to say the word "love" in English than to use the Swedish word. I felt the same. Maybe it had something to do with our early childhood losses, our insecurities. "Love" in a foreign language is not coloured by the memory of loss. "Can't you love me?" her character says in *Autumn Sonata*. Did she see that plea for love in her native Swedish as a sign of weakness? And yet her vulnerability was one of her greatest strengths.

She won many awards for her performance in *Autumn Sonata* and was nominated for an Oscar. Ingmar's screenplay was also nominated and he won many awards. The film won a Golden Globe in 1979.

Ingrid's beauty shone from within. Her skin was luminous, her figure was real—like a woman who enjoyed life and food and work and love. I don't think diet was an obsession with her! Her eyes were magnificent and expressive. When she arrived in Hollywood she didn't have the typical "look" of a movie star of that era. She was tall and sturdy with the innocent appeal of a country girl with good bone structure. You will see that for yourself in the pages of this book. But she was never static like a photograph. She was filled with vitality, spontaneity, wit, and in charge of a deep emotional range that served her well as an iconic personality and a lovely actress.

I remember when the director José Quintero, who had worked with her, told me about how brilliantly she'd accepted an Oscar after being banned from Hollywood. For the first time in many years she appeared onstage at the Academy Awards in Los Angeles, and the audience gave her a thunderous applause. She just stood there. She didn't bow. They gave her a standing ovation. She accepted it—but never bowed or said "Thank you, thanks for taking me back." She was a proud person.

Early in the morning after her death, someone, I don't remember who, called to give me the shocking news. It happened to be the morning of my opening night in a Broadway play. The memory of her invincible strength helped me through that day. She might have said herself, "Such is life."

I still think of her as a wise and mature woman even though I am older now than she was when she died. How I wish she'd had these extra years of good health and productive work to look forward to. I wonder at the depth of love and human understanding she would have brought to film and stage as a much older woman. But then she left us so much, it will have to be enough.

The last time I saw Ingrid was in New York after dubbing *Autumn Sonata*. I was returning to Sweden and I knew she was meeting her daughters. We were at a busy street corner and had a green light. I would have liked to stand there and make our goodbyes a little longer because, who knows, when would we see each other again?

"Bye, Liv," she said, and there she went. She didn't have time to make a big emotional scene; she didn't have time for that. Usually people will turn, especially when they know they may not see each other ever again. Ingrid never turned. She crossed the street and was gone. That was the last time I was with her. She knew it, and I knew it. I never saw her again.

But that was Ingrid: "I never look back. I always look ahead."

INTERVIEW

with Ingrid Bergman by John Kobal

The following interview between film historian John Kobal and Ingrid Bergman was conducted in 1972 and took place on the stage of the National Film Theater in London in the presence of an audience. The transcript was published in 1986 under the title "John Kobal: People Will Talk" *in New York. It is reprinted here in slightly abbreviated form. John Kobal had invited Ingrid Bergman to this public discussion while she was appearing in George Bernard Shaw's play "Captain Brassbound's Conversion" in London.*

JOHN KOBAL: When you played Anastasia, there was a side of that character in which the real person and the mythical person had almost become one. As an actress, when you came to it, which aspect did you go for? How did you decide?

INGRID BERGMAN: My director told me I always played it too sincerely. He said I was playing it as though I *was* Anastasia. "I want people to leave the theater exactly as they leave any newspaper when they read about Mrs. Anderson and her trials fighting for the money she wants and the position. You are giving such a performance of being the *real* Anastasia that not only will they overlook Mrs. Anderson but the Bank of England is going to give the money to you!"

J. K.: Did you meet her when you studied the part?

I. B.: No, not at all. She was living in Germany someplace. I just looked at it as a part I had to play: here's this woman who doesn't know and is frightened and wants to commit suicide, and has been saved and brought to this place by these men, and they're trying to work on her. She believes that she *is* what they tell her.

J. K.: How about St. Joan? She was a real character, yet the image that has grown up around her has turned her into a saint. What did you go for when you played her?

I. B.: The absolute innocence, and the belief she had in her voices, and her courage. She went against her own character. That's what I have against Shaw's *Saint Joan,* because he made

her say that she loved to be with men and people at war and the excitement of it. But if you read her answers in the trial, she says just the opposite—that she wanted to stay home and spin and wash sheets, get married and have children. She was a very ordinary peasant girl. She must have been very strong and healthy too, otherwise I don't know how she put on that armor and rode and did all those things. But she did it all against her own character, with a tremendous amount of courage. She went into the battles saying to her troops, "I'm not going to turn around to see if you're following me—I'm going to run ahead." 'Course all the men had to run after her. That I admire. And I admire her sense of humor; in all the things she said and the way she knocked down all those learned men, you know, who came with all their shrewd questions to try and pin her down for having said something wrong against the Church or God. And of course she never did—she always had that enormous common sense.

J. K.: So you had no trouble deciding between the myth of the woman and her innate saintliness?

I. B.: Some actresses have played her as a saint, but in her lifetime she wasn't. She became a saint when she was dead. I played her as a very innocent peasant—not at all as a saint. When I did Honegger's *Joan at the Stake*—after Honegger came down from Switzerland, and Paul Claudel was there too, they asked me to read for them. Arthur Honegger sat there

smiling in rehearsal and said, "It's so funny to hear you read, for you read it so simply. Everyone who plays this part usually [Ingrid puts on a theatrical voice] goes in for it like that, and follows the music, singing it out. But you don't."

J. K.: How was it for you coming to Hollywood and seeing Garbo and other stars? Did you feel you were seeing "The Garbo" or "Hello, Miss Garbo"?

I. B.: Well, of course, I'd read movie magazines and read about their private lives. But what I admired them for was the performances they gave. The first day I was in Hollywood, I stayed at the Selznicks' home and they had a party the following night to introduce me to Hollywood. I remember sitting there in a dress that I'd bought from a Swedish movie—very nervous that perhaps it wasn't good enough. I just sat there and all these personalities that I had seen walked into the room. I couldn't believe it, it was like a dream.

Ann Shendan walked in and they said, "That's the 'Oomph' Girl." I said "Excuse me" and went up to my room to look in my dictionary to see what "oomph" meant. [Laughs.] Couldn't find it. But nobody talked to me. The all came up to be presented, and I sat there being in heaven watching all these people. There was Gary Cooper talking to Bette Davis and Cary Grant and Fredric March and Norma Shearer. I couldn't believe it. I didn't realize I looked so lonely until this man came up and said, "We've all come to Hollywood for the first time and had this happen. They're all discussing you over there and saying what they think of you and making bets on your potential." I said I hadn't realized I looked lonely, but he said he'd talk to me anyway. Apparently he'd been invited to look me over too and said that I'd be welcome to come to his pool party the following day. I said how very nice it was of him and asked his name. He said, "Ernst Lubitsch."

The following Sunday I went to his place. My maid drove the car because I couldn't find my way around. There were *lots* of cars outside his house. I went in. There were people all over the living room, but nobody recognizes me and nobody talks to me. I go into the next room, the library, the playroom, the dining room, and everywhere people were having a marvelous time. Then I asked a butler where was Mr. Lubitsch and he said he was out at the pool. Everyone was swimming and diving and again having a marvelous time. I walked around the pool and asked another butler, but he didn't know where Mr.

Lubitsch was. So I took the same walk through all the rooms and right out to my car. By that time my maid had just got the car in and parked. I said we were going home! [Laughs.] What can you do when you're alone?

J. K.: So you remember clearly that all you saw was the images of all these people. So you can understand that even when you personally know people, when you read something about "Bergman" in a paper, what you think of while you're reading is "Bergman" and it's only afterwards that you consider how true or false what was written is.

I. B.: It is funny. You know, Ruth [Roberts, her voice coach] says that often to me. I say, "This idiot came to talk to me and he kept stumbling and couldn't get anything out." Ruth always says, "You must remember they didn't expect you to open the door or to answer the phone. They are frightened and tongue-tied." I don't forget that I am a walking image. When you meet people, for instance, in an elevator, they talk about you as though you weren't there: "She's much taller than I thought she was." "Doesn't she look nice?" And you're standing right next to them. They must think you're still on the screen.

J. K.: That's what I mean. They're not really talking about you or to you, but to this other "Ingrid Bergman."

I. B.: Yes, but I've always considered myself as a kind of circus horse. I'm there and I'm responsible for this horse, but when I see rushes, I always talk about "she": "Why does 'she' walk that way?" "Why didn't 'she' stay put then?" It's not really me I'm seeing—that's the person that earns money for me. I'm responsible for it, but it's not really me.

J. K.: You're a trained actress, but not all actors become stars and not all stars are actors. How do you feel about it?

I. B.: I think it means you have talent. I don't think there are any stars truly so-called who aren't talented. It's an acting talent. Lana Turner can act. She may not have been "Lana Turner" if she'd been in the theater, but she is a movie actress. She's survived a lot of bad movies, but she still goes on, and that is talent. And she has good looks.

All parts I play are looked at through my eyes, naturally. Be it a suffering mother or a vindictive countess or an innocent child. Whatever the part is, it all goes through me and I suppose becomes alike in that respect. Because it's what *I* feel as a human being that I deliver. There are limits; I can't play anything that I don't understand or can't feel. I am limited by my

own character. I've never lost myself playing any character.

J. K.: You don't think that's a handicap?

I. B.: Let's consider *The Visit*. I was sitting in my husband's office in Paris, where he has a lot of plays lying around. While I waited for him to finish a meeting, I picked up this play which happened to be *The Visit*. When he was through, I took the play home with me, because it was so amusing. Black comedy, but certainly comedy. I like to laugh, so I look for things that make me laugh, and if I can play something that makes other people laugh, so much the better. My husband said he had seen the play and that it wasn't anything to laugh at at all—it was very dark and very heavy. I said in astonishment, "But it's so amusing. I'm laughing at these things." He said, "Well, she's going to kill him for vengeance." So when 20th Century-Fox came to me—I'd just done *Inn of the Sixth Happiness* and they wanted me to continue with them—they said that they would buy whatever I wanted as a vehicle. So I said I wanted Dürrenmatt's *The Visit* because I thought we could make a hilarious comedy out of it.

Well, three years went by—script after script—they couldn't get anything out of that story. They thought it was awful that the man was killed in the end—they wanted Cary Grant for the part and couldn't have him get killed! So they made the story work the opposite way: *I* was killed in the end! Then they made it a Western with me riding into town! In the end I told them they'd have to stick to Dürrenmatt. Anyway, Cary Grant was never approached.

Then I came to Switzerland to visit friends and I got a telephone call from a film director who said he was a friend of Dürrenmatt's and would like to talk to me. So we met in a hotel and he told me that Dürrenmatt had said if ever *The Visit* were made into a film, then he would be the only man to direct it. So I agreed, though I didn't know who he was—it was Bernhard Wicki. So they started again with the script, and although the man wasn't killed at the end, he was as good as dead because all his friends turned against him and *wanted* to kill him. The picture became a very dark, humorless affair and, from what I saw of it, it didn't seem to come off. That happens very often in my career. But I never regret anything because I always set out to do something I believe in, even though during the process of making it it turns sour on you. Exactly the same thing happened with *A Walk in the Spring Rain*. A marvelous

book, but you just couldn't put that quality into the screenplay.

J. K.: If you'd had complete control over *The Visit*, who would you have chosen as a director?

I. B.: I don't know. But I also read *Promise at Dawn* [Romain Gary's book] and said, "This is me and I want to do it." Fox again very graciously bought it and again we had script after script. But, having had the experience with *The Visit*, I was even more careful and said the scripts were no good. So finally they sold the rights of the script and I took the money because I really couldn't wait any longer. Vittorio de Sica bought it. I knew him and thought he would be marvelous to direct this sentimental story, but he didn't want me. He wanted Ava Gardner. But *he* went on with the script forever and ever and finally sold it to Jules Dassin, who made it with Melina Mercouri. [Giggles.] I remember then I asked Fred Zinnemann because I thought he would be good for it. But that didn't work out.

J. K.: To get back to when you first came to Hollywood, what was the big difference between working there or in Sweden?

I. B.: It was only bigger. It was like buying a perfume bottle that's this big instead of this big. Only more people on set, more clothes, more stand-ins—which we didn't have in Sweden—makeup men and electricians. All those specialized people. In Sweden the same man does the lot. Whereas on the average set in Sweden you'd find twelve people, in America there would be fifty. If I'd stayed in Sweden, I'd have been in movies until I was too old to get the best parts. And then I'd have been on the stage. Exactly as I am now.

J. K.: If you were ever cast as Ingrid Bergman, could you play her?

I. B.: [Giggles.]: Yes, of course I could. Who could play it better? My life seems fantastic because I've never really had to fight for anything—it's just come my way. I made my own image because I refused to change my name or my I hair. They wanted to change me completely when I first came over because that was the standard thing to do. They took stars from Hungary, Germany, France, and then tried to change them—to make them more beautiful to American eyes, I suppose. But then they became just like all the other American stars that were there. Lots of publicity stills in bathing suits and hats and all that. Well, I'd often seen that in the papers and wondered how come they never got anywhere.

Take Michèle Morgan; she failed in Hollywood, but she's

still to this day a very big star in her own country. So I was careful. I said I was coming over to do one picture that is good. I want a top director and a top leading man—because I noticed they didn't have that, these other people. So when Selznick came to me, I told him that was what I wanted and after that I would go home. He said it wasn't done that way. So I said okay, then we don't do it. Well, he gave in. He said we'd do one picture and I could go. But if I liked it in Hollywood, I said I'd stay with him. So that was the contract I made—I was very clever.

Then when I came over, they started in on me: "The name's impossible to pronounce," "The name's German and there's a war on," "Your teeth, eyebrows and hair are wrong." But I said I wouldn't change anything. I told them that they'd got me over here because they'd seen a picture called *Intermezzo* and I was here to do a remake, and I was staying how I was because that's the way you liked me in the picture. Then they started on the publicity. But I didn't want any of it—I wanted the public to discover me. I didn't want to be pushed down their throats, because I've seen that: "MARVELOUS STAR FROM HOLLAND, A GREAT ACTRESS" and then out she comes and just does what everyone else is doing. Well, Selznick listened and said it was a great idea. He said he'd work on the idea of a natural girl from whose head not a hair had been removed. He told makeup he'd kill anyone who touched my eyebrows. We did tests in color with no makeup on at all. However, my face was too red in the heat of the lamps, so I had to have a little makeup on. So I became the "natural" star. And it was just at the right time because everything had become very artificial and all hairdos. My hair got blown, my clothes were simple, I looked very simple and I acted like the girl next door. The public didn't hear about me until the picture came out, and that picture has done more for me than anything else because people come to me today, after thirty years, and say that's the picture they like most because *they* discovered me. It's very funny.

The only other difference between Sweden and Hollywood is that here things are a bit glossier and the homes are a little bigger. But with *Intermezzo* they had every scene from the Swedish version there before them on the set, looked at every setup, and made exactly the same movie. It's just that the sets were a little bit more expensive.

Leslie Howard was a charming man and I had no problems there at all. I have a record at home with our voices on it. Ruth did it for me because we didn't have tape in those days. Everyone's talking: Gregory Ratoff, who directed it; Leslie Howard wishing me well. I went home to Sweden because I was so afraid that I'd have the same fate as those other actresses from Europe. I made one film in Sweden that I'd already contracted to do and then went back to Selznick for four years.

J. K.: The image can limit one, though. Ann Sheridan, who was very sensible about it, couldn't shake that one thing that propelled her from being the nice little girl to the big star. Finally, her career foundered on being "oomph."

I. B.: Yes, it can't last. But I've never built my career on beauty and youth. It can't last, and that's why I was never tied up in the movies for more than three or four years at a time. After that I would ask permission to go onto the stage again because I knew that there's where I would end up. When your youth's gone, there are some smaller good parts you can do, but if you want to continue living the spoiled life to which you've become used, then you must return to the stage for the work. So I've always been working on the stage and have done things with my voice and sung. I knew it wasn't Hollywood that was going to give me my future career.

J. K.: What made you want to become an actress?

I. B.: I never had any hesitation about it in my mind. Alone at home when I was five, six and seven, I was always acting—dressing up in funny clothes and pretending to be someone else. Of course, I didn't know it was "acting" then. I was a lonely child and I think it often happens with "only children," especially when you don't have many friends, that you make up characters to be and be with. My father took me a lot to the opera and one day he took me to the theater—I must have been eleven—and I knew that was it. Acting just grew out of my childhood. It's not that I decided—it was decided for me. Always as a child I play-acted, and then when I got to school and started to go to the theater, I read plays and learned them. I read poetry too. At the Christmas parties for parents and children at the end of term, I would always be appearing—I was a star in school! I've done it all my life.

J. K.: Is there a difference in the attitude toward stars in Sweden, Germany or Hollywood?

I. B.: In the silent days, of course, Sweden led the world. Then

when sound came in, they were stuck with the language. I had offers from Germany and America at the same time, and I took the German offer because I spoke the language. I thought it would be good to find out how it is to work in a foreign language. People forget that I don't work in my own language; imagine how much simpler it is to say a phrase that you know and feel and which all your life you've said that way. You work in a foreign language and when you get to a violent or emotional scene, the words go; you don't remember the phrase because the words haven't grown into you. So I went to Germany and did a picture—but not with the intention of staying in Germany at all. I had my eyes set on Hollywood, of course, but it was a question of waiting for the right opportunity. They wanted me to stay on in Germany, but I said no because I wanted to work in a totally foreign language. It wasn't that Germany wasn't glamorous enough—it was. The war was looming, of course, but I'd never had any interest in politics, so I didn't know what I was doing. I had no idea World War II was at the door. I just wanted to try my wings in a new language. Knowing I could do it in German, I said, Right, it's time to learn English. But I knew from the beginning that I wouldn't stay in Sweden. It was too far away and too small a country. I wanted to go to big places. There's a very good actor in Sweden whom I always tell to learn English. If he did and went to London or America, he probably would be the biggest star in the world. He says he'd rather be a big fish in small waters than a little fish in big waters. Well … I had such a tremendous ego, I suppose, that I prefer to be a big fish in big waters! [Laughs.] His name is Jarl Kulle. But he just doesn't want to leave Sweden. He's like Ingmar Bergman, you see; he feels he has his roots there and he understands the people and recognizes the stones and trees. He knows what he's doing in his own homeland. Ingmar Bergman doesn't move at all. He's been here [England] once, but I think that was the only time he's ever done it … for the *Hedda Gabler* that he produced in Sweden and then did the same thing here.[1] I wanted desperately to travel and get out into the world.

J. K.: How did you think a character through—in Swedish or in the language you were acting it in?

I. B.: I'm always asked that. I dunno. Sometimes I speak Swedish to Ruth, and that must mean I'm thinking in Swedish and it doesn't come out in English. Anyway I don't translate: I don't translate a Swedish thought into English words. Many thoughts don't have a language.

J. K.: But it's where many people have foundered. In a close-up, more is revealed than just the state of your skin—it reveals the way you think. And if you think in a foreign language while you're listening to somebody, it comes across. It slows you up and keeps removing the audience. Ruth was telling me about Ilona Massey [glamorous blond Hungarian who came to Hollywood with Hedy Lamarr in 1937]. I don't know about Hedy Lamarr, but finally it just slowed up everything with Ilona, who was more interested in her social life than in her English lessons, so nothing came across.

I. B.: But, you see, I had the good fortune of meeting Ruth the first day on the set. She is an excellent teacher for English. Being of Swedish descent, she also understood my character and knew how to show me America—not only by teaching me the language, but coaching me in the feeling and thought too. I was terribly happy in America. I liked it until the very last years, when I just got tired of the big walls that are around Hollywood—it didn't seem to belong to the world. Again, you see, I wanted to get out into the world; I wanted to be where the real people are.

J. K.: I think you'd agree that *Under Capricorn* suffered at the box office because of your private life. If it had been made in 1945, it would probably have been a very successful film, for you gave a very fine performance in it.

I. B.: I remember the film being very difficult because of Hitchcock's insistence on shooting whole scenes—you know, he shot those eleven-minute takes which drove all his actors crazy. Usually if you shoot a scene, it takes two or three minutes, a close-up takes another minute, and you've made a whole scene, but it would be intercut. He invented this thing, which he first used in *Rope*, of moving the camera into close-up or away—and he could keep a scene going for eleven minutes. All the walls had to be lifted and taken away, and the lights were tied to men who were walking all over the place, tables were moved in by somebody crawling in with the table on their back! Things moved all around you so you could play a scene for eleven minutes without stopping. He wanted to show the industry he could do that—nobody else had thought of it. Of course, the audiences watching the movie don't wonder how the cuts were made. It was such a terrible

strain. Something would go wrong after five or six minutes and you'd have to go back to the beginning. And the poor person waiting in the doorway just to say "How do you do?" waited and waited and waited, and by the time they finally got to him, he was so broken down and nervous he couldn't remember what he was going to say. It was great hardship to do. In the end he [Hitchcock] had to intercut anyway to bring in certain close-ups.

I remember it was a good story, but I don't think it had much success. But posterity can certainly give new life to a film. *Stromboli* and *Europe '51* and *Voyage to Italy* are now classics. They come on television all the time in Italy, and they write the most marvelous things about them—which they certainly didn't do in the beginning. Even if my private life hadn't overlapped, it [*Under Capricorn*] still needn't have been a success when it was made.

J. K.: After Hollywood you went to Italy even though in Hollywood the exposure was better …

I. B.: But that became very hollow. I'm very realistic and I didn't think the pictures were realistic enough. But I can't complain. I did marvelously well; I had the best actors and directors. Yet there was something inside me that was just straining for a challenge and the *truth*. In *that* mood I saw *Open City*, which I thought was the most beautiful, magnificent picture ever and which told the truth. I remember going outside the cinema and seeing the director's name and thinking I must remember that name. I also thought, "God, he's even written the music"—but actually it was his brother. Then I waited for the second movie by him [Rossellini] because that might have been a one-shot. When I was in New York, maybe a year after that, in a little theater *Paisan* was on. So I went in to see that and then decided to write a letter. For how was a man in Italy to understand that a person who at the time was number-one box office wanted to come to Italy and make a simple little movie like that, you know, with no fanfare around it? So I had to write the letter and tell him. He sent the synopsis of a story he'd invented and that's how I happened to come to Italy.

J. K.: After *Casablanca* the roles you were offered may have been varied, but they were on the whole less demanding.

I. B.: *Casablanca* was early in my career. After that I did *Gaslight*, *Notorious*, *Spellbound*, *Bells of St. Mary's*. I think they all had great variety and were good films. But there came a time when

I got fed up. In *Dr. Jekyll and Mr. Hyde* Lana Turner was cast as the little barmaid and I was to play Dr. Jekyll's fiancé. I went to the director and said I was so fed up playing the same part over and over again. I said I'd like to play the barmaid. He said that with my face I couldn't do that. I said, "What do you know about my face? Let's do a little test." He was amazed because I suppose in those days to test meant you weren't sure of yourself. Anyway the test turned out very well and we switched the parts. I'm sure Lana was just as happy as I was because she was always playing barmaids! So that was lucky.

When I played in *Casablanca*—I must have been over at Warner Brothers because I was already signed up to do *Saratoga Trunk*—anyway Mike Curtiz talked to me about it and said I was making a big mistake trying to change all the time and playing the good girl and the bad girl and what have you. He said that in America they like personalities and pay to see what they expect to see. So once they like you, you should never change. Spencer Tracy, Gary Cooper … they never changed. They were themselves in whatever they did. A wonderful actor, James Stewart, would horrify an audience if he appeared in a beard or funny nose. I replied that I wasn't that kind of person, I was an actress and I *wanted* to change. I want people to say "Who is that?" He said it wouldn't work in America, but anyway I said I'd try. So I tried it in *Saratoga Trunk* and *Dr. Jekyll and Mr. Hyde*, but you see he [Curtiz] was right: Americans *want* the personality they expect. So I wasn't given different parts from the ones you see me in. I had a lot to choose from, I was given wonderful scripts to read and chose the best out of those scripts. But there is the personality, and you don't get away from it. I played *Anna Christie* on the stage and I remember everyone laughing at the idea. I protested that it was marvelous for me—anyway, she's Swedish. I came onto the stage playing the streetwalker and was given a double whiskey and people laughed. They couldn't believe it. If it had been a glass of milk, maybe they'd have accepted it. [Laughs.]

When I came back to Hollywood [after the Swedish film], there were no parts for me at all and he [Selznick] was interested in his work for the government. He said, "You're getting paid, so what are you grumbling about?" Well, I wasn't getting paid very much. I came back and did *Anna Christie* because I had a lot of time off. I went to New York and was offered to do

Liliom on the stage. And I did a lot of radio work in those days and all those Lux things. I don't know, I never liked Hollywood—all that sunshine all the time. So I used to go to New York, which I thought was wonderful, and could go to the theater a lot. My trips were paid for if I did radio shows. I did *Camille, Anna Karenina* and [gasps], oh, an *awful* lot of things. Pictures that other people made—all kinds of things where I wouldn't have fitted in on the screen but playing over the radio was fine: *A Man's Castle* was another [Loretta Young's part]. Yes, all kinds of old scripts I did through the years. I was always on those Lux programs so I could get out of Hollywood.

J. K.: By the time you did *Bells of St. Mary's* you were so popular that Selznick could ask for and almost get the moon. Do you realize that you almost lost *Bells of St. Mary's* to Irene Dunne?

I. B.: No, I didn't know that. But I know he kept raising and raising the price for me, which was awful. He didn't want me to do it. He was very sweet to me in that he never forced me to do anything *I* didn't want to do, but he also said that I didn't have good judgment. He used to say I was too anxious to work and I should wait for the epics. I said to hell with the epics, I want to work.

When the script for *Bells of St. Mary's* came for me, he said it wasn't any good. *Going My Way* had had a big success and he said it was an error to make a repeat performance. And that's true. He said Bing Crosby had played a priest in *Going My Way* and now they were trying to do it again and it wouldn't work. Anyway, what would I do when Bing Crosby was singing? I said that I would be listening to him and anyway the camera wouldn't be on me, it would be on him. Well, we argued this forever and finally he made a very tough deal so that they would refuse: he asked RKO for one year's free use of their studio and three properties—*Animal Kingdom, A Bill of Divorcement* and *Little Women*—and an enormous amount of money of which I only saw my normal contract salary, $50,000 or something like that. Selznick said to Leo McCarey, "Do you still want her that badly?" and McCarey said: "I'm so glad she's for sale." [Gales of laughter.] Well, the picture turned out beautifully, as you know, and it wasn't at all difficult listening to Crosby sing. So he had to eat his words. RKO said I had a marvelous agent—he keeps 90 percent and gives you 10 percent! [Laughs.] It never bothered me at all. I think Selznick handled me marvelously—he was great.

J. K.: Do you think being an actress in Hollywood has changed now?

I. B.: There's not the emphasis on their private lives, who they go out with, the clothes and the hairdos. You don't see that anymore. It's come down to being a job—you're an actor or you're a dentist, it's about the same. It's lost the glory. I look on myself as an entertainer. I went in to do a job to entertain people. If, on top of that, you become a star, it doesn't interest me very much. Why would I have gone to Italy if I'd wanted to be a star and on top of everything? I hadn't fallen down at that time—I still got the best scripts. But I didn't *want* it. I wanted to become a serious actress—and I went to Italy to work with Rossellini.

J. K.: Working with you, Rossellini explored things *he* hadn't done before—less "Italian Realism." He began to give a little. Working together, you both broke images.

I. B.: Having done that, I ought to say that those Italian movies met with no success whatsoever. I then went on the stage in Paris and managed with an awful lot of hard work, because it is an awful lot of hard work to learn a foreign language. I did *Tea and Sympathy* there. My husband went to India at that time.[2] Then *Anastasia* just came up. And why shouldn't I do it? It was an excellent part and I was delighted to do it. It's not a question of being fickle and jumping from one country to another in any kind of neurotic way. It was an excellent part and I was delighted they came and asked me to do it. Also, since everyone said those Italian movies were no good, I thought perhaps it wasn't right for me to stay there. So, especially since my marriage had broken up, there was nothing to stop me going back to do *Anastasia*—but it wouldn't have mattered what country it was being made in. If you give me a marvelous part to play in Australia, I'll go to Australia, I couldn't care less.

J. K.: There's a scene when Yul Brynner is really torturing you. You've always had a rare mouth ...

I. B.: Ah, a *generous* one. [Peals of laughter.] Yes, I've read about it.

J. K.: But your mouth controlled that scene, and gave the audience back the dream it had with *Casablanca*. That was a marvelous movie to come back in, you must agree. [Ingrid had no choice. She agreed. Or allowed me to think so.] Let's talk about Carl Froelich, a big director in Germany.

I. B.: When I got an offer from Germany from Froelich, I knew he was a good director, so I accepted it—merely to see if I

could act in a foreign language. I had a teacher who helped me with the dialogue, and I found I was capable of doing it. Froelich took me to see Hitler speaking in a big, open arena with *thousands* of people there. I remember them all going with their Heil Hitler sign and I didn't do it. Now, I had never been interested in politics, but I just felt, "Why should I, a foreigner, do this?" Carl Froelich was very angry with me and said, "You've *got* to do it. We *all* do." I asked why and he said he'd get into trouble if he was seen with someone who refused to do the sign. He said the picture might not get released. Well, I thought that was awful. Then I remember my leading man, Hans Söhnker, took me out in his car and showed me closed places, telling me that behind the wire they were doing military training. They said the men went around with shovels, but Hans believed they were guns. He said it wasn't any peaceful movement—there was going to be trouble. He told me about concentration camps—oh, yes, he knew about it, he'd heard rumors, though nobody could really find out about it. He said he was terribly worried and unhappy for his country. Then my teacher in German told me she had a son and she didn't want him to join the Hitler Youth. Because of that, he'd been hit and sent home from school, you know. All kinds of problems. Finally, he'd begged his mother to let him join, but she was firm. But in 1938 the choice was plain: either join the Hitler Youth or that boy would get kicked around at school and fail his exams. Anyway, she refused to buy the flag you were supposed to hang out of your window on days of celebration. The next day she found her windows broken. Every time they were mended, they'd get broken again. And though she didn't earn much working in the studios, she stuck to her guns. Then they came to her door and asked her why she didn't buy it. She said she couldn't afford it, so they broke her windows again. As she said, "What can you do in this country? You just have to do what they say and follow the big movement or you get into trouble."

I remember when I came back to Germany with the American troops to entertain the soldiers, right after the war, I met Hans Söhnker in Berlin. He looked me up and I was with Larry Adler, Martha Tilton and Jack Benny. We went from place to place entertaining the soldiers. I did a sketch with Jack Benny and then did the monologue from *Joan of Arc.* I did all of Maxwell Anderson's monologues and explained the story

to them. Anyway, when my American friends heard Hans Söhnker was arriving, they all said, "Watch him come in here and start telling us. … You can't find a Nazi anyplace. They're all against it now." So I just had to tell them he really was against Nazism because he'd told me about it in 1938.

So on the set of *Die Vier Gesellen* it was difficult because you could feel there was something brewing, though, as I say, I wasn't interested and just went there to make a movie. Carl Froelich liked me and wanted me to come back to do *Charlotte Corday.* I was delighted because that was a figure I thought was wonderful. Then came a veto—we weren't allowed to do any such story because that would antagonize the authorities. Then the war started. I came back from that picture and sat at home, having done *Intermezzo* in the spring of '39. I sat through the summer in my living room, sewing curtains, and on the radio I heard about the invasion of Poland. By contrast, everything was so gay and free in Hollywood; in Germany everyone had been so frightened. In a restaurant, if you spoke intimately, you gave what was called "the German look": look left and right over your shoulder and *then* say something. I mean, the *fear* was something unbelievable.

J. K.: Froelich was sort of a mixture of Clarence Brown and George Cukor.

I. B.: Yes, he was very fine. Very professional. I remember in one scene I didn't speak too well, but I played it well. They said, "Stop, you stumbled on a word, it's not perfect." I said, "Well, does it *really* matter!" because I'd really got the force and feeling and strength that was needed in that last shot and anyway everyone knew I was Swedish. But they said my German had to be the number-one priority. They cared more about how I pronounced the German words than about the acting! [Laughs.] That irritated me.

J. K.: It's interesting that two of Germany's biggest stars at that time were both Swedish and they epitomized the Aryan look—Christina Söderbaum and Zarah Leander. You look the same, I'm surprised you had any trouble. When you worked there, did you meet any of the German film colony? Was there a welcoming party as in Hollywood?

I. B.: No, not at all. I was only there for two and a half months at the most. I don't think I met anyone except for the people I worked with. Froelich was a nice, pleasant man, but I don't remember anything exceptionally great about him. I only had ex-

perience of Swedish directors, like Molander, and I certainly liked my Swedish directors much more. The UFA studios were much more professional than in Sweden; technically, everything functioned and there were bigger crews. And Hollywood was even bigger. I went from small to medium to large, that was all. I wasn't particularly impressed by their proficiency because I never think of that sort of thing much.

J. K.: When you were in Germany, was there any propaganda in *Die Vier Gesellen*, made in '37? Nazism was everywhere. Or was it a movie that could have been made anywhere?

I. B.: There was no propaganda in it, as far as I remember, but, as I say, I was politically very naive. I mean, actors aren't like that; they talk about their next picture, and the last play, and about other actors. Of course, today they are more aware; look at Vanessa Redgrave or Jane Fonda. They both realize they must contribute towards making the world better in whatever way they think is most effective. So, though I don't remember any propaganda, the picture was nevertheless very controlled, and anything against the regime, against the establishment, would have been absolutely out. It was really an entertainment film, though. I don't remember if there were any pictures of Hitler in it. Wherever you went in Germany, you see, in private homes, banks, studios, there would be photographs of him on the walls. I was so impressed, I said, "In Sweden the King isn't hanging on the walls. And here is Hitler everywhere." I didn't know it wasn't out of love that he was there, but out of fear.

I remember being told that some comedian in his cabaret act had the line "Heil ... what's his name, what's his name?" I don't know if he went to jail, but he certainly didn't work for a long time. Hitler had no sense of humor. Goebbels was very interested in entertainment, and actresses in particular. It worried me very much because Carl Froelich told me that if Goebbels asks me to go home for a cup of tea, then I was just to go. I'd made up my mind that I wouldn't. I said, "I certainly will *not*. I'm not German, why should I?" With his reputation for being fond of actresses, I didn't want to, though the story went that if you didn't stay very friendly with Goebbels, he could ruin you. The good thing for me was that he never ever approached me. He wasn't interested in Swedish actresses!

J. K.: How does a director stick in your mind? How they got a performance out of you? How they behaved on set?

I. B.: I particularly remember directors who've got a perform-

ance out of me that I couldn't have got out by myself. Very often you get a director who tells you to come a little forward to the camera, to watch out for the lamps and keep your eye on the little mark on the floor, and who to look at when you say your line, and that's all. So your own performance is your own interpretation, and they only come through with very small suggestions about intonation or not to use your hands when you speak. Then there are other directors who can really give you marvelous ideas that you've never thought of. Cukor is one of those, so was Victor Fleming, and Hitchcock, and Leo McCarey was wonderful. It's awfully difficult to explain what they did that was so different. So it's a question of whether an actor can show something and then on top of that a director realizes what an actor can do and gives you another push in that direction. That's what makes you open up.

The boxing sequence, for instance, in *Bells of St. Mary's*— that was completely unrehearsed. We didn't know what would happen. So he gave me the words and showed me what to do and then we just shot it several times and new things would keep coming in. Just little touches—doing things with your feet, looking worried about your clothes, a way of pushing your hair back, that sort of thing. Cukor explains everything in such detail that sometimes you feel like saying, "Please don't say any more because my mind is so full of explanations." I used to tease him by saying if it were a little line like "Have a cup of tea," he would say what kind of a cup it was and what kind of tea it was until you got so worried you couldn't say the line.

J. K.: In *Gaslight* did you study a lot about the Victorian period?

I. B.: No, not at all. That was just a woman—I couldn't care if she lived in England or America or wherever. If it's a book, then I read the book carefully and read what the author has said about the character: whether she limps, smokes a lot, is deaf, how she moves. Those things I remember and try to put into a characterization and into the script. Like in *For Whom the Bell Tolls* there was so much description of the character in the book that didn't appear in the film script; I used to come along and say, "Look, in the book it says ..." and "You've lost this beautiful line in the book ..." So they'd put it in for me. All along in my career they've always told me I read too much [giggles] and that I'm too faithful to the author.

J. K.: Where did you get your idea of how to play Ilsa [in *Casablanca*], since there was never a finished script?

I. B.: Well, I played it the way Curtiz wanted it. I saw the film the other day and it's obvious from the start that she loved Bogart very much, in the true sense of love—she respected and admired her husband and went with him because there was a cause and he needed her and so she went with him from a sense of duty. But her love as a woman was certainly for Humphrey Bogart—at least, that's what I got out of the picture, and I'm sure that's how I played it.

J. K.: Were you in any other films where you didn't know from day to day what would turn up in the script?

I. B.: In my Italian period, yes. Otherwise the scripts usually were finished, but a lot of rewrites were still done. Even *Intermezzo*: David Selznick was always sending notes down. We'd get these rewrites and say, "We've already shot it, for heaven's sakes." We'd do a scene in the morning and in the afternoon a rewrite would arrive! He was impossible. He never could make up his mind, you know, that that was it—he always wanted something better. We went over and over my entrance because he wanted my arrival in the American film world to be like a shock that would just hit people between the eyes. He wanted people to remember it. Omar Sharif certainly had that in *Lawrence of Arabia*, that you'll never forget—a beautiful entrance. The sun and a camel. Now, my entrance was opening a door, hanging my coat up and stopping to watch a father looking at his little girl play the piano—there wasn't much I could do to make a tremendous impression. I can't tell you how many times I did it and redid it. My last day in Hollywood—I'd done so many retakes on different scenes—and he said let's shoot that scene again. I said, "What *can* I do? I mean, there *isn't* anything I can do." We shot until I packed my suitcases to go home. I took them into the studio and I was still doing that scene when my train left. I said I really had to go. I had to run with my makeup and costume on to the station.

J. K.: It was more Selznick's movie than Gregory Ratoff's.

I. B.: Yes. To be honest, it wasn't much Ratoff's movie. We had the Swedish version and a moviola on the set which we watched and did very much what the Swedish director had done. Leslie Howard rehearsed the dialogue with me and helped an awful lot. And what with Selznick and all his retakes, I have to say that Ratoff took a back seat there. I don't know how he felt about it. Sometimes he'd shout a lot on the set when he had to wait too long for some lighting or something.

Yes, he was temperamental, but he was also a dear, sweet man. And very funny. His accent was very funny to listen to. He used to come up to me and say, "You don't read the line right. Listen to me …" And Ruth came up and said, "For God's sake, don't listen to him! Listen to *me*!" Because his accent was worse than mine.

J. K.: One of the big things about Hollywood, besides the films you made and the people you worked with, was the publicity machine, people like Louella Parsons and Hedda Hopper. Was there anything similar in Germany?

I. B.: I'm sure I had a publicity person on that picture too. I had interviews, and stories were written about me because I was well known from my Swedish movies that went over to Germany. So I wasn't an unknown face. But it isn't anything that I can particularly remember as I can the Holly-wood publicity machine, which was really fantastic—everything they poured out. I don't think there was a German equivalent to the power of Hedda Hopper or Louella Parsons. They were absolutely an American fabrication. And nothing comparable in Sweden or Italy. I was very surprised at the power those women had. People were so afraid of them and everyone read their columns—I think it was the first thing they turned to, never mind about the war. It just stunned me that they were so important.

I was doing *Joan of Arc* for Walter Wanger, and this big party was for Louella Parsons in a big locale and *everybody* was going. You had to pay too. You paid $25, I think it was, for the supper. Now, I got my invitation and I threw it in the wastebasket. Then I got a second invitation and I threw *that* in the wastebasket. Then I got a call from my producer, Walter Wanger, saying he'd had a call from Miss Parsons' secretary that she'd sent me two invitations and I hadn't answered. I said, "No, because I'm not going." He said, "You have to go. Everybody *must* go. She has a list of those who refuse to go and we'll be in trouble with the picture." I said I didn't work like that and I didn't see why I should go and honor a woman who has been writing a lot of silly stuff about me and my friends. I didn't want to go to her celebration. He said, "Will you please, then, say that you'll be out of town and can't make it, and send her some flowers?" I said, "No, I will not." I mean, the invitation said are you coming or not, and I wasn't and I didn't see that I had to send her any flowers. Well, there was such an argument about

it and I never did do a thing about it. I'm not quite sure if he didn't send her some flowers in my name. I don't know. But she had *that* much power—it's unbelievable.

J. K.: Did you ever reach an understanding with Hopper, Parsons and what they stood for?

I. B.: Well, no. I was always against them. I certainly *never* invited them to *my* parties and I knew they were against me because I never sent gifts. They couldn't get into their houses on Christmas Eve for all the gifts they were sent! But I never sent them anything, ever. They were against me, but they couldn't get anything off me. But Hopper was funnier because she was openly nasty and asked direct and nasty questions which made you just laugh. But Louella tried it the other way round; she would be very, very sweet and try to trick you into … For instance, she said to me once, "We have so much in common, you and I." I said, "Oh, really? What?" "We're both married to a doctor," she said. "How do you keep *your* doctor?" [Laughs.] But anyway, when I went to Italy and stayed there, they were delighted because for ten years they'd wanted to get something on me. And they certainly did. All hell broke up. Louella Parsons was the first one. She said she cried over her typewriter when she had to write the news [laughs] that I was delivering a son! I think they were tears of joy.

J. K.: Did Selznick ever say to be more careful how you treat them?

I. B.: Oh, yes. I was warned all the time that I should be nice to them and so on. But I didn't do anything. Hedda Hopper came to Italy—I invited her to come to a place in the country. And my husband [Rossellini] absolutely refused to say anything. It was very funny because everything she asked him, he said, "I don't know." He knew they were important too. I asked him should we invite her or not. He said, "Well, I don't know. If you really want to see her …" I said I thought it might be good if we talked to her because if we refused she might go back and write a horrible story, so maybe it's better she sees how happy we are, how nice everything is, with her own eyes. And then that might stop things they were continually writing about how unhappy I was in Italy and what a terrible mistake I had made, you see. Then, when she came, the first questions she asked were about people in the industry, and was it true that so-and-so did such-and-such. And he hated her gossipy attitude immediately. He said, "I don't know what you're talk-

ing about. Those things don't interest me." I was getting terribly nervous because I *had* invited her, so now I had to at least talk and say things. But he was absolutely no fun and walked away. Anyway she wrote a very nasty article saying that I'd had tears in my eyes all the time. You know the sort of thing: "*She* said she was very happy, but I could see through that … and as I left she was standing at the window staring after my car, longing for the freedom to go with me and come back to America." I mean, she made the whole thing up! Just the way she wanted. So that's what I got from inviting her to my home. [Laughs.]

When I first came there, I said to Mr. Selznick—when I realized what the publicity machine was like—I said I wished he wouldn't build *any* publicity. Let the audiences discover me with no publicity at all. Well, he said it wasn't done like that in America; when they got stars from Europe, the machine had to go with stories about their temperament and breaking mirrors, screaming and yelling, and their great loves. People have to see their names and photograph them in bathing suits. I said, "I'm terribly sorry, but I'm not going to make one picture in a bathing suit, and I'm *not* going to have my photograph taken in a funny hat. I'm only going to have pictures taken that belong to the movie." He was so stunned by it. He said, "How do you mean, 'let the audience discover you'?" I said to let the picture come out and we'll see what the critics write and what the people say, and then we can go on from there. If they didn't like me, I said, I wouldn't come back to America, because I didn't want my career in Sweden to be ruined for nothing. I said that if they built me up and then the audiences didn't like me, it could ruin me in Sweden. But if we were very humble and I was just presented as someone new from Sweden, then we could go from there.

Well, he was so surprised by this approach that he accepted it. During the whole time [shooting the film] I had no interviews—Hopper and everyone was trying to get on the set, but they weren't allowed, except the last day before I left, I was supposed to see Louella Parsons. He [Selznick] kept it up—he was terribly good. And of course he got a lot of publicity from it: that he had an actress from Sweden that he refused to let anyone talk to. That made everyone think, "What is she?" Everyone but Garbo gives interviews, you see. I went to Louella Parsons in her home to talk. She was very sweet to

me—there wasn't much she could say or do to me. But I never did see Hedda Hopper that first trip to America. I was very carefully prepared for the Parsons interview: Don't tell them you have a child, because here actresses don't have children—we don't want that image of pregnant women around. You know that most people in Hollywood adopted children to keep their image of the beautiful woman with the beautiful body.

J. K.: But you were young and unknown and too tall, and here was this man who'd made *Gone With the Wind* and for ten years had been one of the most fêted producers. How come he was so easy with you?

I. B.: Well, he just was. I gave him good ideas. He was always easy and *wonderful* to talk to. Oh, yes, absolutely. We had a problem when I went away to do Joan of Arc. I'd always wanted to do that and I'd finished my contract with Selznick and wanted to be independent—working for myself, getting the money myself and not giving it to him! But I liked him so much. My husband had arguments with him in those days about contracts, but I wasn't involved in the business part of it. But I remember I was terribly unhappy when I went to New York to do the play [*Joan of Lorraine*] because we weren't on friendly terms since I hadn't re-signed with him. Then I saw him at a party one day, sitting at a table not looking in my direction. I finally sat down beside him and said, "David, I cannot go to New York and do Joan of Arc if you don't wish me good luck. I want us to be friendly again." I think he thought it was a mistake that I was going to be on the stage again. But finally he said very gruffly, "Good luck." Then he started a big campaign that he would do the movie of *Joan of Arc* with Jennifer Jones. I was then in the play when big ads started appearing all over the place saying, "The next Selznick production will be *Joan of Arc* with Jennifer Jones." I talked to him on the phone and he said, "You see, I'm going to do the movie." I said, "So am I. When I've finished the play, I'm going to do a movie too." He said, "You can't do that because my movie will come out first." I said, "That's fine because then I can rent all my costumes from you—I'll get them cheaper." He said, "You know very well two movies can't come out together." I said, "Why not? It's interesting. You can compare the performances and the qualities of each." Well, he never did do the movie and I did do mine. But there was just that little period of difference. We

got on fine afterwards. I was never unhappy about him selling me for such high prices to other studios and me not seeing a cent of it. People tried to make me angry about it, but I just said that I signed the contract and if he could get $250,000 to my $50,000, it was all right by me because he was clever and I was not.

J. K.: How many of your films did he personally supervise?

I. B.: Only two: *Intermezzo* and *Spellbound*. On all the others he sold me to Warner Brothers or whoever. Paramount, RKO.

J. K.: When you came to Hollywood, you were given really good parts—better than most actresses of the period. You were idealized, worshipped. Why, then, by 1947 couldn't you wait to get out?

I. B.: I was tired of it because it was the same thing somehow. It was very unrealistic—the pictures—and the censorship was very harsh. So if you wanted to do something a little more risky, it was out. Things were too glossy and everybody talked about box office and more box offices. I remember saying, "That picture wasn't very good, was it?" and they said, "Wasn't very good! Why, do you know how much money that picture made?" Well, so you talked about how much money it made and didn't bother about the quality of the picture.

And I wanted to move out of there. I wasn't very happy. It was neither town nor country and you felt as though you were in a factory. Then when I saw *Open City*, it struck me because I had this hunger for something realistic. I saw the picture and it had such humanistic qualities, it was so *true*, and it was shot the way people look—no makeup, no hairdressing, the clothes were right. Maybe there are pictures in America that way. I remember someone saying, "My goodness, those pictures we made twenty years ago when we didn't have good lights and couldn't afford things." Actually, my husband, Rossellini, told me that Neo-Realism came about through lack of money. They had to go out and get what they could: they couldn't reshoot much, people wore their own clothes and the lighting was very poor. So it was very true to life and I wanted to try that.

I've always wanted to be in places where there was great exchange of thought, where I can learn something. I adore to learn new things and know people's reactions to things. Sweden seemed too small and I felt I had to get to a bigger country. When I got there, I felt I'd learned everything Hollywood had to give.

I'm not ungrateful, you know, for the pictures I made there, because they *were* the best and wonderful people to work with. But there was some kind of longing to make something that was more of an event, more dangerous. I didn't want things to be steady, and there was too much security in Hollywood. I just would like to go out and fly a little higher, you know? I wasn't disappointed when I got to Italy either. I did learn an awful lot and it was as different from Hollywood as night from day. There was not the organization or money to be had, and there was no waste shooting from all different angles. It was shot one way because he had his story already written in his head and he knew what he wanted. It was fast going except for the days when he just didn't feel like work. So there were some days when we did very little because he just didn't have the ideas. He works instinctively on something— he's not a man that can work from 9:00 to 5:00, he works when the spirit moves him.

I certainly *did* find the reality I was looking for in the Italian movies. But I'd then been trained for ten years in America and years in Sweden having a script and dialogue and rehearsal time. I was very upset by having to improvise in Italy. You had to just make the dialogue up. Well, I couldn't. There was a cocktail conversation in *Europe '51* and he said to make up the conversation just as I do when people come into my home and have drinks. But I didn't know what to say. It was difficult. Another scene in the film was me talking to a man about the housing problems: the poor in the slums and the problems they had and how things should be improved. It was kind of a Communistic way of speaking, and I didn't know what to say … just "Yes" and "Really?" They wanted this man's thoughts on film and he wasn't an actor but a real man who lived in that community. They'd built a track and we were supposed to walk along in conversation. It was unrehearsed, and whenever he gave me a chance, my dialogue was "Oh, yes" and "Really?" We finished the track and he went on talking, and finally I see the director and the cameraman standing over in a corner having coffee and there's no one around us. So I stopped and said, "What's going on here?" Roberto said, "You can stop talking to him now because we ran out of film a long time ago." [Laughs.]

He built *Europe '51* around me because he had me and he knew he had a good story and it was for me. He had the idea:

What would happen if St. Francis of Assisi, or a man like that, came back today? He'd be called a Communist immediately. He switched the part to a woman to give me the part. So it's a woman who leaves her family and riches to help the poor and lives the humiliation of St. Francis of Assisi. What you would say of such a woman today is that she's insane: she ruins the reputation of her family and she'd be put in an insane asylum. And that's what happens at the end of *Europe '51*.

J. K.: Having made six films together, did you get more used to the improvisation technique?

I. B.: No. And I think I realized that I wasn't that kind of an actress. There was Alexander Knox and George Sanders[3] there as well, but I felt very foreign to the rest of the cast and bewildered by the technique. We also did a German film, in which Mathias Wiemann played my husband. We were all actors in that. But that picture didn't turn out well either.

These pictures were not at all bad pictures, it was just that people didn't like them. Today they like them better. At the time I thought *Stromboli* was a very touching movie and a very true, believable story. But people were so taken by the private scandal [the Bergman-Rossellini love affair] that they were against it from the beginning. I remember reading in *Variety* when the picture came out in several movie houses at the same time that they would see if the movie were a success, and if it weren't, they'd ban it. I was very fond of *Europe '51* too. The one I didn't particularly like, *Voyage to Italy*, is now shown very often on the television and is considered an extremely *avant-garde* picture for its time. But at the time I didn't enjoy it. George Sanders too was very unhappy and couldn't get into the mood of improvisation—he was a problem on the picture and everything was very difficult. I'm surprised that now it is well received. I never thought that would happen.

But I'm surprised at *Casablanca* coming back too and all those old films that get shown on television, cinémathèques and national film theaters. At the time one just thought, That's it, and there was no future for the films. When I was in Hollywood, old films were dead. There were no art houses—that came much later. People would come from Europe and say, "How come Hollywood doesn't have a museum? Shouldn't they have Chaplin's shoes and walking stick, and Chevalier's hat, and Garbo's clothes?" There was absolutely nothing saved. I remember people at Cinémathèque saying, "If we had the

money, we'd go over and buy *everything*. The trains, the boats and the clothes. The Americans don't understand that one day these things will be terribly appreciated." People were what they were because of the work they'd done—I mean, you knew that Cary Grant was a great actor and wonderful performer because what he'd done remained in the memory. But I can't remember them bringing back any of those old pictures then. Everything was absolutely for the present. The Museum of Modern Art in New York started the whole thing by collecting old movies—Pickford and Fairbanks. Only in New York could you see Dreyer's *Joan of Arc*.

J. K.: *Spellbound* brought you into close contact with Selznick and the way he worked. Hitchcock was very much his own man, but Selznick had a reputation for interfering. How was their relationship?

I. B.: Well, I think Hitchcock was the only director who was independent of Selznick—he wouldn't stand for the notes. On any of Hitchcock's pictures, if a producer or author came onto the set, he'd stop the camera and say there was a mechanical fault. Soon they got the hint that the camera would work when they were *not* present, but not while they were on the set. He was absolutely marvelous doing what *he* wanted, cutting it all himself. I think he handled Selznick the same way and Selznick accepted it. Selznick kept sending the notes, but this didn't perturb Hitchcock, who just said, "That's too bad" if he didn't agree. The movie was his.

J. K.: How did *Spellbound* come about?

I. B.: Hitch must have gone to Selznick with the story and he accepted it and asked for me. It was all Hitchcock's story, I don't think Selznick had found it—I don't know. I was offered the part and read the script, I'd met Hitchcock before because he was a friend of Selznick's and I used to tell him that I got so many really *awful* scripts that I got so mad I'd throw them at the wall and say I just couldn't *stand* it. Anyway I got this script from Hitchcock and he said, "Remove your husband and child before you throw it at the wall!" That was *Spellbound*.

J. K.: How about *Notorious*?

I. B.: That was made at RKO and was another Hitchcock story. Selznick had nothing to do with that. Hitchcock had said let's work together again and that he'd find another story. Michael Blandford wrote the story[4] and RKO paid Selznick for me. We worked together again in England on *Under Capricorn*. Then I'd already got fed up working on the back lot. Since the story was set in Australia, I suggested we go there, but they said it was out of the question. Finally, they gave me the satisfaction of getting out of Hollywood to go to England. It was only because I nagged about getting out and seeing new places that it wasn't done on the back lot as usual.

J. K.: Was there never any attempt to let the character in that be German or Norwegian, or did she have to stay Irish?

I. B.: Hitchcock wanted her Irish and he said it would be very easy for me to learn the accent. I believed him and I had a teacher to help me.

J. K.: Outside Rossellini, you had the closest working relationship with Hitchcock: in four years you did three films with him. Did you have a special simpático or was it just business?

I. B.: No, we were just very good friends. I still see him now. He's an extraordinary human being and I like him very much.

J. K.: He sometimes refers to actors as cattle.

I. B.: Well, he thought they were stupid, I suppose. He didn't like arguments, you see: "I can't do it this way," "I'm not in the mood," "I don't understand what you mean"—that sort of thing. He had this phrase and I've always been grateful for what it taught me: he had very clear ideas of how he wanted scenes shot and if you started complaining about the difficulties—like "The door's too narrow for me to come through with this big dress, couldn't I possibly just stay in the room?"—he'd sit there as though listening attentively to your problems and then say, "Take it. Go through the door and fake it."

J. K.: His complete control must have been the antithesis to Rossellini's "act as you would at a cocktail party."

I. B.: Yes. And they were both difficult! There are some directors who give out the feeling that they're pleased to be working with you—as Leo McCarey put it, "You are my springboard"—and that naturally makes the actor feel more important. Hitchcock is so sure that what he wants is *it* and that whatever you suggest is something that has to be argued out—which is tiresome for him. But at the same time I'm sure he's liked some of the actors he's worked with and appreciated what they've given to him. But he's cut the picture before he shoots it. He doesn't shoot a lot of angles so that later on he has a lot of footage on the cutting-room floor.

J. K.: Did Selznick or anyone mind the fact that the character you played in *Notorious* was rather dubious morally?

I. B.: It was only that she drank so much and drove the car fast, had lots of parties and false hair. That was my idea. Do you remember? You see her waking up in bed and she has a bun. Hitchcock accepted that. I'm always making suggestions like that in a film and many people tell me I'd make a good director. But I think I'm a better prop man! I always push furniture around because the normal set looks so unlived in. I'm always putting my own things in, tossing paper around, mushing up things or doing something. All my directors have said I'm a marvelous prop man: "The room looks splendid, but I wish you'd learn your dialogue." It's important to me that sets look lived in. In *Cactus Flower* I was writing in that book [a prop] all the time—you can't work with an empty book, you have to have all the names written down or it doesn't look right, it doesn't look like an office. Clothes have to look crumpled and worn and the shoes mustn't be new shoes. That's what gave the false quality in so many of these movies: you saw that their hairdresser was always right behind, brushing their hair and making it nicely for the shot. You know, they wake up in the morning after a terrible night and they look absolutely splendid with long eyelashes and their hair tumbling down so nicely. That was the sort of thing I was fighting against.

J. K.: Did Louis B. Mayer ever come along or have anything to do with *Dr. Jekyll*?

I. B.: No. I don't think I ever saw him in the studio. But I know him because he's my best friend's father—Irene Selznick, David's first wife, is his daughter. I met him in his home and at parties all the time. Maybe he sat in his office and complained about certain things, but he never came on the set ever.

J. K.: Did any company ever try to buy your contract from Selznick?

I. B.: Selznick wanted me to stay on with him after my four-year contract was up. But then the new trend was for actors to be independent. Then they started getting percentages of the movies instead of being on a company salary, and then they made their own companies and worked for themselves. Tapes get switched, answers get lost, thoughts get changed—somehow a question about producers became an answer about Salvador Dalí's contribution to Selznick's *Spellbound*.

I. B.: The dream sequence in *Spellbound* was originally longer. It was beautiful. We worked on it so much. That statue ... my death mask was made and then this whole body of a statue.

Then the body flew away, revealing the real woman underneath. So much of that was cut out. But I suppose someone didn't like it. Dalí was around then—he was already strange! He's stranger now! He enjoyed it very much. There was also a notorious dream sequence in *Jekyll and Hyde*. Lana Turner and I were tethered together like carriage horses and Spencer Tracy was whipping us on with our hair streaming behind us. There was also a drowning sequence. I don't know who designed that—it must have been Fleming. But you know in those days they had a man called Menzies, and he designed every setup. So think what help a director had! First there's the cameraman, who could give suggestions on what a good angle would be, then they had this marvelous artist who drew it. It was all designed—just fabulous. I kept some of those drawings because they were beautifully done. That's a métier that's completely gone now—I'm sure they don't do that anymore.

J. K.: In some respects, artists like William Cameron Menzies were as important as the directors?

I. B.: Well, of course the director directed the actors and Menzies only chose the beautiful angle. We had him on *For Whom the Bell Tolls* and I remember his beautiful drawings. They dictated the setup and the director just had to make sure the camera angle was right. So, whereas in Sweden and Europe the director gave the total concept, in Hollywood it was split between the director and the producer and the designer. Then you had a marvelous cameraman who made sure the lighting was just right. So it's the job of many to make a movie, whereas when you're on the stage you're alone—it's up to you.

J. K.: Hedy Lamarr regretted throwing away the script of *Casablanca*. Did you ever throw away anything you regretted?

I. B.: No, I never regretted it even when the actress who eventually played the part got the Academy Award for it. I threw away *The Farmer's Daughter* and *The Snake Pit*—Olivia de Havilland finally got the Oscar for that.[5] I threw it away because I didn't like the idea of playing everything in an insane asylum—it was too depressing. I'm always told I'm an idiot for throwing that away. I admit it was a good part, but I didn't like it, and I can't do anything I don't feel comfortable in.

J. K.: Did you react at all to the fact that the great producers— Cohn, Selznick, Mayer—who were not really creative, nevertheless had great power over a movie?

I. B.: I thought it was unpleasant that producers and directors

had battles. But the producers very rarely got in contact with the actors; it was usually through the director. Sometimes, though, you did feel that the producer had interfered terribly with the director's point of view, and that he was under tremendous stress—he knew that if he didn't do what the producer said, he'd be fired. Now, over the producer would be another executive producer and then over all was Mr. Mayer. He was so high up he'd never come down to a set: if you ever saw Mr. Mayer, you were always called up to his office, but there were layers of people he'd call up before he ever called the actors. I don't think I ever put my foot in Mr. Mayer's office—that was God himself up there. Then there were archangels and angels, and then it got to us working people. I met Harry Cohn, but I have no stories to tell of him. I never read his biography and he never interfered with anything I did. But I'm sure the directors who worked for him sometimes were quite unhappy because of his very strong … you know, precision. Everyone knew they were very easily fired. There was no lack of putting another man on the job.

J. K.: Are the numerous books now written about Hollywood by people who were never there accurate?

I. B.: Well, I haven't read the books. I did read *The Lion's Share* by Bosley Crowther, the New York critic. That was terribly interesting for me because I learned things I hadn't dreamed were going on. I suppose some of it upset Mr. Mayer greatly, I would think. But these were things I was never involved in— it was a completely different group of people. I think if I'd known what was going on, I'd have left Hollywood earlier! [Laughs.] I mean, everyone was walking around with milk bottles because they all had ulcers. If you said, "Who's put that lamp there?" the answer would be this person had told that person, who'd told so-and-so … there was never anybody there who'd say, "I am responsible"—it was always a long line of giving the blame to someone else, you know. Because of fear of losing their jobs.

Of course, there were so many people on a job, because everyone had to be a specialist: there was only one person allowed to plug in things, and if he'd gone to the men's room, we all had to sit around and wait. Victor Fleming, I remember, would lose patience and plug it in himself—well, that was not good. In *Joan of Arc* I had a girl who was my dresser and she had a whole wagon to put my armor on. She worked like a dog and there'd be lots of people standing around. When I asked them to give her a hand, they refused because they said they'd lose their jobs—they said they could only do their own jobs and nothing else. It was hopeless; the time you spent waiting for the union man was criminal. But the unions became so strong, and if anyone did a job they weren't meant to, somebody else would squeal and the guy would be out. I was told if I wanted shoes, to call the wardrobe gin; if I wanted to rearrange the flowers, call the prop gin; and if you want something else, call the script gin, but for heaven's sake don't do it yourself. I never found that in Italy—everyone does everything there, and in Sweden we were twelve people on the set: the cameraman says he's ready—he doesn't have an assistant to say it for him; the electrician doubled as my stand-in, the hairdresser was the makeup girl and everything was much more simplified.

J. K.: Does this make for better films?

I. B.: No, but it makes for *cheaper* films! The cost of American films became tremendous because of the overhead and all the people who had to be engaged. I remember a Christmas celebration when I was on the stage at New York—there was a party for all the cast and crew. There were people I'd never seen before, and when I asked who they were, they said they were the musicians. I said, "But we don't have any music in the show." They said, "No, but you ought to and we're on the payroll." When I bring my own makeup man, he's English, they pay him a salary, but they also have to pay the makeup man who's on the set as well: he has to be on the picture, but he doesn't do anything. It's not that I don't trust anyone else—I just like my makeup man and I like to work with the same people.

J. K.: Why do you think old movies are so affectionately thought of now, even though they were produced in those union-bound days? Is it just sentimentality?

I. B.: The movies were better. They had stories and marvelous *performances*. They were very good people making them. In Hollywood there was such a collection of talented people: the best musicians, the best actors, the best directors, and they came from all over the world. There only was Hollywood. The other places to make movies—Paris, for example—were good, but if a French director got the chance to go to Hollywood, he *went*. Hollywood was terribly worried that the Germans, Italians or French would get too good, so they'd literally buy up the talent and bring it over to Hollywood.

J. K.: You said that when you watch yourself, you see yourself as a circus horse: is that a kind of protective device so that you yourself don't get involved? Do you think other actors did this?

I. B.: It's just something about being able to see yourself on a screen. When you're onstage, you can't see yourself, you don't know what it looks or sounds like—because, though I can hear my voice, that's not the way *you* hear it. But when you're on the screen, you can hear and see, and I can certainly judge that person as well as the one standing next to it. I can say, "He's not giving a very good performance, and neither is she." You see, it becomes a "*she*" up there—not yourself.

J. K.: Do you think if you have one major failing, it's that you see everything too clearly, that you can't take things for granted?

I. B.: I don't take anything for granted.

1 Events in Sweden changed all that when the Swedish tax man came.
2 While making the documentary *India* (1958), Rossellini, in a repeat of his affair with Ingrid, fell in love with the Indian screenwriter Somali Das Gupta, who became pregnant and whom he married after his divorce from Ingrid. Suddenly it was Ingrid who was the wronged party, and public opinion in America and elsewhere began to turn in her favor. Here was this Italian Lothario who bad wrecked her career and now, after all she had sacrificed for him, he was throwing her over for someone new. It paved the way for an American reconciliation and intensified interest and sympathy in her return as the much put-upon and suffering *Anastasia*.
3 Knox co-starred in *Europe '51*; Sanders was her leading man in *A Trip to Italy*.
4 Ben Hecht wrote the story.
5 De Havilland was nominated—she did not win.

I.

SWEDEN

1915–1939

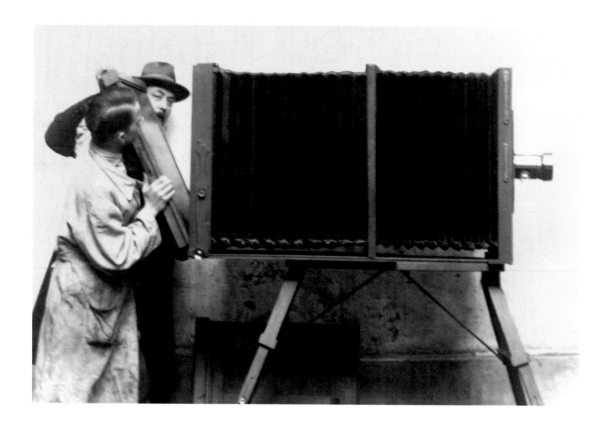

Ingrid's father Justus Bergman and
an employee of his photography studio
in Stockholm with a gigantic plate camera
that bears emphatic witness to the
magnitude of his technical interest,
ca. 1926. Photo: Studio Bergman

A FAMILY ALBUM

Childhood and early sorrow
Adolescence and early joy

Her flirtation with the camera begins at an early age—as a wee tot: one-year-old Ingrid toddles towards her father, who is holding an oddly whirring box in front of his face. Justus Bergman runs a prosperous photography studio in Stockholm. Movie cameras for everyday use are still a rarity, but he is already making home movies.

Ingrid's mother Friedel, nee Adler, comes from an upper-middle-class family in Hamburg. Her parents initially oppose the alliance with a painter lacking a steady income, but they acquiesce after Justus establishes a middle-class livelihood as a photographer.

"My father was a bohemian, an artist, very easygoing, and my mother was the complete bourgeois. But they were very happy together. My mother had three children."[1] The first died during birth, the second shortly after birth. Ingrid was born seven years later, on 29 August 1915, but her mother died before Ingrid turned three. Ingrid is raised by her father; she spends the summer holidays with her grandparents in Hamburg. Justus fosters his daughter's artistic talents. He takes photographs of her in various costumes, sees to it that she receives voice and piano lessons, and he takes her along to the opera and the theater. There she saw:

"Grownup people on that stage doing things which I did at home, all by myself, just for fun. And they were getting paid for it! They were making their living doing it! … And I turned to my father … , and they probably heard me all over the theater I was so excited, as I said, 'Papa, Papa, that's what I'm going to do!'"[2]

When Ingrid is twelve years old her father dies, followed six months later by her aunt, who had kept house for her brother. Ingrid moves in with the family of her uncle Otto and spends her teenage years in his seven-member household. She experiments with her father's camera equipment and takes self-portraits in various poses and costumes. The family spends the summer in the Stockholm archipelago.

Ingrid's wish to apply to the Royal Dramatic School in Stockholm following graduation meets with little understanding as she is viewed as an extremely shy and introverted girl:

"If people asked me what my name was, I'd blush bright scarlet. At school, I knew the answers to many of the questions but I'd never answer them because as soon as I was on my feet I'd go a deep crimson and start to stammer. … Since those days I've discovered that many actors and actresses are like this—extremely shy people. When they're acting, they're not themselves; they're somebody else … "[3]

Ingrid must promise her uncle that she will become a sales clerk or secretary should she fail the audition.

That problem never arises—75 young women and men competed for eight available spaces at the Royal Dramatic School in 1933; Ingrid Bergman is accepted even though she is quickly dismissed from the stage during her audition. One of the jurors, Alf Sjöberg, tells her years later: "The minute you leapt out of the wings onto the stage, and stood there laughing at us, we turned round and said to each other: 'Well, we don't have to listen to her, she's in! ... Look at that stage presence. Look at that impertinence.' "[4] The minutes in the school archive note: "While she has too much the appearance of a country girl, she is very natural, and is the type that does not use of makeup on her face or on her mind."[5]

At the age of 18, shortly after entering drama school, she meets Petter Lindström, a successful dentist eight and a half years her senior.

"I was very impressed with him. ... Then we started to meet regularly. ... Looking back, I'd say it was a slow friendship, which gradually turned into love. ... I began to ask him questions, rely upon his judgment. ... We went to the theater and movies, but I don't think that marrying an actress was part of his future."[6]

When Ingrid Bergman and Petter Aron Lindström exchange vows on 10 July 1937, she has already appeared in five films and become a favorite of Stockholm's cinema fans. The couple cannot, therefore, celebrate their wedding as they intended—in complete privacy and without the press in attendance—in Stöde, Lindström's native village in northern Sweden. A young reporter was hiding in the bushes in front of Papa Lindström's house:

"Someone hauled her out and Petter was being very stern when Papa Lindström came out and said, 'Petter, my boy, you mustn't talk like that to a young lady on your wedding day—I mean, good manners. Now, young lady, will you please come in and have a cup of coffee with us.' ... We chatted away and became good friends, and we've been good friends ever since."[7]

So it comes to pass that, next day, *Dagens Nyheter* bears the headline "Sweden's most beautiful bride avoids the public eye" and runs a picture of the couple.

A year later, on 20 September 1938, daughter Friedel Pia is born: Friedel after Ingrid's mother, and Pia for Petter, Ingrid, and Aron, Petter's middle name.

Baby Ingrid in the arms of her mother Friedel. Stockholm, ca. 1915. Photo: Justus Bergman

Left
**Family portrait with mother (right)
and aunt. Stockholm, ca. 1916.**
Photo: Justus Bergman

Right
**Ingrid's first tentative steps, captured
by her father with his camera. Stockholm,
ca. 1916. Photo: Justus Bergman**

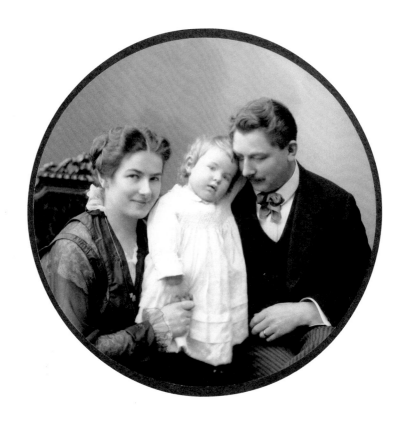

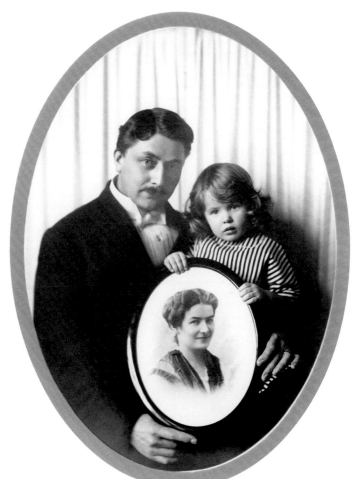

Top
"We are three." The official family portrait of Friedel, Ingrid, and Justus Bergman. Stockholm, ca. 1917. Taken by fellow photographer H. Harsjon, Royal Court Photographer, Stockholm

Bottom
"We were three." The mourning photo—the young widower Justus and half-orphan Ingrid with the portrait of her deceased mother. During the following years until his early death in 1929, her father will be the most significant person in her life. Stockholm, ca. 1918. Photographer unknown

Top
Ingrid around the age of
four with her father's guitar.
Stockholm, 1919.
Photo: Justus Bergman

Bottom
Ingrid cleaning house with
a dustpan and brush.
Stockholm, 1919.
Photo: Justus Bergman

Ingrid posing for her
father in a hammock.
Stockholm, 1919.
Photo: Justus Bergman

Top
Ingrid with her toys.
Stockholm, 1919.
Photo: Justus Bergman

Bottom
Ingrid with a small friend
dressed up to go out as
ladies with hats and
umbrellas. Stockholm, 1919.
Photo: Justus Bergman

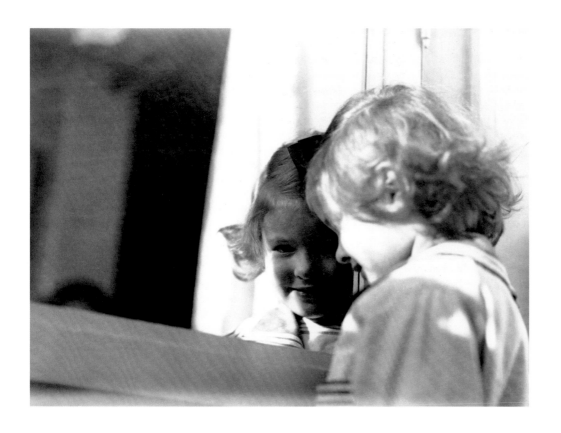

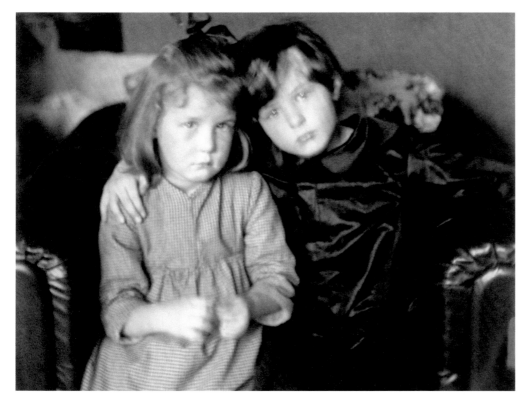

Top
**Portrait of little Ingrid in the
mirror. Stockholm, ca. 1919.
Photo: Justus Bergman**

Bottom
**With cousin Britt (right).
Stockholm, ca. 1919.
Photo: Justus Bergman**

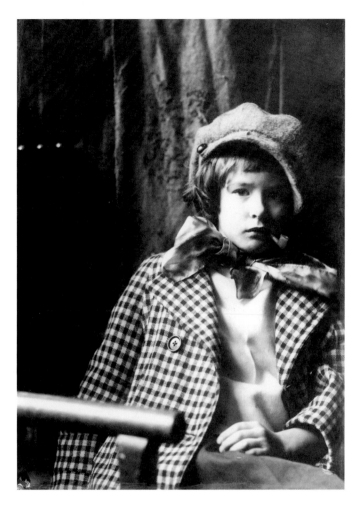

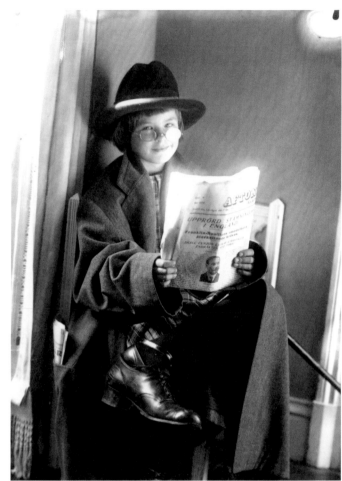

"I used to dress up . . . and my father helped me to put funny hats on, a pipe in my mouth, glasses, that sort of thing ... and he photographed me as I was having fun in his big shoes and all that."[8] Juvenile role playing while her father took pictures was a splendid pastime, and it acquainted Ingrid with posing in front of a camera at an early age. Ingrid is seen here dressed up as a young boy (ca. 1920), as a grown man with men's shoes and a newspaper (ca. 1925), and as a flower vendor (right, ca. 1928). All photos: Justus Bergman

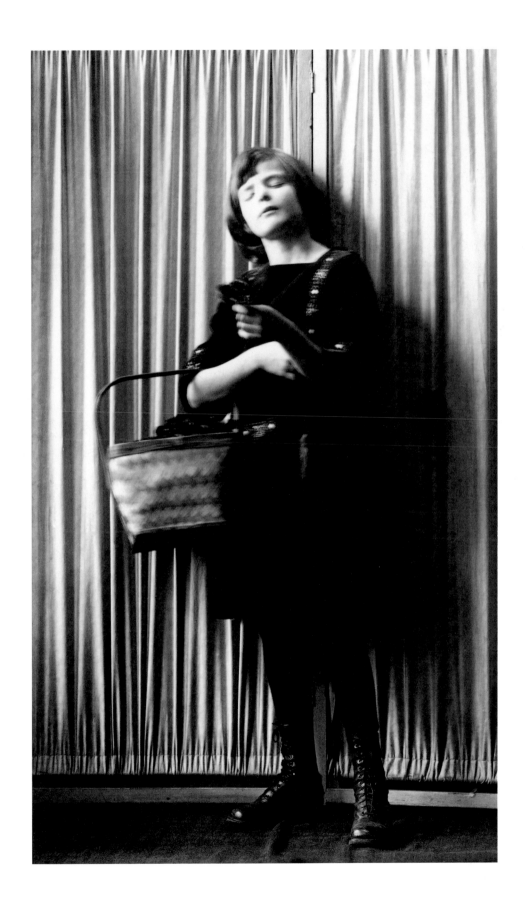

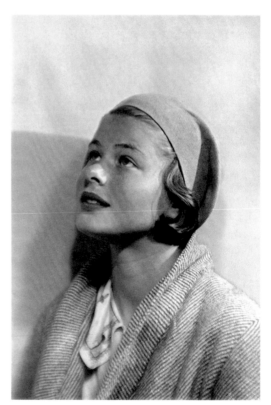

Following her father's death, Ingrid—now an orphan—continues her self-inquiry and search for identity with the camera. Stockholm, ca. 1928

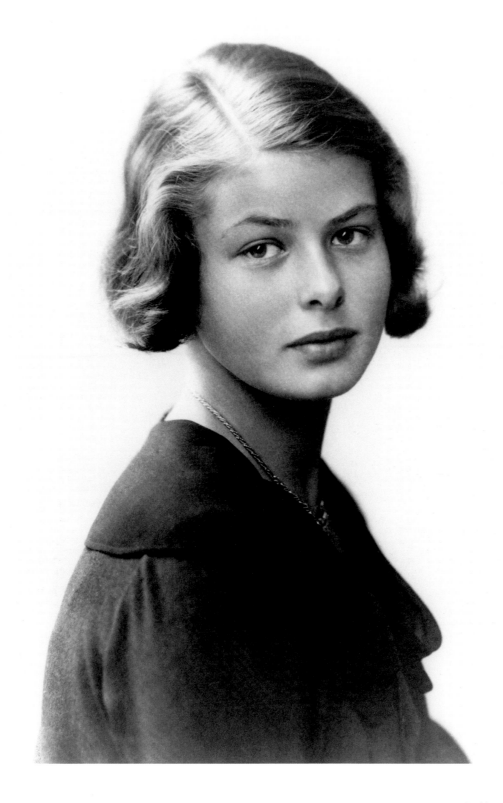

Ingrid, youthful beauty in full bloom, took this self-portrait with her deceased father's camera equipment at around age sixteen.

Summer holiday at Lake Mälaren.
"In the summer, during our school
holidays, there was the little summer
house which Aunt Ellen had left to
me in her will, about an hour's boat
ride from Stockholm. Often Britt
[her youngest cousin] and I would
stay there alone all week, and the
boys and Aunt Hulda would join us
on the weekends. It was a freshwater
lake called Mälaren, and we swam
and sunbathed."[9] Photo ca. 1932,
photographer unknown

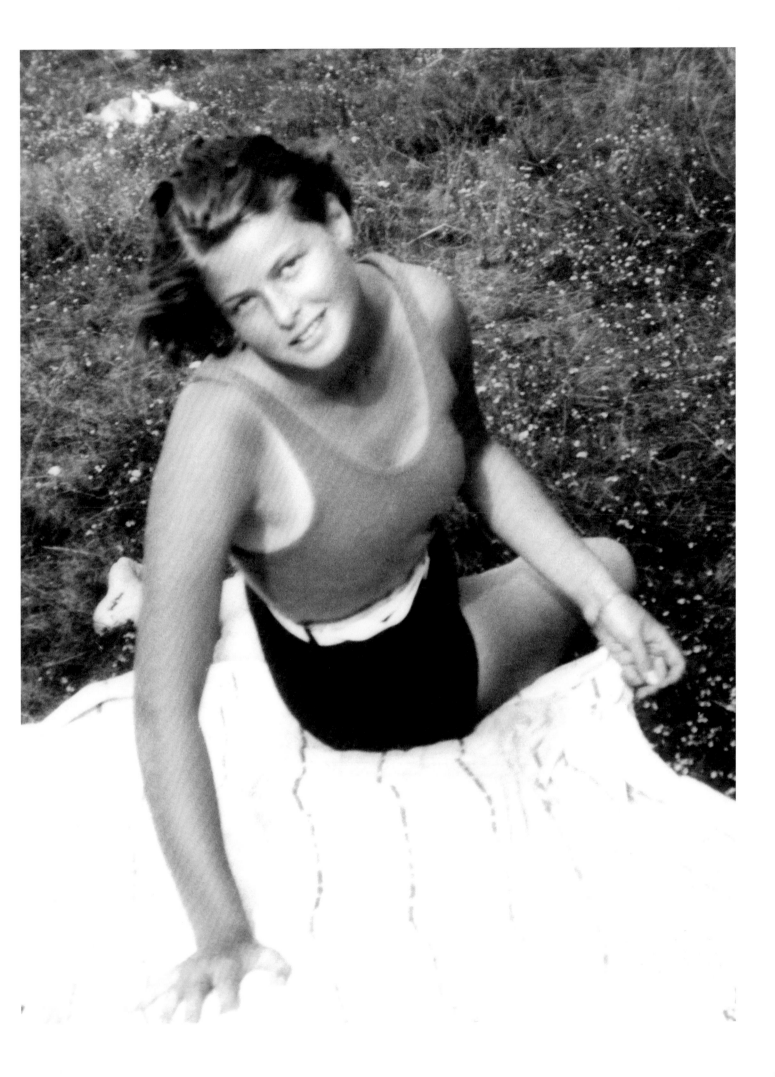

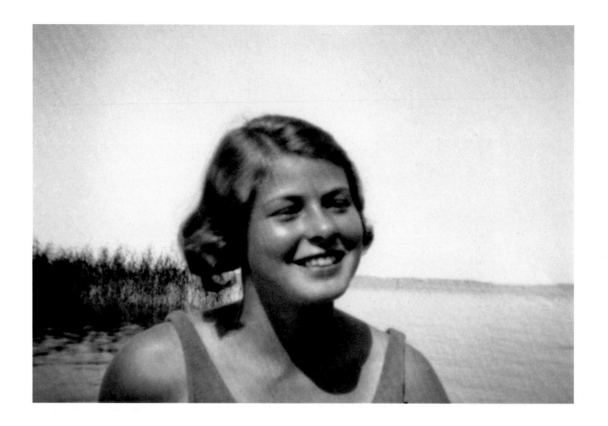

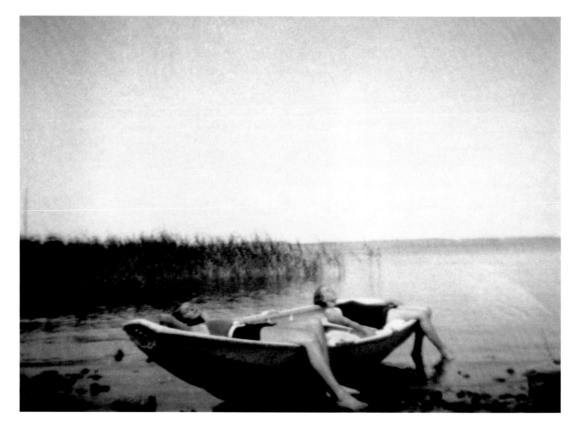

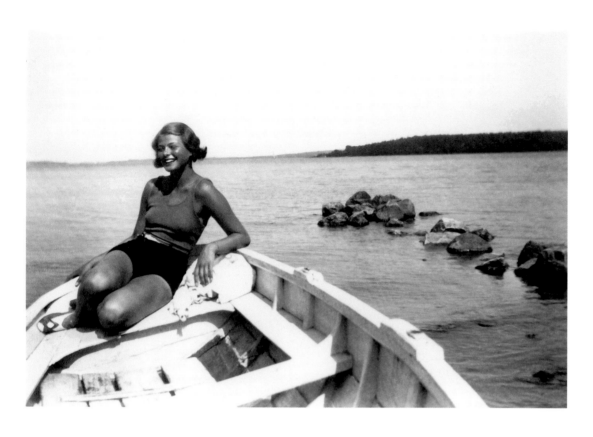

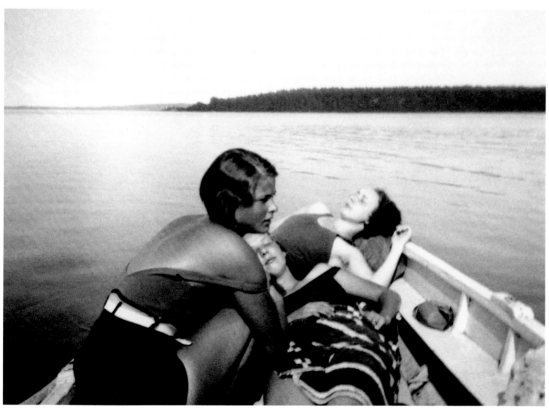

Sunbathing in a boat
on Lake Mälaren with
cousin Britt, ca. 1932.
Photographer unknown

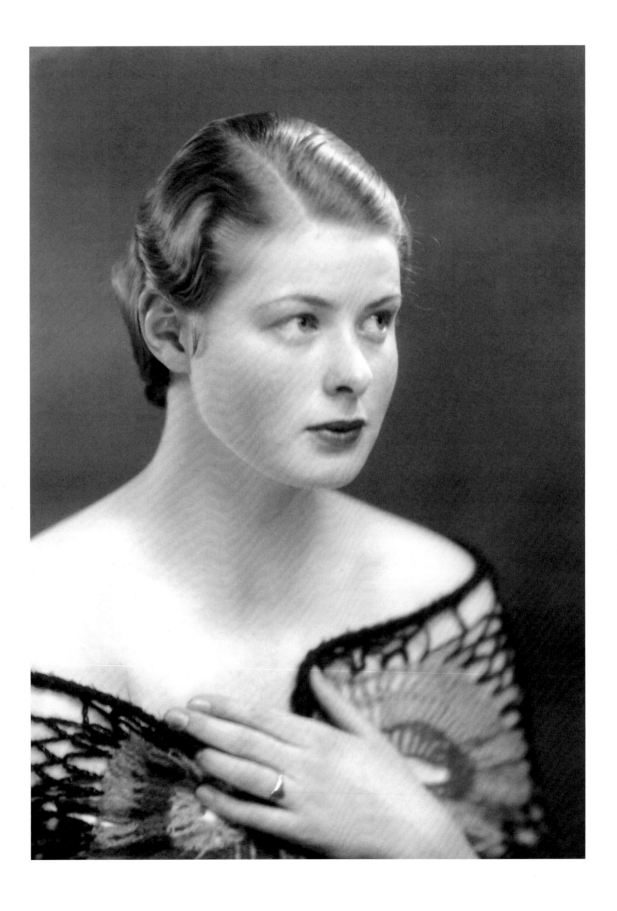

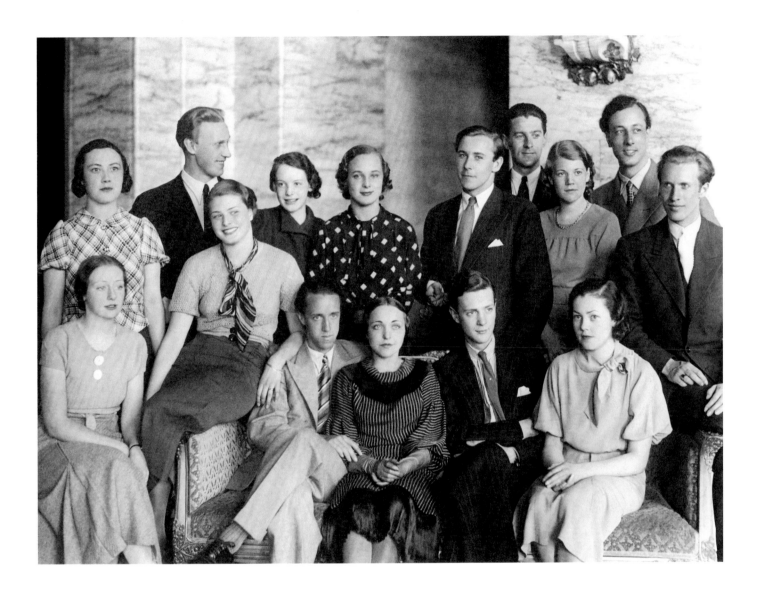

Left page
A publicity shot of the
up-and-coming actress, ca. 1933.
Photographer unknown

This page
Students of the Royal Dramatic School
in Stockholm during the fall of 1933.
Eighteen-year-old Ingrid Bergman is in
the second row, second from the left.

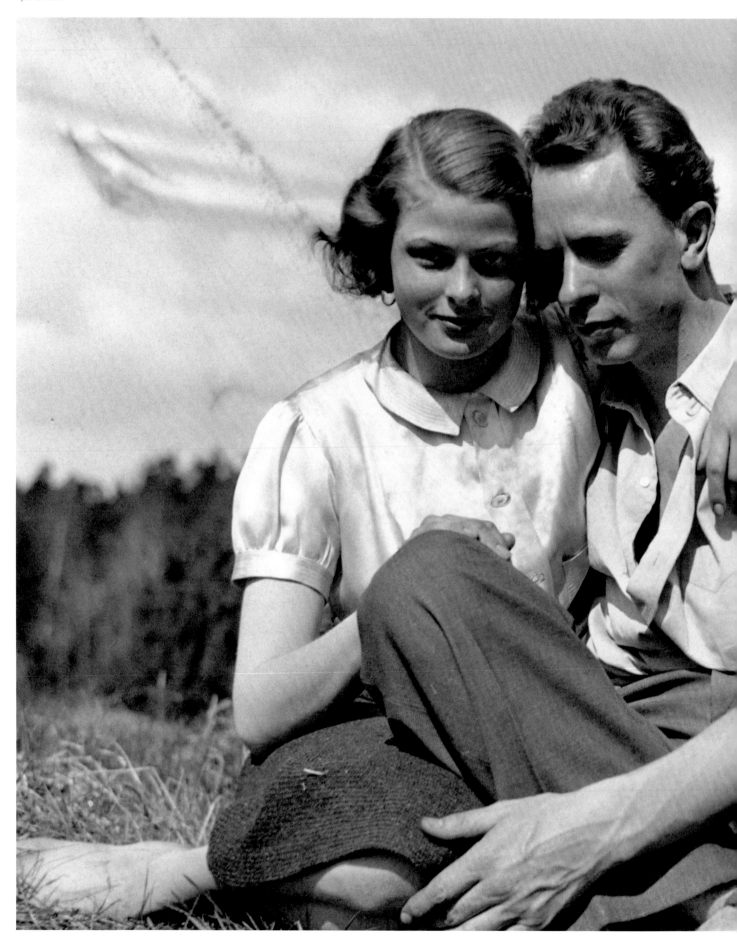

In love. Ingrid Bergman with Petter Lindström, ca. 1936, the year of their engagement. When the drama school closed down for three months during the summer of 1934 and all her classmates traveled to Russia in order to acquaint themselves with the fledgling Soviet theater, Ingrid remained at home because she had fallen in love with Petter Lindström and didn't want to be separated from him. It was a fateful decision in every respect, for it was during this summer break that her film career began—somewhat by chance at first, but then with ever-increasing momentum.

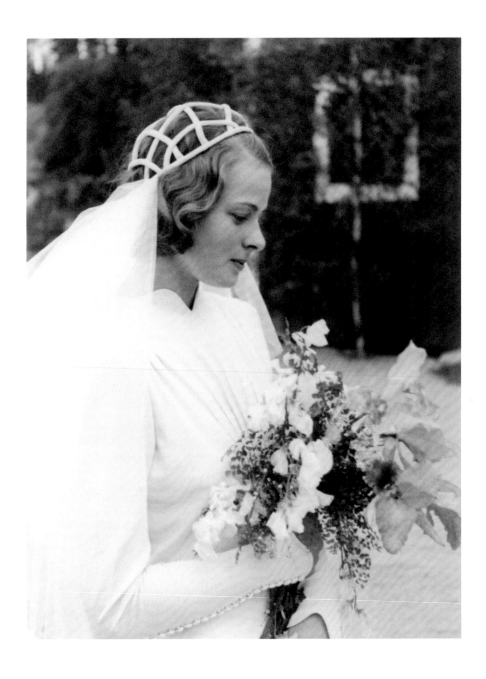

Portrait of the lovely bride on her wedding
day, 10 July 1937, in Stöde, the bride groom's
native village in northern Sweden.
Photographer unknown

Right page
The happy newlyweds
leaving the church.
Stöde, 10 July 1937.
Photo: Barbro Alving

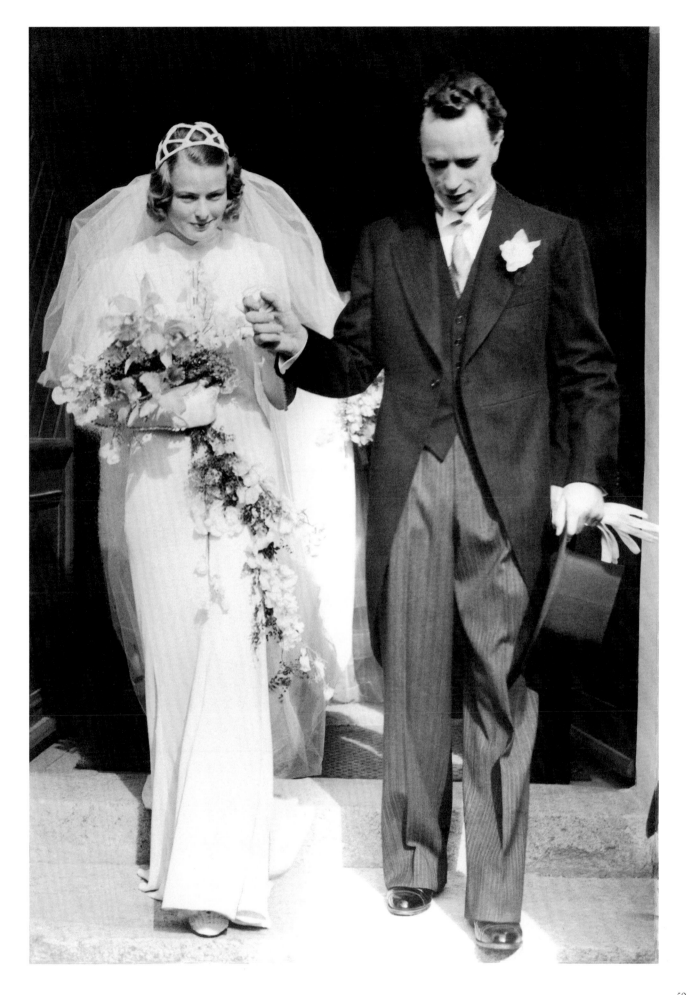

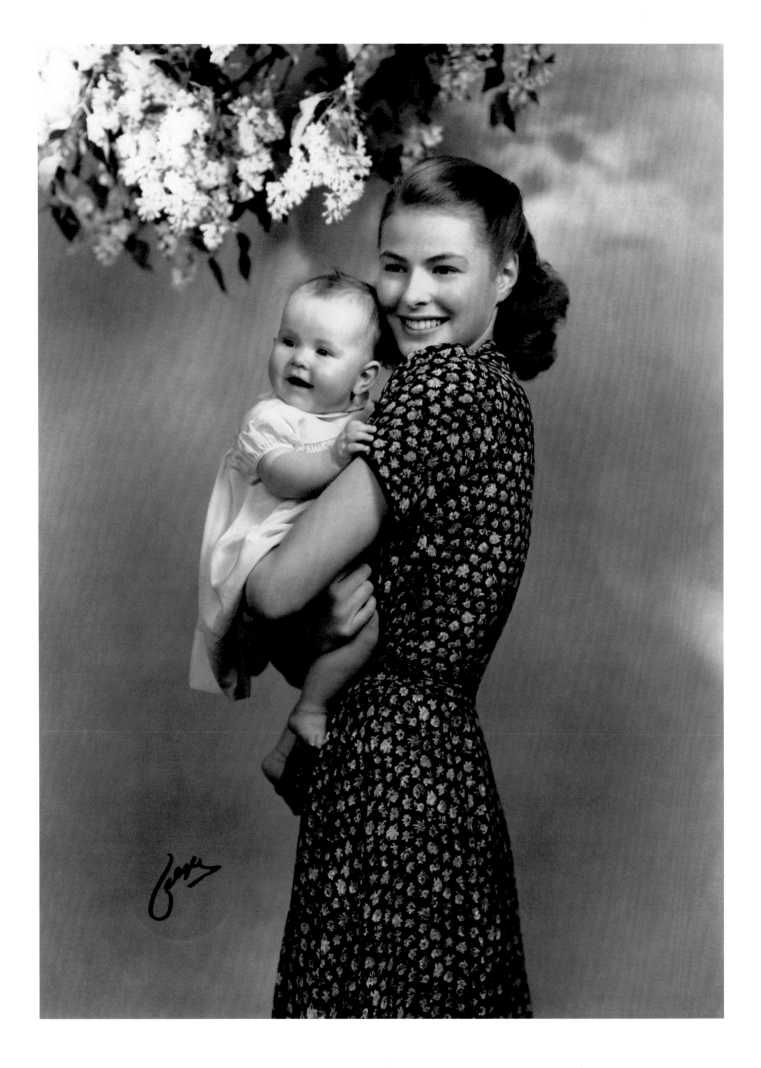

FIRST FILMS IN SWEDEN

During her first year at drama school, Ingrid Bergman is offered an important role in a play directed by her teacher and mentor Alf Sjöberg. This is viewed as preferential treatment and arouses much envy and jealousy at the school:

"The other students—the girls who had done their full time at the school … were livid. … I was so hated they actually attacked me physically … And the accusations they made, about the things I must have done to get the part. My Uncle Otto would have had a heart attack if he'd heard."[10]

The director of the school, Olof Molander, demands that Sjöberg take Bergman out of the cast in order to avoid a palace revolution.

When the school year ends, Ingrid's classmates travel to the Soviet Union with the intention of observing Soviet theater, which is considered the cutting edge of thespian art. She intends to spend the summer holidays sitting in on Stockholm's film studios. There she is invited to a screen test—without sound—and is so convincing that well-known director Gustaf Molander recommends her for a small role in the comedy *The Count of the Monk's Bridge* (*Munkbrogreven*), which Ingrid gets despite the initial reservations of actor-director Edvin Adolphson. The film depicts a day in the life of young artists who know how to circumvent the Prohibition in force in Stockholm in 1934. Ingrid Bergman plays Elsa the maid. But she does not content herself with playing her part impeccably: in one scene in which well-known comedienne Tollie Zellman portrays a fishwife and is required to wrap the merchandise, Ingrid butts in unasked and shows her colleague the proper way to wrap fish.

But in any case, Gustaf Molander had recognized her talent and doesn't want to let her go. As soon as the shooting is over, he offers her a studio contract. This would entail dropping out of drama school. Olaf Molander, director of the school and Gustaf's brother, is furious when he finds out, but she decides in favor of motion pictures, a decision that is bound up with the hope of being able to afford private acting lessons in future from her fees.

During the following three years, Ingrid Bergman appears in no less than seven more films: *Ocean Breakers* (*Bränningar*/1935), *Swedenhielms Family* (*Swedenhielms*/1935), *Walpurgis Night* (*Valborgsmässoafton*/1936), *Intermezzo* (1936), *On the Sunny Side* (*På solsidan*/1936), *Dollar* (1938), and *A Woman's Face* (*En kvinnas ansikte*/1938). "We go from one film to another. I never stop," she complains in her diary.[11] In *Ocean Breakers* she already plays the leading role—a young girl who is seduced and left pregnant by a priest, and the film is shown at the

Their daughter Pia is born fourteen months later on 20 September 1938. Ingrid Bergman with approx. eight-month-old Pia in her arms. Location and photographer unknown

Venice Film Festival. *Swedenhielms Family* (1935), directed by Gustaf Molander, is her first film with her idol Gösta Ekman. "I thought I had filmed enough for a while. But no, they want me to be Astrid in Swedenhielms … What made me change my mind was when they told me that Gösta Ekman was going to play the lead. To be in the same film as Gösta. That is marvelous."[12] Ingrid Bergman plays a rich young girl who wants to marry into a poverty-stricken, chaotic family of inventors. The film receives glowing reviews. In the melodrama *Walpurgis Night* she is in love with her unhappily married boss; in *Dollar* (directed by Gustaf Molander) she plays an actress married to a successful businessman. Her co-star Edvin Adolphson, with whom she made her screen debut, hounds her with romantic overtures. As a result, she declines to attend an official dinner given by the film company—a thing unheard of for an aspiring actress—on the grounds that she must prepare for her wedding.

Her most important film during this period is *Intermezzo*. Once again under the direction of Gustaf Molander, Ingrid Bergman plays a young pianist who falls in love with a world-famous violinist. He leaves his family for her sake, but she realizes that the relationship has no future. Ingrid Bergman attracts the attention of an American film magazine for the first time with *On the Sunny Side*—the reviewer from *Variety* writes on 16 September 1936 that she is "capable of rating a Hollywood berth." And she receives the highest accolades in the USA for her performance in *A Woman's Face* in which she plays the leader of a criminal gang with a disfigured face. Her dentist husband Petter constructs an intraoral prosthesis that distorts the left side of her face. The *World-Telegram* calls her "a second Garbo."

Ingrid Bergman as Elsa, a chambermaid, in her first movie role in *The Count of the Monk's Bridge*, a slapstick comedy that was shot in the summer of 1934 and premiered in Stockholm in January 1935. It is a prodigious role for a novice. She bought herself a leopard skin coat and a used gramophone from her first salary (which amounted to $200). Her self-confidence is given a major boost and her shyness melts away.

Production still from her second movie *Ocean Breakers*, 1934, in which Ingrid now plays the leading role. Shooting commenced immediately upon completion of *The Count of the Monk's Bridge*. Ingrid had to drop out of drama school when she signed the contract.

Right page
In this melodrama, Ingrid Bergman plays the role of Karin Ingman, a fisherman's daughter who is seduced and left pregnant by a priest. She is shown here in the arms of her deceiver, who is played by Sten Lindgren. Scene from *Ocean Breakers*, 1934

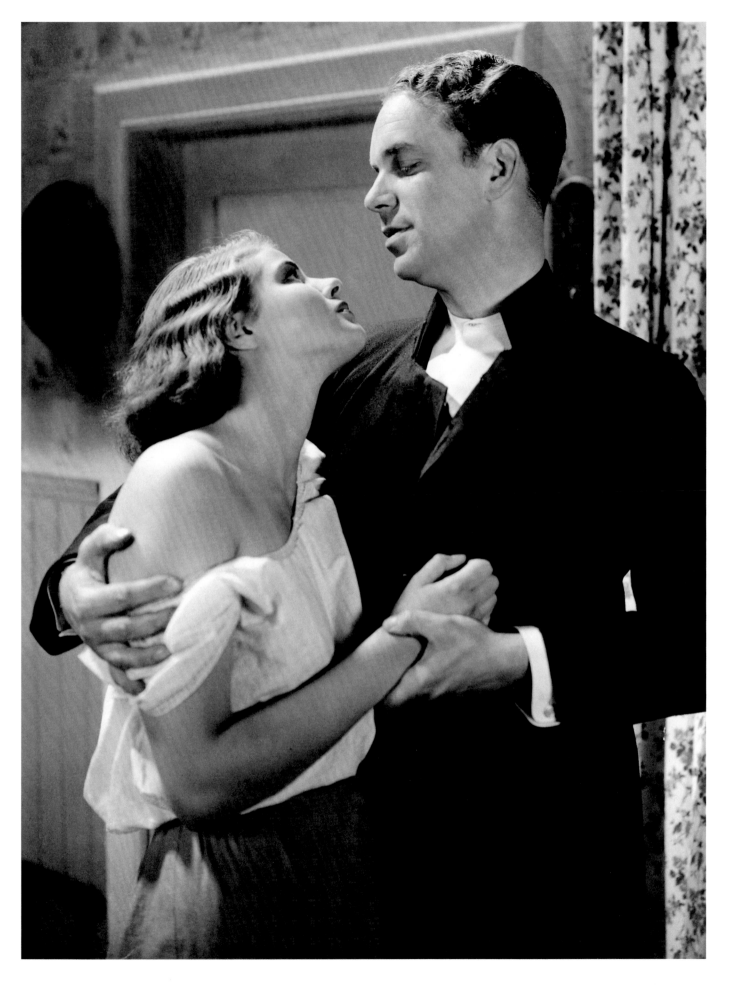

Production still from
Ocean Breakers, 1934

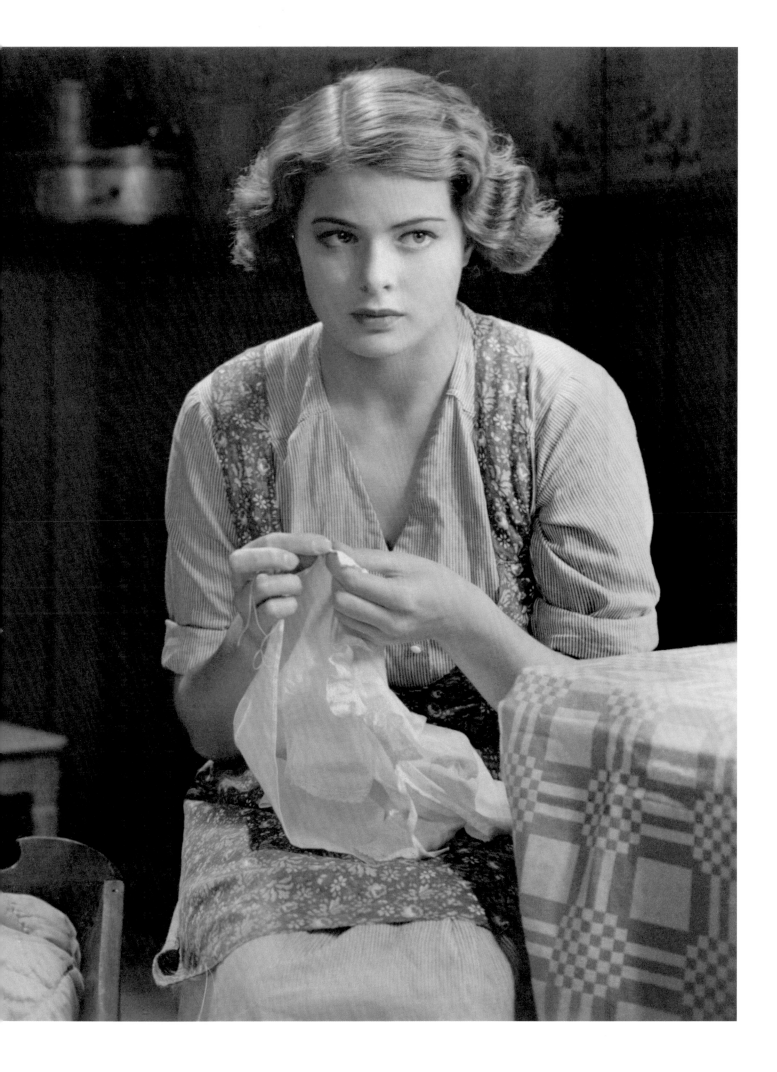

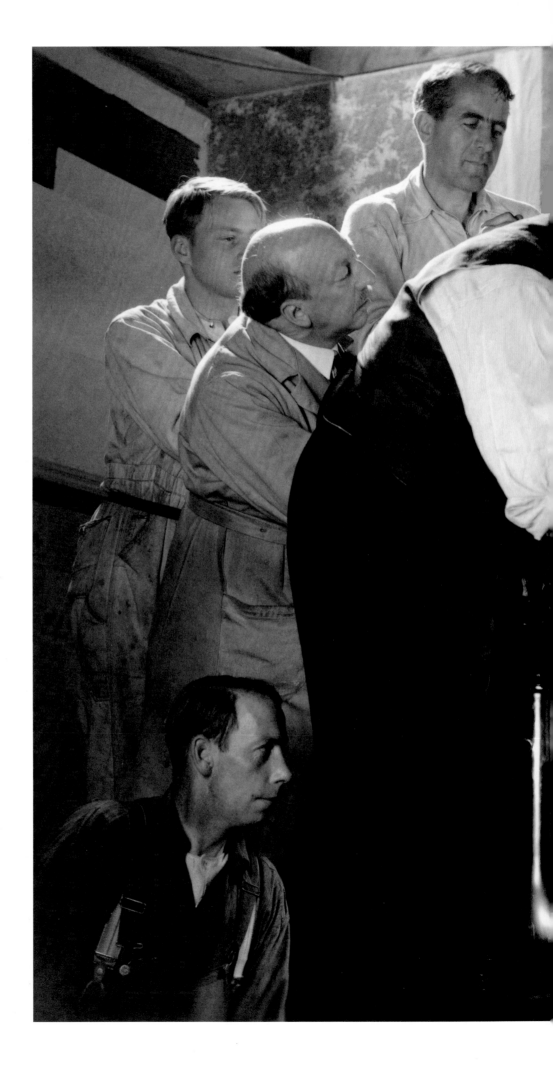

Ingrid Bergman with co-star
Sten Lindgren and film crew on
the set of *Ocean Breakers*, 1934

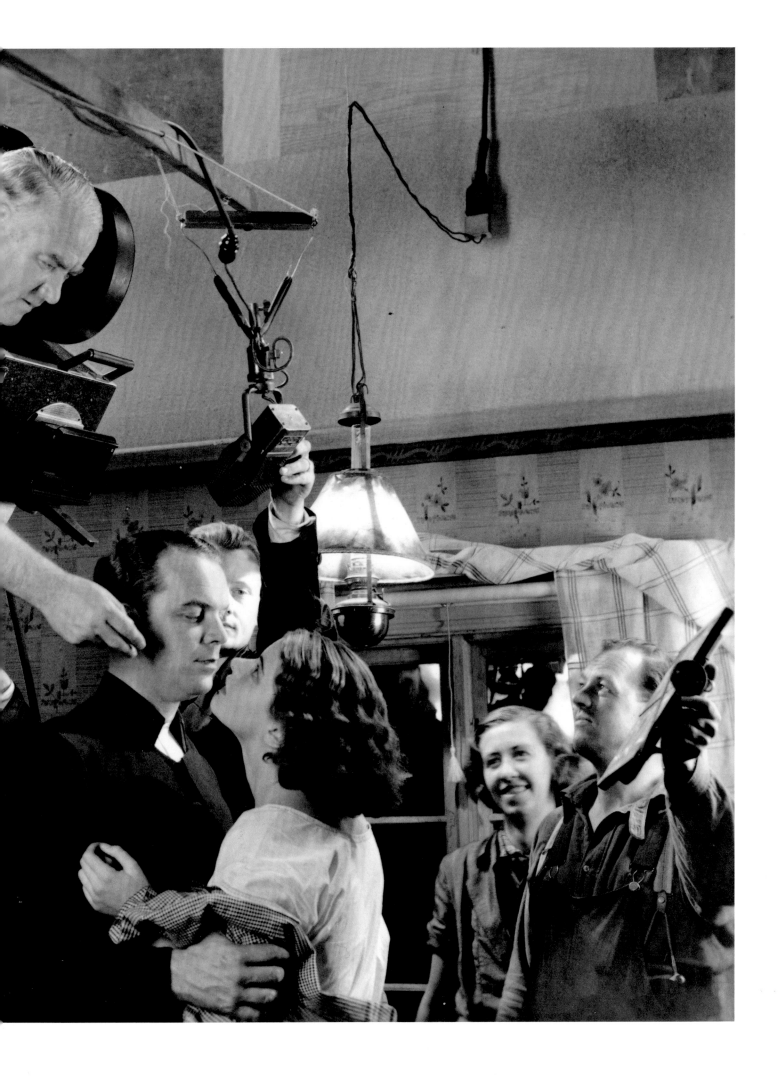

With the active participation of local youngsters,
the film picks up speed: outdoor shots of a carriage
ride during the shooting of *Ocean Breakers*, 1934

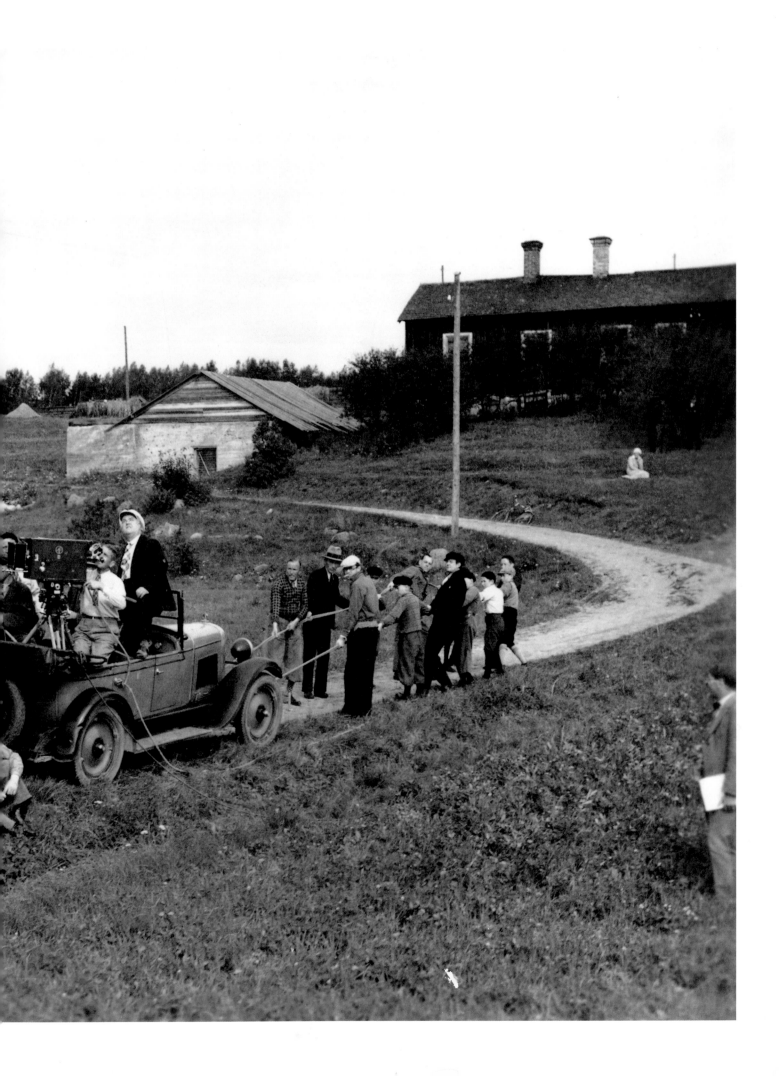

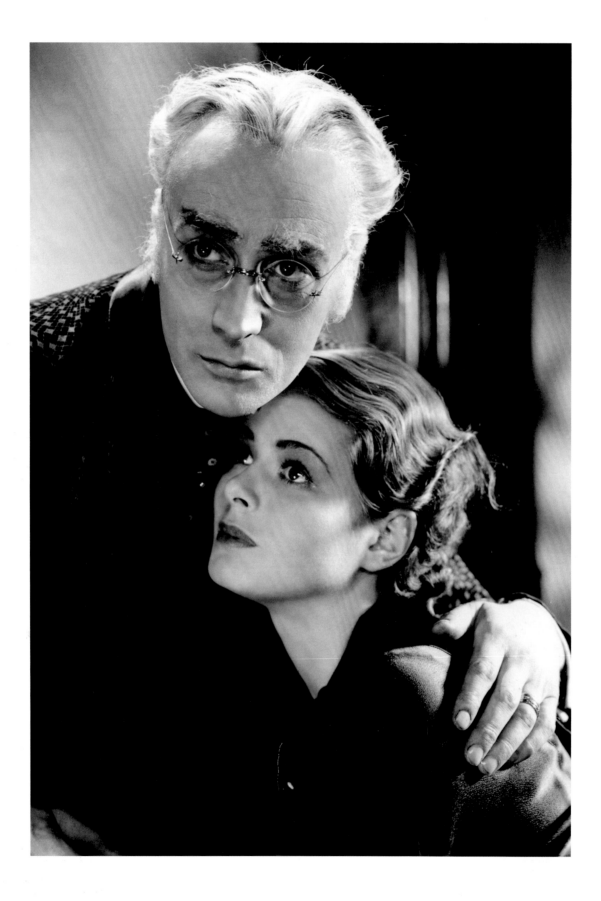

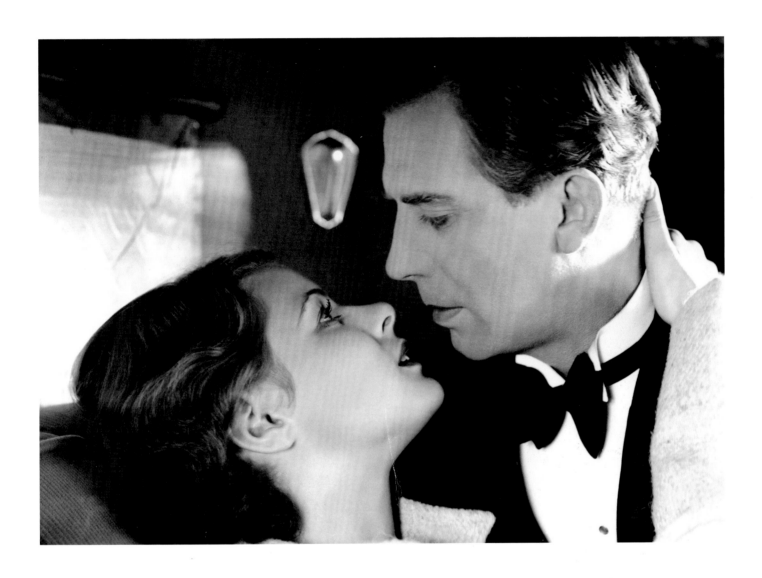

Left page
The first film with her true discoverer
Gustaf Molander is *Swedenhielms
Family*, 1935. She stars opposite her idol
Gösta Ekman, the most famous and
internationally best-known Swedish
actor of the day. He played the leading
role in Murnau's *Faust*.

This page
Ingrid Bergman with co-star Lars
Hanson in *Walpurgis Night*, *1935*, a
melodrama about a secretary who falls
in love with her married boss. Lars Hanson
had already made a name for himself
in Hollywood starring opposite
Greta Garbo.

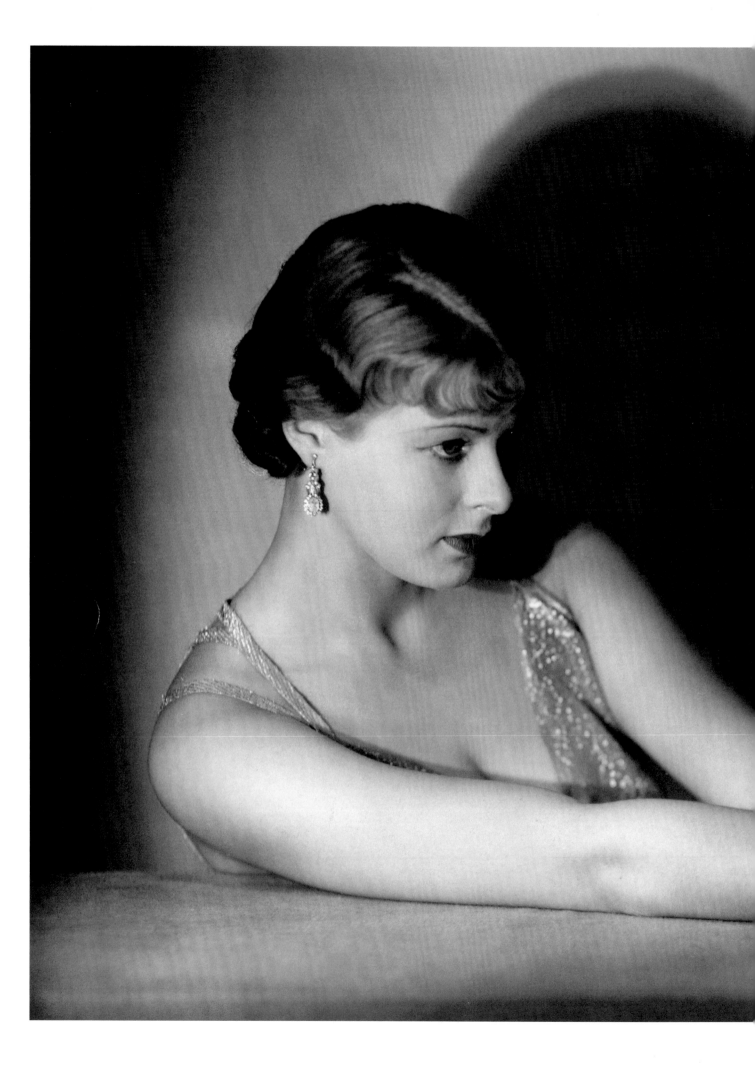

In the role of Eva Bergh in *On the Sunny Side*, 1936, again under the directorship of Gustaf Molander. Ingrid's acting talent is now recognized across the Atlantic for the first time. "She is pretty, and capable of rating a Hollywood berth," writes *Variety* on 16 September 1936. And the *New York Times* declares: "The natural charm of Ingrid Bergman, the young Stockholm actress whose star has risen so rapidly in the Scandinavian film firmament, makes it worthwhile ... Miss Bergman dominates the field throughout."

In the role of Anita Hoffman in Gustaf
Molander's *Intermezzo*, 1936. It is the
film that establishes 21-year-old Ingrid
Bergman as an international star. She
plays a young piano teacher who falls
in love with the world-famous and con-
siderably older violinist Horlger Brandt,
played by Gösta Ekman, but in the end
she realizes that the relationship has no
future. Ingrid Bergman, on the other hand,
definitely has a future. She attracts the
attention of Hollywood's star producer
David O. Selznick.

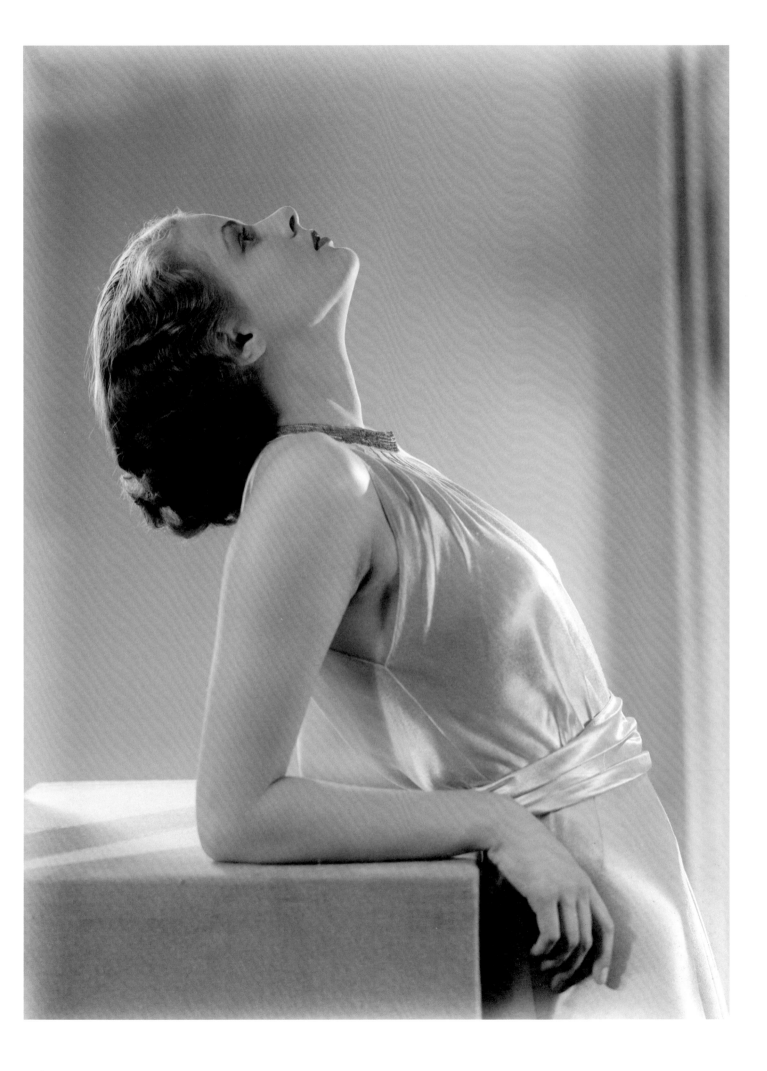

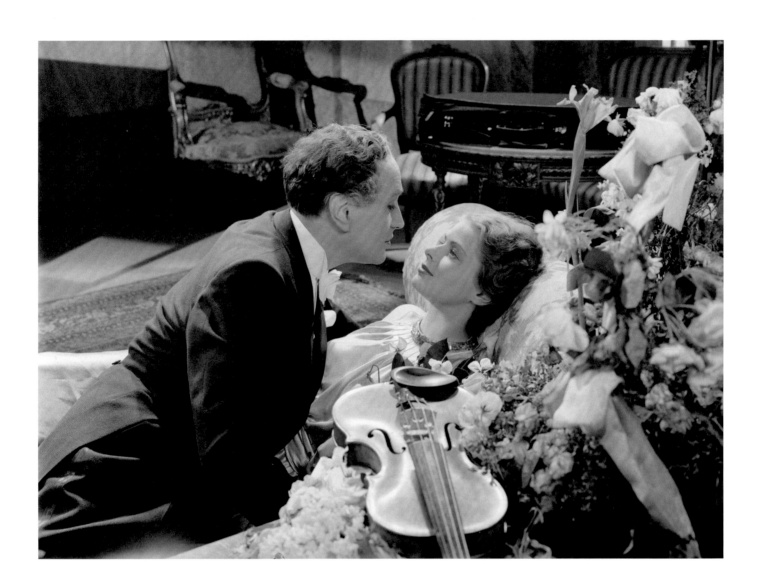

Ingrid Bergman with Gösta Ekman
on the set of *Intermezzo*, 1936

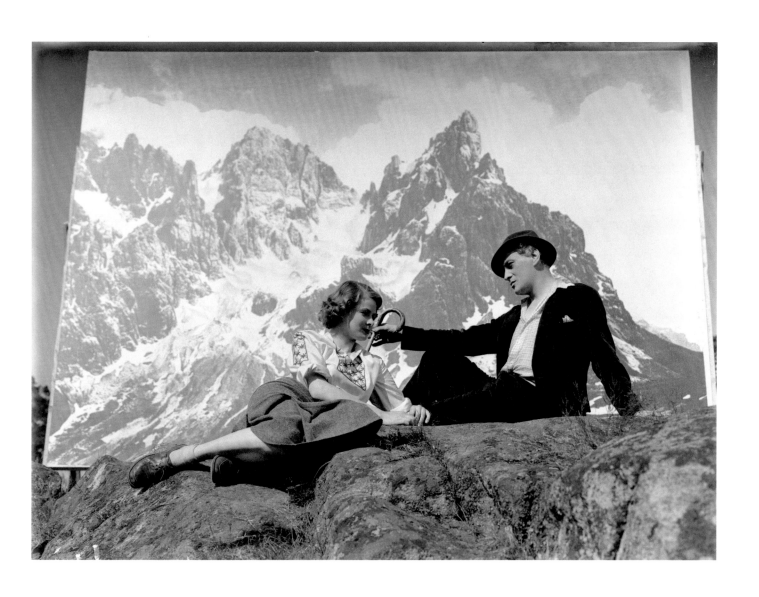

The Tyrolean Alps on the set of
Intermezzo. The painted scenery
in the Swedish countryside serves
as a backdrop for a love scene.

"Ingrid Bergman's catlike aura as the wife of an industrial tycoon predominates everything," writes *Svenska Dagbladet* regarding the actress's performance in the witty comedy *Dollar*, in which big money naturally also plays a part. After the completion of shooting in 1937, Ingrid Bergman marries Petter Lindström in real life.

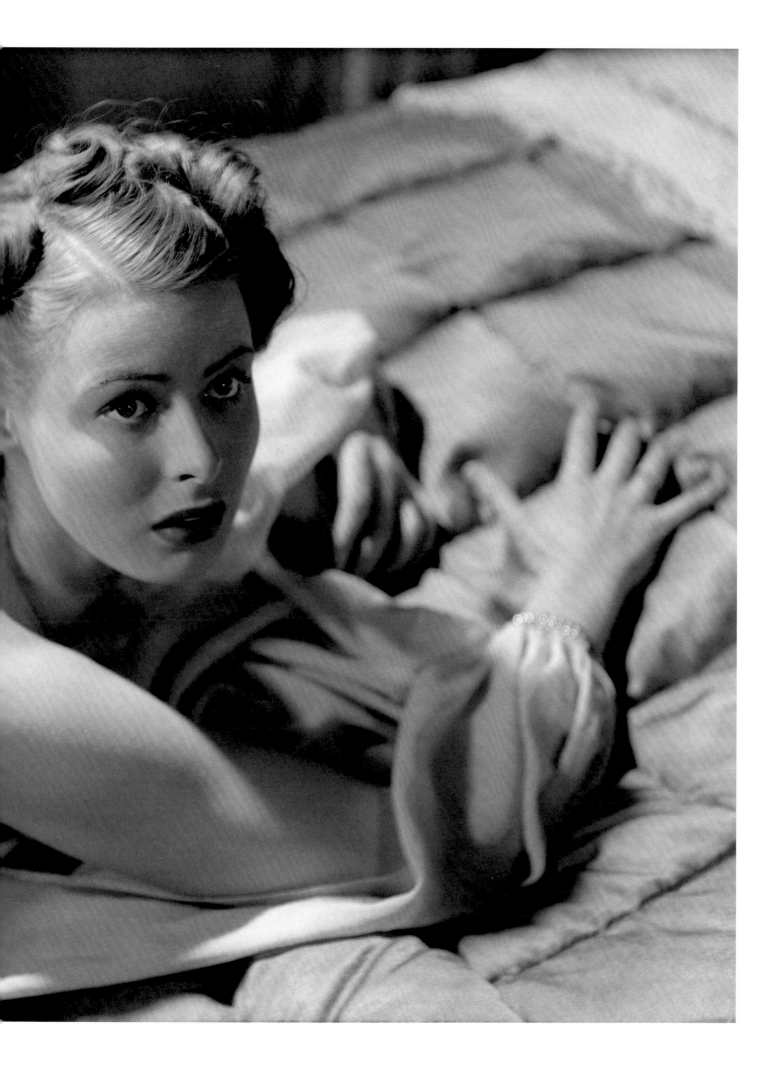

Ingrid Bergman with cigarette holder
in conversation with a cockatoo. Scene
from *Dollar*, which hits the cinemas
in September 1938.

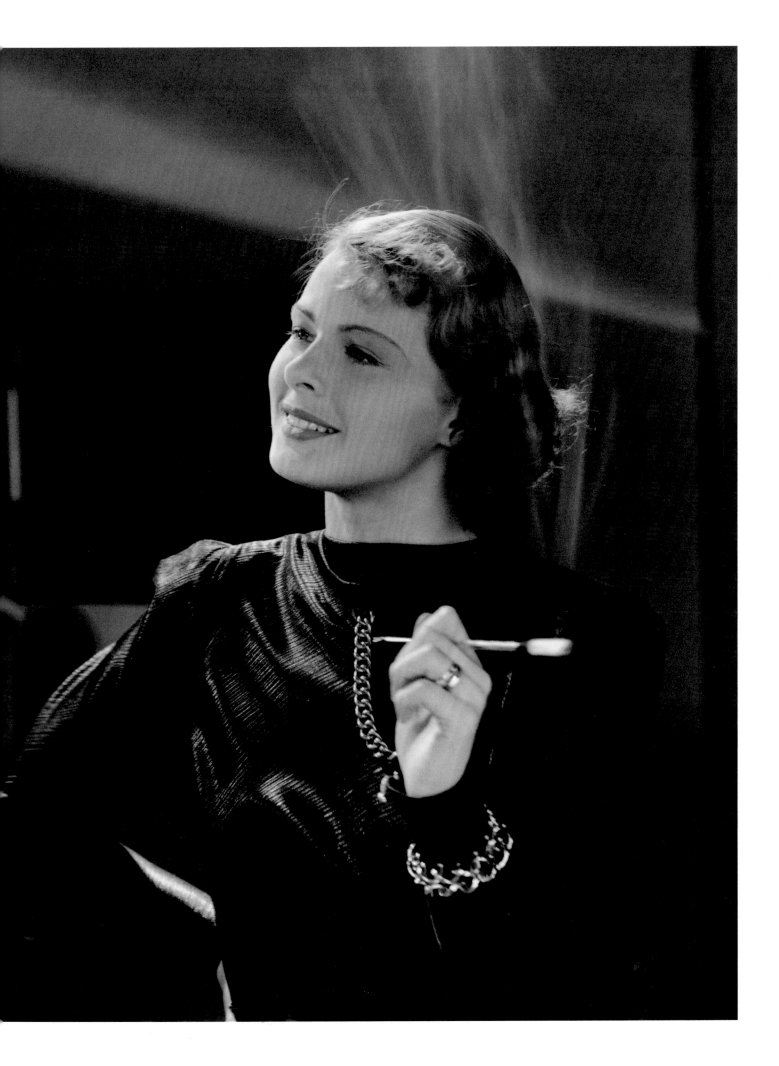

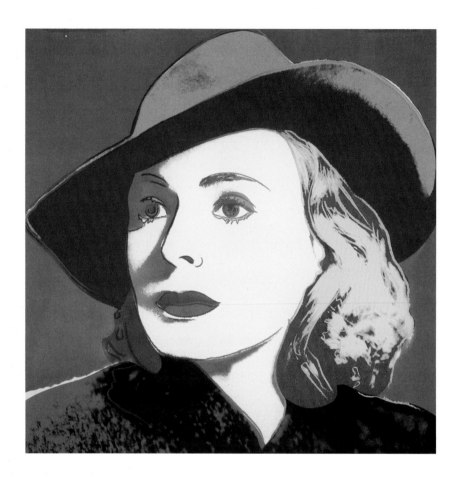

Andy Warhol, *Ingrid (With Hat)*, 1983.
Warhol, who had a strong affinity for
cosmetic surgery, chose a film still from
A Woman's Face as the basis for one of
the famous silkscreen prints in his Ingrid
Bergman series.

Right page
In the thriller *A Woman's Face*, Ingrid
Bergman plays Anna Holm, a criminal
whose face has been hideously disfigured
since childhood. A surgeon finally succeeds
in healing her, both physically and psycho-
logically. Ingrid commented dryly on her
transformation: "Oh, did I look a fright.
Of course you only saw me looking like
Frankenstein at the beginning of the film;
then I have plastic surgery and become as
beautiful as you can get...."[13]

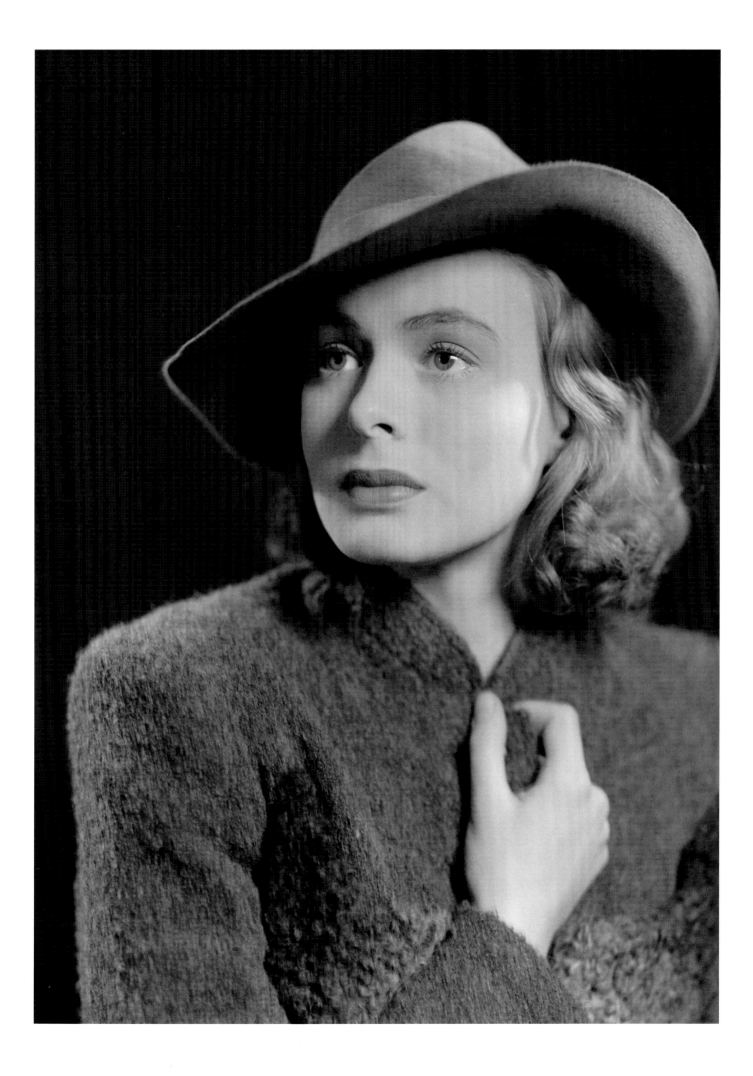

INTERMEZZO IN BERLIN
1938

In 1938 Ingrid Bergman receives an offer from UFA to shoot three films in Berlin. The contract comes at a most welcome time:

"Of course I knew that having made a little success in my own country, Swedish pictures were not the beginning and end of acting … There was a place called Hollywood … But I also knew that my experience and my English were not good enough for that yet. And … my French wasn't so good either. But German was my second language."[14]

The first picture is *The Four Companions (Die Vier Gesellen)*. "It wasn't a big budget film, but it was a new challenge. Could I perform in German? Could I … play dramatically in that language and make an impact?"[15] The plot revolves around four young women who found an advertising agency and their adventures with men.

When Ingrid arrives in Berlin on 29 March, Hitler's regime is at the zenith of its power and foreign-policy successes. On 12 March Hitler had forced the "Anschluss" of Austria into the German Reich and initiated his policy of aggression against Czechoslovakia immediately thereafter; the "Munich Agreement" of 29 September sealed the cession of Sudeten German lands and thus marked the beginning of the end for a democratic Czechoslovakia. On the domestic front, he had begun an unparalleled policy of persecution, exclusion, and disfranchisement against German Jews, which culminates in the government-sanctioned pogrom on the night of 9/10 November 1938.

It is against this backdrop that the filming in the UFA film studios in Berlin takes place, a film company that answers directly to Joseph Goebbels' Ministry of Propaganda.

Ingrid is pregnant at the time, and Petter, who has a keen sense for the dangers of the political situation, spends most of the two months of shooting with his wife in Berlin.

Ingrid Bergman ignores the danger: her work takes precedence. She finds her director Carl Froelich to be "a very worried man,"[16] but she is spared having to make unequivocal political statements, and the impending invitation for tea from Propaganda Minister Goebbels never comes to pass. "I wasn't his type."[17] Her co-stars in *The Four Companions* are Ursula Herking, Sabine Peters, Carsta Löck, and Hans Söhnker. Their fond memories of their successful colleague from Sweden will later include how she sent them CARE packages to bombed-out Berlin in 1945.

At the end of May, Petter and Ingrid depart Berlin on a trip to Paris and Monte Carlo. In July they return to Stockholm where Ingrid busies herself with preparations for Pia's birth (20 September).

She looks forward to having a child, but she also wants to move forward with her career:

"It never occurred to me that I shouldn't have a child, or that it would interfere with my career. I was so surprised when I arrived in America that everybody should be shocked that I had a baby. 'A child! You've ruined your figure! You've ruined your image as a beautiful young movie star.'"[18]

She considers fulfilling her contract with UFA and playing the role of Charlotte Corday, the woman who killed Marat, in a second film. In view of the deteriorating political situation, however, Petter Lindström is categorically against further work in Berlin. In order to provide his wife with alternative possibilities, he asks theater agent Helmer Enwall to be on the lookout for roles in England and the USA. "He [Petter] wanted me to go to Hollywood … he'd manage with Pia, and his mother would look after her for the months I would be away."[19]

And Hollywood wouldn't be Hollywood if they hadn't already gotten wind of her there.

She had come to Berlin as a young girl to star in director Carl Froelich's
"The Four Companions." I read in one of the trade magazines that Froelich,
the doyen of German directors, had begun preparations at the Tempelhof Studios,
and I drove out there to introduce myself under the assumption that one of the four
companions might be suitable for me. Well, not one of them was because all four
of them were girls. When I was brought before the Master, he was sitting with one of
the "companions" and discussing the script: a radiant young girl with a seductively
guttural Swedish accent, endless legs, clear, gray-blue eyes, melancholy and secretive
when she was in a serious mood, impish and droll when she laughed.
When she laughed, her wide, full mouth opened up, showing
her teeth … such teeth![20]

CURD JÜRGENS

The UFA publicity shot for Ingrid's German
film *The Four Companions (Die Vier Gesellen)*,
1938, displays for the first time her capabilities
in striking more aggressive erotic attitudes,
as exemplified by the teeth and open mouth
so admired by Curd Jürgens.

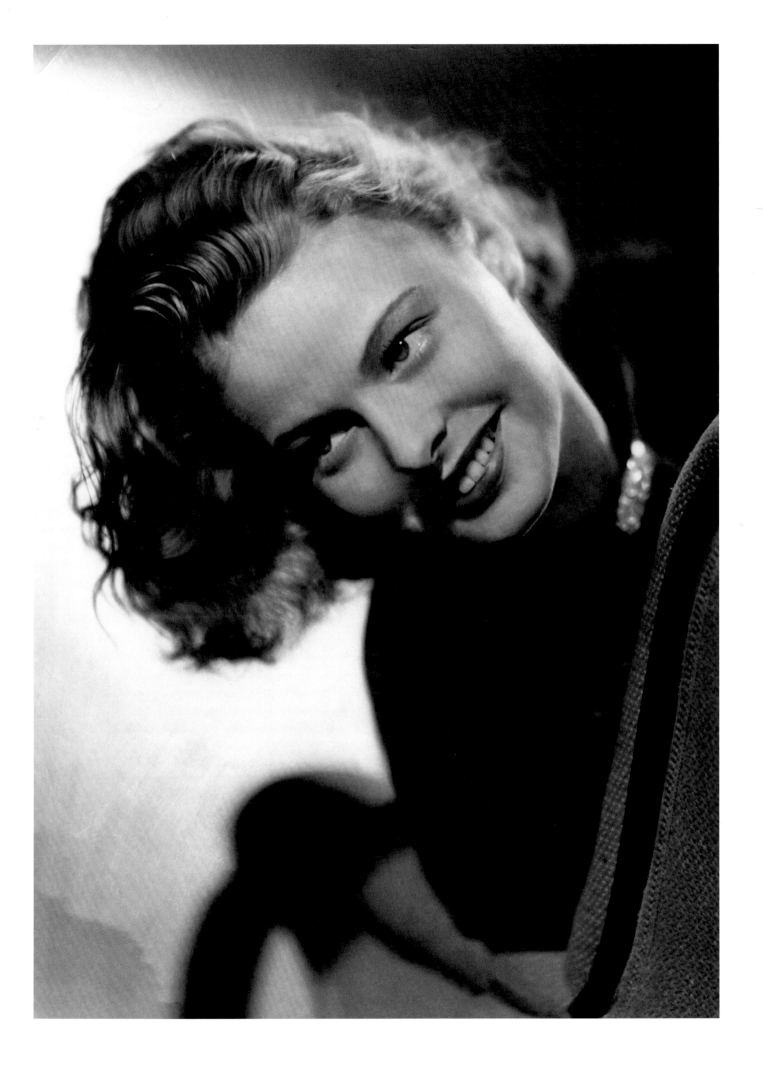

The "four companions" from left to right:
Ingrid Bergman and, standing in the door,
her female co-stars Sabine Peters, Ursula
Herking, and Carsta Löck, 1938

Ingrid Bergman with her male co-star
in *The Four Companions*, German actor
Hans Söhnker, 1938

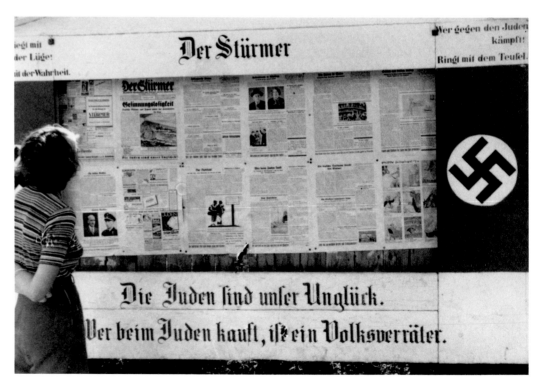

Top
Berlin street scene from
The Four Companions, 1938

Bottom
This photograph was probably taken
by Petter Lindström in May of 1938.
It shows Ingrid Bergman in Berlin
standing in front of a newspaper
showcase displaying the Nazi hate
sheet *Der Stürmer*, which spread anti-
Semitic propaganda slogans of the
most abominable sort. These verbal
attacks will culminate in the acts of
violence and murders of the govern-
ment-sanctioned pogrom on the
night of 9/10 November 1938.

Top
A close-up with leading man
Hans Söhnker. Production still
from *The Four Companions*, 1938

Bottom
With Carl Froelich, the director of
The Four Companions, in Berlin, 1938

93

Ingrid with friends in Berlin.
Probably taken by her husband
Petter Lindström, 1938

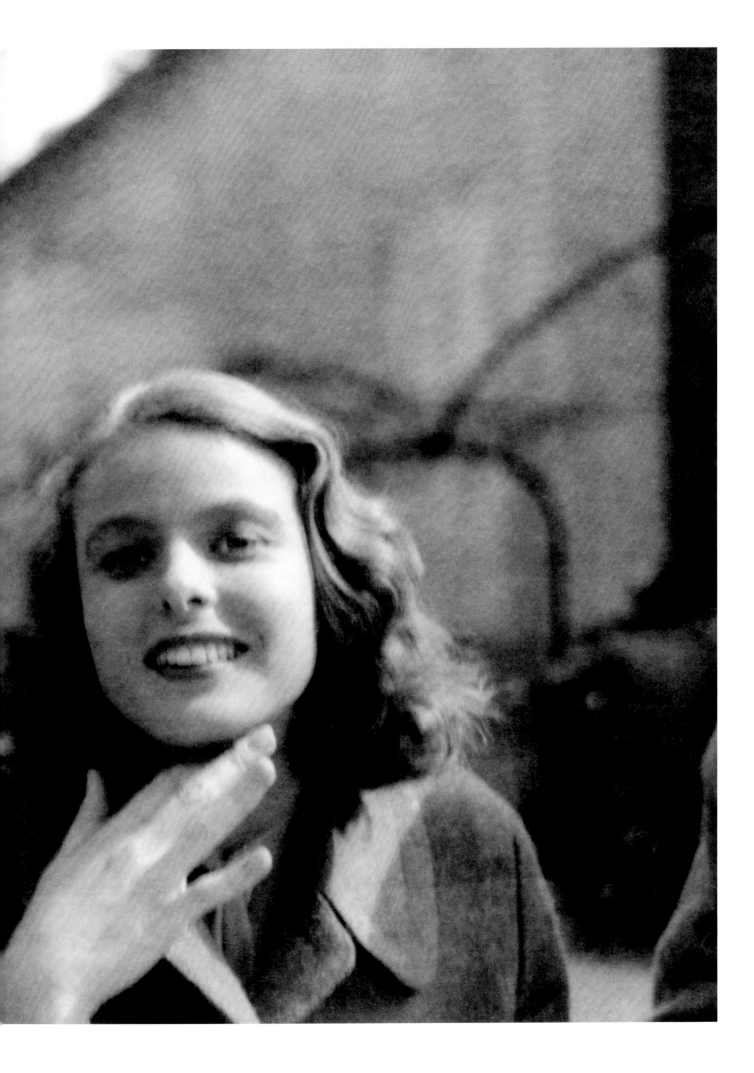

FAREWELL TO SWEDEN

Ingrid Bergman bids farewell to her Swedish fans and her homeland with two films.

Only One Night (En enda natt) hits the Swedish movie theaters in February of 1939. It is her fifth movie directed by Gustaf Molander and had been filmed in the fall of 1937. Ingrid Bergman only accepted a part in the bombastic melodrama starring opposite her Swedish "dream couple" partner Edvin Adolphson—who was opposed to her at the onset of her career and later made overtures—in order to get the leading role in *A Woman's Face*. She portrays a reticent philosophy student and pianist, the ward of a wealthy aristocrat. Adolphson plays a former circus performer who turns out to be the illegitimate son of said aristocrat. When she rejects his love, he returns to his former life, and she remains alone with her books and piano.

In the fall of 1939, following Bergman's return from her first excursion to Hollywood, *June Night (Juninatten)* was shot by director Per Lindberg, who had made a name for himself as an experimental theater director. Ingrid Bergman plays an apothecary's assistant who falls in love with a sailor and is shot by him when she tries to leave him. She flees the rumor-ridden town to Stockholm, but her past catches up with her there as well. The hard-hitting story of sexual exploitation, misguided passions, and unscrupulous sensation mongering receives excellent reviews following its premiere in Stockholm in April 1940.

This occasion finds her in the USA once again. In view of the war, she decided to leave her native country and try her luck in Hollywood. Sweden's film critics send her "greetings from across the water."[21]

Women's hats were a distinct challenge during the 30s—not just for costume designers in the movie business. Publicity shot for *Only One Night*, 1937/39

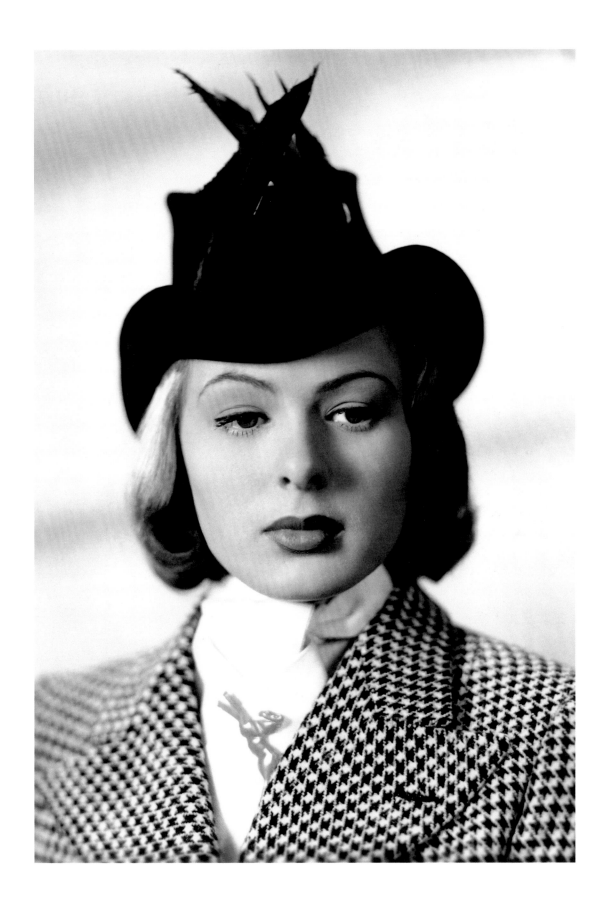

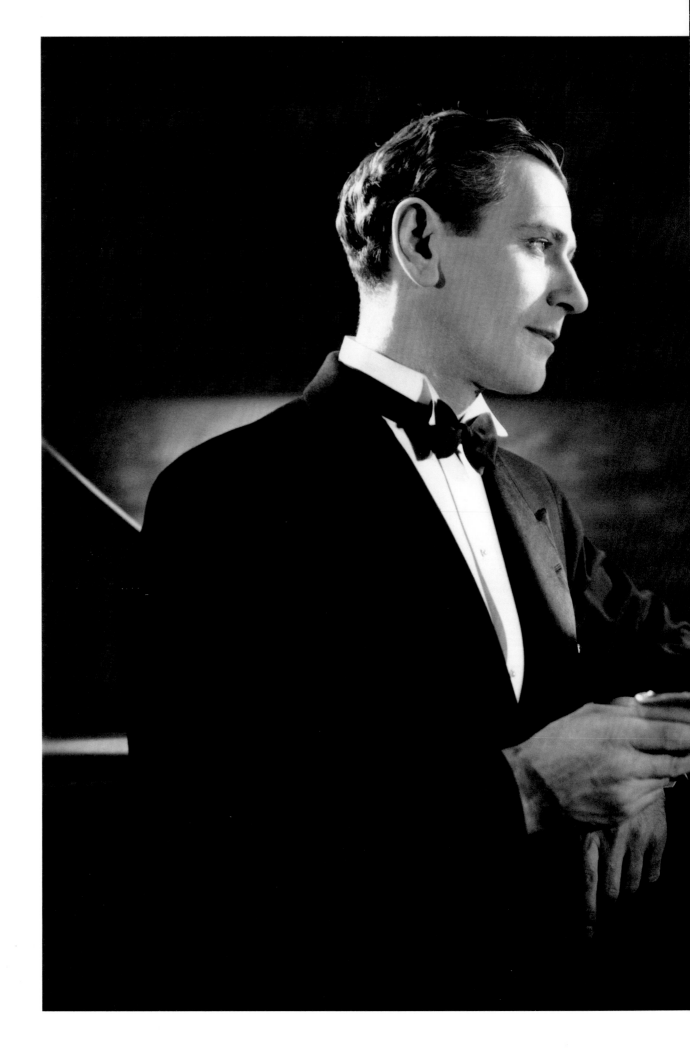

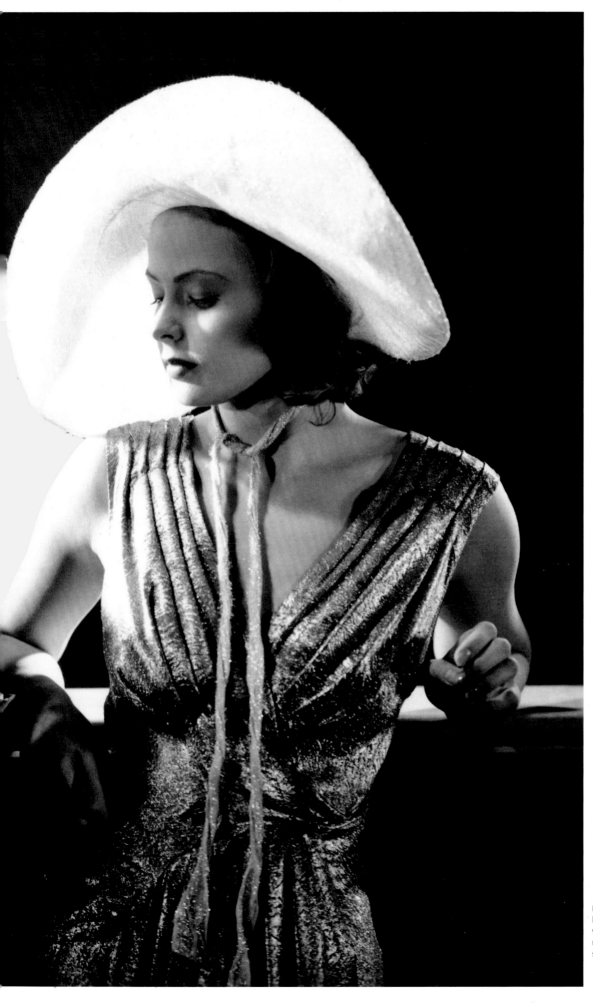

Ingrid as Eva Beckman with leading man Edvin Adolphson, whose overtures were not only restricted to the film. Production still from *Only One Night*, 1937/39

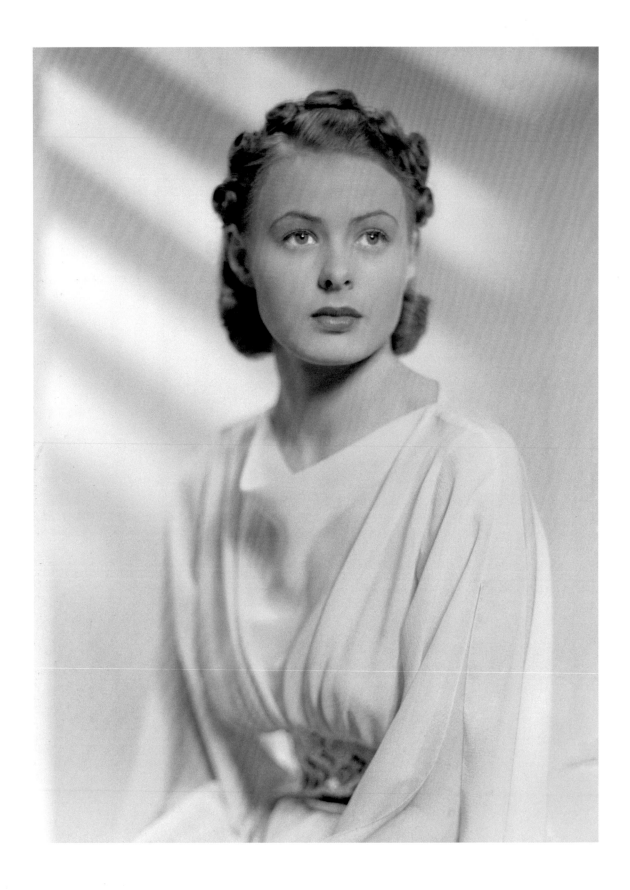

Beautiful, ladylike, and elegantly
dressed—Ingrid in *Only One Night*

Ingrid with her director, Gustaf Molander, during the making of *Only One Night*. The film was shot prior to Ingrid's stay in Berlin, but did not have its premiere until the spring of 1939, shortly before her first excursion to the US.

Ingrid's farewell to Sweden is *June Night*, shot in Sweden in the fall of
1939. The Second World War is already underway in Europe. The ship
that will take her to New York departs Genoa during the first few days
of the new year. When the film premieres in Stockholm in April of 1940,
Ingrid is already performing onstage in New York.

II.

HOLLYWOOD
1939–1945

The journey to Hollywood covers half
the globe: from Stockholm to Cherbourg
by train, then across the Atlantic to New York
aboard the *Queen Mary*, and finally three
weeks transversing the United States to
California by rail. This souvenir picture taken
by the ship's photographer captures Ingrid
during a festive dinner at the officers' table
on board the *Queen Mary*, 1939

INTERMEZZO. A LOVE STORY

The First Trip to Hollywood, 1939

As early as July 1938, the Swedish film *Intermezzo* and its leading lady had been brought to the attention of David O. Selznick, the powerful producer for RKO, Paramount, and Metro Goldwyn-Mayer, by his agents in London and New York: "Keep it most confidential," he writes in a memo on 15 August, "I want to make a deal to remake the picture; for the director; and for the girl."[1] The negotiations are lengthy and drawn out; Ingrid Bergman still has hopes for the Corday project in Berlin and does not feel up to traveling to the US so shortly after childbirth. And Selznick, who is preoccupied with *Gone with the Wind* and the preparations for *Rebecca*, is in no hurry either: "I am commencing to feel that the way to handle this subject is to wait for Bergman, ballyhooing her debut in it."[2] The prospect of working with big stars like Leslie Howard finally induces Ingrid Bergman to accept Selznick's offer.

In April of 1939 Ingrid Bergman travels to New York on board the *Queen Mary* and experiences her first disappointment upon arrival. She had expected to be met personally by Selznick, but he sends agent Kay Brown to the gangway. He doesn't want to start a large-scale publicity campaign before Ingrid's screen appearance "because building up on foreign importations has reached a point where the American public resents the players when they do appear … I think we should avoid interviews with her at the boat and should let her arrive in Los Angeles very quietly …"[3] Accompanied by Kay Brown, she continues her journey by train to Pasadena, only to be met there by a member of the studio's press department.

When Ingrid Bergman meets him a few days later at a party, Selznick is in no wise certain he is willing to let her appear under her own name or with her present physical appearance. But she insists not only on keeping her name, but also her teeth, her eyebrows, and her nose—and on using as little make-up as possible. Years later, she recalls: "I made my own image because I refused to change my name or my hair. They wanted to change me completely when I first came over because that was the standard thing to do."[4] She asserts her will; Selznick backs down and later ascribes the "revolutionary" idea to himself.

A spiritual kinship exists, however, in their common view of work on the set as a raison d'être. "She thinks of absolutely nothing but her work," writes Selznick. "She practically never leaves the studio … All of this is completely unaffected and completely unique …" As a shrewd producer, he realizes the potential: "I should think it would make a grand angle of approach to her publicity, spreading these stories all around, and adding to them as they occur, so that her natural sweetness and consideration and conscientiousness become something of a legend."[5]

William Wyler had originally been slated to direct *Intermezzo. A Love Story*—but Selznick fires him shortly after shooting commences and replaces him with the temperamental Gregory Ratoff. Bergman's co-star is Leslie Howard, who had just completed *Gone with the Wind* and been made co-producer by Selznick as a means of getting him to accept the role of the violin virtuoso. Shooting takes place in June and July of 1939, and it doesn't stop until the very last minute. Aboard the train, she writes to her language coach Ruth Roberts: "What a marvelous time I have had in Hollywood!"[6] In a letter from Stockholm written in the fall of 1939, she adds, "And perhaps I will be back soon."[7]

The professionalism of the Hollywood studios convinces her that "it's so much easier to make films here than in Europe … There are more people on the set, more clothes, more stand-ins—which we didn't have in Sweden—more makeup men and electricians … The only other difference is that here things are a bit glossier and the sets more expensive."[8]

Petter meets his wife at the dock in Cherbourg and accompanies her on the train back to Sweden, where the family spends autumn together. In the weeks preceding Christmas, Ingrid Bergman stars in *June Night*, which is to be her last Swedish film for many years to come.

A beaming Ingrid Bergman upon her arrival in New York, where Kay Brown met her at the pier, 1939

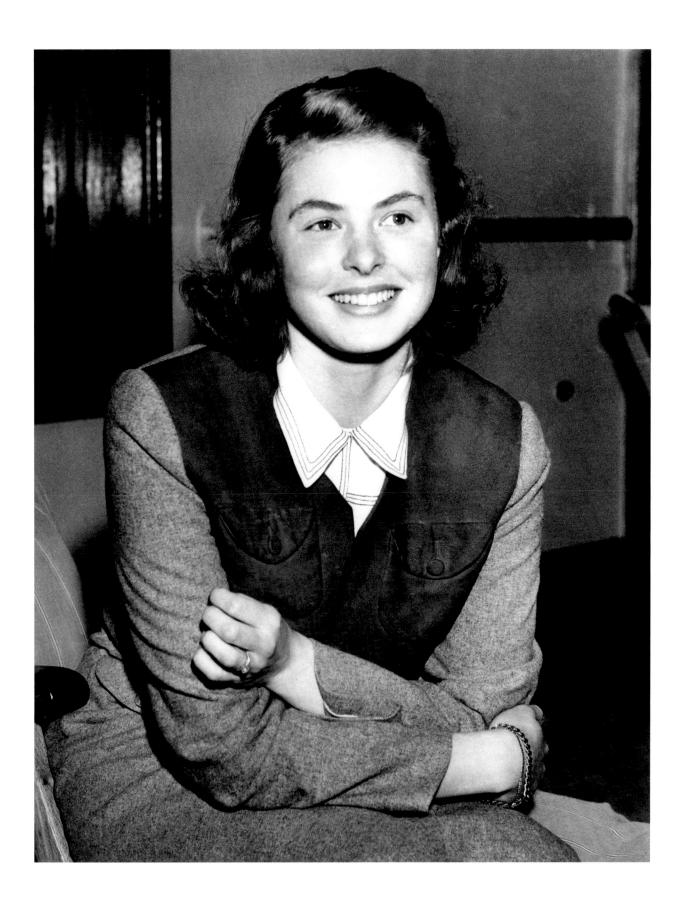

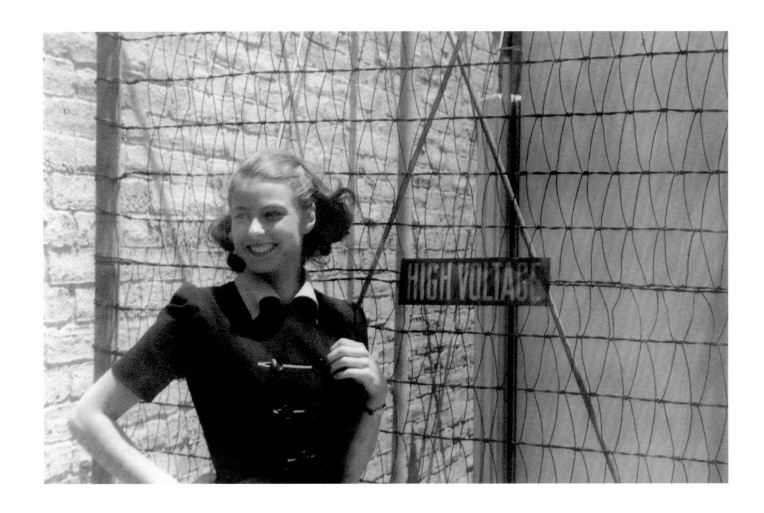

First excursions and personality shots
on the studio lot in Hollywood

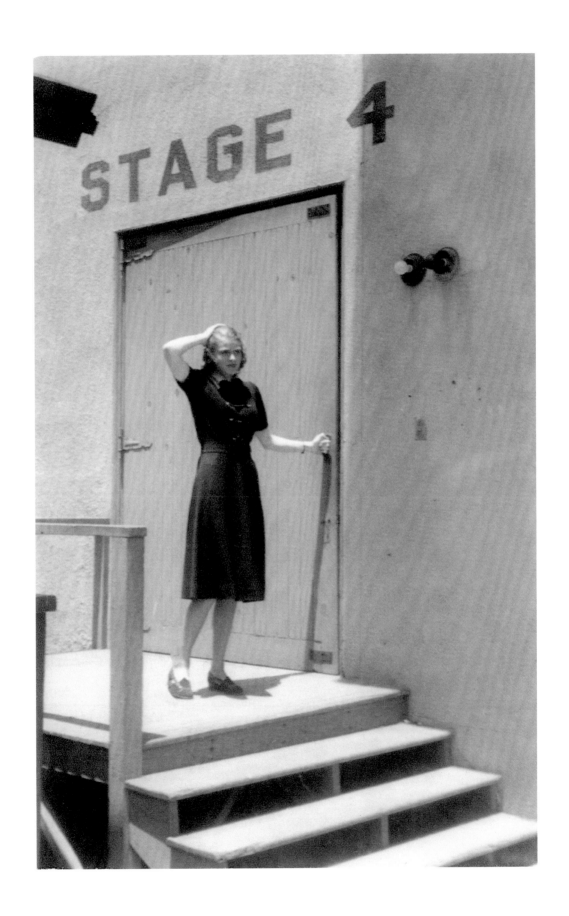

"America, here I come," Ingrid seems
to say as she greets the camera on the
set of *Intermezzo*. Hollywood, 1939

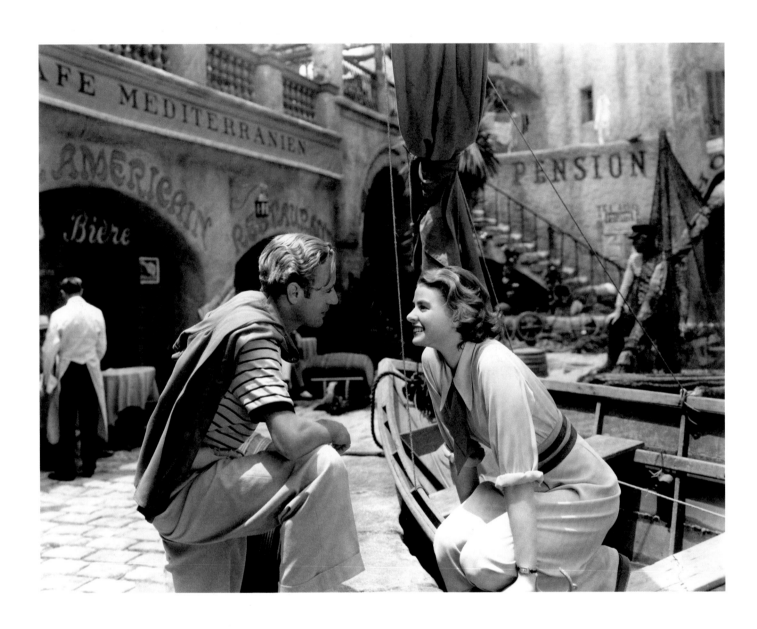

Ingrid Bergman with Leslie Howard
on the set of *Intermezzo*. Howard had
just completed *Gone with the Wind*.
Hollywood, 1939

Right page
With director Gregory Ratoff on the
set of *Intermezzo*. Hollywood, 1939

Close-up with Leslie Howard
in *Intermezzo*, 1939

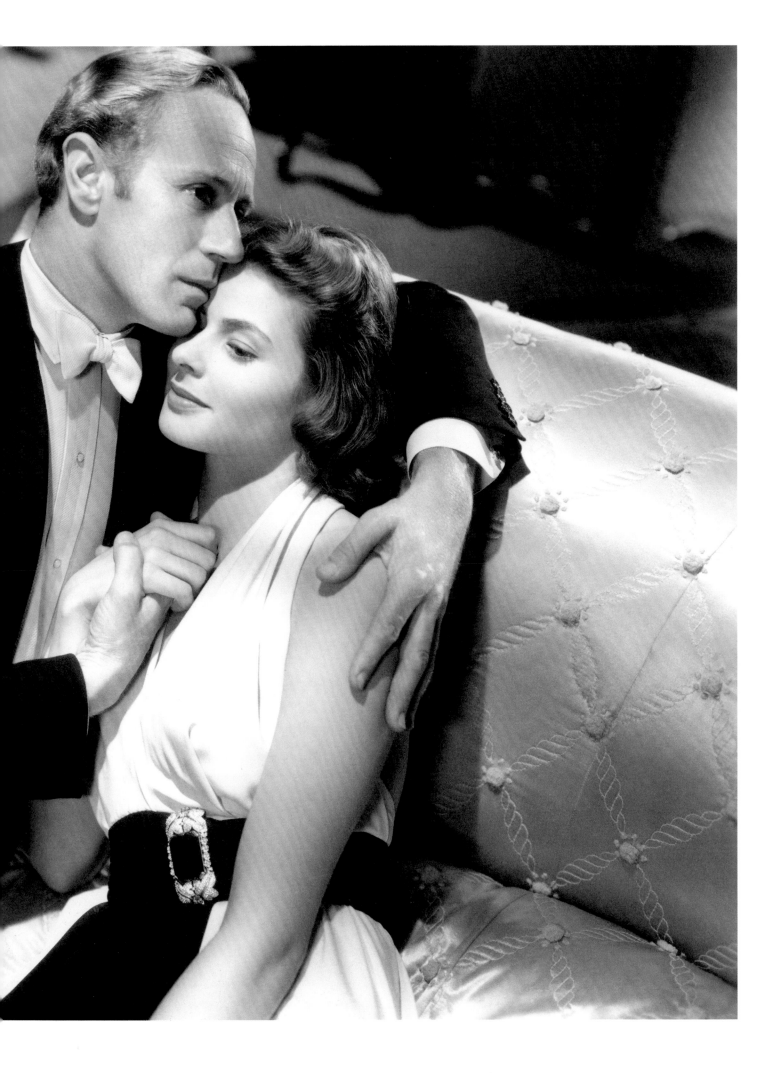

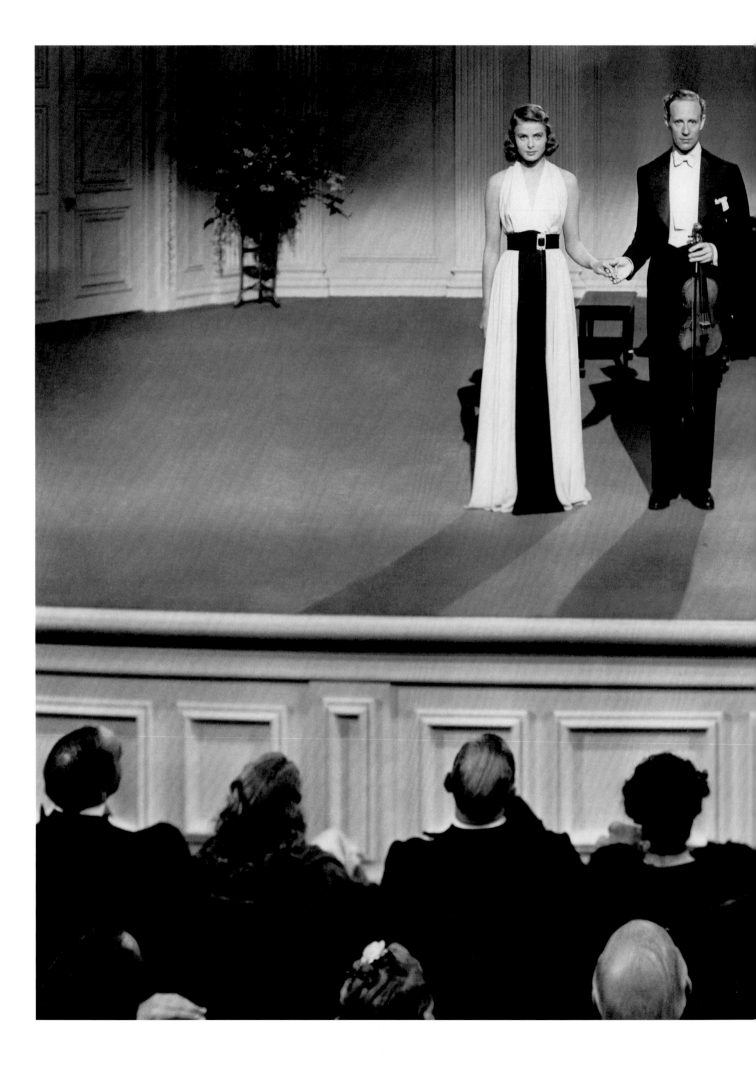

The maestro and his muse.
Leslie Howard and Ingrid Bergman
in *Intermezzo*. Hollywood, 1939

Top
Ingrid's boss and the producer of
Intermezzo, David O. Selznick,
viewing dailies in the screening
room. Hollywood, 1939.
Photo: Peter Stackpole

Bottom
Selznick and his then-wife Irene Mayer
Selznick in their home in Beverly Hills.
She and Ingrid are destined to become
lifelong friends. What really bonds
Ingrid Bergman und David O. Selznick
together is their common work ethic
and an almost unsurpassable dedication
to the task at hand. Hollywood, 1939.
Photo: Peter Stackpole

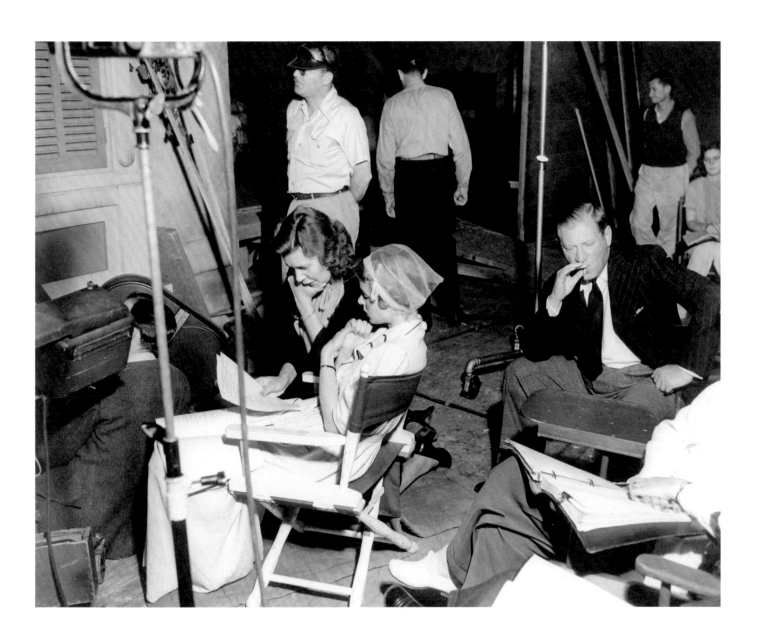

Ingrid's second lifelong friend is Ruth Roberts, her English teacher, who instructs her above all in the phonetics of the American language. She is seen here discussing the script with Ingrid on the set of *Intermezzo*, 1939. Not until later will she learn that Ruth Roberts is herself of Swedish descent and speaks excellent Swedish.

OUTBREAK OF THE WAR – DEPARTURE FOR AMERICA

1939/40

The Second World War erupts on 1 September with Germany's invasion of Poland, and the European film industry finds itself in an increasingly precarious situation. UFA places a freeze on production planning shortly after the outbreak of hostilities. "My German picture cancelled,"[9] Ingrid cables Selznick on 29 September.

Intermezzo. A Love Story premieres in the US on 6 October. Selznick's strategy pays off; the critics are ecstatic about Ingrid Bergman: "Selznick has discovered a new film diva." – "The most talented and most attractive new talent to be recruited abroad by the studios in a long time." – "A new discovery for the American cinema, the kind of which dreams are made." – "A shining nova in Hollywood's starry sky."[10]

The Soviet Union invades Finland in November of 1939, and the war draws nearer to neutral Sweden. Selznick is concerned and, in view of the success of *Intermezzo. A Love Story* at the box office, urges his new star to return to the United States with her husband and child while she still can.

An overseas voyage during wartime is not as simple as it had been a few months earlier. Most harbors are closed to passenger ships; the only steamers to New York depart from Italy. The family must travel by rail via Berlin and Austria to Genoa, where Ingrid Bergman, together with Pia and her nursemaid, boards the ocean liner *Rex* to New York shortly after New Year's Day, 1940.

Petter, who had accompanied his wife to Genoa, remains behind on the pier. He had volunteered to perform several months' duty with the Swedish Army.

The separation from her husband is difficult for Ingrid Bergman. She is worried about Petter. At this point in time she does not know when—if ever—she will see him again. But Hollywood offers a safe haven from the war—the US had declared itself neutral in September—and Selznick entices her with a role she had long been dreaming of: he offers the prospect of portraying Joan of Arc on the screen.

On account of the war, the *Rex* is forced to make two unscheduled stops during the voyage: in Lisbon and in Horta. The ship takes on another 90 passengers who also want to go to America. Among them is Martha Gellhorn, Ernest Hemingway's wife, who had been covering the Russo-Finnish War. Gellhorn and Bergman, the "woman with a baby on her back,"[11] become acquainted. The baby must be hidden from the press when they arrive in New York, however.

Ingrid's joy at her arrival in New York on 12 January is dampened while still in the harbor—Selznick sends word to her not to mention *Joan of Arc* to the waiting press: the project was postponed.

And this postponement is paradigmatic of what awaits her in the coming months: "They didn't want me in California. They had nothing out there for me for the time being … "[12] Her five-year contract with Selznick, which took effect on 1 April 1940, stated that she could make one or two pictures a year. But he is busy with other big projects. He advises her to remain in New York for the time being, to visit the theater, and to take Pia to the zoo.

Being idle is unbearable for Ingrid Bergman, and she badgers Selznick incessantly to give her work. In order to pacify her, he summons her to Hollywood in late January for a radio adaption of *Intermezzo* and arranges an extensive interview with the *New York Times*. He blames the postponement of *Joan of Arc* on the political situation: in view of the war in Europe, in which France and England are allies, he claims it is an inopportune time for the project.

With the exception of a short interruption in March when she appears alongside Burgess Meredith and Elia Kazan in Franz Molnár's stage play *Liliom*, Ingrid Bergman spends the entire spring and summer on the beaches of Long Island, where—sometimes as the guest of fellow actors like Burgess Meredith, or of her agent Kay Brown—she plays with her child and suffers intensely from boredom. In June, Petter arrives from Sweden for a visit.

The long wait. Ingrid and her daughter Pia on the beach at Amagansett on Long Island.

Ingrid Bergman can't bear the idleness, even if it is summer and the weather fine. "I feel very lonesome since Petter left and Long Island bores me no end,"[13] she writes to Ruth Roberts. Long Island, 1940

A STAR ON LOAN –
FILMS FOR SELZNICK
Adam Had Four Sons

In the fall of 1940 Ingrid Bergman again pressures the studio. She can't bear the idleness any longer. Selznick still has no project for her, but he recognizes that it would do more harm to keep Ingrid waiting than to waste her talent on substandard material. He therefore decides to loan his star to Columbia. The shooting of *Adam Had Four Sons* begins in late September. It is a schmaltzy family story in the guise of a costume drama. Gregory Ratoff is once again the director, with Warner Baxter as Adam. "I'm the new governess who arrives to look after Warner Baxter's sons. His wife dies shortly afterwards, the stock market crash of 1907 wipes him out so they're broke and I'm sent back to France. Ten years later … Adam has made a fortune again so he sends for me … Adam at last realizes he's in love with me, and it all ends happily ever after."[14] No one involved in the picture truly believes in it, and Kay Brown remarks dryly, "Anyone who could come through a stinker like that is destined for success."[15]

Ingrid as Emilie Gallatin, the governess hired by a widower to care for his children, in *Adam Had Four Sons*. Hollywood, 1940

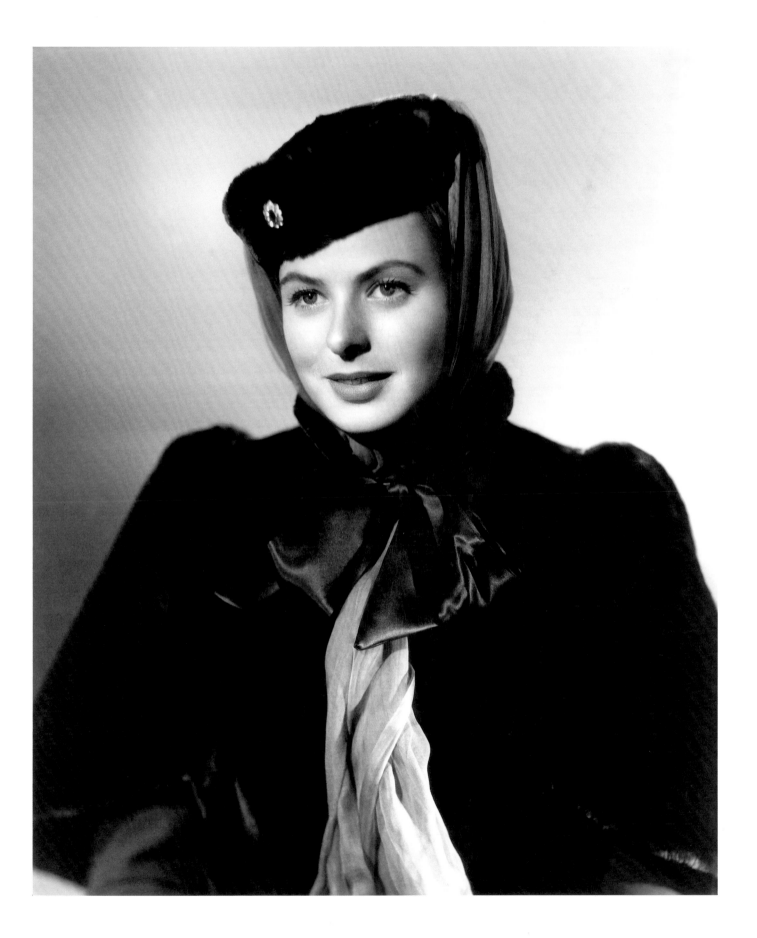

Rage in Heaven

The day after the shooting of *Adam Had Four Sons* is completed in December of 1940, Ingrid Bergman is again in front of the camera: alongside Robert Montgomery in *Rage in Heaven*, for which Christopher Isherwood had written the screenplay.

Selznick had put her on loan to MGM this time. The melodramatic story is about a woman caught between two men; she chooses one over the other, only to realize she's gotten mixed up with a psychopath. Ingrid Bergman is not so much bothered by the appalling plot or the robot-like performance of Montgomery, who argues over every detail for hours. It is the military tone of the director, W. S. Van Dyke, with his iron adherence to production schedule, that causes her difficulty. Because Selznick will not come to her aid, she takes matters into her own hands and reproaches him for being incompetent and callous. Van Dyke apologizes and promises to do better: "I will try and change. You know, you are very good in this part."[16] This opinion is shared by the critics, who pan the film, but praise its leading lady.

Robert Montgomery and Ingrid Bergman in a production still from *Rage in Heaven*. Filming commences just one day after the shooting of *Adam Had Four Sons* is completed. Selznick had again put her out on loan: this time to MGM. Production chief is Gottfried Reinhardt. Hollywood, 1940. Photo: Clarence Sinclair Bull

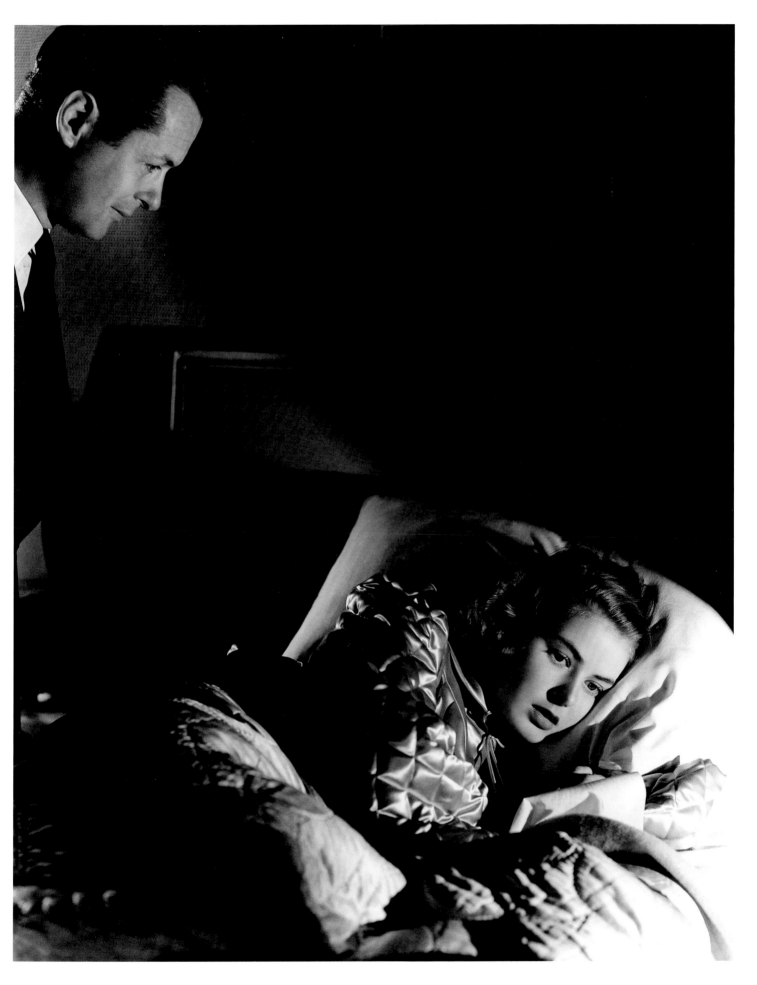

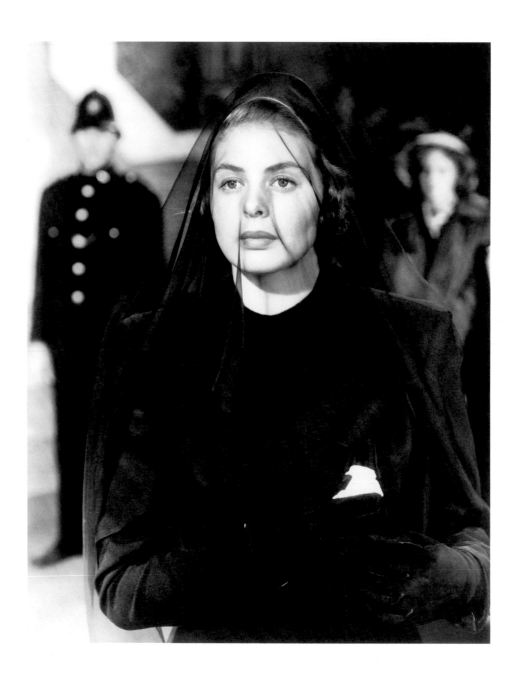

Production still from *Rage in Heaven*.
Ingrid Bergman as the grieving widow
of a psychotic man who commits suicide
and stages it as murder in an attempt
to frame his romantic rival.

Right page
Production still from Laszlo Willinger's *Rage
in Heaven*, 1940/41. Christopher Isherwood
is fascinated: "In some ways she was the
most beautiful woman I ever met—not
that women are my specialty."[17]

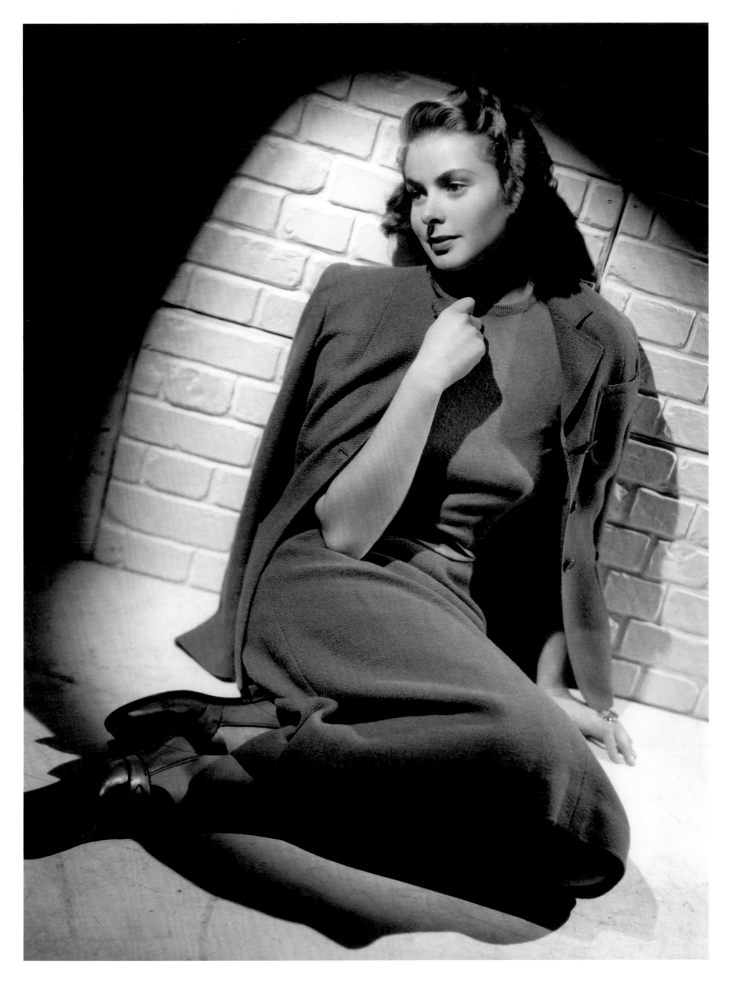

Dr. Jekyll and Mr. Hyde

Victor Fleming, the director of *Gone with the Wind*, wants to film *Dr. Jekyll and Mr. Hyde* with Ingrid Bergman, Spencer Tracy, and Lana Turner in February of 1941. But the distribution of roles has yet to be clarified. Selznick and Fleming agree that Bergman should play the role of the chaste fiancée Beatrix, while Lana Turner plays Ivy, the barmaid; but Ingrid Bergman has other ideas:

"Now they gave me the part of another sweet girl in *Dr. Jekyll and Mr. Hyde*, and I was really fed up having to play it again. I went to Mr. Fleming and I said, 'Couldn't we switch, and let Lana Turner play the fiancée, and I play the little tart in the bar, the naughty little Ivy?'

He laughed. 'That's impossible. How can you with your looks? It's not to be believed.'

"But I *am* an *actress!*"[18]

Ingrid Bergmann has it her way and is soon crazy about her new director.

"Victor Fleming was marvelous … He got performances out of me which very often I didn't think I was capable of. That scene when he wanted a frightened distraught hysterical girl, faced by the terrifying Mr. Hyde—I just couldn't do it. So eventually he took me by the shoulder with one hand, spun me around, and struck me backwards and forwards across the face—hard—it hurt. … I stood there weeping, while he strode back to the camera and shouted 'Action!' … I wept my way through the scene. But he'd got the performance he wanted. By the time the film was over I was deeply in love with Victor Fleming. But, he wasn't in love with me. I was just part of another picture he'd directed."[19]

She notes in her diary:

"I would have paid anything for this picture. Shall I ever be happier in my work? Will I ever get a better part …, a better director …, a more wonderful leading man …, a better cameraman …? Never have I given myself so completely. For the first time I have broken out from the cage which encloses me, and opened a shutter to the outside world."[20]

This film also receives mixed reviews. Ingrid Bergman, however, finds mention as the young Swedish actress who can upstage even veteran Hollywood star Spencer Tracy.

Petter has been residing in the US since Christmas, working as a dentist in Rochester, in upstate New York. This means that the couple is able to lead a normal family life for an extended period of time during the winter of 1941/42. But it soon becomes apparent that it is not Ingrid Bergman's cup of tea. She writes to Ruth Roberts in February of 1942: "I am so fed up with Rochester … I am ready to cry … I don't care about anything … My English teacher is still here every day and I know now 466 words more." But she asks herself to what end? And she writes to Selznick: "I'm down now, deep down … Month after month I have been told by you, by Dan or by Kay, that you at last were going to start a production again. I cannot stand being idle. In these days more than ever I feel one has to work, one must *accomplish* something."[21]

Selznick again puts Ingrid
Bergman on loan to MGM,
but the contracts are becom-
ing more lucrative. Under the
direction of Victor Fleming she
stars alongside Spencer Tracy
and Lana Turner in *Dr. Jekyll
and Mr. Hyde*.

Top
Discussion with Victor Fleming
(left) and Spencer Tracy.

Bottom
Fleming giving instructions
on the set. Ingrid had asserted
her will and was given the
role of the disreputable
barmaid Ivy. Hollywood, 1941

Under a ghastly shadow.
Production still with Ingrid
Bergman and Spencer Tracy
from *Dr. Jekyll and Mr. Hyde*.
Hollywood, 1941

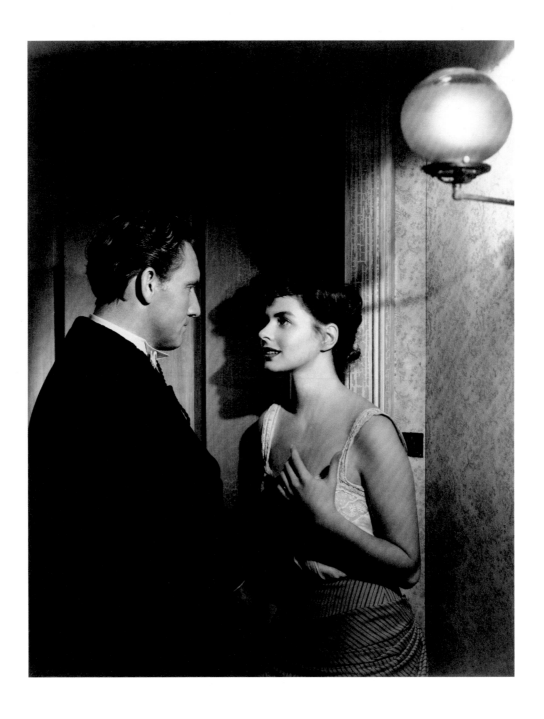

Ingrid Bergman with Spencer Tracy in
Dr. Jekyll and Mr. Hyde. Hollywood, 1941

Right page
Ingrid Bergman in a rare, revealing pose.
She views this film as the turning point
in her career. It leaves no doubt that
she can also portray licentious women
quite convincingly.

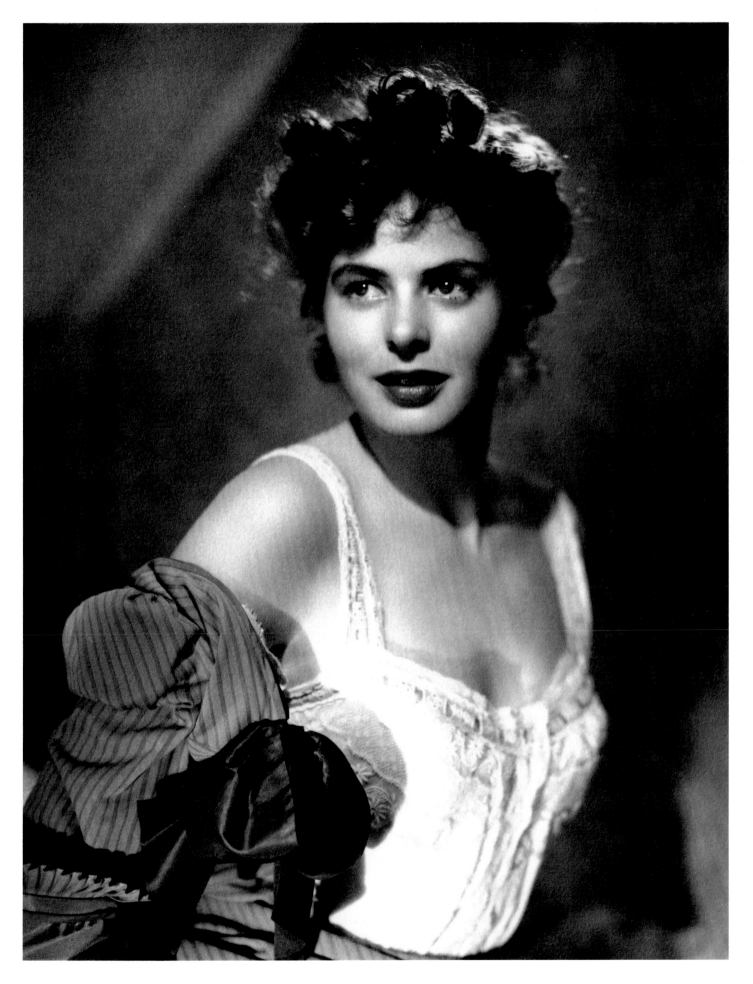

Casablanca

The US enters the Second World War after the Japanese attack on Pearl Harbor in December 1941, and this also has a major impact on the American movie industry during the following years.

For the underemployed Ingrid Bergman there is no light at the end of the tunnel until April of 1942: "Oh, Ruth, … I received news that definitely I have another film … I tried to get drunk for celebration at dinner, but I could not. I tried to cry. I tried to laugh, but I could do nothing … The picture is called *Casablanca* and I really don't know what it's all about … "[22]

The film is a Warner Bros. production with Michael Curtiz directing. She is not very enthusiastic about the role she has been offered, however. She feels she has again been type-cast and wants a change. She later relates: "In *Casablanca* I fell right back where I'd come from. David O. Selznick liked it because at last I was going to wear lovely gowns and clothes and look pretty." Michael Curtiz explained that a star was expected to play the same role again and again: "The audience wants it at the box office. … So you are going to ruin your career by trying to change and do different things."[23]

Producer Hal Wallis has to pull out all the stops in order to pry her away from Selznick; and since *Algiers* with Charles Boyer and Hedy Lamarr is currently enjoying such a huge success, he promises Selznick "a lot of that *Algiers* schmaltz—lots of atmosphere, cigarette smoke, guitar music."[24] The shooting proves difficult, the script is a work in progress, and no one knows just how the story will end. When Ingrid Bergman asks her director with whom she is supposed to be in love, her former lover Rick (Humphrey Bogart) or her husband Victor Laszlo (Paul Henreid, who had torn up his lucrative contract with UFA in 1936), Curtiz replies: "We don't know yet—just play it well … in-between."[25] Humphrey Bogart's *Maltese Falcon* was playing to rave reviews at the time, but Ingrid Bergman never really got to know him like she had her previous leading men: "He was polite naturally, but I always felt there was a distance; he was behind a wall. I was intimidated by him."[26]

Just what made *Casablanca* one of Hollywood's greatest classics—whether it was the uncertainty of the ending, or the politically charged plot, or the great actors, some of whom, like Peter Lorre, Curt Bois, and Trude Berliner, had themselves fled from the Nazis, or the "ideal" musical score—is still a matter of controversy.

It is ironic that while shooting the role that would immortalize her, Ingrid Bergman was constantly thinking of another role—that of Maria in the planned screen adaptation of Hemingway's *For Whom the Bell Tolls*. It had come to her ears that Paramount no longer intended to cast dancer Vera Zorina and instead wanted to give the role to her. Another irony: *Casablanca's* theme song was retained by chance. The original intention was that it be replaced by another composition, but Ingrid Bergman is unavailable to re-shoot the necessary scenes. Two days after completion of the final publicity shots for *Casablanca*, Ingrid Bergman is already en route to the Sierra Nevada to do the outdoor shots of *For Whom the Bell Tolls*.

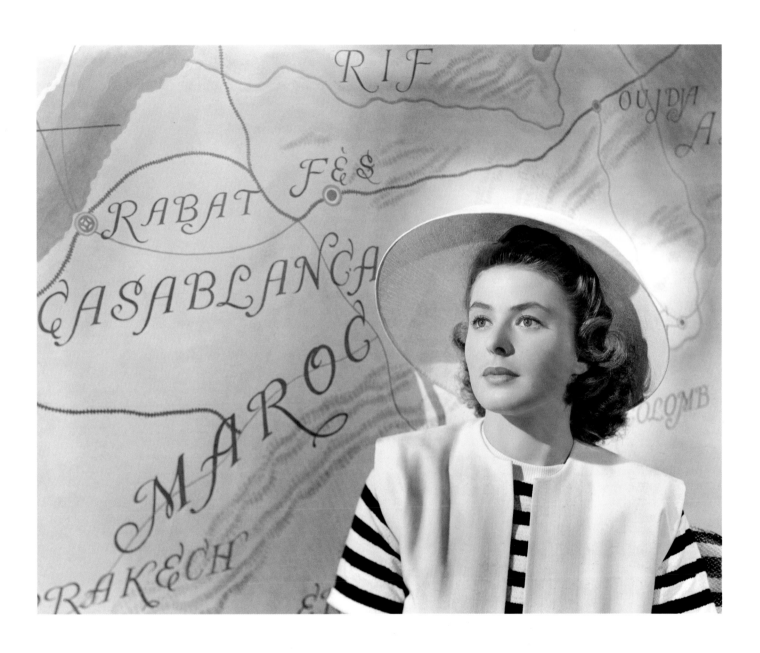

Selznick puts Ingrid on loan to Warner Bros. for *Casablanca*. The picture is shot in black & white, but the advertising campaign makes use of color photographs. Ingrid posing in front of the map of North Africa that was used for the opening credits.
Hollywood, 1942

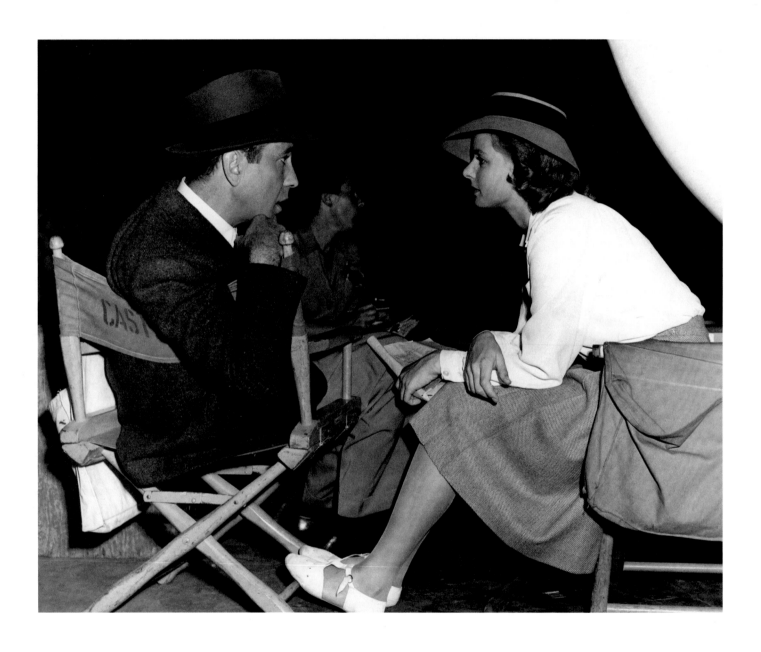

Humphrey Bogart and Ingrid Bergman
wearing the elegant hats from the final
scene—on the set during a shooting break.
Hollywood, 1942

Right page
From the left: Paul Henreid as Victor Laszlo,
Ingrid Bergman as Ilsa Lund, and Humphrey
Bogart as Rick Blaine standing in front of the
entrance to "Rick's Café Américaine."
Production still from *Casablanca*, 1942

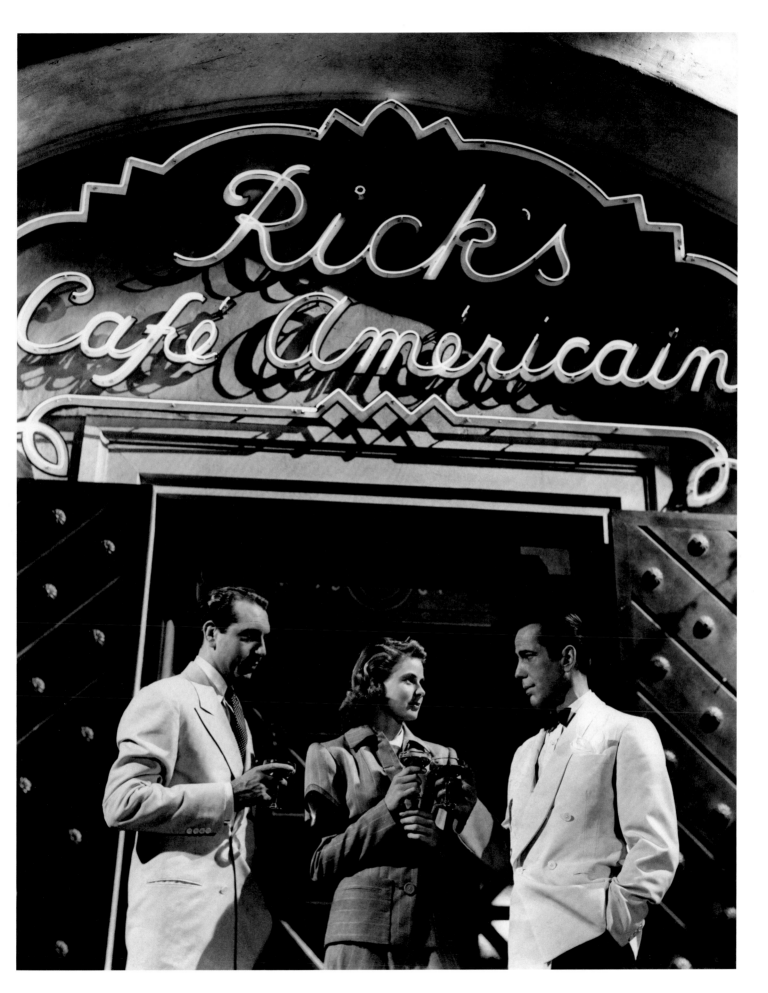

Flashback to the happy time in Paris:
the nightclub pianist, Sam (Dooley Wilson),
intones *As Time Goes By*. The piece soon
becomes the theme song of all lovers
whose paths are parted by fate.
Production still from *Casablanca*, 1942

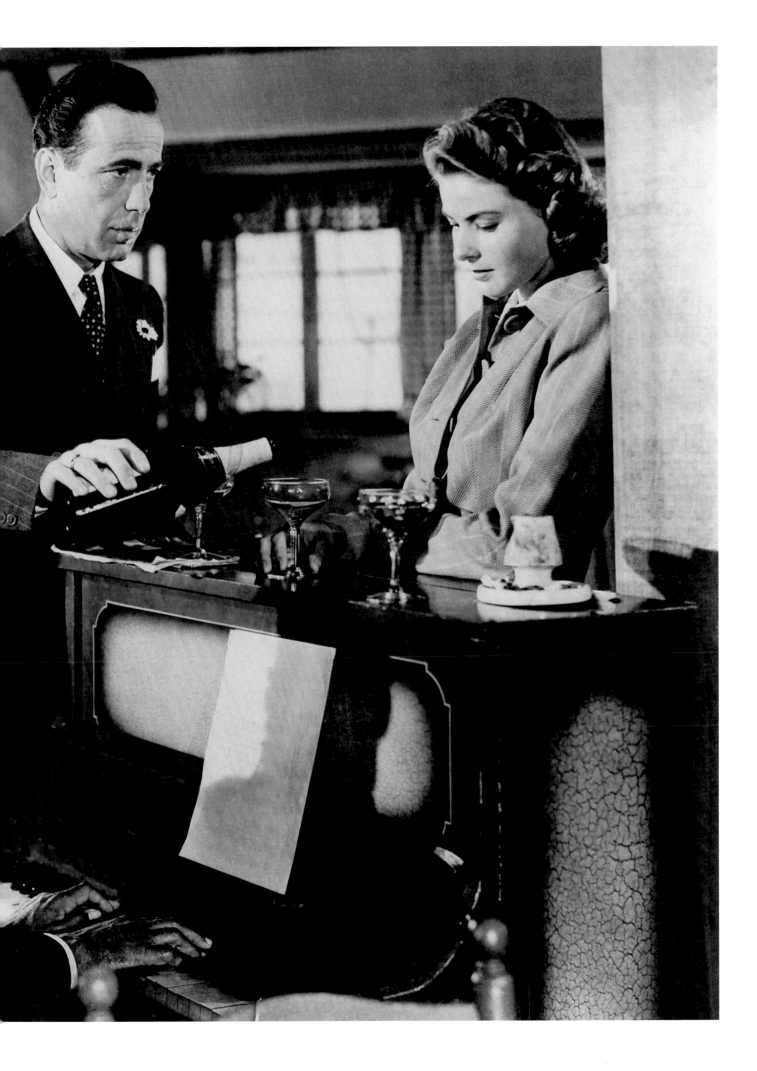

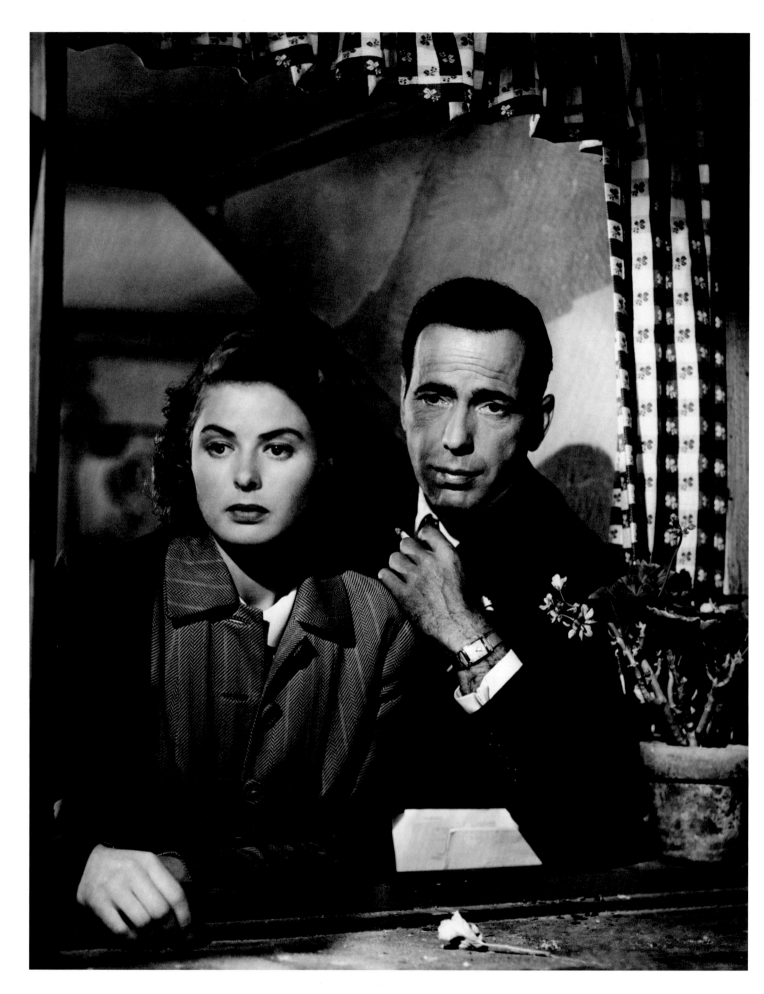

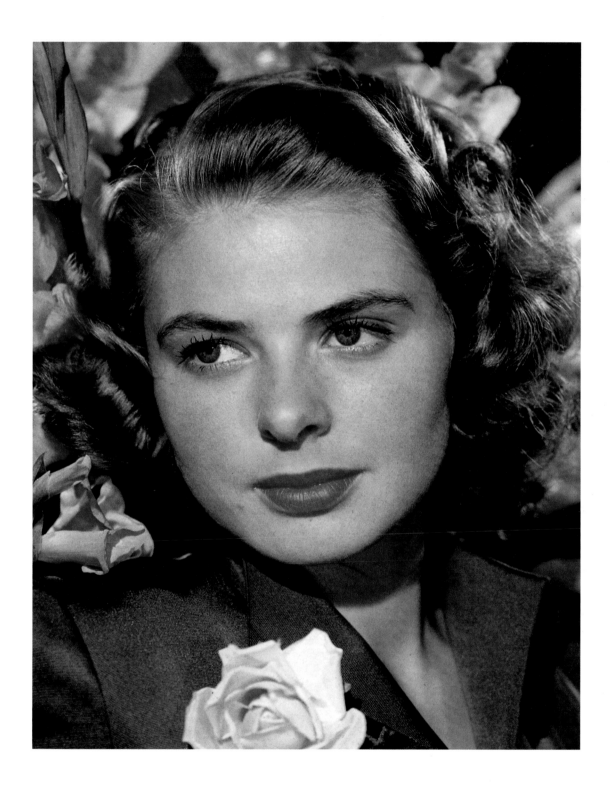

Left page
Another flashback to Paris.
Ingrid Bergman and Humphrey Bogart
listen to a loudspeaker announcement
proclaiming the German invasion.

This page
Publicity shot for *Casablanca*
in color: Ingrid Bergman wearing
the costume worn in the Paris
flashback.

143

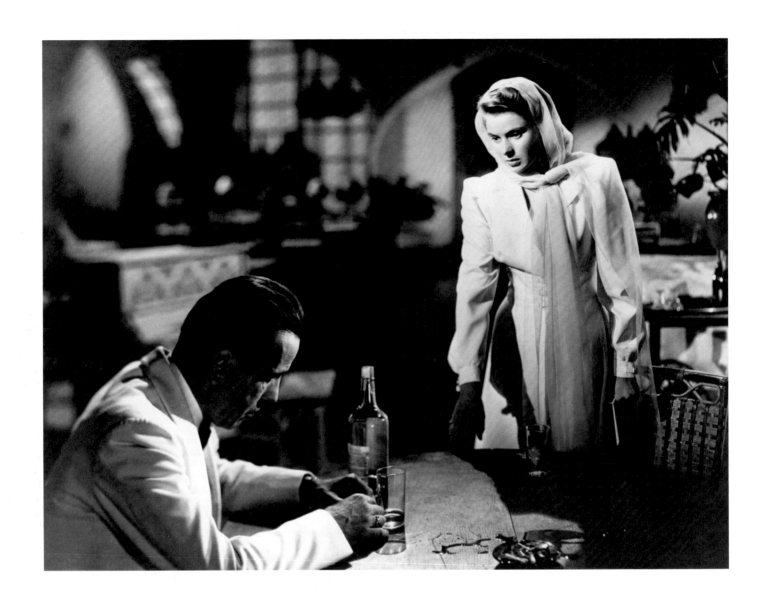

Casablanca: Humphrey Bogart
and Ingrid Bergman during a late-
night encounter in "Rick's Café"

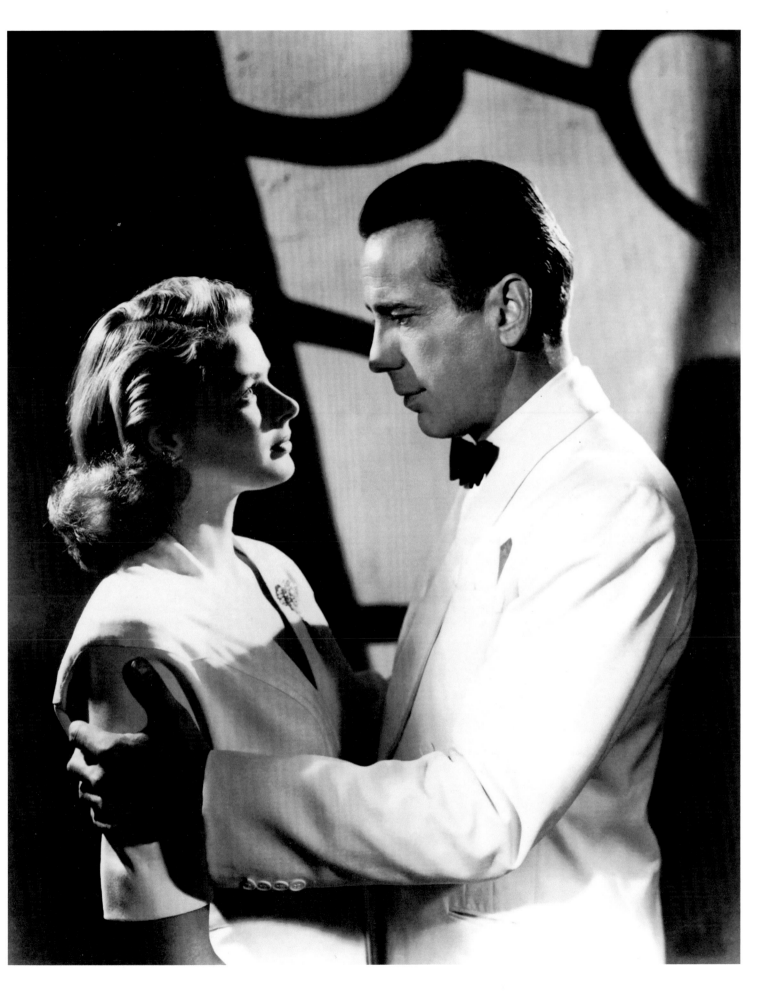

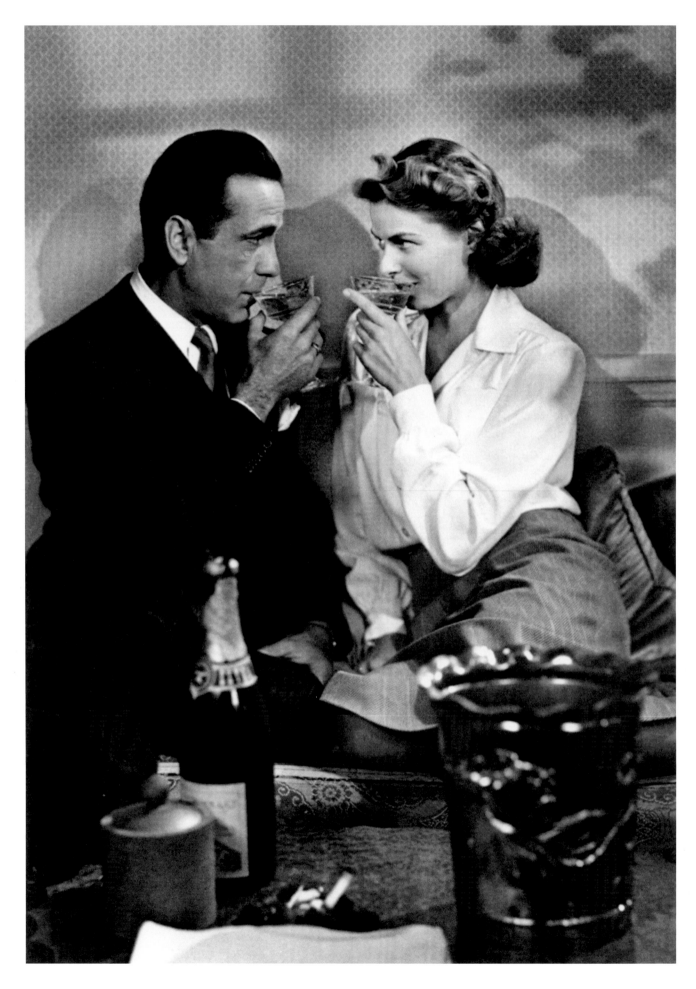

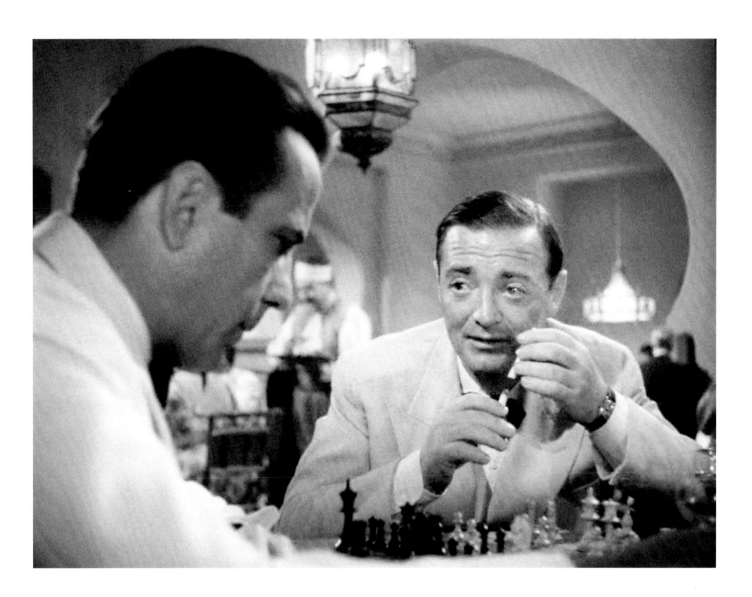

Left page
Humphrey Bogart described working with
Ingrid Bergman in these words: "I didn't do
anything I've never done before, but when the
camera moves in on that Bergman face and she's
saying, she loves you, it would make anybody
feel romantic."[27] Production still from
Casablanca, 1942

This page
Rick with black marketeer Ugarte (Peter Lorre),
who asks him to keep the two stolen visa.
Scene from *Casablanca*, 1942

Ilsa (Ingrid Bergman) and Victor Laszlo (Paul Henreid). A woman on the run and caught between two men—Ingrid has to keep up a peculiar emotional balancing act in *Casablanca* because the screenwriters have not yet decided which man she will ultimately choose.

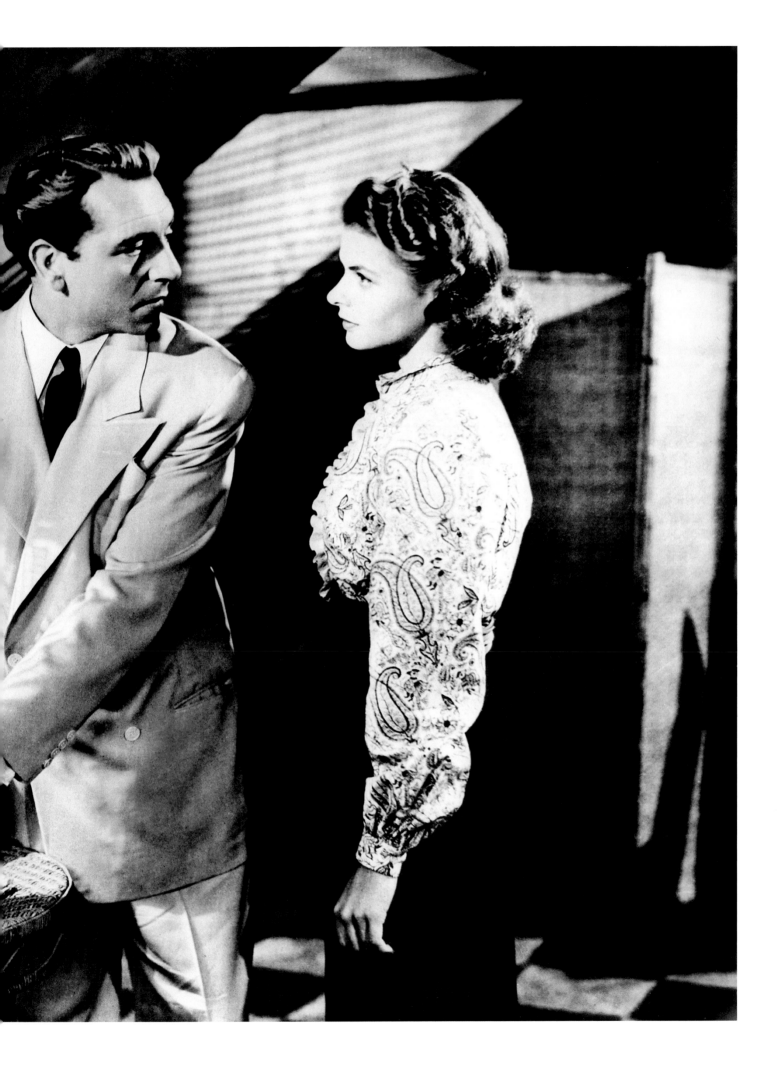

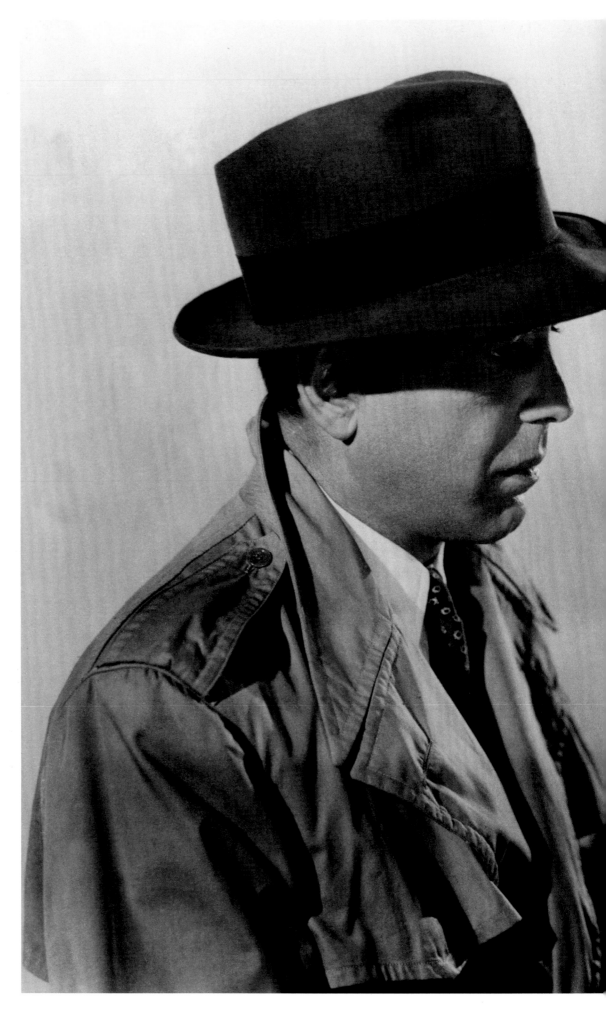

Probably the most famous
farewell scene in the history
of motion pictures. "Here's
looking at you, kid." Production
still from *Casablanca*, 1942.
Photo: Jack Woods

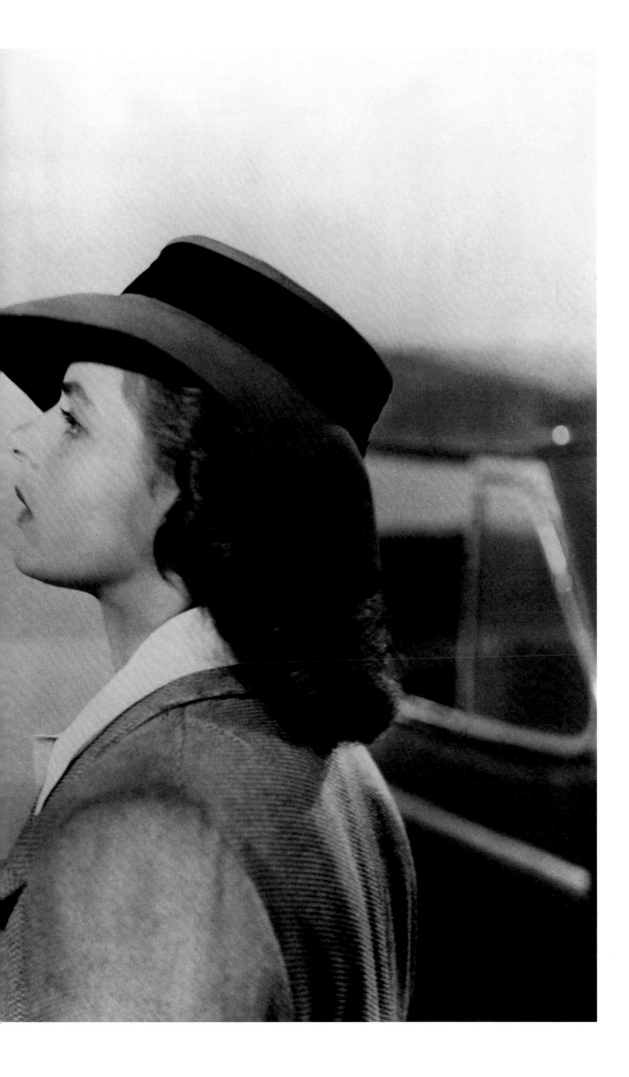

Close-up of the farewell scene.

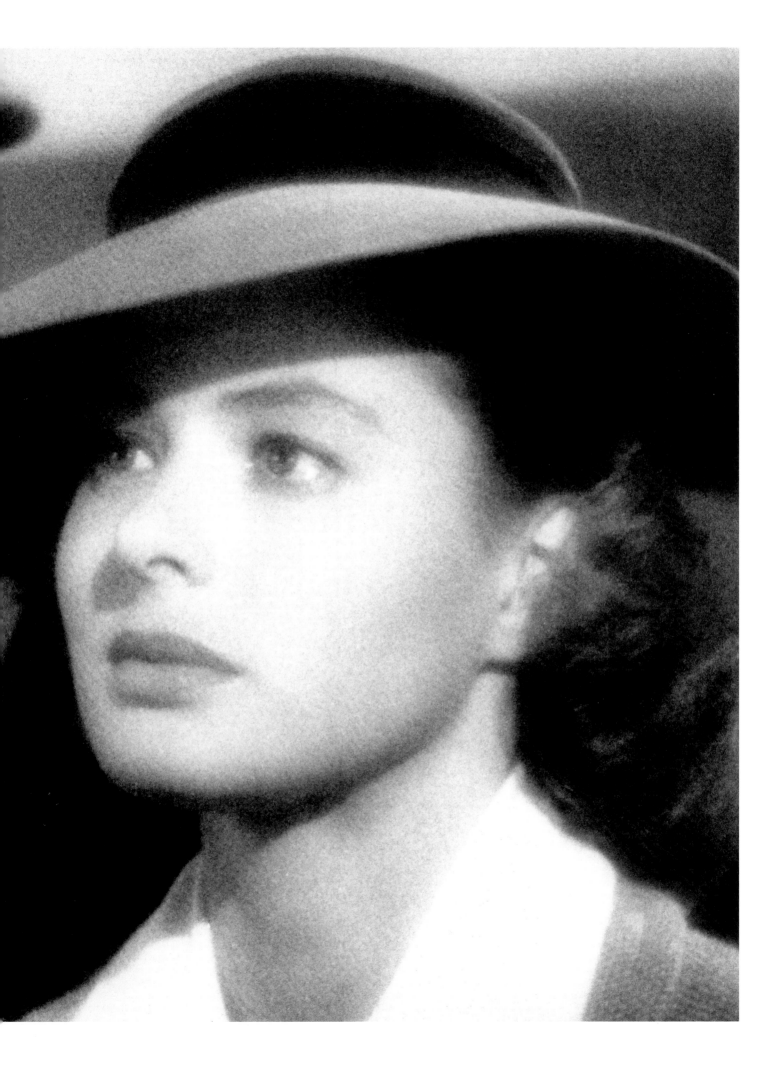

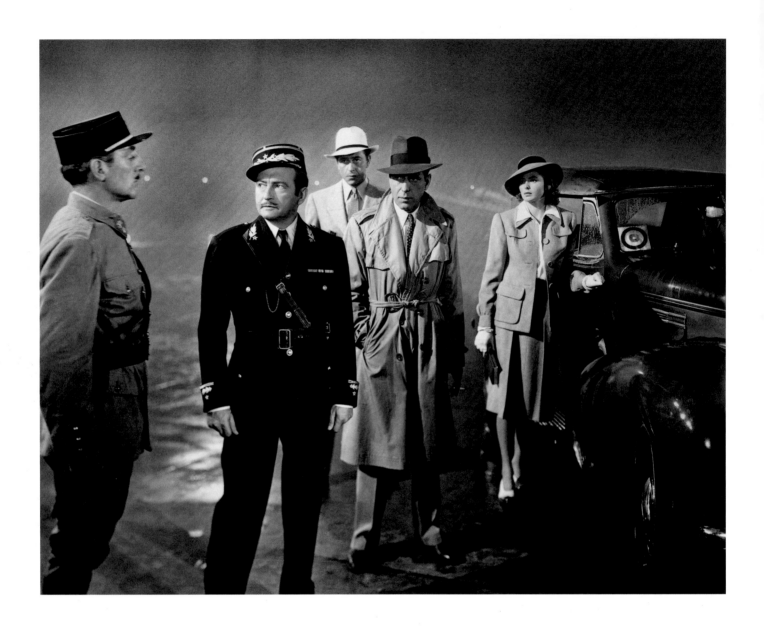

The countdown starts. From the left: an officer
announcing the arrival of Major Strasser, the Prefect
of Police (Claude Rains), Victor Laszlo (Paul Henreid),
Rick Blaine (Humphrey Bogart), and Ilsa Lund (Ingrid
Bergman) at the airfield in Casablanca.

Right page
The farewell scene of *Casablanca*,
seen over the shoulder of brilliant
cameraman Arthur Edeson.
Hollywood, 1942. Set still: Jack Woods

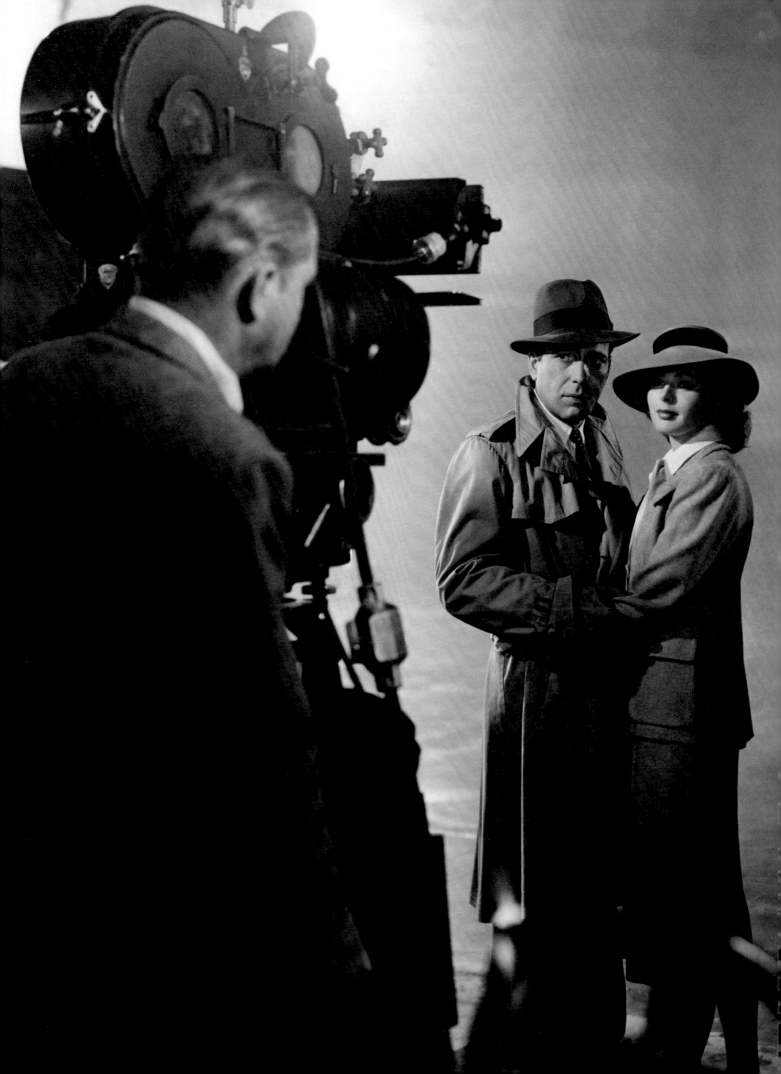

For Whom the Bell Tolls

A meeting took place between Ingrid Bergman and Ernest Hemingway in San Francisco—with a *Life* photographer in attendance—in February 1941. Hemingway wanted Ingrid Bergman to play the role of the young orphan Maria in the film version of his novel set in the Spanish Civil War. Maria lives with the guerillas and falls in love with American Robert Jordan (Gary Cooper), who is fighting in the International Brigades for the Republicans. Hemingway's wife Martha Gellhorn originally came up with the idea of casting Ingrid Bergman in the part of Maria. She had noticed the "woman with a baby on her back" during the voyage from Genoa to New York aboard the *Rex*. Ingrid Bergman's disappointment comes as no surprise when Paramount initially casts dancer Vera Zorina and even begins shooting. Her elation is all the greater when Paramount recasts the role and offers it to her.

She bobs her hair, as called for by the novel upon which the film is based: Maria had been raped and shorn by the Falangists. Ingrid Bergman spawns a new look with her bobbed hair and finds countless imitators, not just in the US.

Working under experienced Hollywood director Sam Wood, she enjoys the shooting this time. Wood ignores the political aspect as much as possible, preferring to make a romantic war movie: "We had such a lot of fun up there in the Sierra Nevada mountains … It was so primitive and romantic up there among the stars and the high peaks … "[28] The attraction between the leading man and lady does not only exert itself in front of the camera, but both are married. "Luckily for Ingrid, the movie was being filmed away from the prying eyes of Hollywood."[29]

Following a long post-production period, the picture starts its run on 16 August 1943, and endless lines form at the box offices. Selznick congratulates his star at having become America's favorite actress. The critics, on the other hand, pan the film as a clumsy monstrosity, and Hemingway is so appalled that he walks out four times before seeing it in its entirety: "I went in to see it. After I'd seen the first five minutes I couldn't stand it any longer so I walked out. They'd cut all my best scenes and there was no point to it … It took me five visits to see that movie."[30]

After *Casablanca* (which has played to sold-out audiences ever since starting its run in November 1942 and received three Oscars for outstanding motion picture, best director, and best screen play—but not best actor) and *For Whom the Bell Tolls*, Ingrid Bergman is approaching the zenith of star heaven.

Ingrid Bergman, Ernest Hemingway, and his wife Martha Gellhorn in front of Jack's Restaurant in San Francisco on 1 February 1941. The meeting was arranged by Selznick in order to secure the role of Maria, the heroine in the screen adaptation of Hemingway's novel *For Whom the Bell Tolls*, for Ingrid Bergman. Photo: Bob Landry, 1941

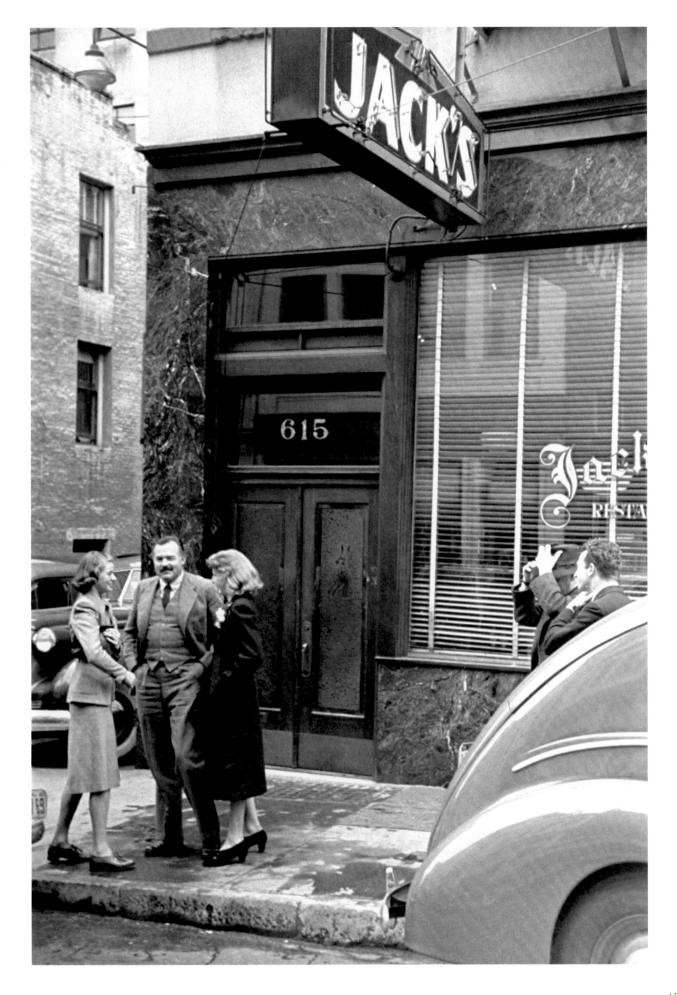

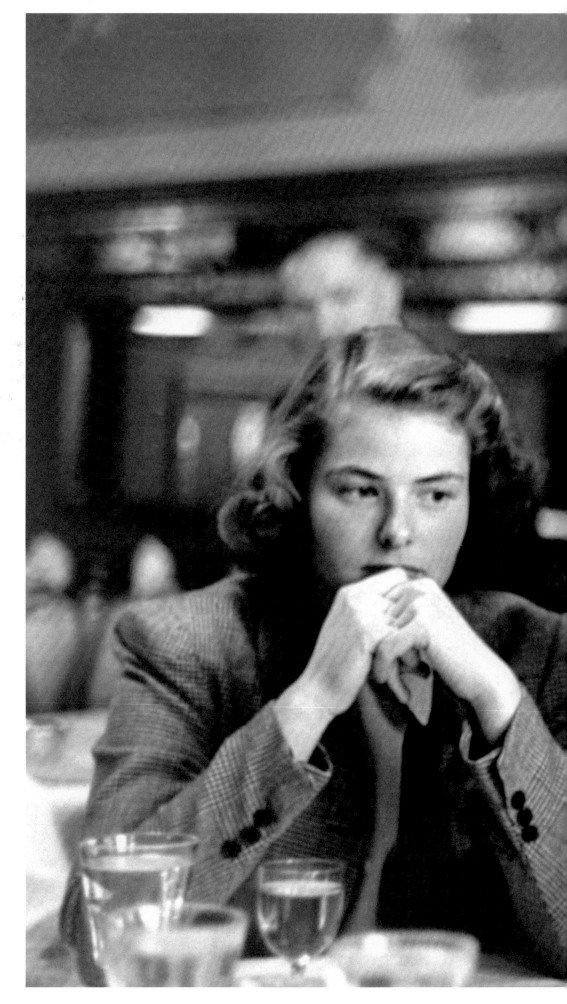

Ingrid Bergman and Ernest Hemingway during the same meeting. *Life* magazine quotes Hemingway as saying, "If you don't act in the picture; Ingrid, I won't work on it." Ingrid's reaction is described as being "shy" at first, "but then she laughed." Hemingway gives her a copy of the book with the inscription, "To Ingrid Bergman, who is the Maria of this story."[31]
Photo: Bob Landry

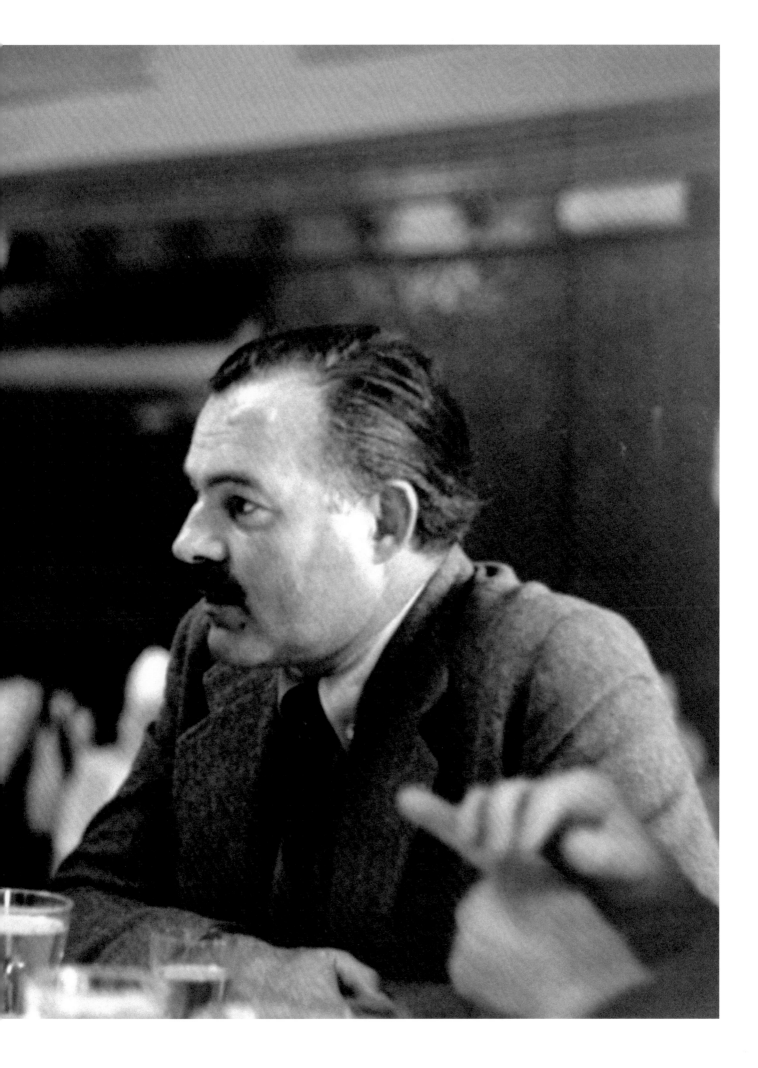

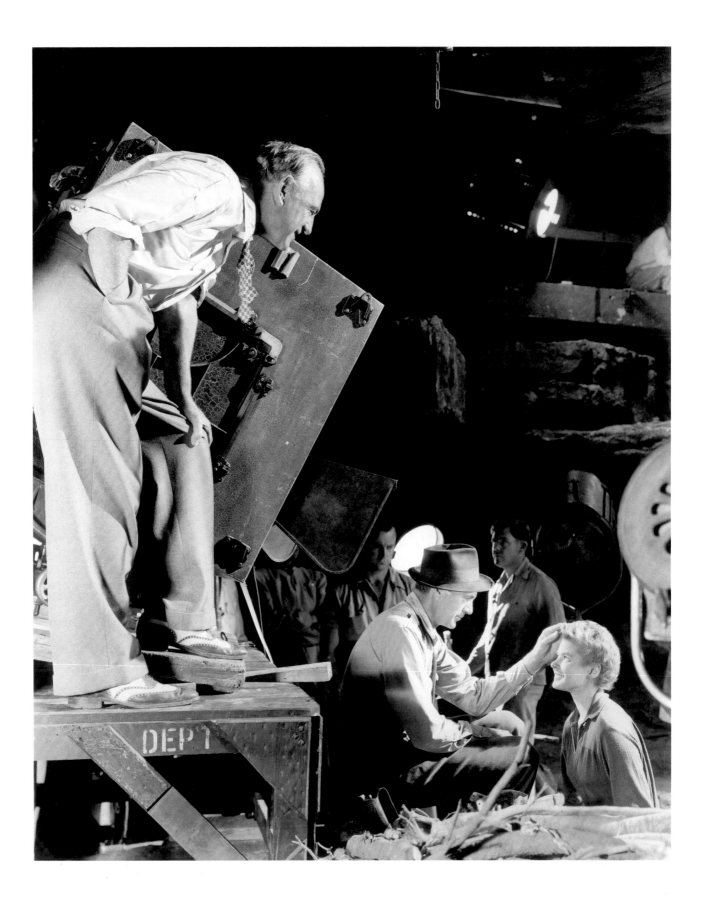

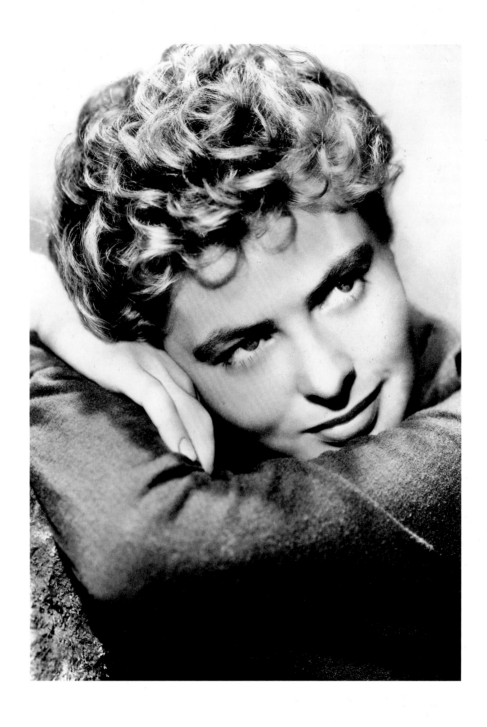

Left page
Director Sam Wood observes the love
scene between Gary Cooper, who plays
teacher-turned-mercenary Robert Jordan,
and Ingrid as Maria. *For Whom the Bell
Tolls*, Sierra Nevada, 1942

This page
Publicity shot of Ingrid as Maria for *For Whom the Bell
Tolls*. Bergman had cropped her hair for the role: "And
the short hair became all the rage in America. All the
women wanted the Maria cut ... They didn't know I had
a hairdresser who followed me around like a shadow
and rolled my hair up every minute of the day."[32]

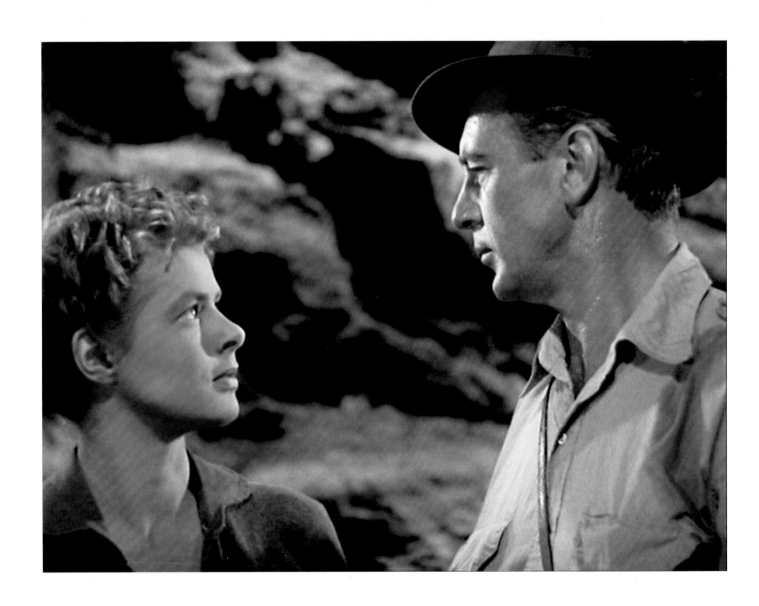

For Whom the Bell Tolls is Bergman's
first movie in color. Production still
with Gary Cooper, 1942

Right page
The movie was shot in color, but black &
white production stills were still the rule.
Gary Cooper and Ingrid Bergman in *For
Whom the Bell Tolls*, Sierra Nevada, 1942

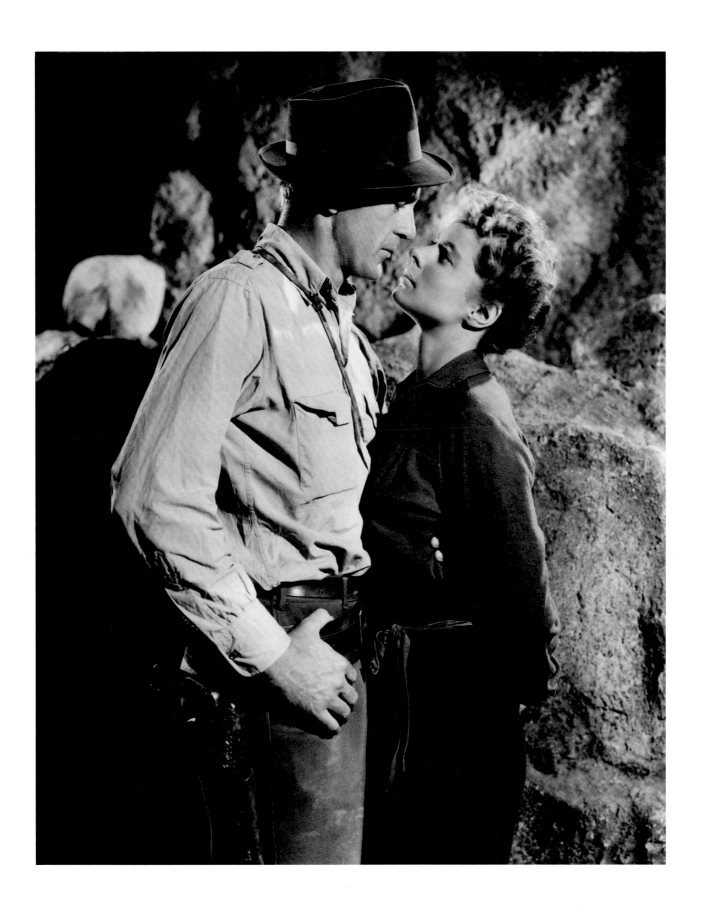

Love scene between Ingrid/Maria and Gary Cooper/Robert Jordan. Dealing in emotions is an ambivalent business. Ingrid comments: "What was wrong was that my happiness showed on the screen. I was far too happy to honestly portray Maria's tragic figure."[33] And Gary Cooper recalls it thus: "In my whole life I never had a woman so much in love with me as Ingrid was. The day after the picture ended, I couldn't get her on the phone."[34] Production still from *For Whom the Bell Tolls*, Sierra Nevada, 1942

Ingrid Bergman and Gary Cooper in
For Whom the Bell Tolls. "It was so
primitive and romantic up there
among the stars and the high peaks …
I loved my wardrobe: an old pair of
man's trousers tied around my waist
with a piece of string, and an old shirt
… We were up there a long time …
nine or ten weeks in all."[35]

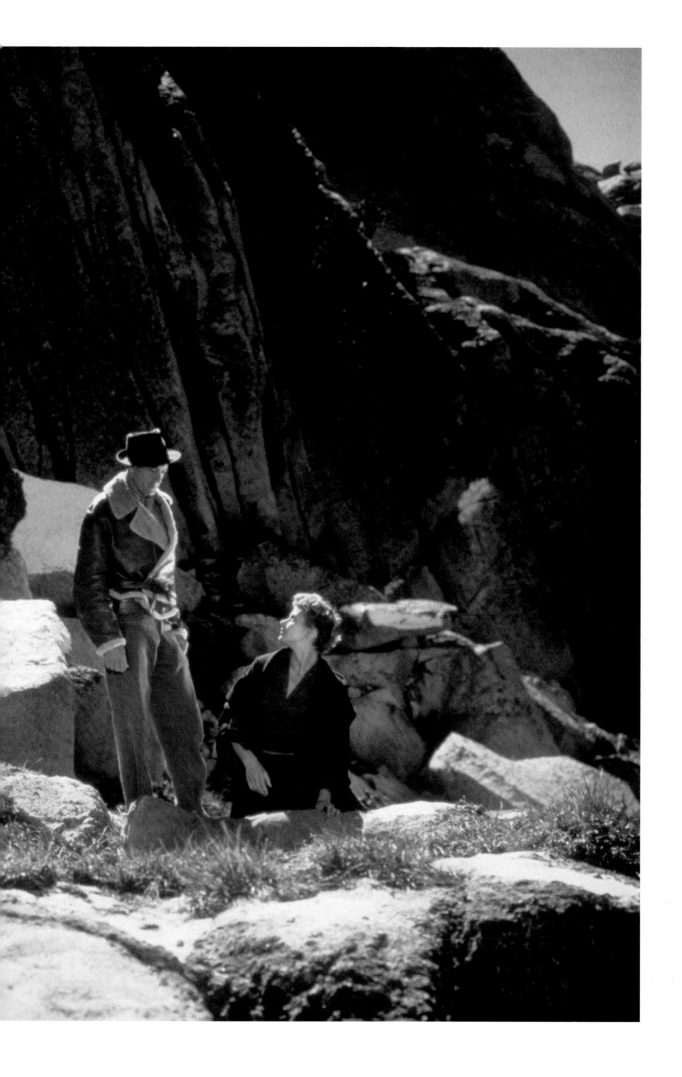

Saratoga Trunk

While still on the set of *For Whom the Bell Tolls* in the Sierra Nevada, director Sam Wood, Gary Cooper, and Ingrid Bergman make plans to work together again. They all read the novel *Saratoga Trunk* by Edna Ferber and begin planning the screen adaptation—a frivolously funny Southern adventure to follow behind the heroic drama set in the Spanish Civil War. Selznick balks at first, but Gary Cooper's signature on the contract clinches the deal: Selznick puts his star on loan to Warner Bros. for $250,000. It is Warner Bros.' most expensive production to date, with 96 sets, over 11,000 props, 200 stuntmen for a single one-minute scene of a nocturnal train wreck, and a myriad of crinolines, carriages, and gas lanterns. Ingrid Bergman plays Clio, a dark-haired beauty and illegitimate daughter of a wealthy French aristocrat, who wants to avenge the mistreatment of her mother by her father's family and falls for a Texas gambler (Gary Cooper).

Her affair with Gary Cooper is rekindled, but ends when the film is wrapped up because the entire Lindström family has meanwhile moved from Rochester to an upper class section of Beverly Hills and taken up residence on Canyon Drive. Petter Lindström, who had come to the US during the winter of 1940/41, initially practiced dentistry in Rochester, New York, and then completed his degree in neurosurgery. Now he moves to California to finish his internship at a hospital in San Francisco.

Shot between February and July 1943, *Saratoga Trunk* got lost in the shuffle of war movies that flooded the movie houses following America's entry into the war. It did not have its public premiere until November 1945, three months after the war had ended.

On the set of *Saratoga Trunk*, which was shot in early 1943, but was not officially released until 1945. Ingrid Bergman in the role of Clio, Gary Cooper as Clint, and between them the diminutive Jerry Austin as her manservant Cupidon. Photo: Jack Woods

Right page
Her small amateur film camera is now a constant companion on the set. In *Saratoga Trunk* she continues the collaboration with director Sam Wood and Gary Cooper which started with *For Whom the Bell Tolls*. This time Selznick puts her on loan to Warner Bros. Hollywood, 1943. Photo: Jack Woods

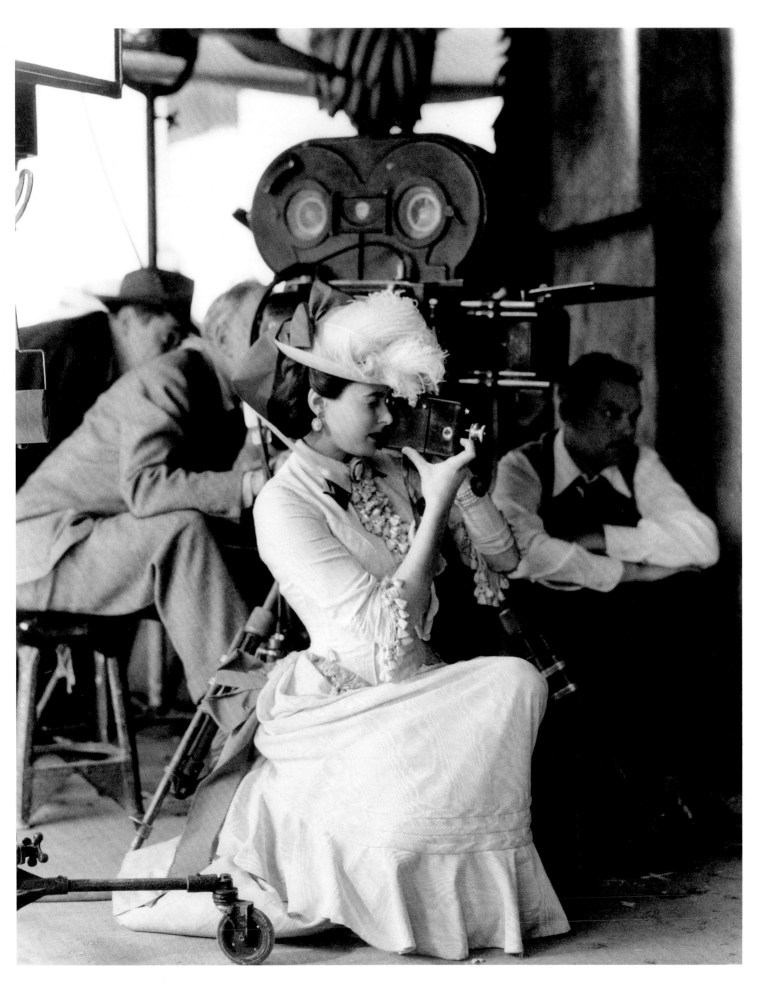

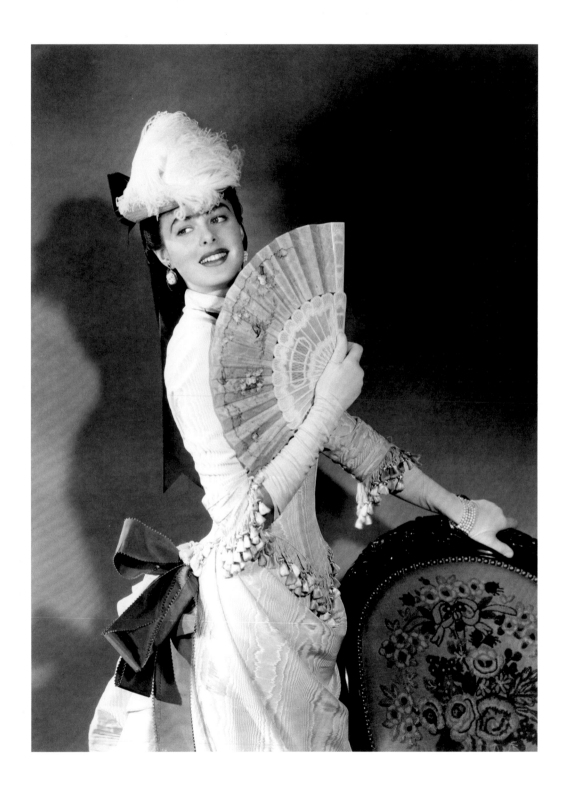

Ingrid as Clio, the illegitimate daughter of
a wealthy aristocrat and a Creole woman.
Production still from *Saratoga Trunk*, 1943

Right page
Ingrid as Clio and Gary Cooper as Clint,
two children of fortune who have found
one another. Production still from
Saratoga Trunk, 1943

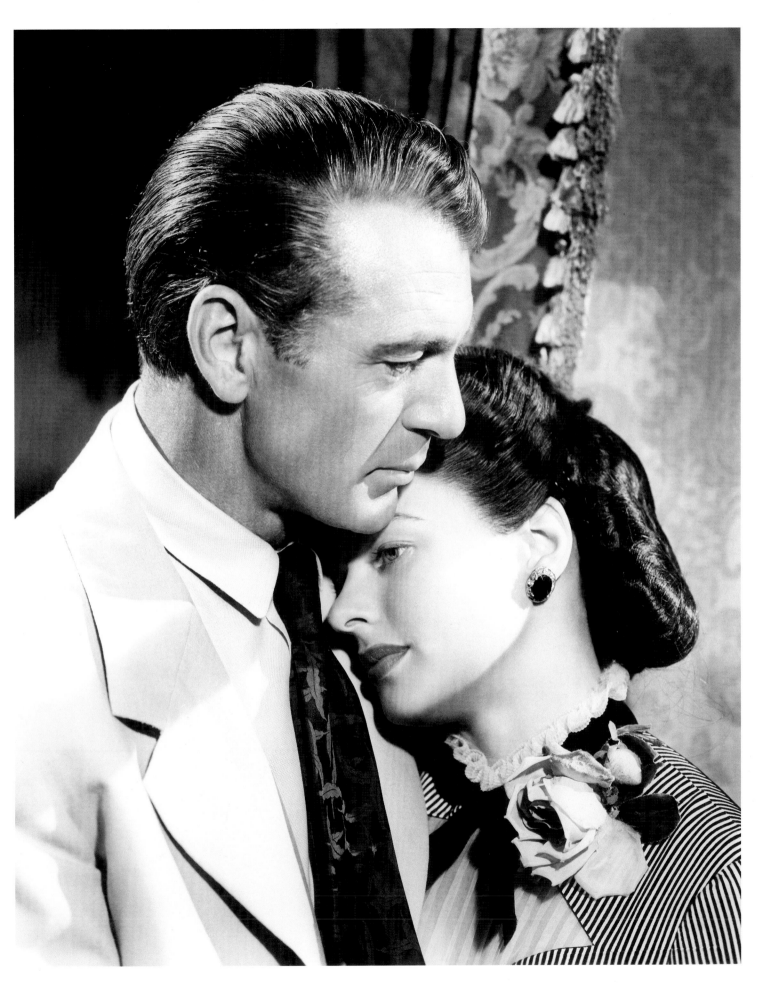

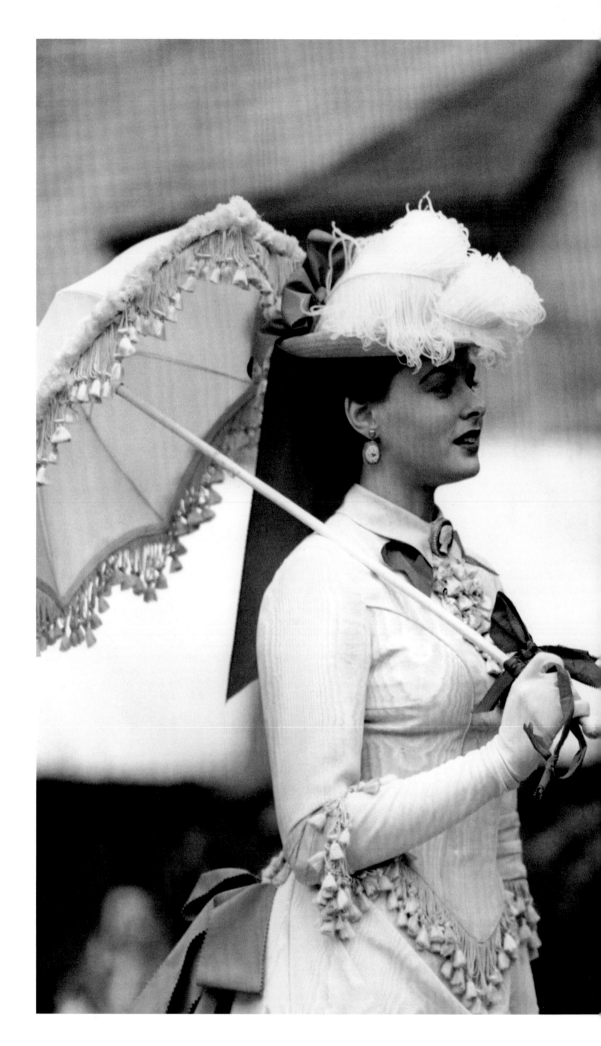

The two principals, dressed up in their summer finery. Ingrid's transformation into the Creole half-caste Clio was so complete that her own agent didn't recognize her in the studio's canteen, as she proudly notes in her autobiography.[36]
Production still from *Saratoga Trunk*, 1943

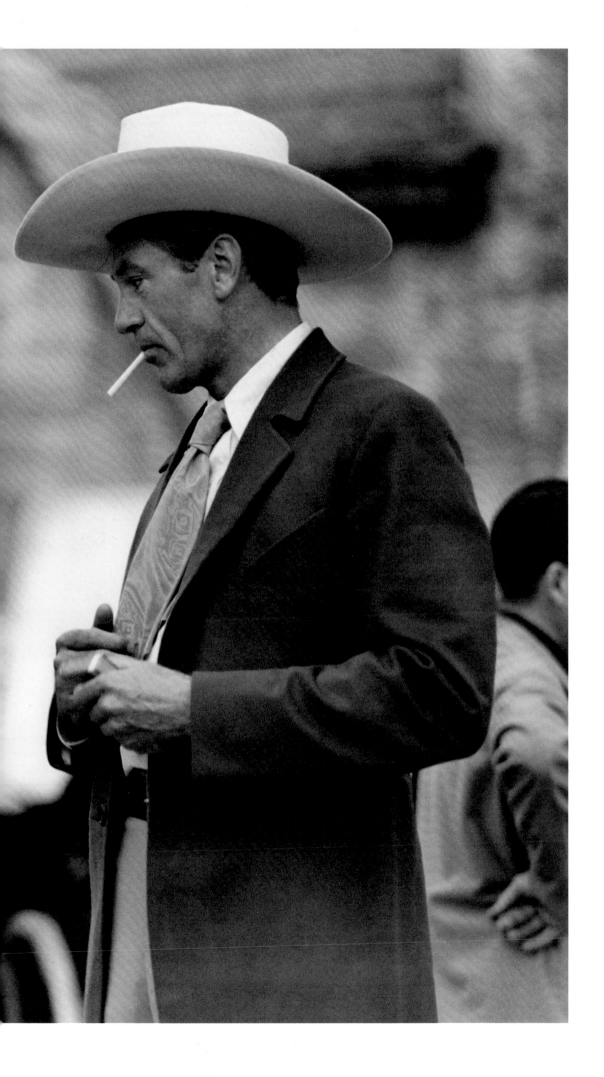

Gaslight

The next project on the agenda at Metro Goldwyn Mayer is *Gaslight,* a thriller based on the play *Angel Street* by Patrick Hamilton, which is to be directed by George Cukor. Charles Boyer is slated to be Ingrid Bergman's leading man, but David O. Selznick nearly calls the project off because Boyer insists on having top billing: "We almost lost that movie—at least *I* almost lost that movie—because Charles Boyer was very mad and he was not going to give in because he'd been a big star far longer than I had. So I had to cry, I had to sob, I had to plead before David very, very grudgingly, gave way."[37]

Ingrid Bergman stars as Paula Alquist. Together with her husband she moves into the house bequeathed to her by her aunt, who was murdered under mysterious circumstances. Strange things occur there, which only she seems to notice, and she begins to doubt her sanity. It turns out that her husband is trying to drive her insane. He is also her aunt's murderer and a jewel thief, but he is brought to ground by a Scotland Yard inspector, played by Joseph Cotten.

As part of her preparations for the role of Paula, Ingrid Bergman makes several visits to a patient suffering from hallucinations in a mental institution. Shooting commences in July 1943. *Gaslight* finally provides her with an opportunity to fully employ, and further expand, her mimetic and acting repertoire. Unlike *Saratoga Trunk,* the picture immediately begins its run at the cinemas, and a year later, it fetches Ingrid Bergman a Golden Globe and her first Oscar.

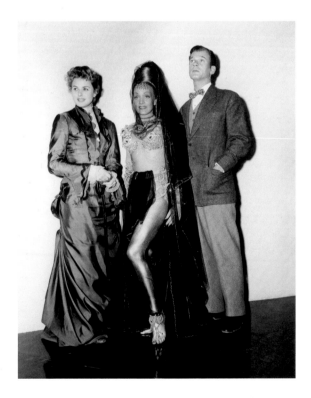

A visit from next door: Marlene Dietrich, who is portraying an oriental dancer in *Kismet* in the adjoining studio, stops by the set of *Gaslight* and poses for photographers between Ingrid Bergman and Joseph Cotten. Hollywood, 1943

Right page
Under the direction of George Cukor for the MGM production *Gaslight*: Ingrid Bergman in the role of the fragile Paula Alquist. Production still. Hollywood, 1943

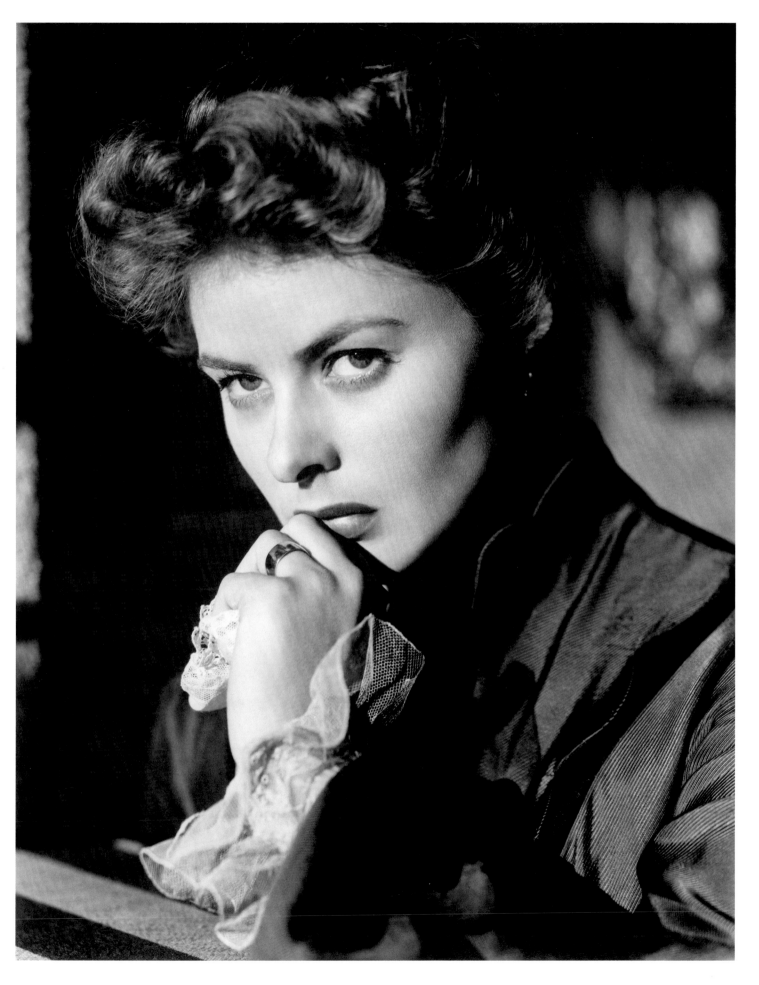

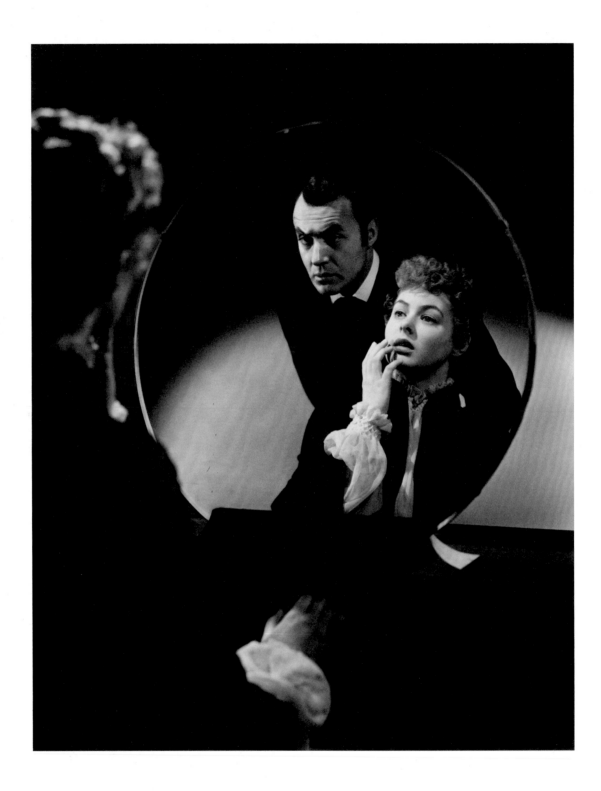

Charles Boyer, who must stand on a box to compensate
for his lack of height, plays Ingrid's shady husband. He
turns out to be a murderer sought by the authorities.
Ingrid admires him greatly off the set as well: " ...
I thought Charles Boyer was the most intelligent actor
I ever worked with, and one of the very nicest."[38]
Production stills from *Gaslight*. Hollywood, 1943

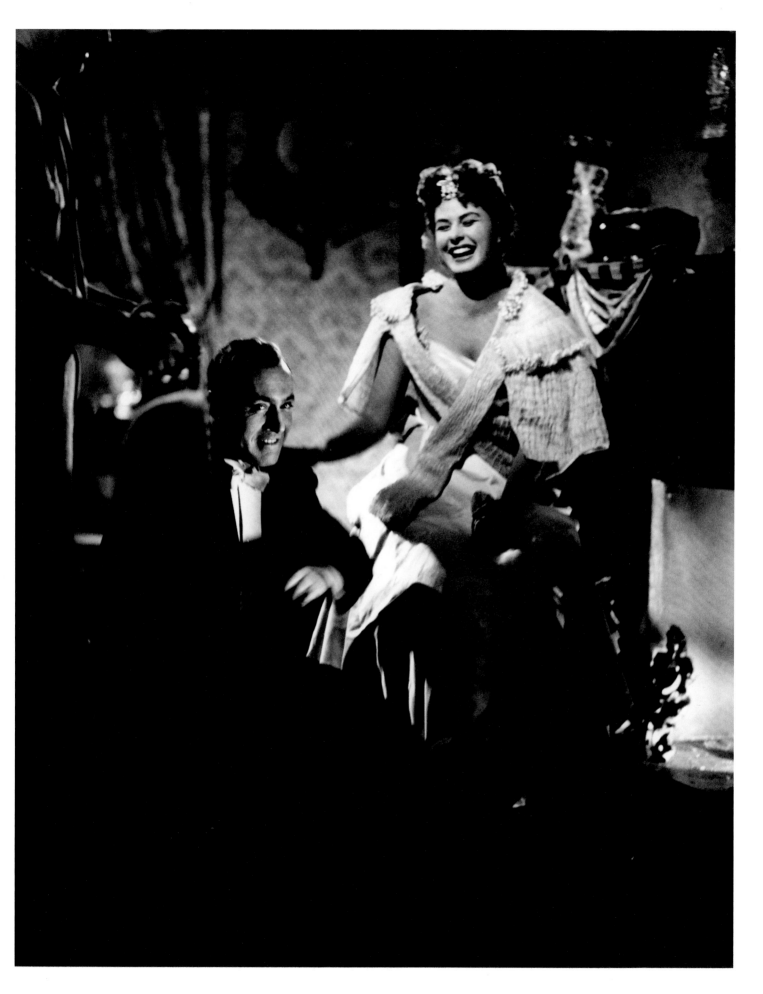

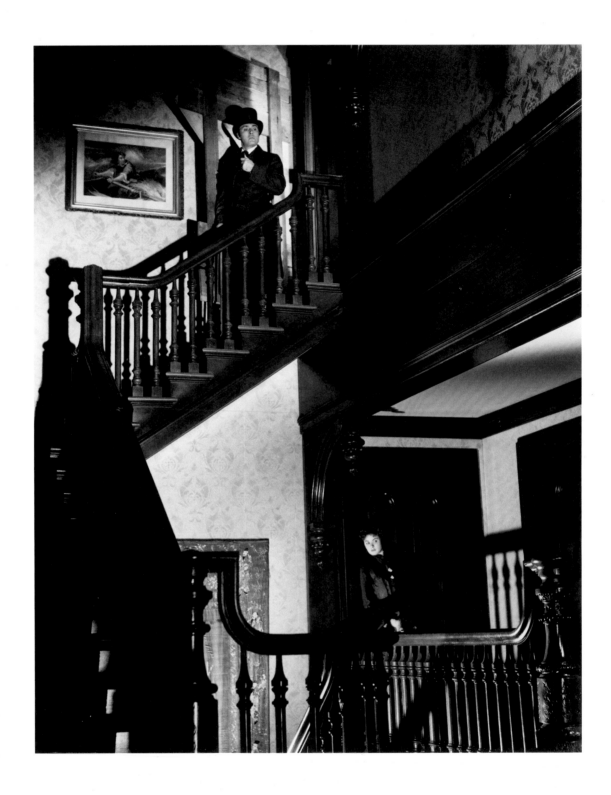

The eerie house plays a central role in *Gaslight*. Charles Boyer is at the top of the stairs. On the floor below, Ingrid Bergman.

Right page
The scene on the stairs necessitated the installation of a large camera crane and the construction of an open staircase. Detective Brian Cameron (Joseph Cotten) and Paula Alquist (Ingrid Bergman) are seen here descending the stairs.
Set stills from *Gaslight*. Hollywood, 1943

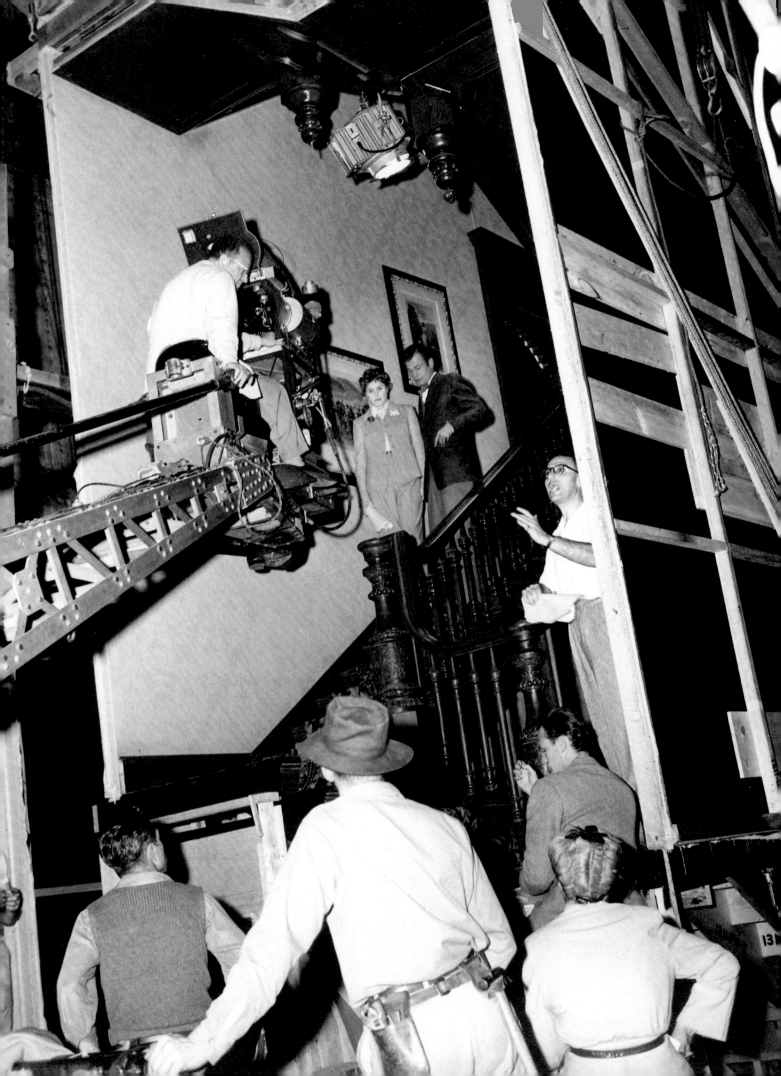

After the completion of *Gaslight*, Ingrid has
no pending engagements and at the behest of
her husband volunteers to entertain American
servicemen stationed in Alaska. At the turn of
the year 1943/44, Ingrid goes on a five-week USO
tour entertaining American troops stationed in
Alaska. This time it is not Selznick who sends her
off, however: her husband Petter had arranged
the tour. Although it means leaving her family
alone over the holidays, Ingrid and Petter view
it as a natural gesture of gratitude to a nation
that had given them so much. At remote out-
posts in the frozen North, Ingrid Bergman recites
passages from plays, sings Swedish folk songs,
signs autographs, and eats and dances with the
enlisted men.

Right page
Ingrid mingling with the crowd. "They have a
wonderful time and say that we are the first
ones to mix with them and not the generals."[39]
The arctic cold takes its toll on her, however, and
she has to break off the tour. She is admitted to
a hospital in Seattle with double pneumonia.

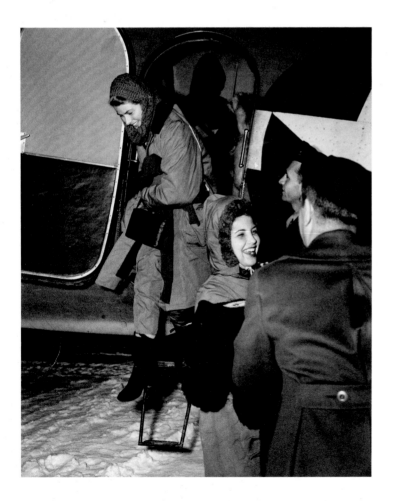

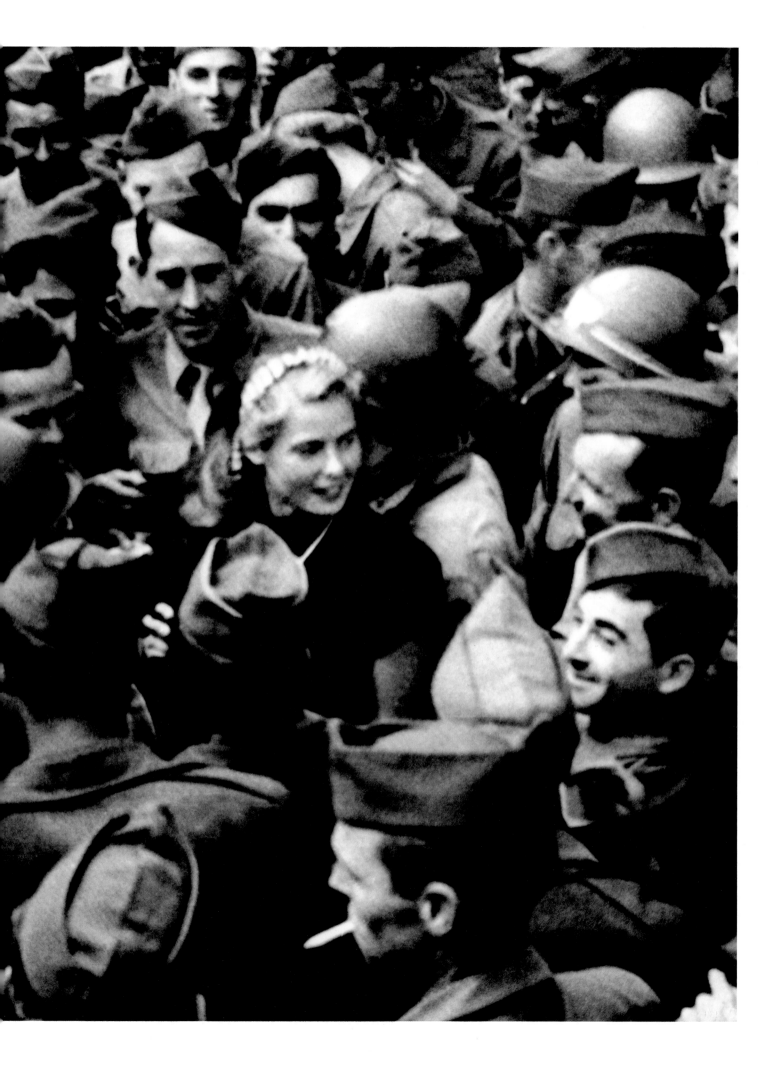

Spellbound

For the first time in five years, Selznick takes the initiative in finding a role for Ingrid Bergman in the spring of 1944. Alfred Hitchcock—who is also under contract with him, but is constantly on loan to other studios even though his first film won an Oscar for Selznick—is working on a screenplay for a "psychological story." Selznick is undergoing psychoanalysis at the time and wants him to make a picture based on the novel *The House of Dr. Edwardes* (by John Palmer and Hilary Saint George Saunders writing as "Francis Beeding"). The film is to feature Ingrid Bergman and Hollywood's new rising star Gregory Peck, who is also under contract with Selznick.

The story is about "J. B.," a man who suffers from amnesia and ends up assuming the identity of Dr. Edwardes, the director of a mental hospital. Dr. Constance Petersen, a psychoanalyst working there, soon discovers that something is amiss with her new colleague. Upon discovering that the real Dr. Edwardes is dead, J. B. believes he must have killed him. Constance has fallen in love with the impostor and uses psychoanalysis to find the real murderer.

Ingrid Bergman hesitates to accept the role at first because she finds the love story implausible, but Hitchcock persuades her when he mentions that he plans to make extensive use of technical innovations. These include dream sequences conceived by Salvador Dalí, one of which was cut from the final version, however, much to the disappointment of Ingrid Bergman: "It was a wonderful twenty-minute sequence … It was marvelous, but someone went to Selznick and said, 'What is all this drivel?' and so they cut it. It was such a pity."[40]

Hitchcock falls in love with his leading lady, but the attraction is not mutual. Nevertheless, *Spellbound* marks the onset of a collaboration that will bring forth three international cinematic hits in rapid succession, as well as the beginning of a friendship that will last until Hitchcock's death in 1980.

Three of David O. Selznick's top stars turn *Spellbound* into a unique work of art. The producer teams up Ingrid Bergman as psychiatrist Dr. Constance Petersen with director Alfred Hitchcock and Gregory Peck. *Spellbound* is his own production, the second with Ingrid since *Intermezzo* in 1939.
Photo: Madison Lacy

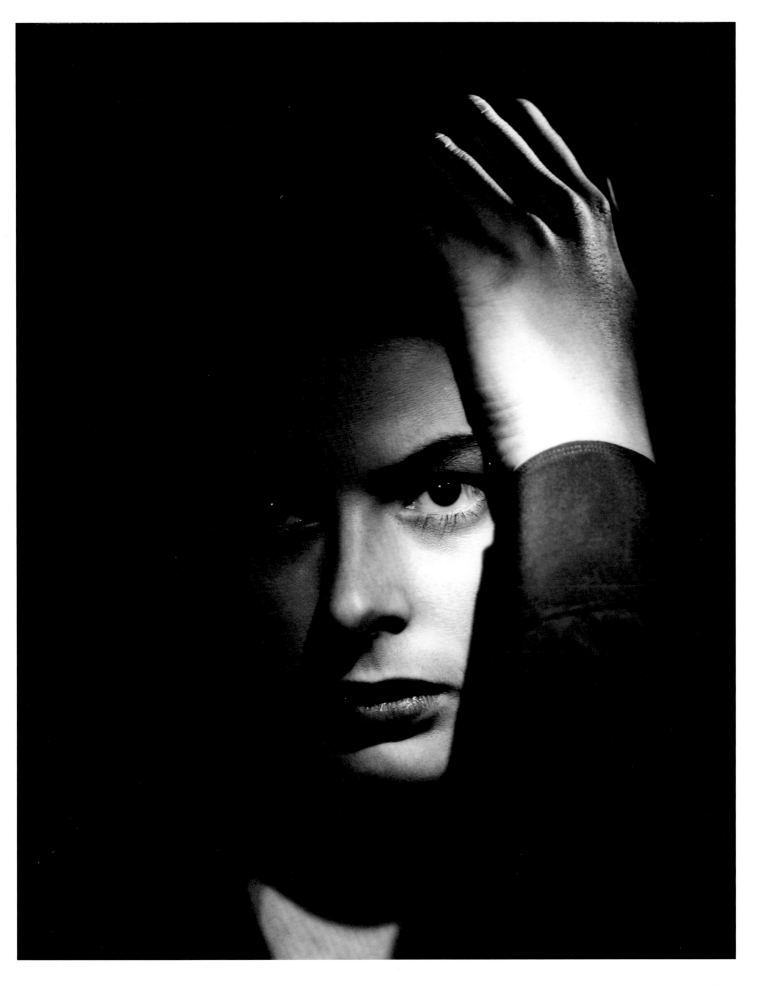

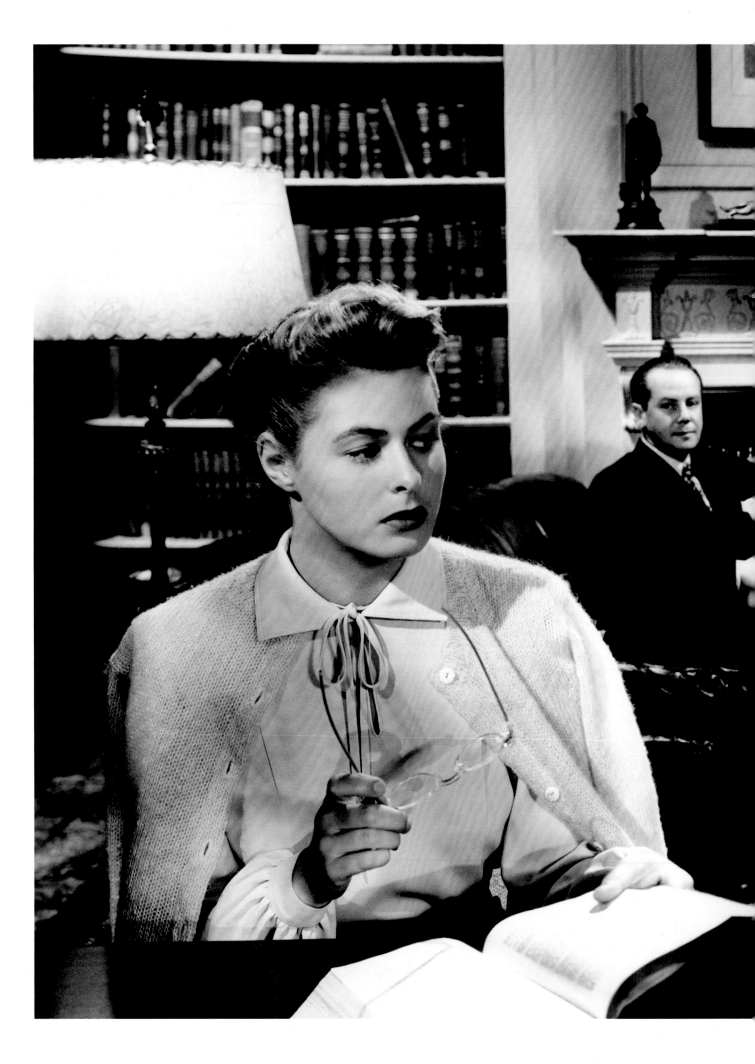

Psychoanalysis is central to the plot of *Spellbound*.
Dr. Constance Petersen, seen here with her colleagues,
employs it to unearth a murder and its cover-up in
a mental hospital. Production still from *Spellbound*.
Hollywood, 1944

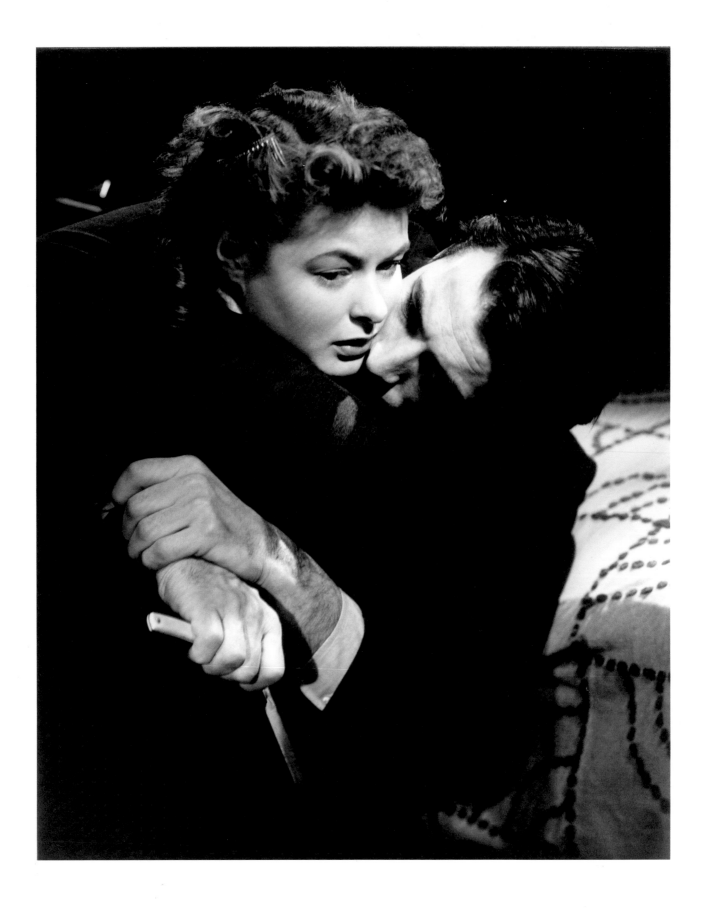

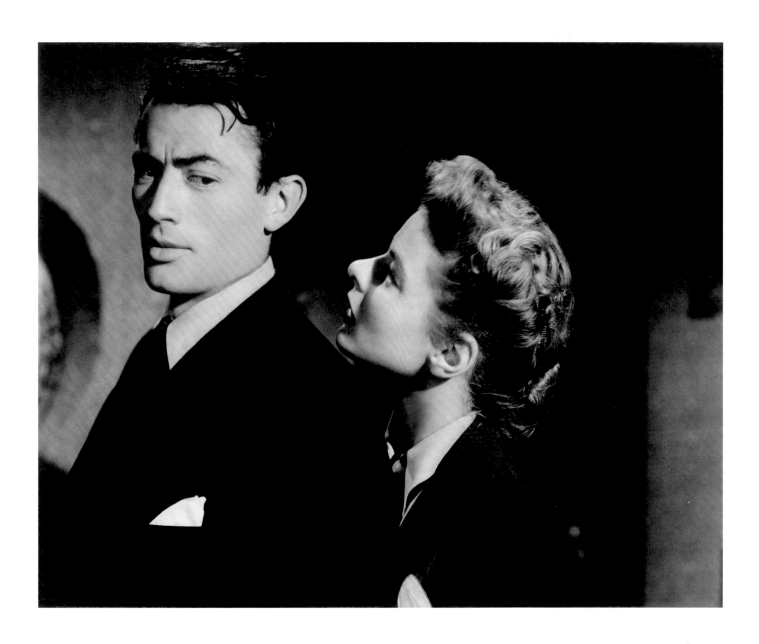

The straight razor signifies the
danger involved in Dr. Petersen's love
for John Ballantine (Gregory Peck).
Production still from *Spellbound*.
Hollywood, 1944

Is John Ballantine a dangerous psychopath—
or a victim in need of Constance's professional
help? Production still from *Spellbound*.
Hollywood, 1944

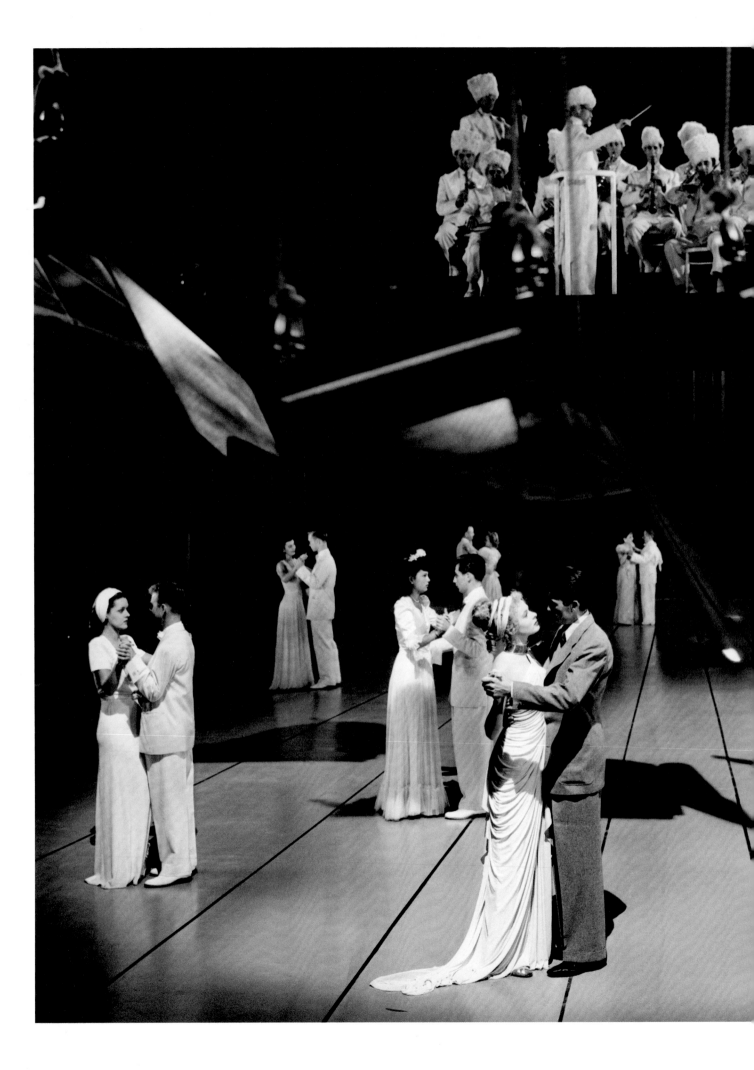

Selznick secures the help of Salvador Dalí for the dream sequence. Dalí is spending the war years in the US; most of the scenes he designs will end up on the cutting-room floor. This scene shows a ballroom with three gigantic grand pianos suspended from the ceiling. The dancers are rigid.

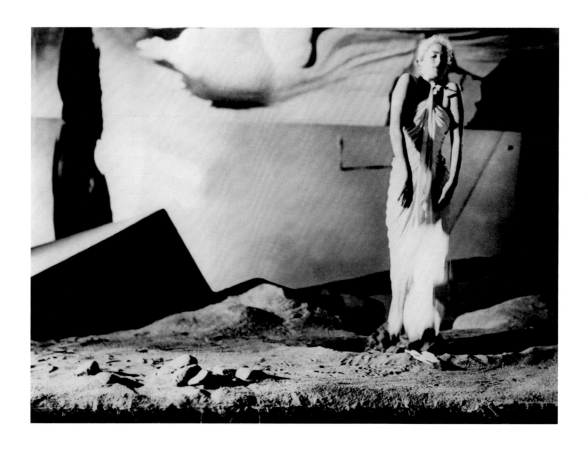

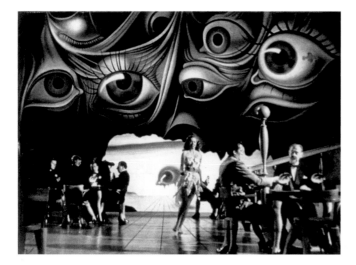

Top
Production still from the dream
sequence in which Ingrid turns into
a statue.

Bottom
A Dalí painting which served as a
basis for one of the film images in
Spellbound. Hollywood, 1945

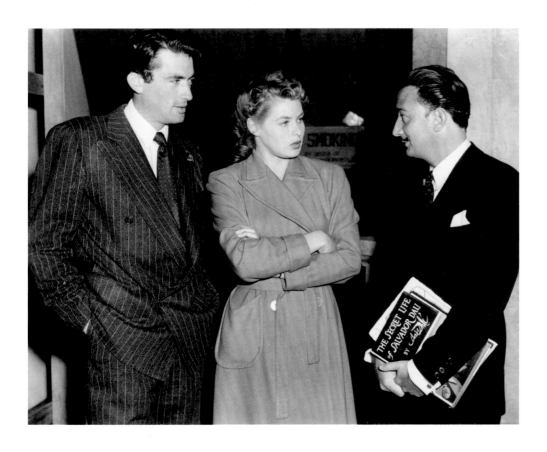

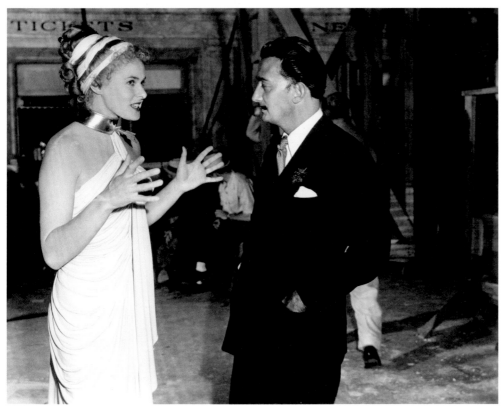

Top
Salvador Dalí on the set of *Spellbound* with Gregory Peck and Ingrid Bergman. Under his arm he is holding a copy of his first autobiography *The Secret Life of Salvador Dalí*.

Bottom
Ingrid and Salvador Dalí discuss the dream sequence in which she appears as a statue. On the set of *Spellbound*. Hollywood, 1944

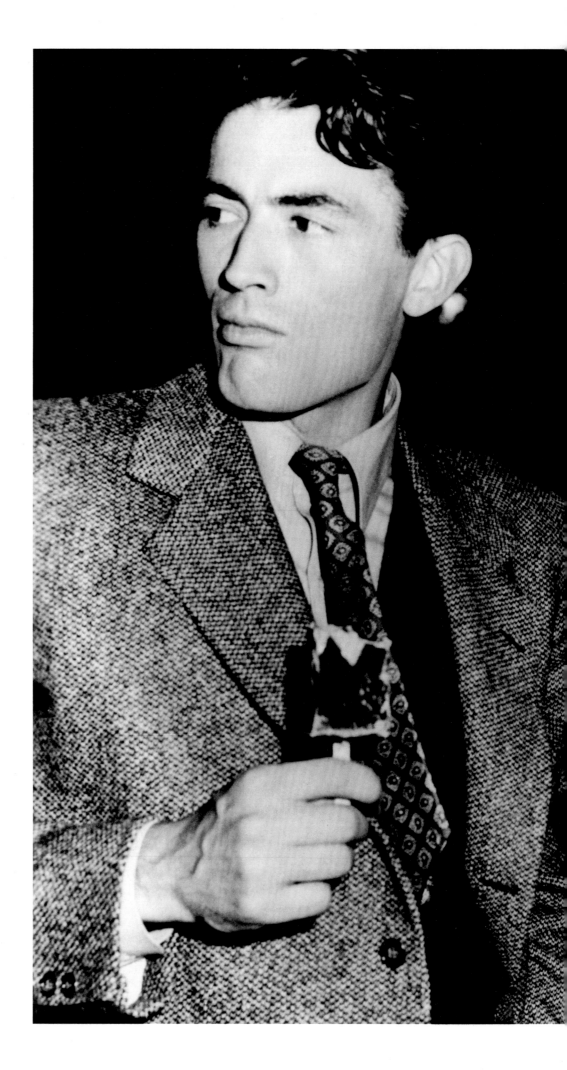

Gregory Peck and Ingrid Bergman
enjoying ice cream bars during a break
in shooting. Eating ice cream was one
of the great culinary delights Ingrid
permitted herself—sometimes with
abandon and in violation of all dietary
regimens. On the set of *Spellbound*.
Hollywood, 1944

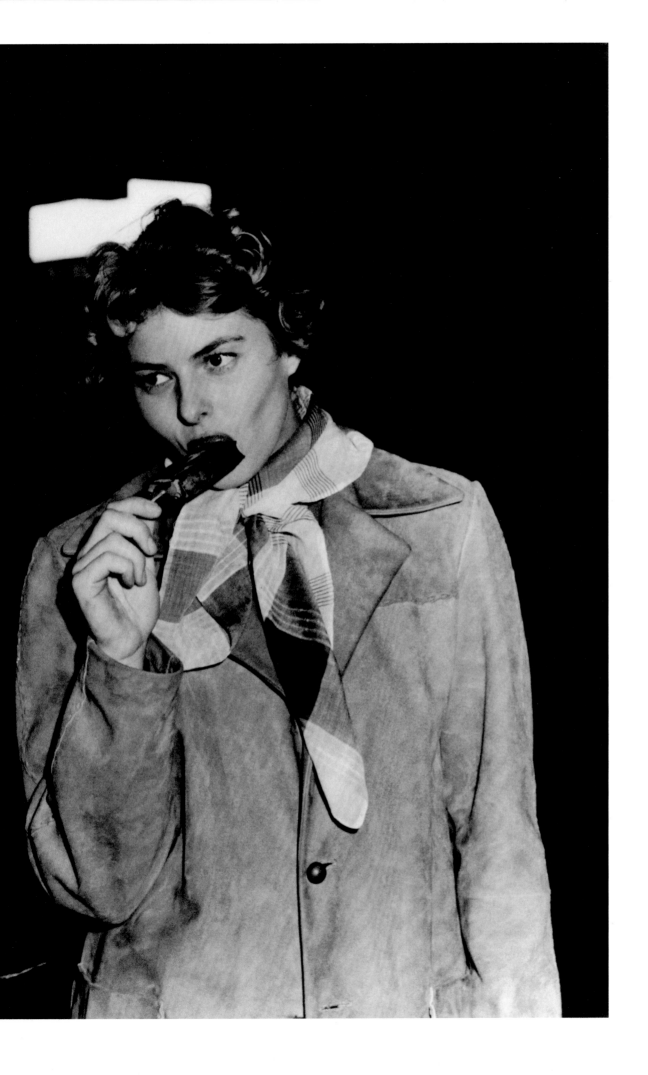

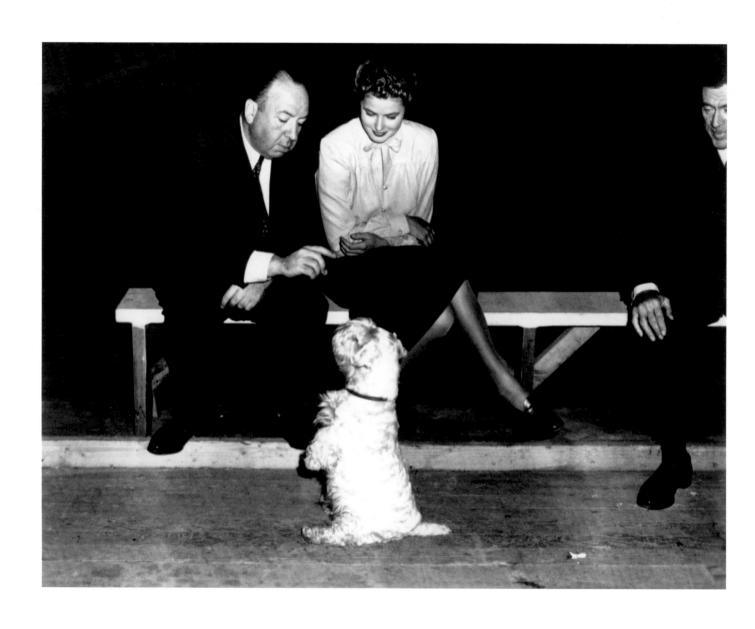

Ingrid and Hitchcock had a
very close relationship. Here
the acclaimed director is seen
demonstrating the art of dog
training for his leading lady.

Right page
Ingrid "in bed with Hitchcock"—
on the set of *Spellbound*.
Hollywood, 1944

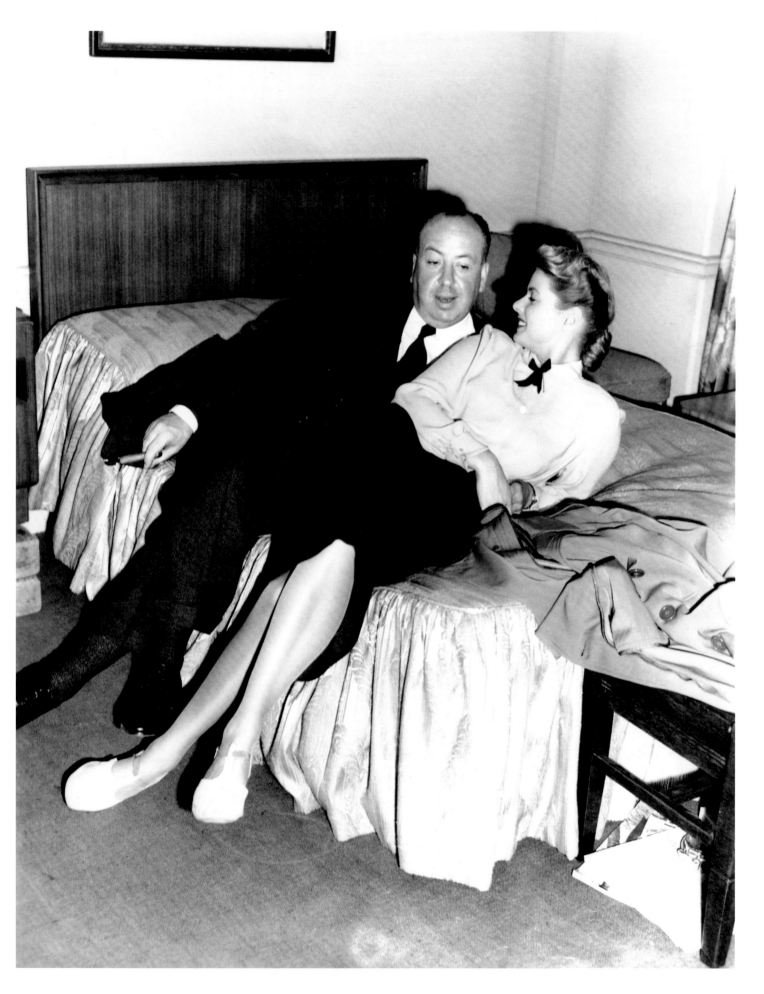

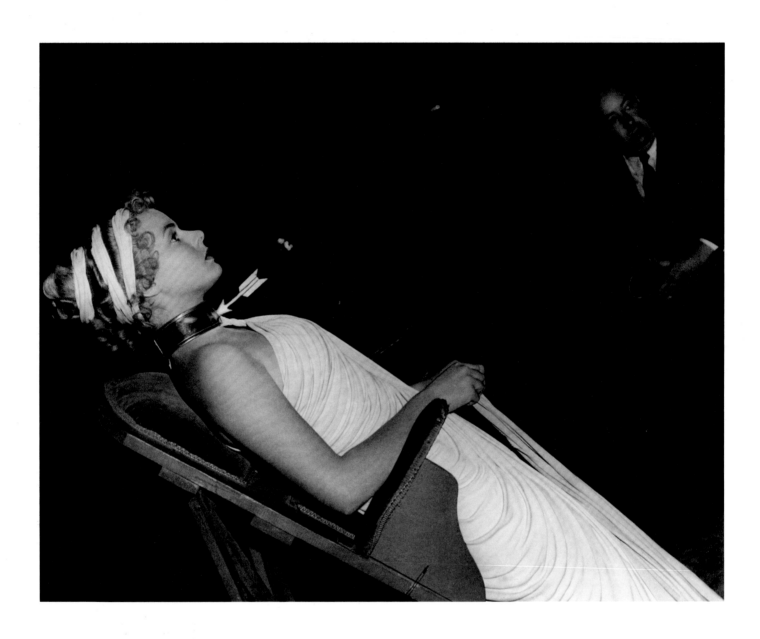

Ingrid dressed for the dream sequence.
She is lying on a special recliner designed
to safeguard her costume and makeup.
On the set of *Spellbound*. Hollywood, 1944.
Photo: Madison Lacy

Right page
Ingrid seeks Hitchcock's advice during a break in shooting. Perhaps he
is saying: "Fake it," the advice he once gave her when she was having
difficulties with a particular scene in *Spellbound*. She later recalls,
"Well, that was the best advice I've had in my whole life, because in
all the years to come there were many directors who gave me what I
thought were quite impossible instructions and many difficult things
to do, and just when I was on the verge of starting to argue with them,
I heard this voice coming to me through the air saying, 'Ingrid, fake it.'
It saved me a lot of unpleasant situations and waste of time."[41]
On the set of *Spellbound*, 1944

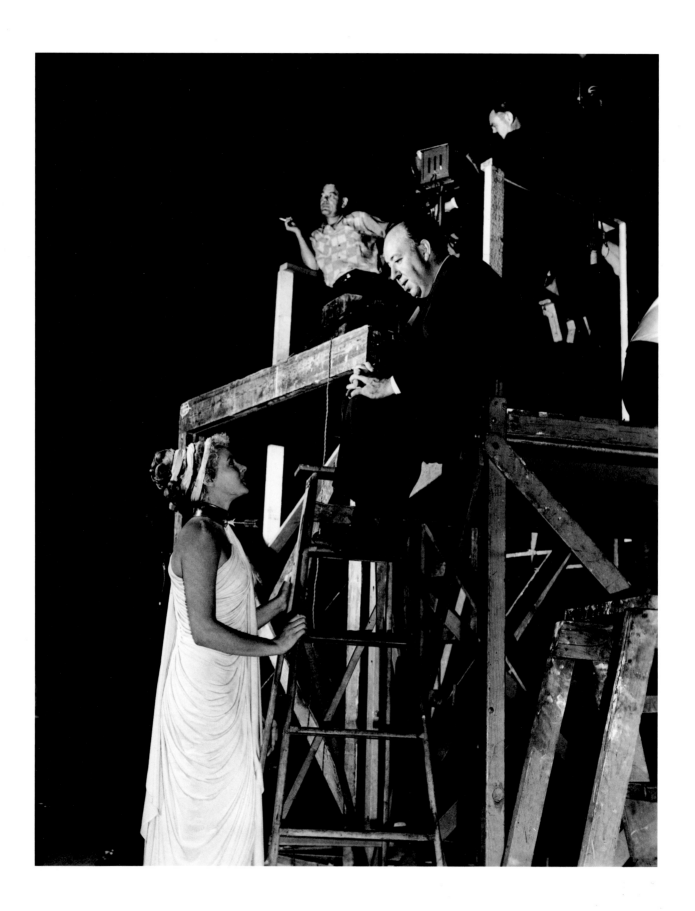

The Bells of St. Mary's

Following the success of *Spellbound*, which begins its run in 1945 (and is nominated for six Oscars in 1946), Selznick would like nothing better than to press on immediately with the next Hitchcock/Bergman/Peck project. Hitchcock is already working on the screenplay for a spy story, but Ingrid Bergman had previously been invited by the War Department to go on a tour of the US, during which she attends large-scale events, cocktail parties, and press conferences in order to sell war bonds and solicit blood donations. Meanwhile, Leo McCarey is planning a sequel to his hit comedy *Going My Way*, and he approaches Selznick. He wants Ingrid Bergman to play Sister Benedict, a nun in New York City struggling to prevent the closing of her school. As was the case in the preceding picture, the leading man in *The Bells of St. Mary's* is to be Bing Crosby—one of the best-loved comedy stars of the forties. McCarey is prepared to make concessions in order to pry Bergman loose for RKO, and Selznick, who believes the role is "a little beneath a 'Selznick star,'" negotiates "one of the most lucrative loan-out agreements in the history of Hollywood filmmaking."[42]

Before shooting commences, Ingrid Bergman receives the Academy Award for Best Actress in *Gaslight*. Due to the war, the statue is made of painted plaster, not gold-plated bronze. Both Bing Crosby and Leo McCarey also won Oscars that same evening, and she accepts the award with the words: "I am deeply grateful for this award. I am particularly glad to get it this time because I'm working on a picture at the moment with Mr. Crosby and Mr. McCarey. And I'm afraid if I went on the set tomorrow without an award, neither of them would speak to me."[43]

Ingrid as Sister Benedict
in *The Bells of St. Mary's*.
Production still. Hollywood, 1945

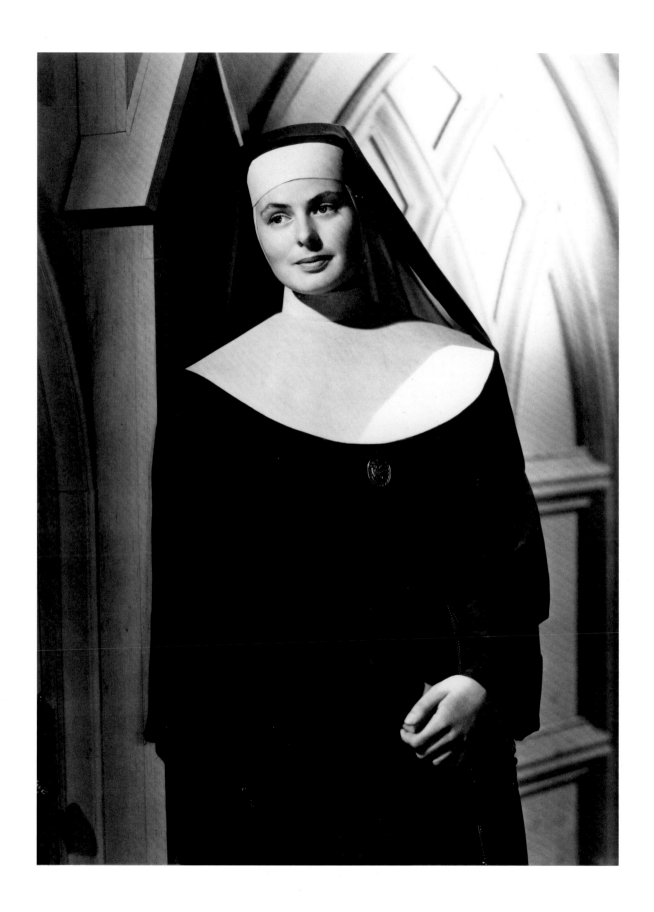

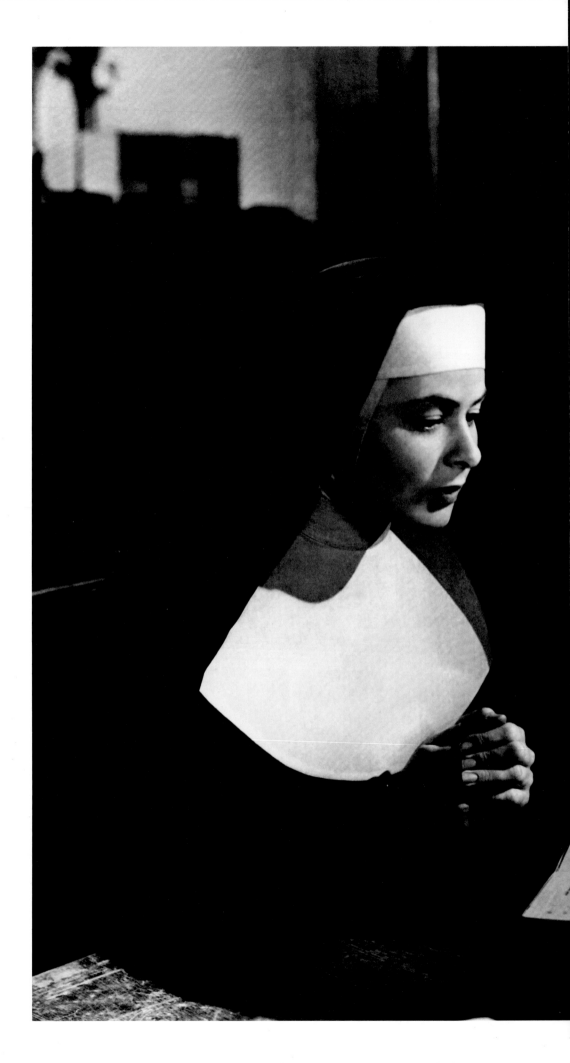

Her co-star is singer and comedian
Bing Crosby, who plays Father O'Malley.
Production still from *The Bells of St.
Mary's*. Hollywood, 1945

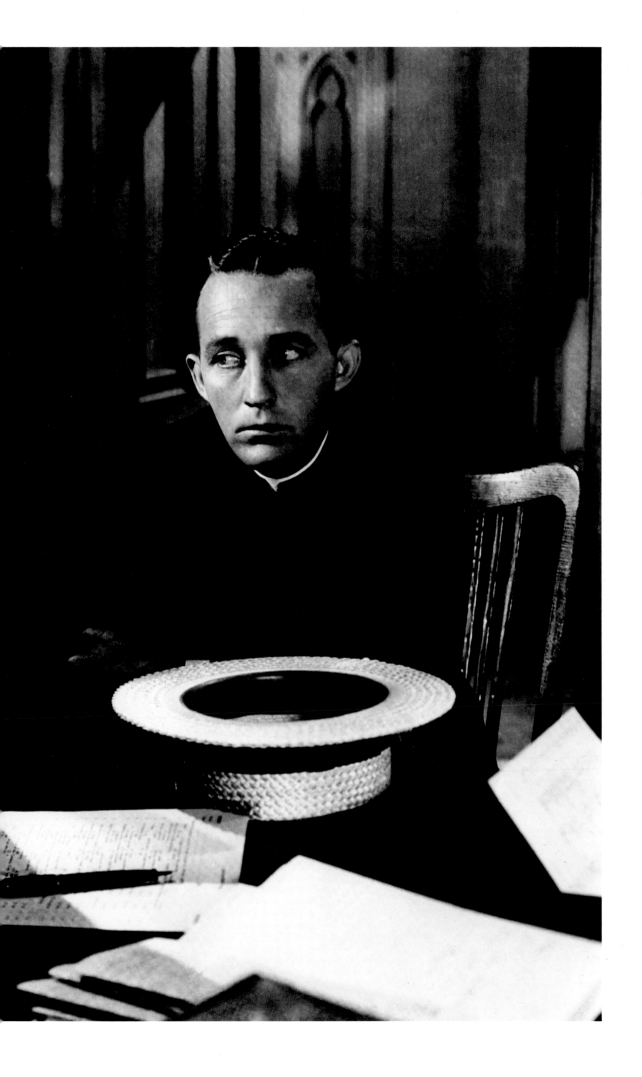

Andy Warhol, *Ingrid Bergman (The Nun) No. 34*, 1983.
Warhol chose the adjacent character portrait of
Sister Benedict for one of his famous silk screens of
the Bergman series.

Right page
Portrait of Ingrid Bergman in the role of Sister Benedict.
Hollywood, 1945. "*Look* magazine chose Ingrid for its
lush color cover on September 18—but it was a photo
of Ingrid in the nun's habit. The distinction between
the role and the woman was increasingly blurred."[44]

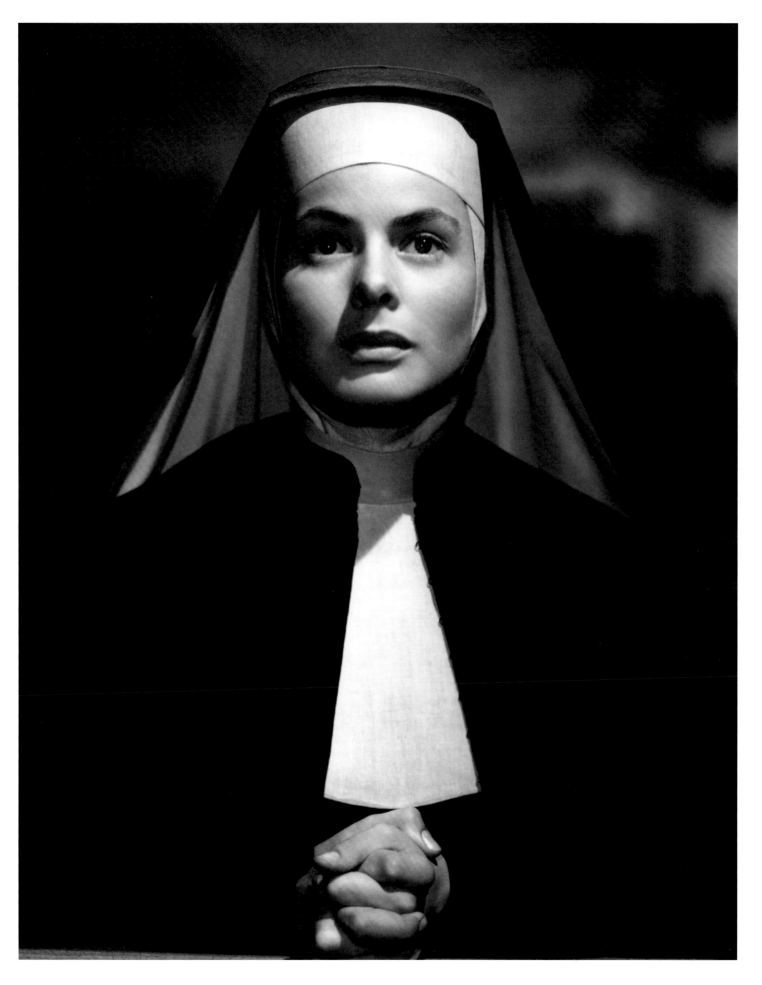

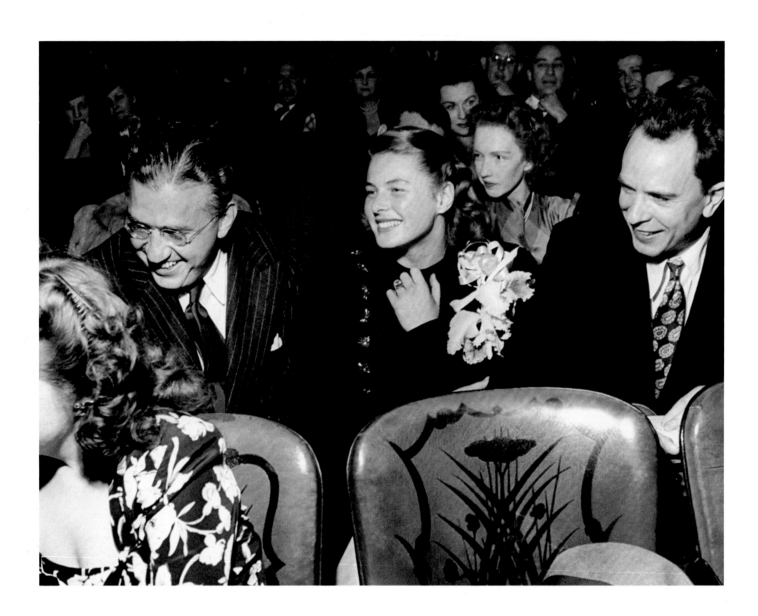

This page
During the Oscar ceremonies on 31 March 1945 in Grauman's Chinese Theatre. Left, David Selznick; in the middle, Ingrid Bergman; on the right, her husband Petter Lindström. Hollywood, 1945. Photo: Louis Dean
A pleasant coincidence: one day before her five-year contract with Selznick expires, Ingrid Bergman is awarded an Oscar as Best Actress of 1944.

Right page
Jennifer Jones hands Ingrid her first Oscar, for her performance as Paula Alquist in *Gaslight*.
Hollywood, 1945

Next page top
Three happy Oscar winners of 1945 star together in *The Bells of St. Mary's*. From the left: Ingrid Bergman with director Leo McCarey and co-star Bing Crosby. Hollywood, 1945. Photographer unknown

Next page bottom
From the left: Bing Crosby and Ingrid Bergman during a celebration on the set of *The Bells of St. Mary's*, 1945. Photographer unknown

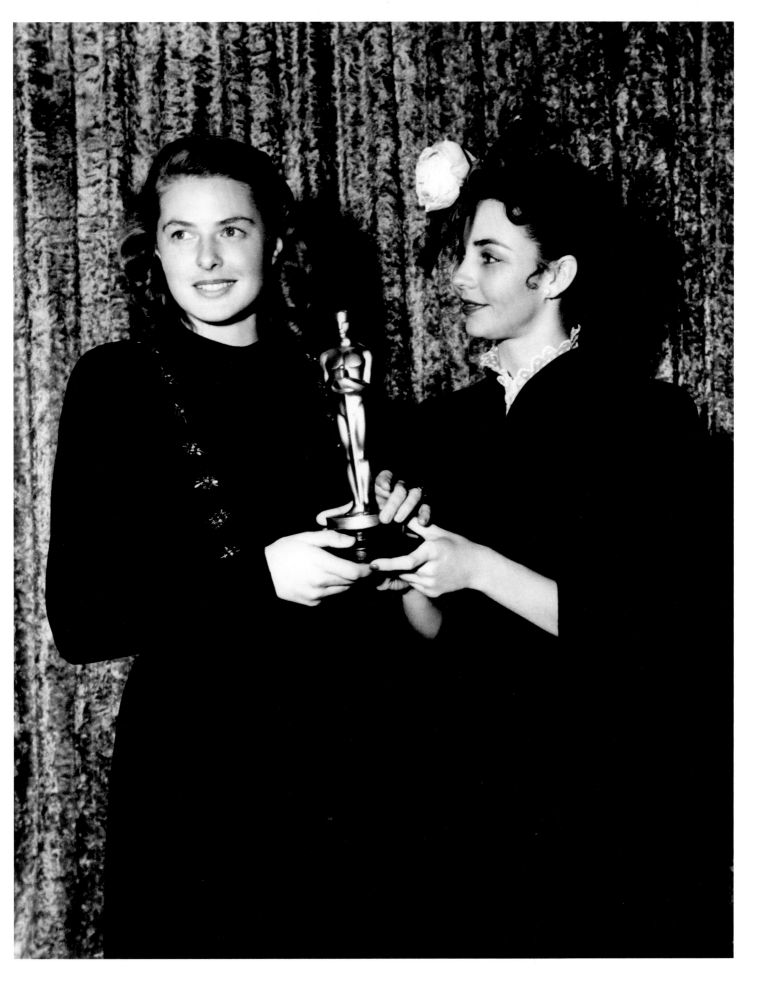

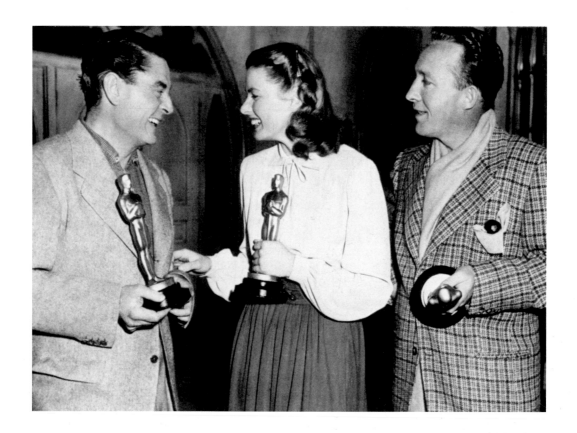

III.

END OF THE WAR IN EUROPE – NEW HORIZONS

1945–1949

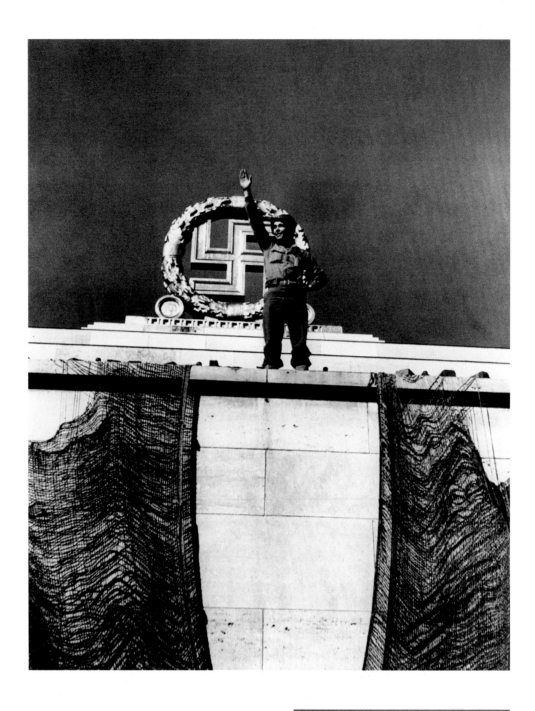

Capa chooses a compelling setting for his photo of the end of the war. At the Nazi party rally grounds in Nuremberg, he has his jeep driver—an ordinary GI—give the Hitler salute while standing beneath the large stone swastika on the tribune. *Life* magazine runs the photo on the cover of its 14 May 1945 edition—Victory in Europe Day.

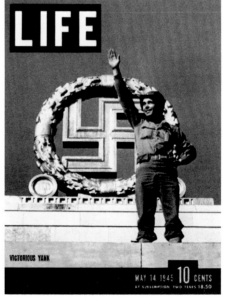

LOVE AFFAIR WITH CAPA –
ENTERTAINING TROOPS IN GERMANY

"When I arrived in Paris on June 6, 1945, to start a tour of Germany with Jack Benny, Larry Adler, and Martha Tilton to entertain the troops, the war had ended less than a month before. Paris was wonderful … I hadn't been in Europe for eight whole years. It was like starting to live all over again."[1]

With these words, Ingrid Bergman describes her return to Europe. She has, in fact, only been gone for five and a half years, but the exaggeration may be viewed as an "it felt like" and a measure of her joy at her return. She and her colleagues stay at the Ritz, which is the headquarters for entertainers, the press corps, and American war correspondents in Paris.

On 28 June, the handwritten note reproduced on the following page is slipped under her door. It is an equally charming and witty dinner invitation from two men she has never heard of. Her curiosity aroused, she accepts the invitation and enjoys a wonderful evening in the company of photographer Robert Capa and his friend Irwin Shaw, an Army warrant officer destined to become a well-known author. The scene is filmworthy, and both men could have been characters from a screenplay.

"From that very first evening I liked Robert Capa very much,"[2] she later writes in her autobiography. "It was a marvelous start to the tour I was going to make."[3]

Capa, who "spoke five languages but said he dreamed in images,"[4] is also a genius in his dangerous line of work, a genius with charisma and star potential. He makes a deep impression on Ingrid, and an affair ensues that will last for the next two months of summer and continue, at irregular intervals, for two more years. Martha Gellhorn, who was a friend to both Ingrid and Capa, can perhaps best describe their relationship to those of us who were not there: "I've often thought of Capa and have two photos of him, one with Shim (sic), which Ingrid Bergman gave me. A nice woman. She fell desperately in love with him when he went to Hollywood after the war and of course wanted to marry him and of course Capa never really wanted to marry anyone and fled. She told me she had never before met such 'a free human being.' I loved him but not in that way ever; he was my blood brother."[5] Ingrid will later say of him: "Capa is wonderful and crazy and has a beautiful mind."[6] And Capa will write to Ingrid: "It was, it is, your merry mind that I love, and there are very few merry minds in a man's life."[7]

Subject: Dinner - 6/28/45

TO: Miss Ingrid Bergman

Par. 1. This is a community effort. The
community consists of Bob Capa and Irwin Shaw.

2. We were planning on sending you
flowers with this note inviting you to dinner this
evening - but after consultation we discovered
it was possible to pay for the note and flowers
or the note and dinner - not both. We took a vote
and dinner won by a close margin.

3. It was suggested that if you did
not care for dinner, flowers might be sent.
No decision on this has been reached so far.

4. Besides flowers, we have lots of
doubtful qualities. (This is a direct quotation
from Capa.)

5. If we write much more we will
have no conversation left, as our supply of charm
is limited.

6. We will call you, among the last ones,
at 6:15.

7. We do not sleep.
 Signed,
 WORRIED.

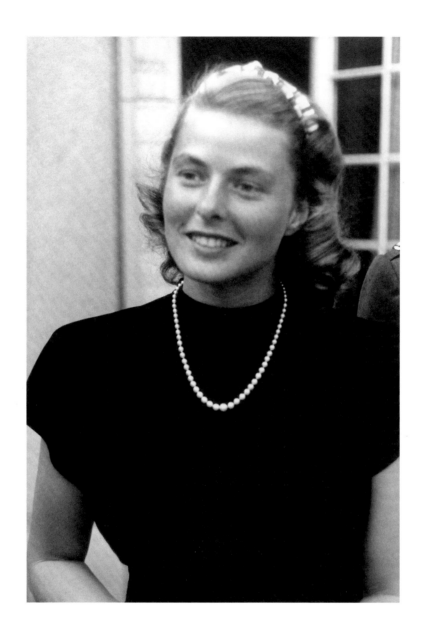

Left page
The note on the hotel room door that started it all. She will keep it until the day she dies. It reads:

Subject: Dinner. 6.28.45. Paris, France.
To: Ingrid Bergman.
Part 1. This is a community effort. The community consists of Bob Capa and Irwin Shaw.
2. We were planning on sending you flowers with this note inviting you to dinner this evening—but after consulting we discovered it was possible to pay for the flowers or the dinner, or the dinner or the flowers, not both. We took a vote and dinner won by a close margin.
3. It was suggested that if you did not care for dinner, flowers might be sent. No decision has been reached on this so far.
4. Besides flowers we have lots of doubtful qualities.
5. If we write much more we will have no conversation left, as our supply of charm is limited.
6. We will call you at 6.15.
7. We do not sleep.
Signed:
Worried[8]

This page
Ingrid's happiness is threefold: the war is over, she is back in her beloved Europe, and Robert Capa has come into her life.

The show in Heidelberg, 1945

Following pages
In the summer of 1945 Ingrid Bergman takes an entire series of photos of Berlin in ruins: "The city had been blown to bits: it was absolutely unbelievable. No roofs on the houses, everything outside."[9]

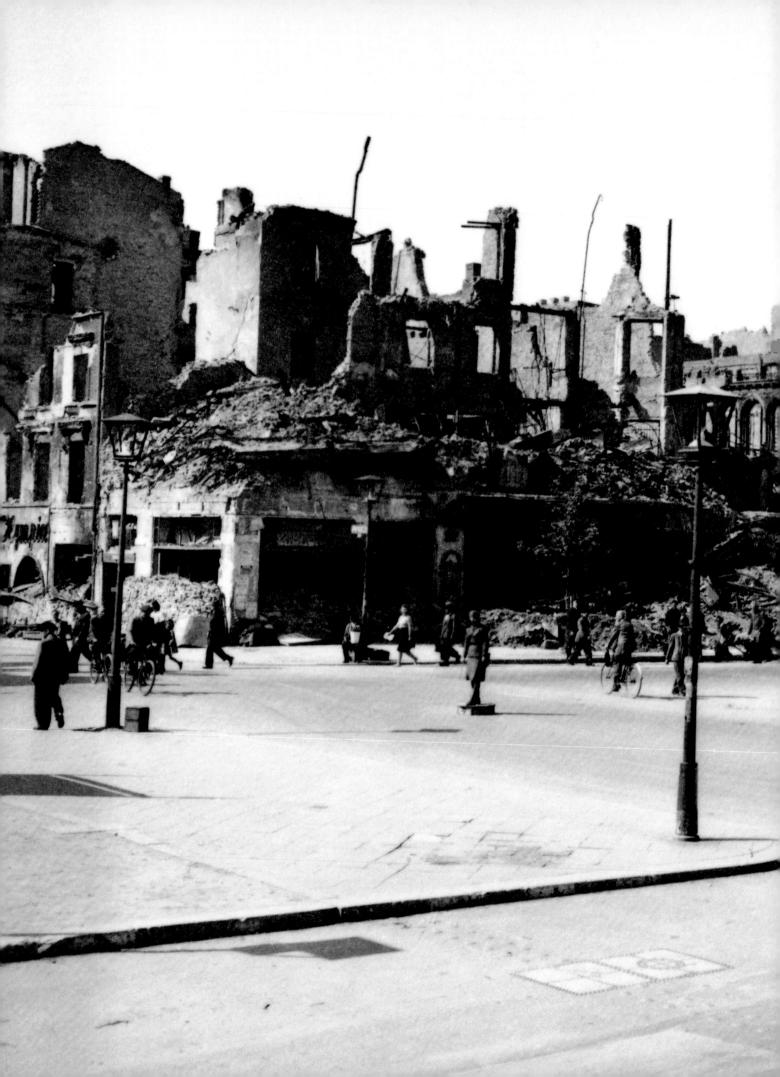

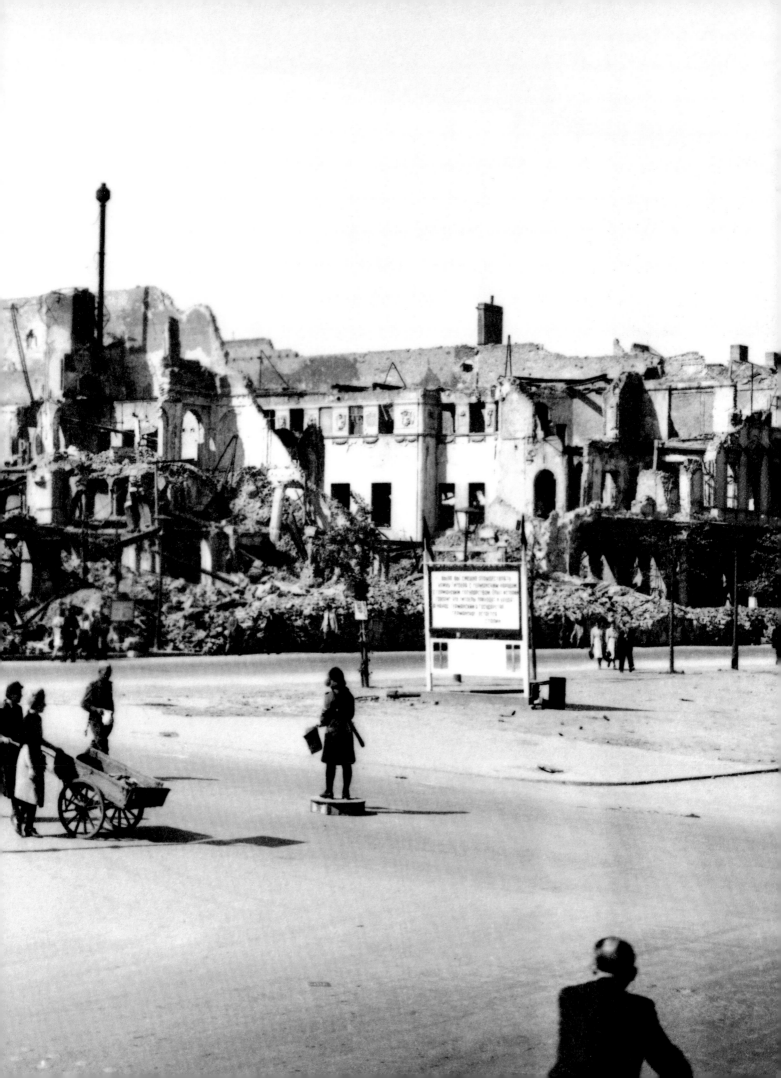

Portrait of Capa belonging to Ingrid Bergman. Born in Hungary,
Capa was a gambler, a doubter, and, in his own way, quite
self-confident: "It's not enough to have talent, you also have
to be Hungarian," is one of his immortal witticisms. This is
probably the inversion of a saying coined by his fellow
Hungarian, director George Cukor: "It's not enough to be
Hungarian, you also have to have talent."

"I met Capa again in Berlin ... Capa found a bathtub in the street. He said this was going to be his scoop: for the first time, Ingrid Bergman photographed in a bathtub. I laughed and said 'Okay.' And so there I was, sitting in a bathtub out in the street ... fully clothed. He was so excited about what he'd done he rushed back to develop his films, and somehow in his hurry the negative was ruined. So the famous scoop—the future center-page pull-out of Bergman in the bathtub—never did make any magazine."[10]
One photo from this scene has survived. It was not taken by Capa, however, but rather by photographer Carl Goodwin, who obviously witnessed the scene and took his own photographs. Berlin, 1945

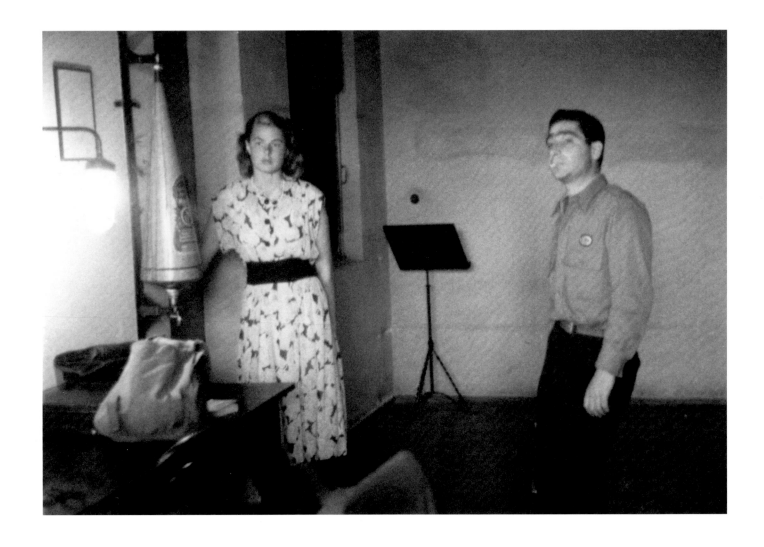

Ingrid and Capa in Berlin. Photo
also taken by Carl Goodwin, 1945

Right page
A portrait study of Ingrid, obviously
taken on the same occasion.
Berlin, 1945. Photographer unknown

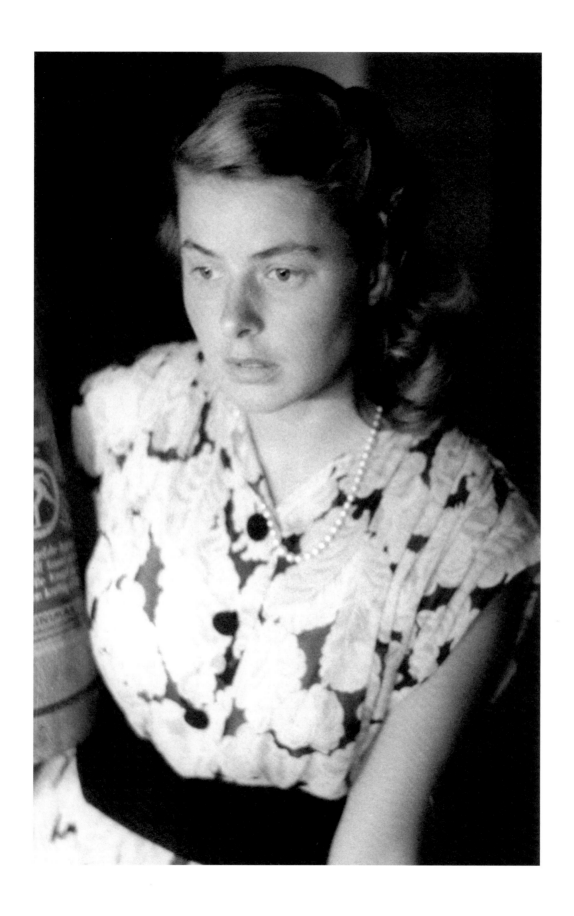

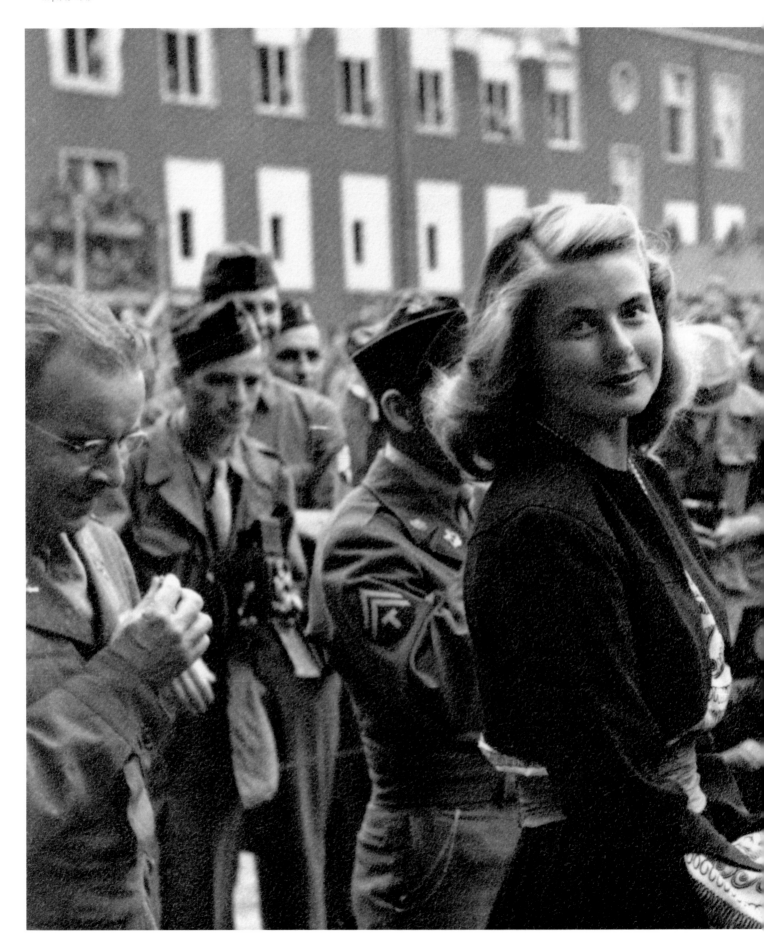

Surrounded by GIs
in Berlin, 1945.
Photographer unknown

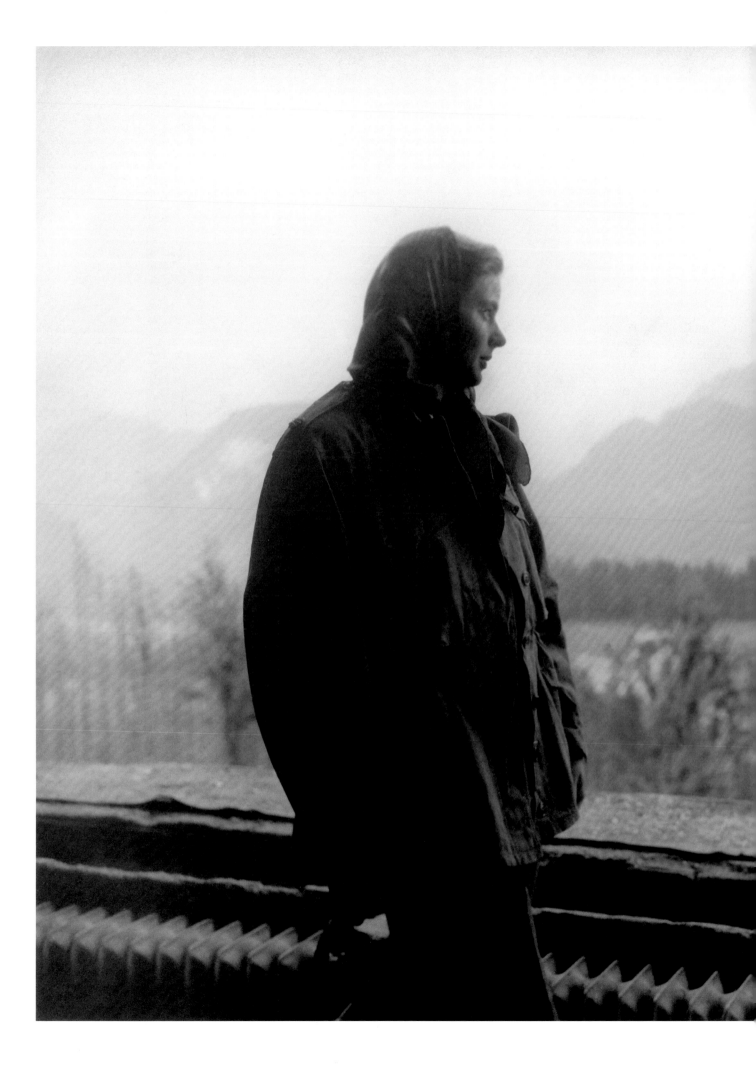

Ingrid Berman in Berchtesgaden, 1945.
Photographer unknown

Notorious

Hitchcock was so taken with Ingrid Bergman's performance in *Spellbound* that he suggested a second project before the film was even completed. It was to be an espionage thriller for which he would write the screenplay himself. Selznick considered such plans to be his sole prerogative and balked at first, but following the enormous success of *Spellbound*, he was more than willing to team them up again. Both were under contract to him, after all, and Bergman's contract was soon due to expire. As she recalled later, "Hitchcock was one of the few directors who really stood up to Selznick, and Selznick for the most part left him alone … They were two strong men, but they had great respect for each other."[11] But then Selznick sold the entire production as a package to RKO and made the largest profit he ever made during his career as an independent producer.

In *Notorious* Ingrid Bergman plays Alicia Huberman, whose father was a convicted Nazi spy. She is enlisted by an American agent to infiltrate a suspicious group of Germans living in exile in Rio de Janeiro. Although she falls in love with the aloof agent Devlin (Cary Grant), she marries the head of the Nazi group, Alexander Sebastian (Claude Rains), in order to spy on his activities. Sebastian sees through the ruse and attempts to kill her slowly by poisoning. Devlin comes to the rescue and admits that he loves her. According to Hitchcock, he was kept under surveillance during shooting. The top secret Manhattan Project was then in full swing, "And the use of uranium as a plot motive around the time the first atomic bomb was detonated attracted the attention of the FBI."[12]

Shooting for her next movie commences in Hollywood on 15 October 1945 and ends in February 1946. Cary Grant and Ingrid Bergman in *Notorious*, Ingrid's second film directed by Alfred Hitchcock. Production still. Hollywood, 1945

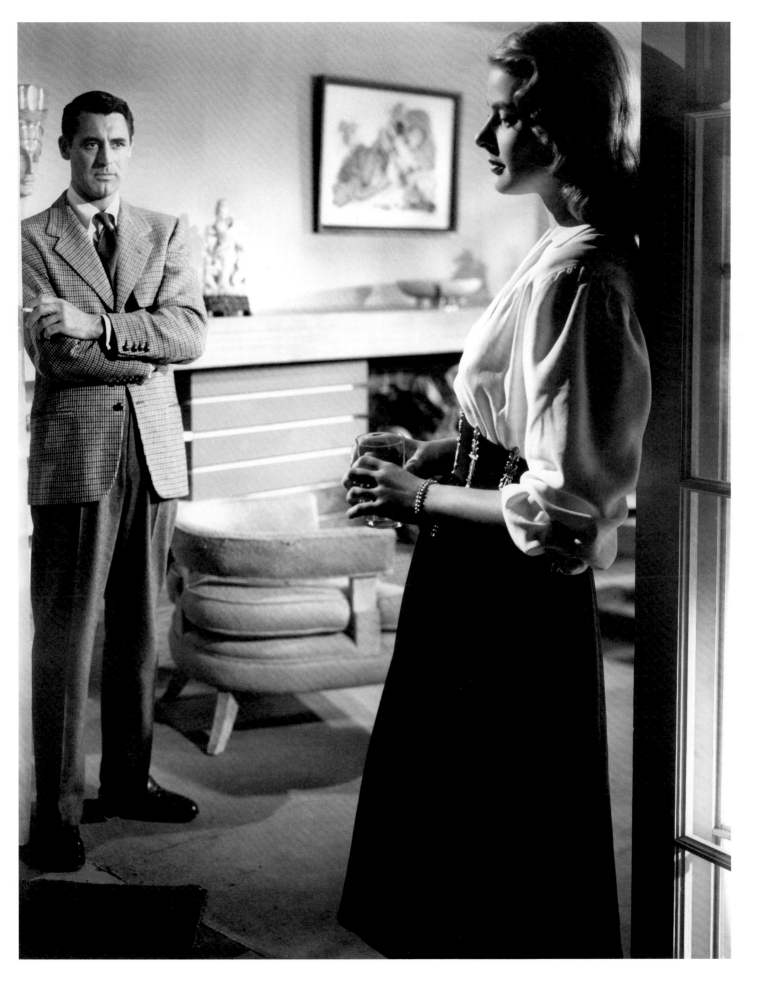

Cary Grant and Ingrid Bergman in what was then the longest
screen kiss in film history. The FBI's snooping had so aggravated
Hitchcock that he set out to get even. He decided to circumvent US
censorship regulations and feature a kiss between his two principals
that lasted five times longer than was then permitted. Ingrid
describes Hitchcock's idea and his motives: "A kiss could last three
seconds. We just kissed each other and talked, leaned away and
kissed each other again. Then the telephone came between us,
then we moved to the other side of the telephone. So it was a kiss
which opened and closed; but the censors couldn't and didn't cut
the scene because we never at any one point kissed for more than
three seconds. We did other things: we nibbled on each other's
ears, and kissed a cheek, so that it looked endless, and became
sensational in Hollywood."[13]
Production still from *Notorious*. Hollywood, 1945.
Photo: Ernest Bachrach

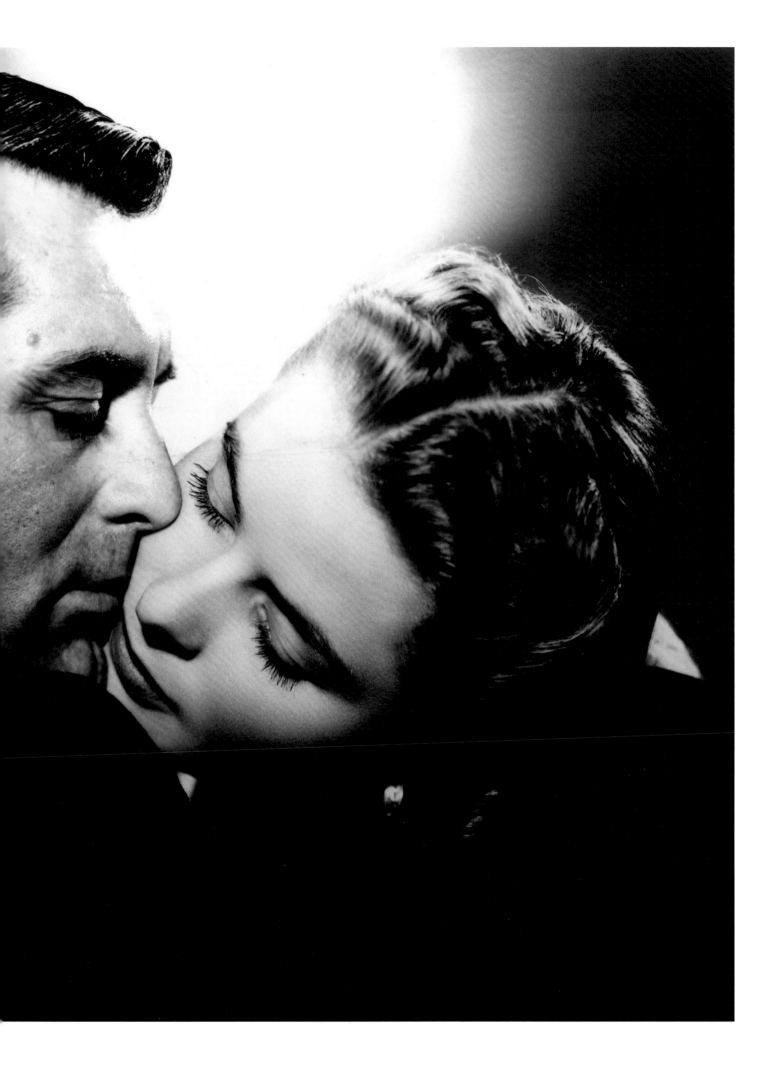

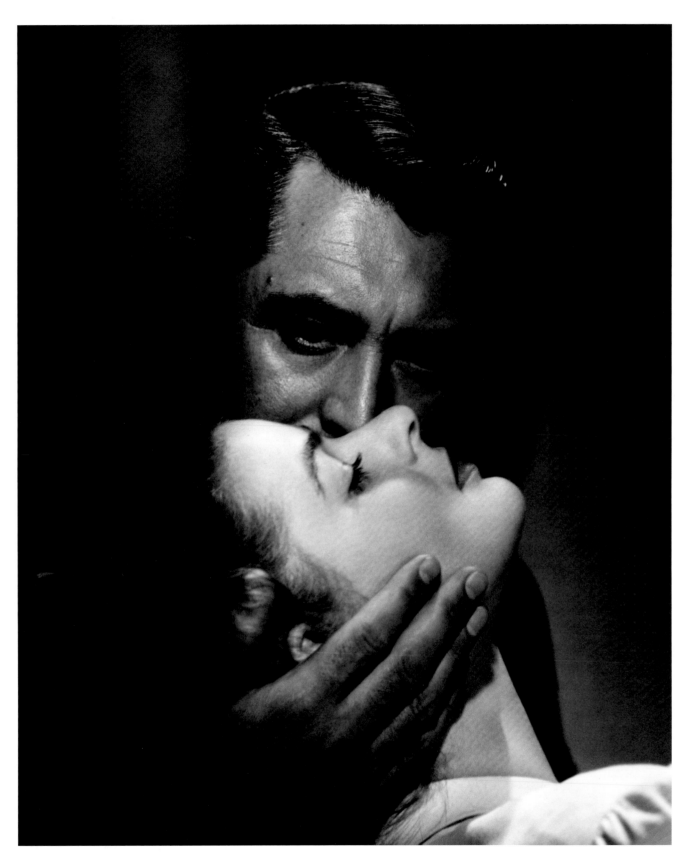

The longest screen kiss in movie history, part two.
Production still from *Notorious*. Hollywood, 1945.
Photo: Ernest Bachrach

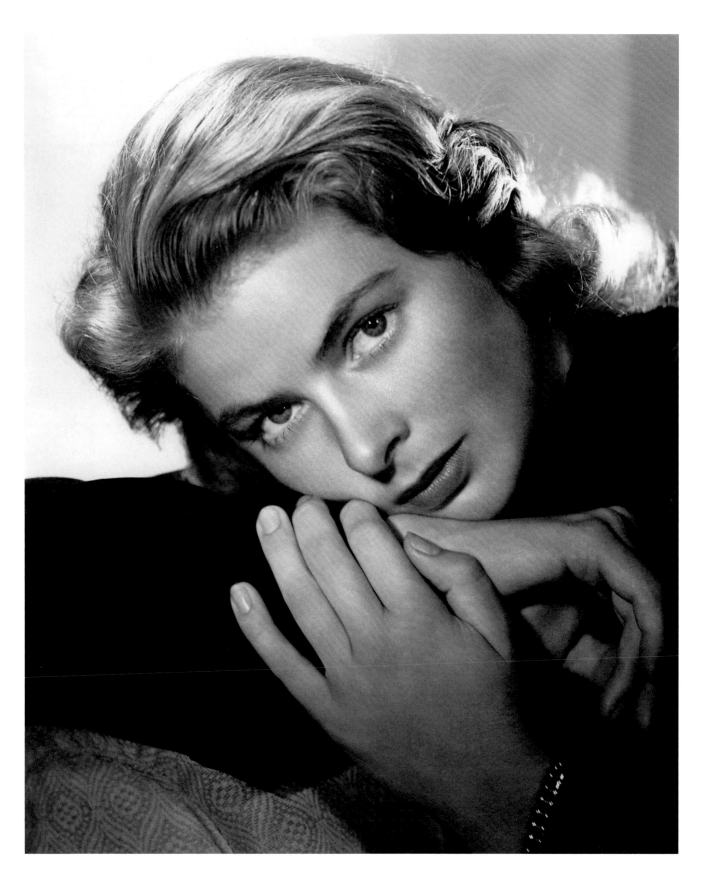

Publicity shot for *Notorious*.
Hollywood, 1945. Photo: Ernest Bachrach

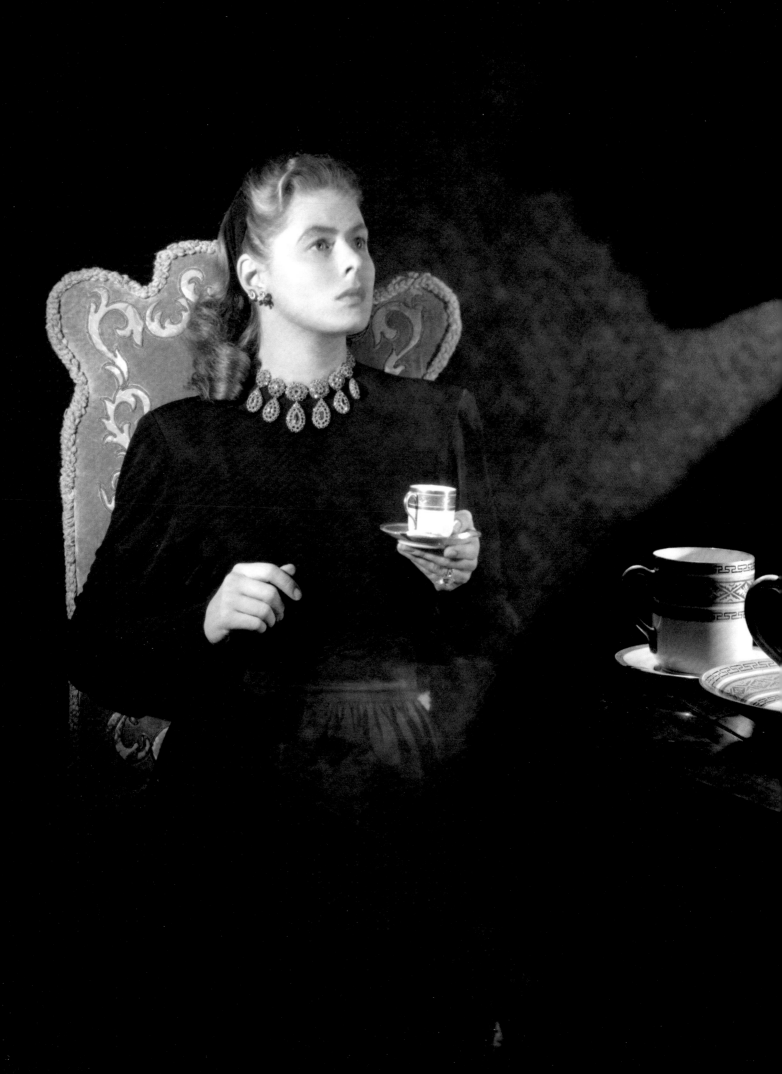

Ingrid Bergman in the role of Alicia.
The coffee her husband gives her
contains poison. Production still
from *Notorious*. Hollywood, 1945.
Photo: Gaston Longet

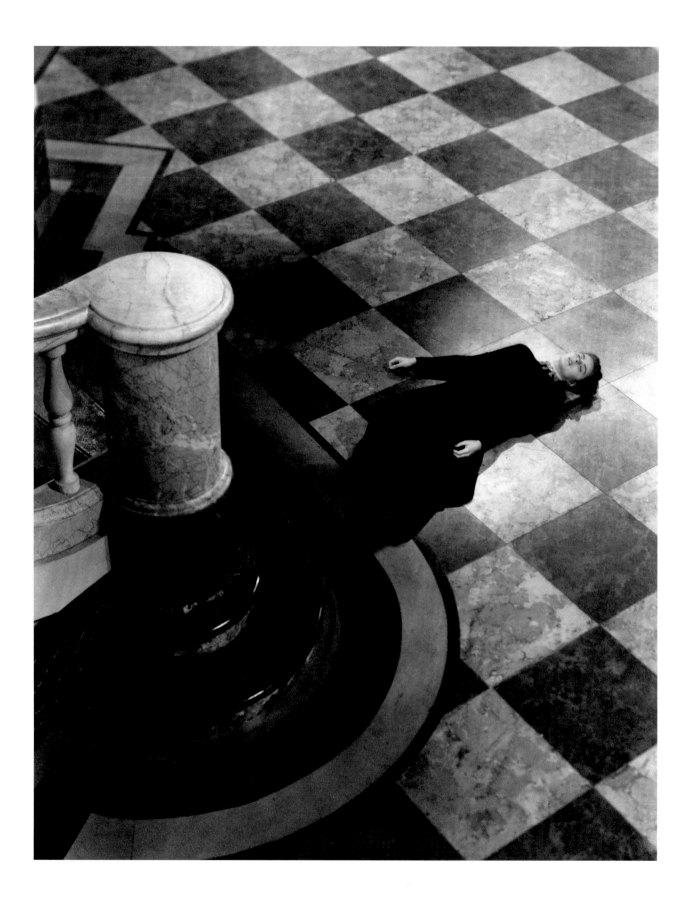

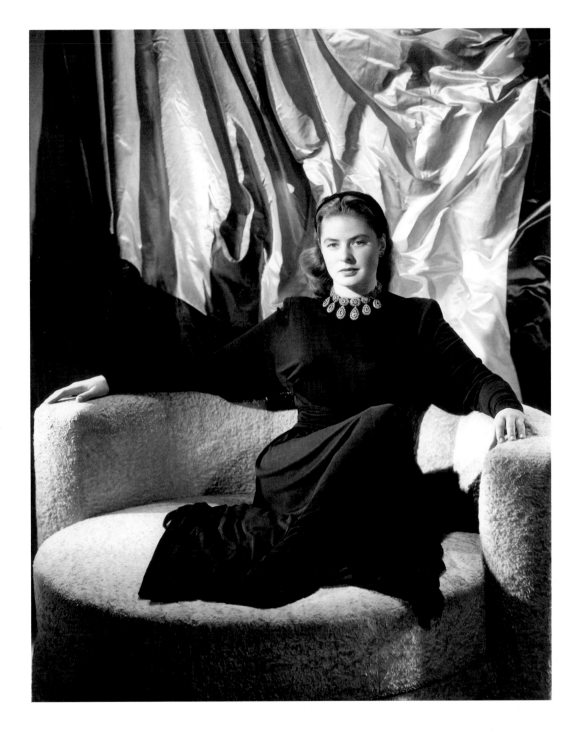

Left page
The insidious poisoning leads to
dramatic fainting spells. Production still
from *Notorious*. Hollywood, 1945

This page
Ingrid Bergman as Alicia. Production still
from *Notorious*. Hollywood, 1945/46.
Photo: Ernest Bachrach

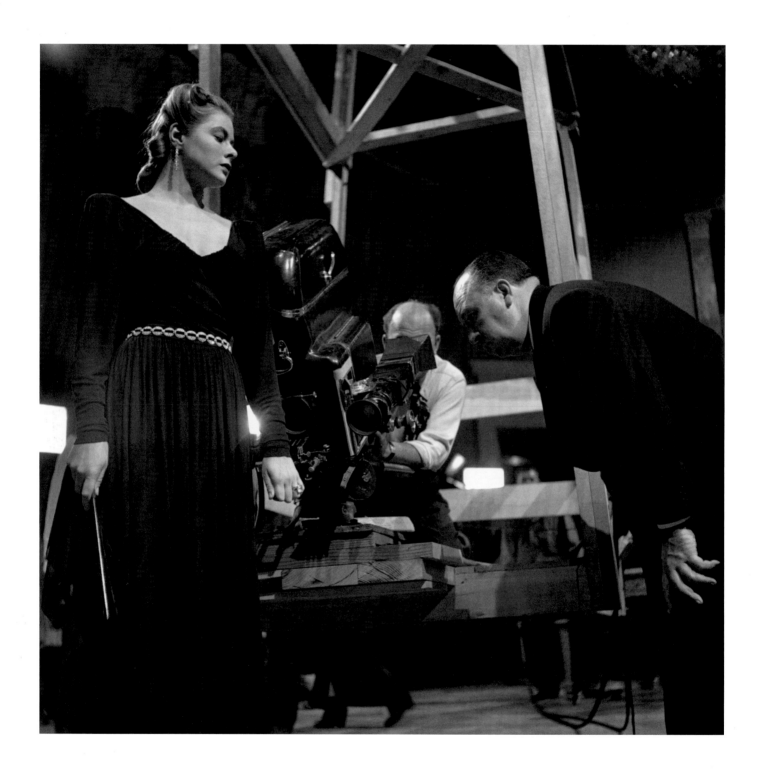

Robert Capa makes a visit to Hollywood.
Ingrid takes him along to the set and sees
to it that Hitchcock hires him as a publicity
photographer for *Notorious*. Robert Capa
photographs Hitchcock, who is checking the
camera settings for the "key" scene on
the set of *Notorious*. Hollywood, 1945

Right page
Hitchcock had this special scaffold built for
the "key" scene. It allowed the camera to
quickly track from the ceiling down to Ingrid's
hand in order to get a close-up of the telltale
key. Set still from *Notorious*. Hollywood, 1946

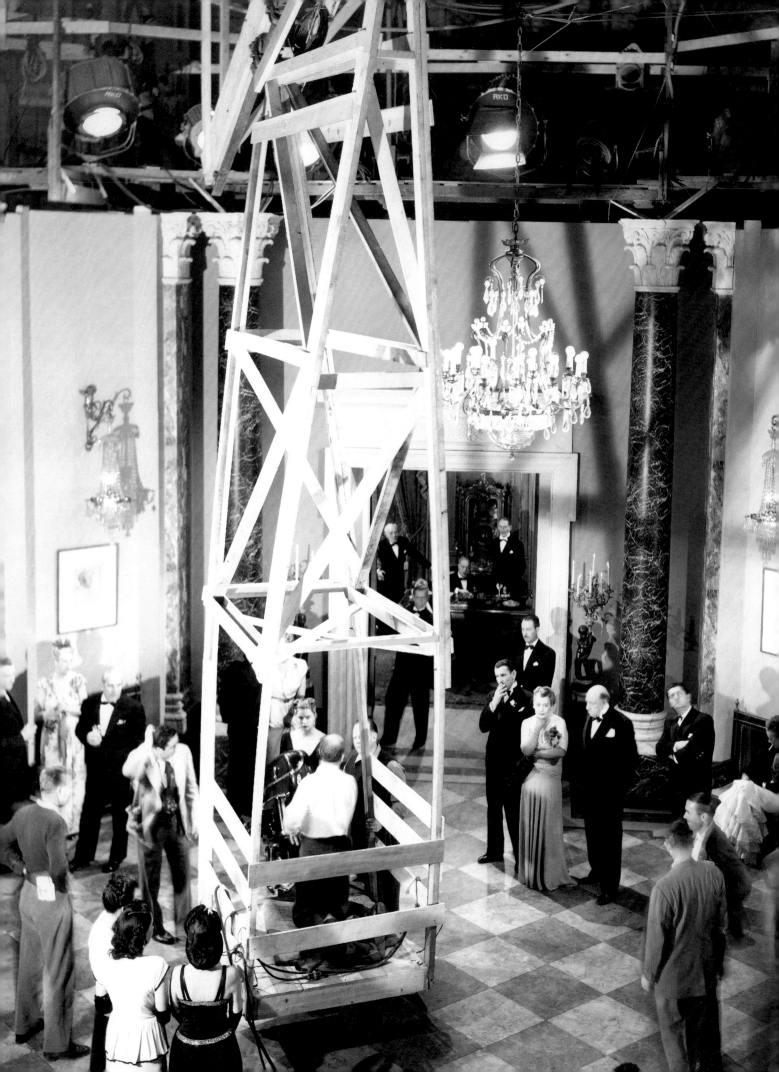

Joan of Lorraine

The time is ripe for a break from Hollywood's movie industry: "In Hollywood it was just movies, movies, movies. I mean, I like movies, but you also have to have time to talk about something else—and meet other people. So I came to New York and worked in the theater."[14] And on Broadway her dream role awaited her, the role Selznick had used to lure her to move to the US in 1940, only to postpone it again and again: "Joan of Arc always obsessed me. I don't quite know where this deep compulsion came from, ... every time I was at a cocktail party, I used to walk around and see if I could catch some director or producer and say, 'Now what about Joan of Arc?' It didn't do me any good ... Then I got a telephone call in Hollywood from Maxwell Anderson in New York."[15]

Anderson's play revolves around an acting company grappling with the staging of a Joan of Arc piece and the many political questions they address in the process. During rehearsals, Ingrid Bergman made sure that the role of Joan was given more weight.

In late October the company travels to Washington, D.C., for a pilot run. Demonstrators there are protesting the local ordinance restricting the sale of theater tickets to whites only. Ingrid publicly denounces the discrimination, stating that, "she would not have agreed to appear ... had she known that Negroes would not be permitted to see the performance."[16] Another twenty years would pass before racial segregation was abolished in the US.

The play has its Broadway premiere on 18 November 1946 at the Alvin Theatre. Ingrid Bergman had signed a six-month contract for 199 well-paid, but strenuous, performances that end in May 1947.

Following one of the jubilant performances, Victor Fleming awaits her in her dressing room. They had worked together in *Dr. Jekyll and Mr. Hyde*, and now Fleming proposes that they make a film based Anderson's play.

Ingrid as Joan in Maxwell Anderson's play *Joan of Lorraine*. It premieres on 18 November 1946 at the Alvin Theatre in New York. The play is the prelude to the large-scale film project about Joan of Arc of which Ingrid has long been dreaming. New York, 1946. Photo: Vandamm Studio

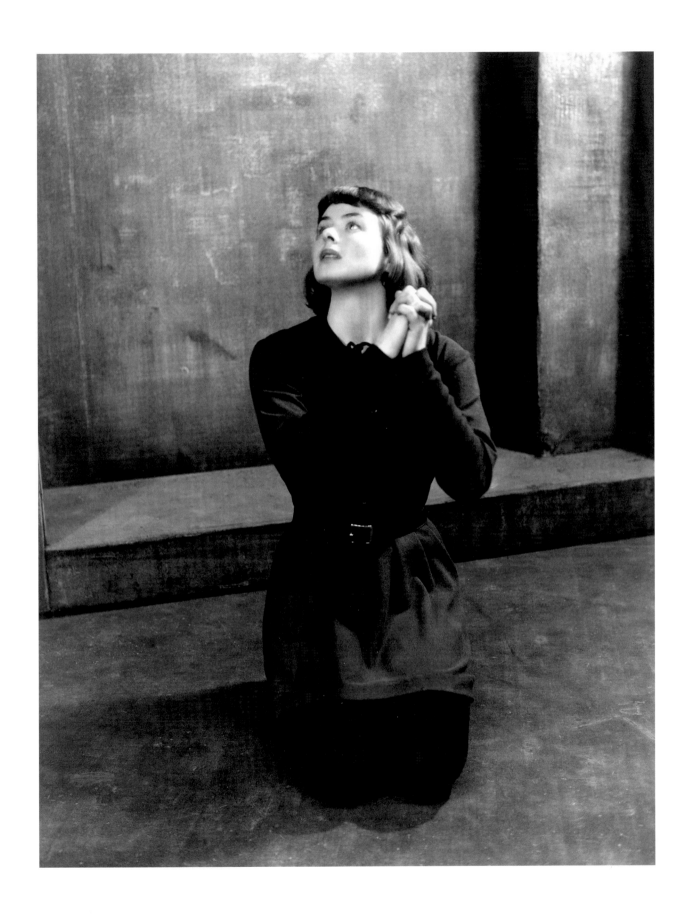

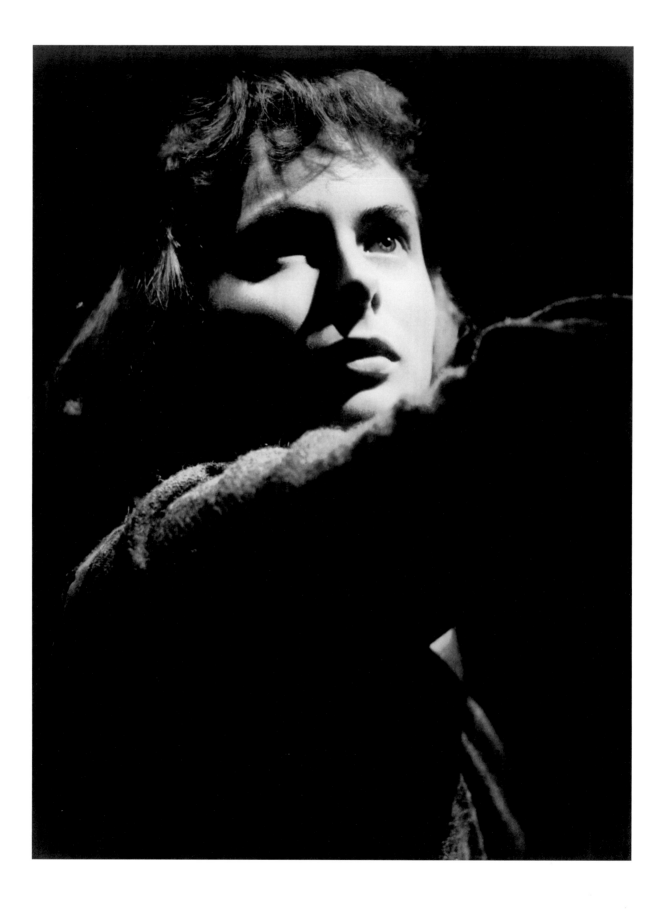

Arch of Triumph

Now that the exclusive contract with Selznick is a thing of the past, Ingrid is free to accept other offers. She agrees to do the screen adaptation of Erich Maria Remarque's novel *Arch of Triumph,* with Charles Boyer and Charles Laughton as the male leads, and director Lewis Milestone, who had won an Oscar for his screen adaptation of Remarque's *All Quiet on the Western Front.* Now she finally lands a lucrative contract—with newly founded Enterprise Studios—plus a percentage of the profits, and she has a voice in scheduling. She also sees to it that Robert Capa—who is, as always, short of cash—is given a job as a still photographer for *Arch of Triumph.* The story about Austrian refugee Dr. Ravic (Boyer), who has already been deported many times and practices medicine illegally, and Italo-Romanian chanteuse Joan Madou (Bergman) seizes upon motifs from the real-life relationship between Remarque and Marlene Dietrich.

Filming commences in the summer of 1946, but it proceeds slowly, and Ingrid is impatient because she is scheduled to appear on Broadway in October.

Following a production time of two years and production costs amounting to a gigantic four million dollars, the gloomy film with a dismal ending turns out to be a total flop. Even Bertolt Brecht's contribution to the screenplay was of no avail. Enterprise Studios goes out of business in 1949.

Ingrid Bergman in the role of Joan Madou with Charles Boyer as Dr. Ravic. This time the curb compensates for the difference in their heights. Production still from *Arch of Triumph.* Hollywood, 1947

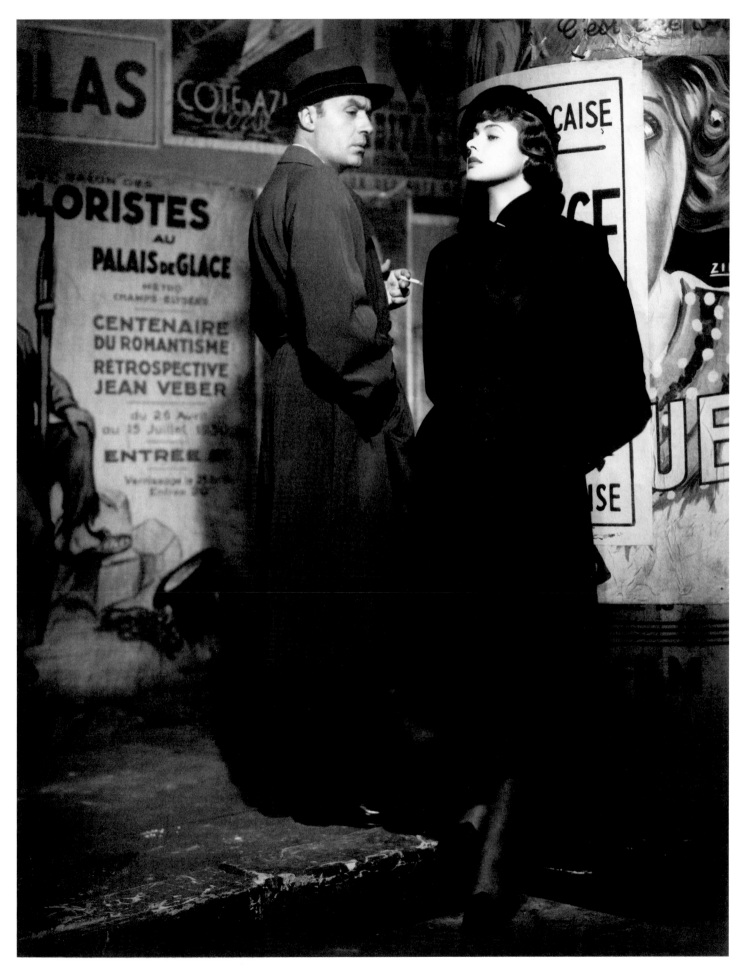

Ingrid Bergman as Joan Madou.
Production stills from *Arch of
Triumph*. Hollywood, 1947

Ingrid Bergman and Charles Boyer
in *Arch of Triumph*. Hollywood, 1947

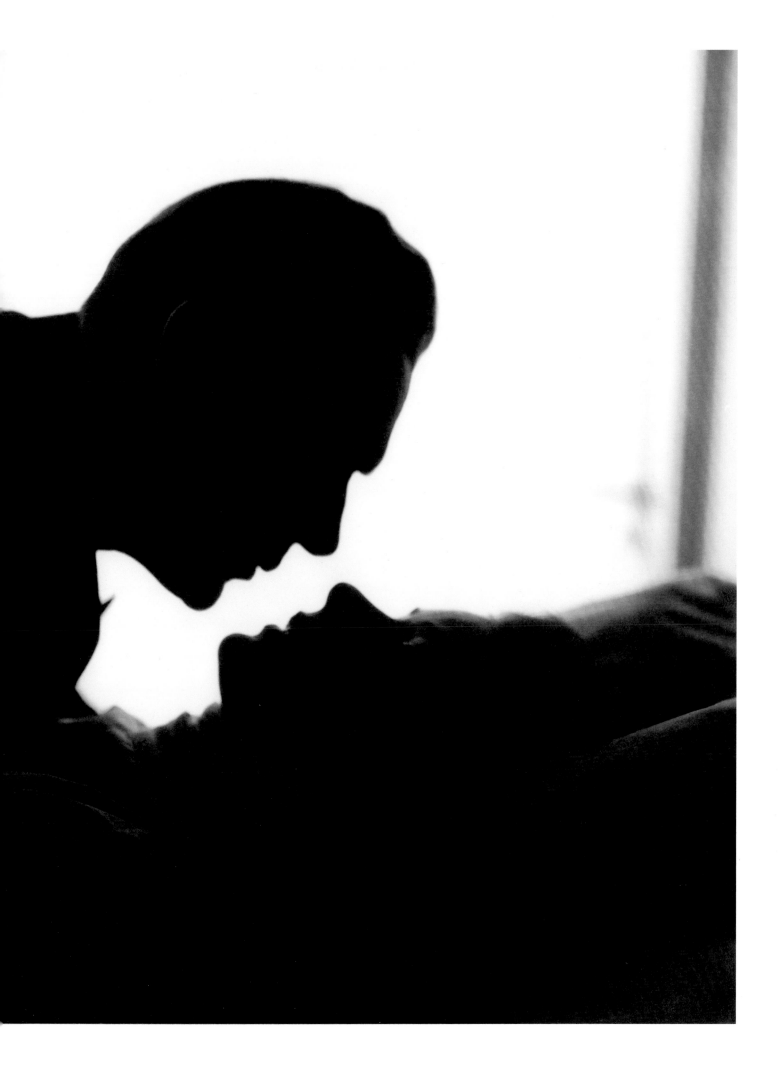

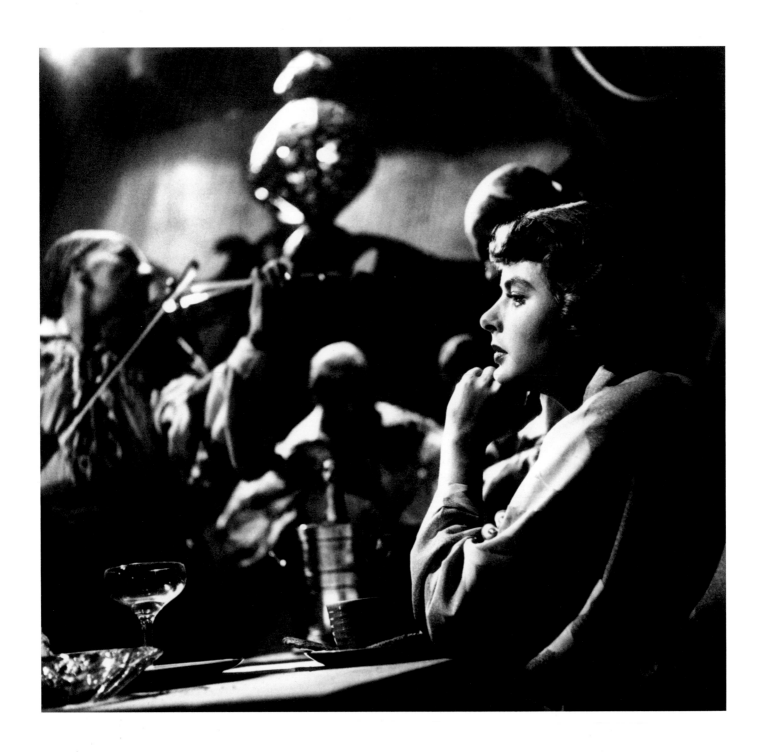

Capa is back in Hollywood for a visit. Ingrid comments dryly: "Bob Capa came to Hollywood not only because I was there, but also because many of his friends were there, and he thought he might give it a try. I was doing *Arch of Triumph*, and Capa said, 'What about me coming on the set and taking a few pictures?' So I asked the director ... Bob Capa took many interesting photographs of me but somehow Hollywood wasn't his scene."[17] Capa sums up his Hollywood experience in far more drastic terms: "Hollywood is the biggest mess of shit I have ever stepped in."
Two production stills by Capa of Ingrid in *Arch of Triumph*. Hollywood, 1947

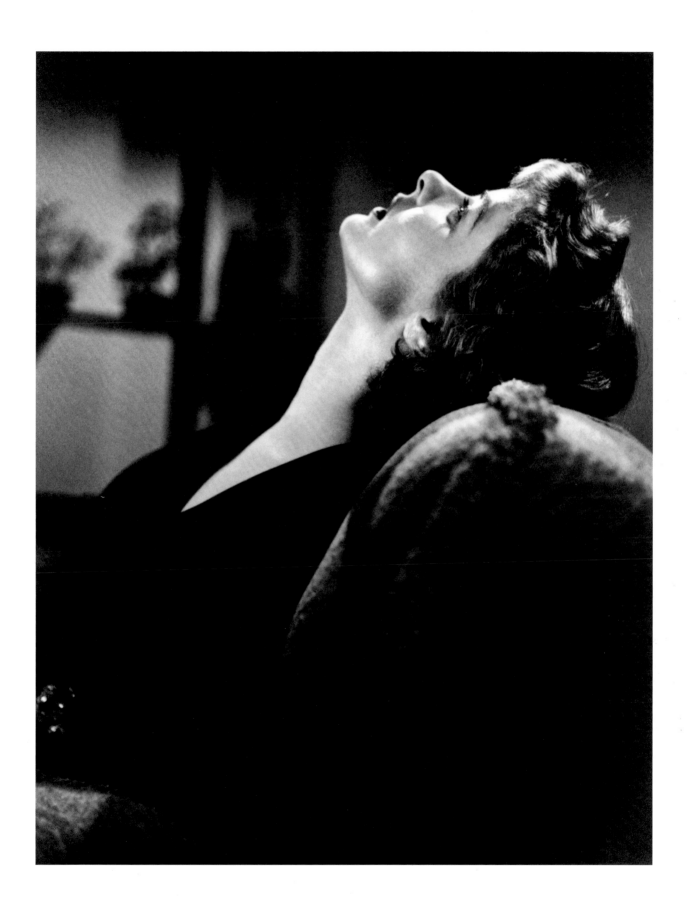

Victor Fleming's *Joan of Arc*

Victor Fleming approached Ingrid Bergman with the idea of filming Maxwell Anderson's play *Joan of Lorraine* with her in the leading role, but the screenplay bears little resemblance to the stage version. Anderson himself turned it into "a kind of medieval Western, with the Maid of Orleans as a pious Calamity Jane, fighting the English instead of the Indians."[18]

Although David O. Selznick had once promised her the role, the film is not produced by him, but rather by Sierra Pictures. Shooting commences in September 1946 in Culver City, and although it proves to be a difficult and extremely costly undertaking, Fleming says of his leading lady: "She is bullet-proof … You can shoot her [from] any angle, any position. It doesn't make any difference—you don't have to protect her … Ingrid's like a Notre Dame quarterback."[19] And indeed, her Joan of Arc "is no portrait of a plaster saint, but rather a recognizably human, confused woman who knows that God sometimes writes straight with crooked lines."[20]

Victor Fleming, 58, and Ingrid Bergman, 32, bring Joan of Arc's short life to the screen. She was burned at the stake at the age of 19. Culver City, 1948. Photographer unknown

Right page
Fleming gives the cast final instructions for the battle scene. Set still from *Joan of Arc*. Culver City, 1948

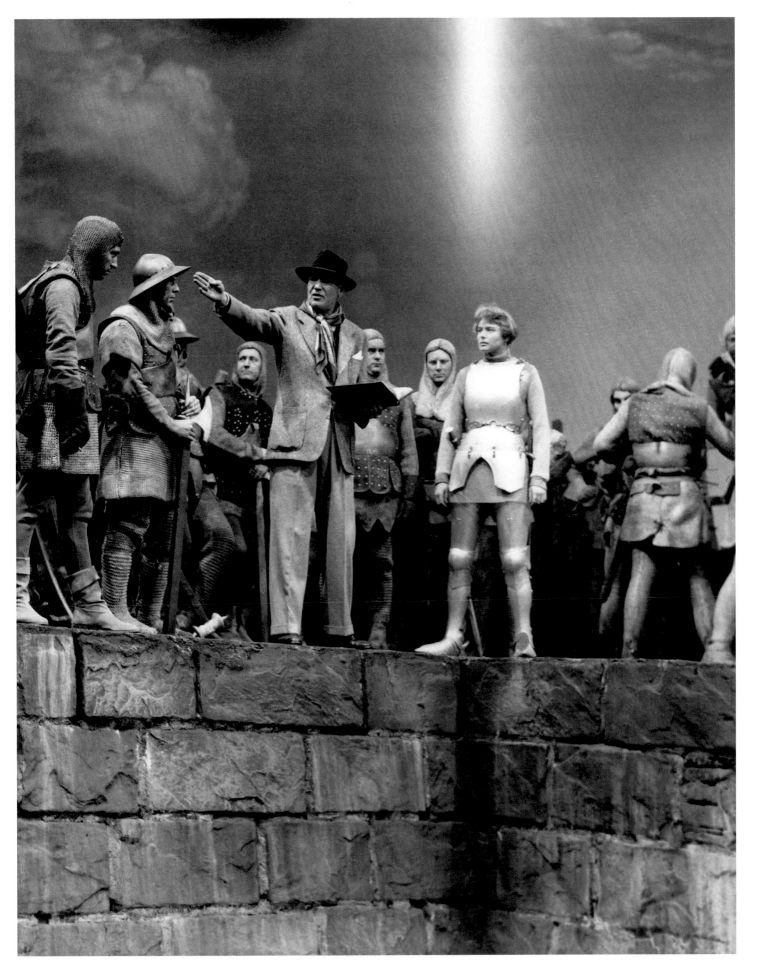

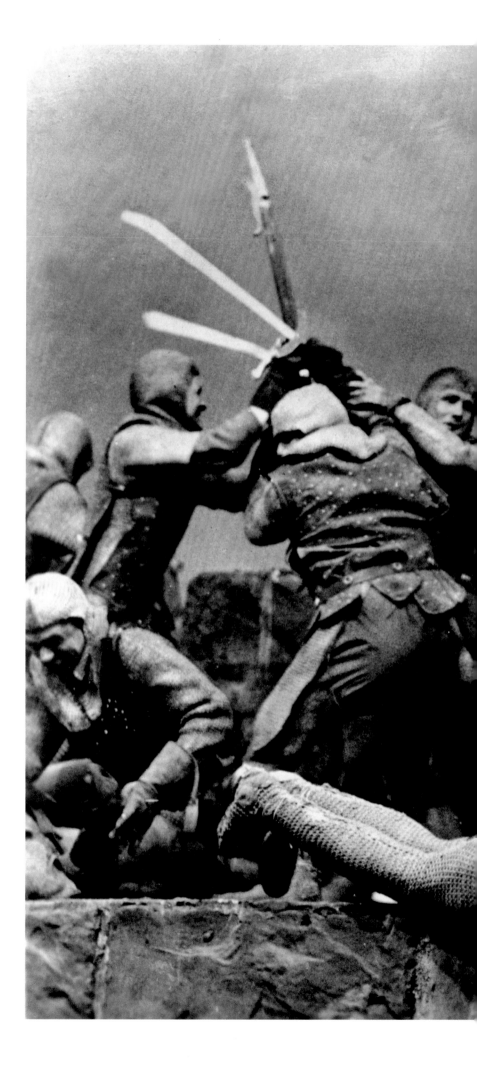

Production still from *Joan
of Arc*. Culver City, 1948

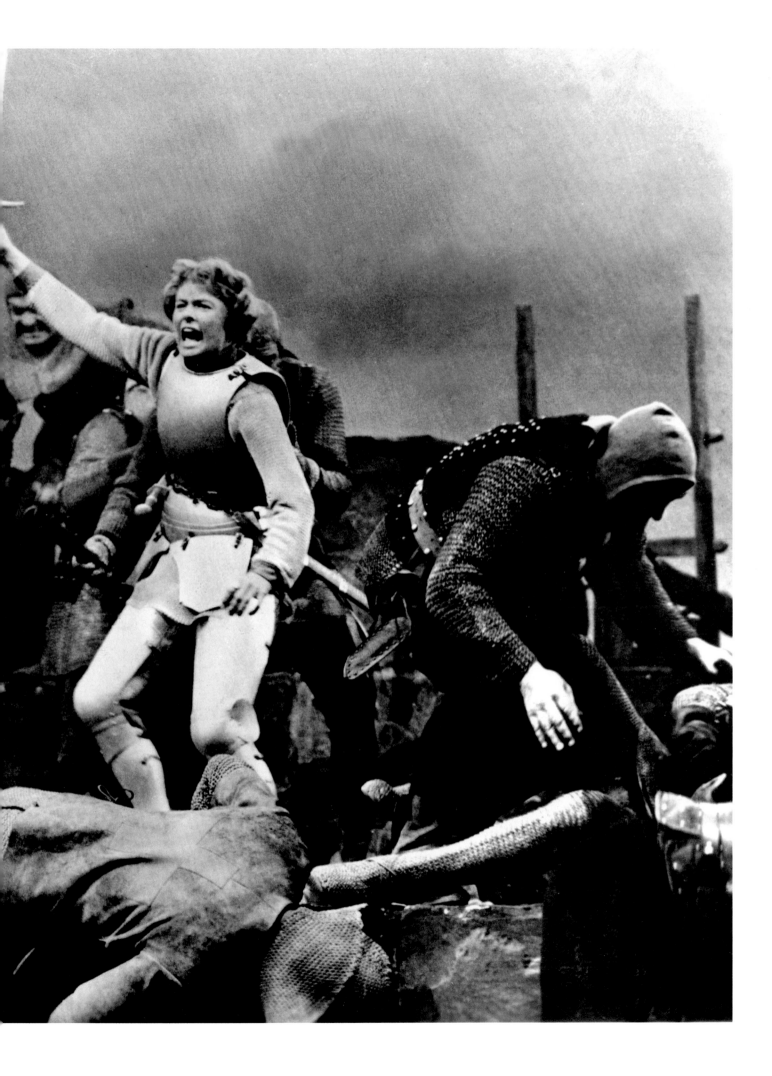

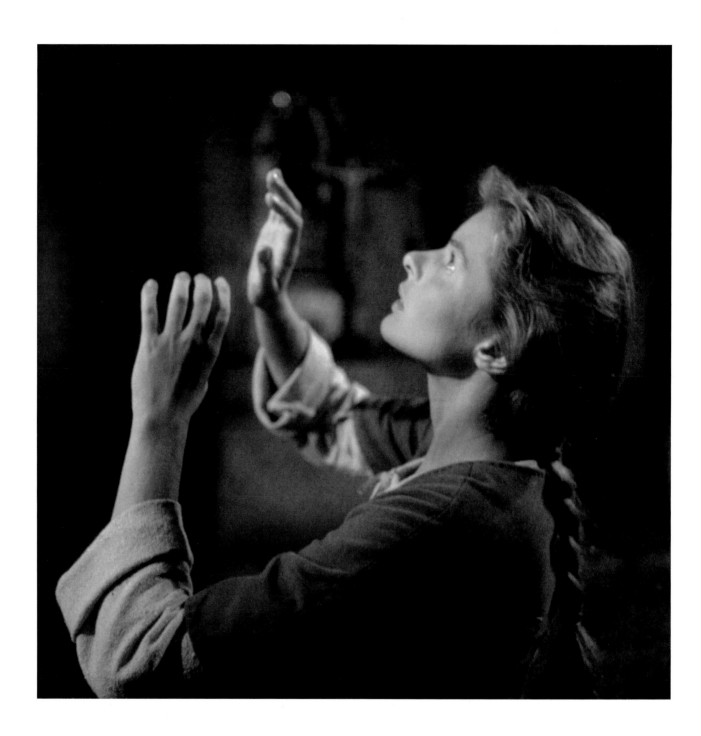

Ingrid as Joan of Arc. "What we tried
to do in the movie was the real Joan,
from the documents and the trial ..."[21]
Culver City, 1948. Photo: Louis Dean

Right page
A pensive Joan, following a religious vision
(left). Production still from *Joan of Arc*.
Culver City, 1948

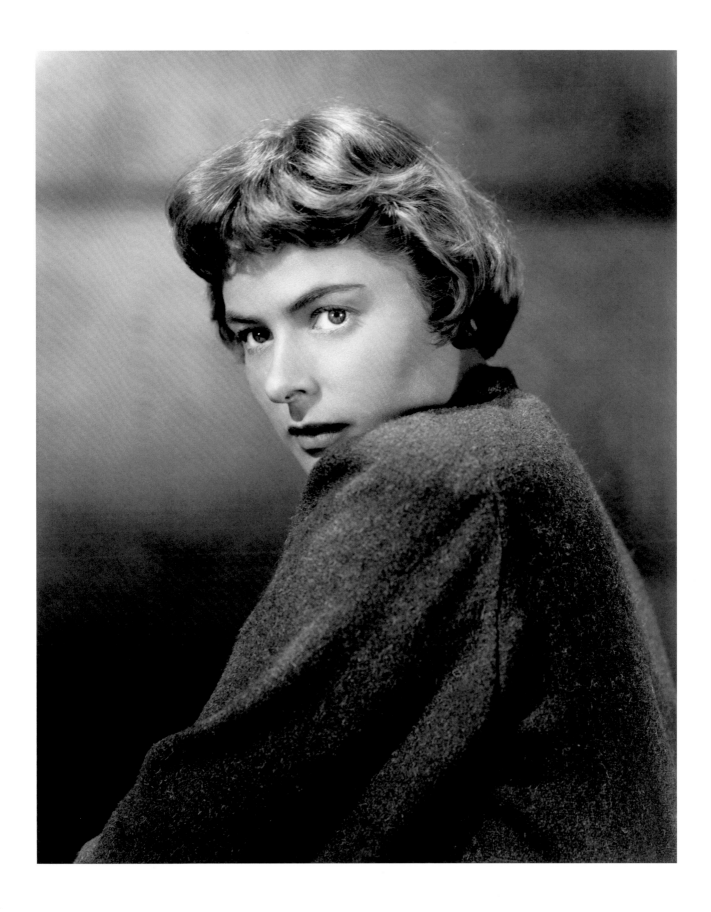

Victor Fleming joking with Ingrid Bergman during the making of *Joan of Arc*. Cupid's arrows pierce Ingrid's heart, but only for the duration of the shooting. Culver City, 1948

Prior to the film's release, Ingrid goes on a publicity tour through France. She retraces the footsteps of the real Joan of Arc and describes the journey thus: "So with Father Donceur as a guide and instructor we started off in France at Domrémy where Joan was born ... They closed the schools and had the kids lining the streets throwing flowers ... It was unbelievable. Wherever I went, they treated me as if I were the reincarnation of Joan of Arc ... I was mobbed, not because I was a movie star but because I was Joan of Arc—it was most moving."[22]

Right page
Ingrid Bergman beside the statue of Jeanne d'Arc in Paris, 1948.
"We ended up at Rouen, and there was the last photograph of me on my knees placing flowers on this slab of stone where she was burned. And for years after that ... when I came back to France, the customs and immigration men looked at me and said, 'Ah, Jeanne d'Arc ... welcome home.'"[23]

Under Capricorn

Ingrid Bergman had brought Helen Simpson's novel *Under Capricorn* to Selznick's attention as early as 1944. In 1947 Alfred Hitchcock, who was also no longer under contract with Selznick, acquired the film rights for his newly founded production company Transatlantic Pictures. Production commences in the summer of 1948. For tax purposes, shooting takes place at Elstree Studios on the outskirts of London.

The story is set in the year 1831. Lady Henrietta (Ingrid Bergman) has followed her father's stableman Sam Flusky (Joseph Cotten), who has been deported from Ireland for murder, to Australia. There she falls victim to periodic bouts of drinking even though Flusky has meanwhile become a prosperous landowner and loves his wife dearly. A cousin's visit from Ireland finally brings deliverance from guilt and hope for a happy future.

Hitchcock had just completed *Rope*, his first color picture (in Technicolor), in which he had experimented with extremely long takes. He also wanted to shoot *Under Capricorn* in this fashion, but the subject matter was not well-suited to ten-minute takes, as Ingrid Bergman recalls:

"He got such pleasure out of doing those camera tricks, but of course those continuous shots and the moving cameras were very hard on everybody … Then the propmen had the job of moving all the furniture while the camera was rolling backward and forward … and the walls were flying up into the rafters as we walked by, so the huge Technicolor camera could follow us. It just drove us all crazy! … The floor was marked with numbers and everybody and every piece of furniture had to be on the cued number at the right moment. What a nightmare!"[24]

Ingrid Bergman as Lady Henrietta Flusky.
Production still from *Under Capricorn*.
London, 1948

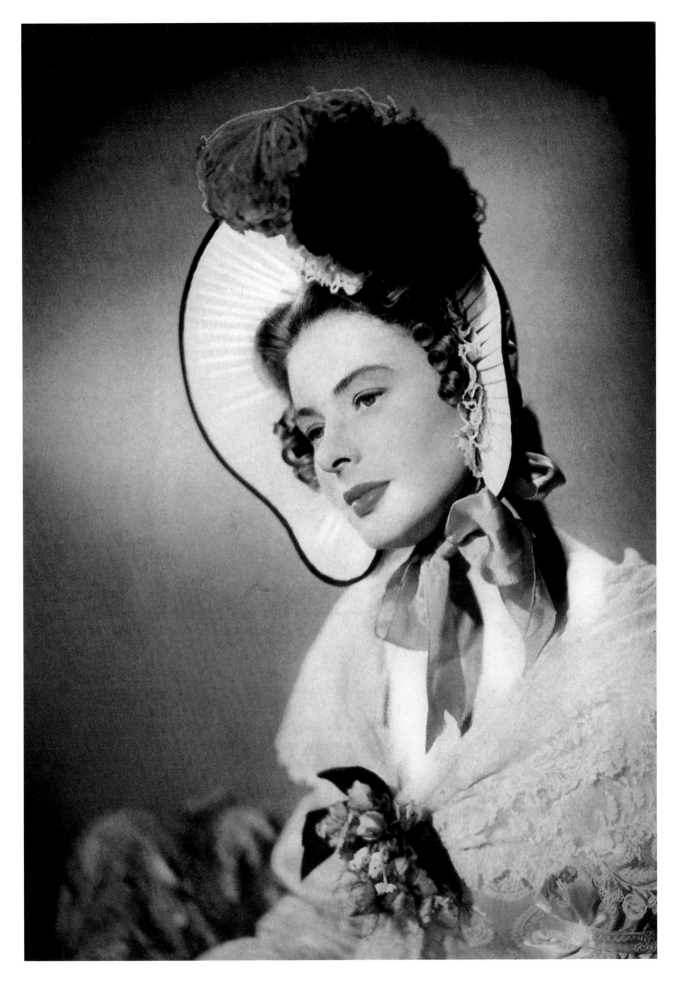

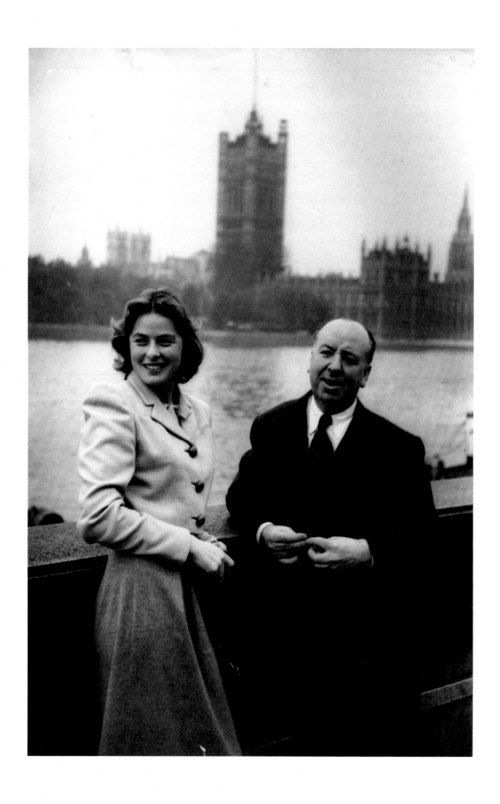

Accompanied by photographer Kurt Hutton,
Ingrid Bergman and Alfred Hitchcock take
a walk through London for a story in *Picture
Post*. 23 October 1948

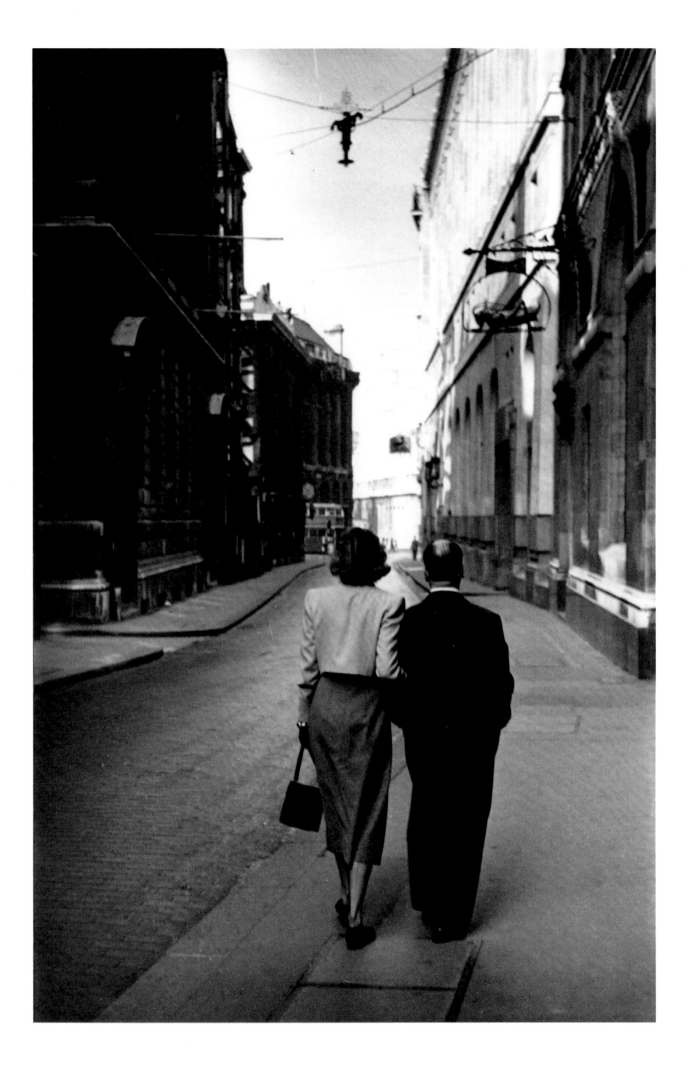

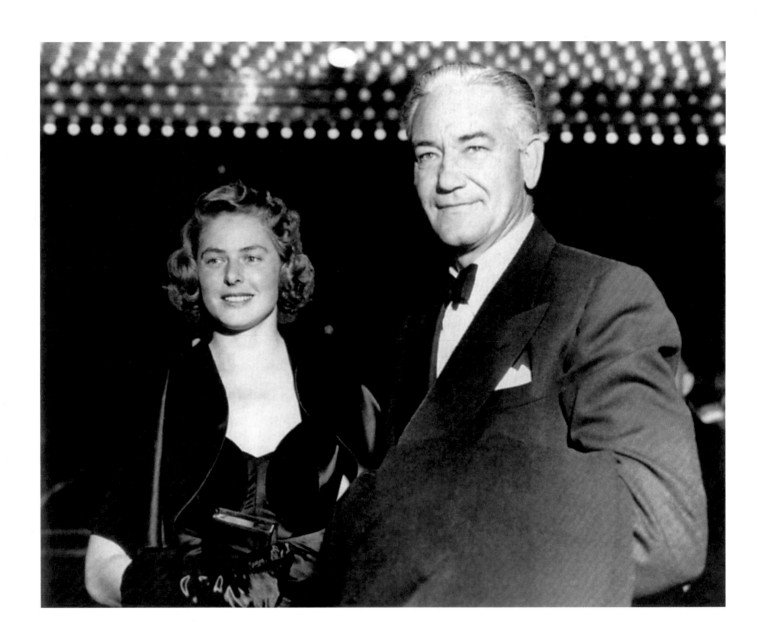

The last joint appearance: Ingrid Bergman
and Victor Fleming at the premiere of
Joan of Arc in New York on 11 November
1948. Seven weeks later, in January of
1949, Victor Fleming dies of a heart
attack. New York, 1948.
Photographer unknown

Right page
A huge turnout for the premiere of
Joan of Arc in New York, 1948

Billboard for *Joan of Arc* on Times Square,
New York, 1948. Despite mixed reviews,
the movie was a box office success.

1948 comes to a close with a pending visit from Roberto Rossellini in Hollywood. Petter
and Ingrid had previously met him in September of that year in Paris, where they discussed
film plans. Ingrid recalls departing London for that meeting: "We went across to Paris,
Petter and I, and we all met at the Hotel George V. ... We were introduced and Petter said
something to me, and I didn't hear him. I was looking at those dark eyes of Roberto's ...
I liked him from that very first moment ..."²⁵
Roberto Rossellini arrives in Hollywood on 17 January 1949. He lives with the Lindströms
and flies back to Rome on 28 February. This picture from Ingrid's archive by an unknown
photographer was obviously taken during a stopover in New York in late 1948.

IV.

THE SCANDAL: THE RELATIONSHIP WITH ROSSELLINI

1949–1955

ESCAPE TO ROME

The flight to Italy, where she is to star in a film by Roberto Rossellini tentatively titled *Terra di Dio*, bears signs of an escape. It was probably Robert Capa who introduced Ingrid Bergman to *Rome, Open City* in 1946, as well as to the new way of filmmaking it established and its creator, Italian director Roberto Rossellini. Having experienced the destruction wrought by the war in Europe, and no longer under contract with Selznick, Ingrid no longer feels complete in Hollywood. The estrangement from her husband does the rest. In any case, Ingrid seems determined to do more than just make a new movie. In her autobiography she describes her situation at the time thus:

"I think that deep down I was in love with Roberto from the moment I saw *Open City*, for I could never get over the fact that he was always there in my thoughts. Probably subconsciously, he offered me a way out from both my problems: my marriage and my life in Hollywood. But it wasn't clear to me at the time … If people had looked suspicious when I mentioned Italy, I would certainly have said quite indignantly, 'I'm going to make a movie—that's all I'm going for.'"[1]

Ingrid's close friend Irene Selznick, who was then divorced from David Selznick, recalls the circumstances and causes of the departure in her memoirs:

"Ingrid, who loved the theatre, had always come to New York more than my other Hollywood friends. Late in 1948 she was at loose ends, without a producer and unhappy about her work. Her movies hadn't turned out too well after she left David. She was still the very top star, but none of her many offers included a great director. She told me she didn't care about money; she wanted opportunity. She was prepared to take a real cut for the chance to work with any one of five directors; she named William Wyler, Billy Wilder, George Stevens, Roberto Rossellini, and, I believe, John Huston. She wondered what to do about it.

I came up with a plan that was as simple and direct as Ingrid herself. The thing to do was to write each one, in her own charming style, asking him to bear her in mind in case the right story came along.

She was unimpressed, in fact dubious. I told her it was a beguiling idea that only she could get away with. I could just imagine the astonishment of a director receiving a handwritten note from Ingrid Bergman asking for a job. I told her how to reach them, including Rossellini, with whom I had recently dined in Paris and whom I had found charming. Some months later, Ingrid told me

Ingrid Bergman arrives in Rome on 20 March 1949 and is met at the airport by Robert Rossellini. She recalls: "Arriving in Rome was just like something out of a dream. I've never experienced a welcome like it anywhere else in the world … There were so many people at the airport you'd think it was a queen arriving, instead of just me. Roberto shoved a big bouquet of flowers into my arms and we forced our way into the cars."[2]
Rome, 1949. Unknown press photographer

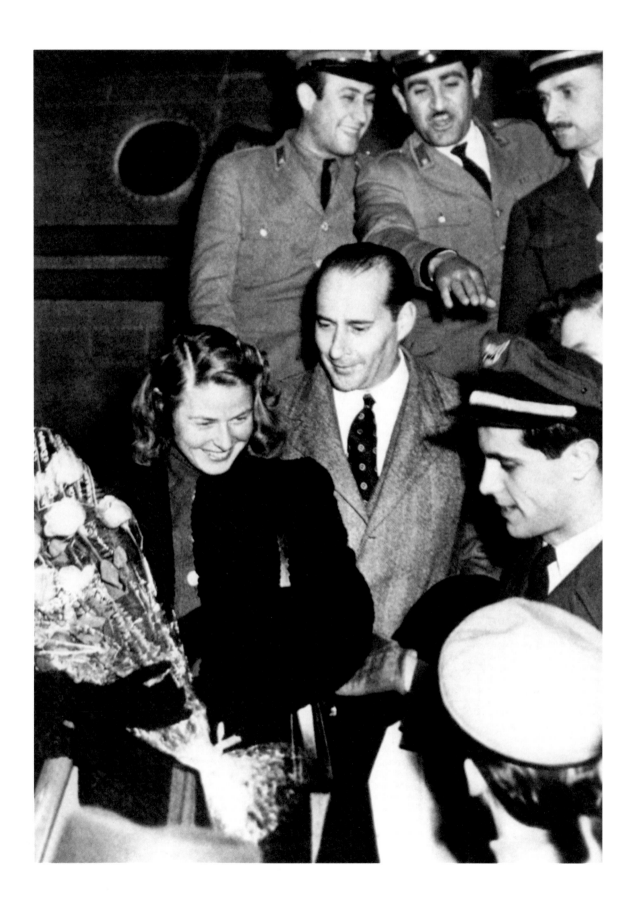

she'd had a marvelous letter from him. I asked if she'd also heard from the others. She said of course not; she had only written to Rossellini. That summer the Lindströms met him in Paris, and he visited them in the winter.

In March Ingrid was in New York, all set to fly to Italy to make her first Italian picture. Everything considered, it was natural to spend the last evening with me. We wound up at my place for a drink. Ingrid talked and talked. She was not so much exhilarated as fevered. Her spirits were higher than a couple of highballs would account for. I asked no questions, because if something was afoot, I preferred not to know it. It got pretty late, so I got undressed. When she didn't take the hint, I went to bed.

She didn't leave. She sat down beside me and phoned Roberto in Rome. I tried not to listen and still didn't pry. She didn't want to be alone or go back to the hotel at that hour. I had a great big bed; if I didn't mind, she would sleep right there. I gave her a nightie and a toothbrush, and on the way to the bathroom she slipped on the polished floor and cracked her head on the corner of the air conditioner. She fell so heavily I thought she was a goner. An eighth of an inch in a different direction and she wouldn't have gone to Rome.

She sent a cable on arrival. I have it still: 'I AM HERE, INGRID.' It didn't say much. On the other hand, it said a lot and left no doubt. Ten days later there was another cable, which said more. It read: "WE DON'T HAVE TIME TO WRITE BECAUSE WE ARE SO HAPPY. BERGELINI.' For an awful moment I thought, 'What have I done?' Actually, nothing at all. It wasn't my fault she hadn't written the other four directors."[3]

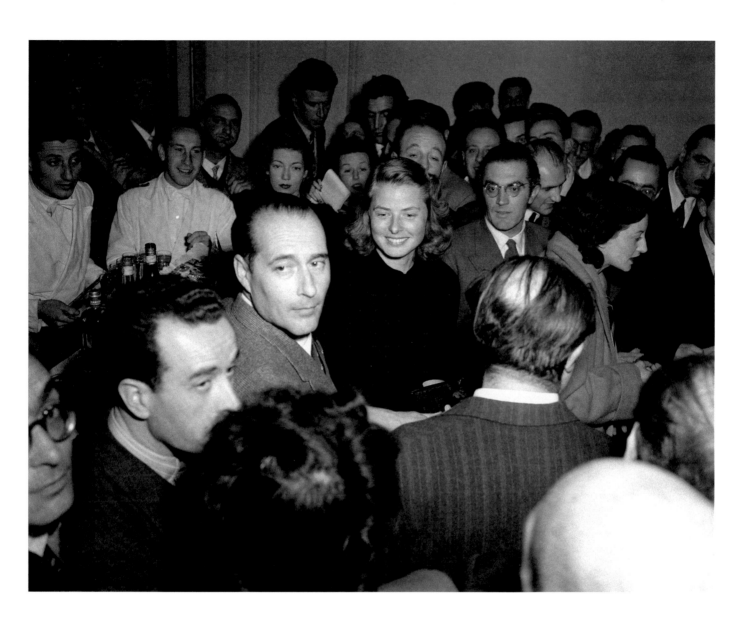

Ingrid Bergman und Roberto Rossellini at
an improvised press conference upon arrival
at the Hotel Excelsior. Rome, 1949.
Photo: Jim Pringle for AP

From Ingrid's private photo album, a picture
she entitled "The first cigarette." Rossellini
throws a welcome party at the hotel at which
he introduces Ingrid to his friends. Taken in
the early morning hours of 21 March 1949 at
the Hotel Excelsior in Rome.
Photographer unknown

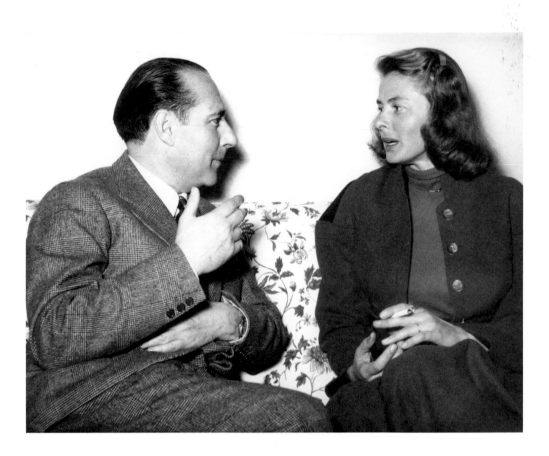

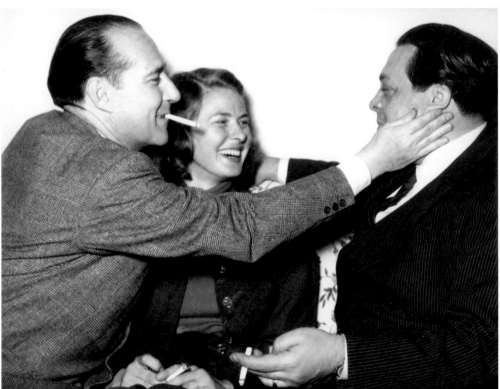

Ingrid Bergman and Roberto Rossellini
during the welcome party. In the bottom
two photos they are joined by Rossellini's
friend and colleague Aldo Fabrizi.
21 March 1949. Hotel Excelsior, Rome.
Photographer unknown

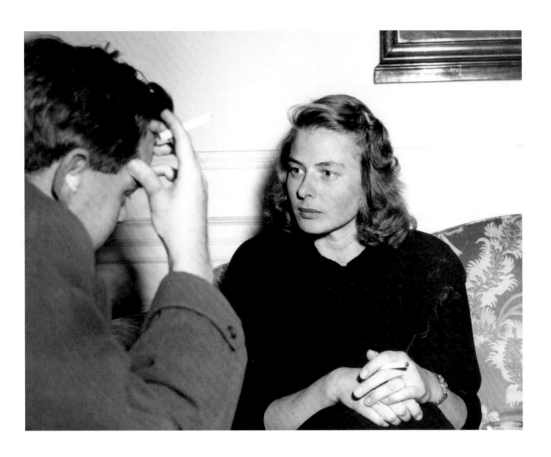

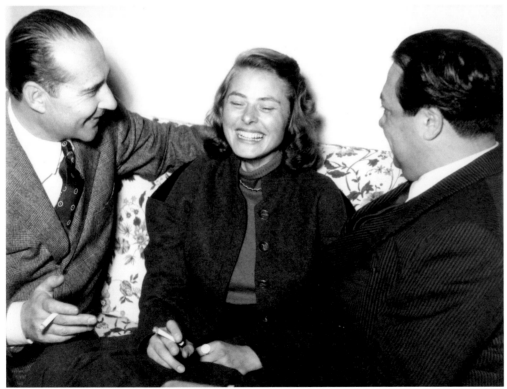

That weekend, Ingrid Bergman and
Roberto Rossellini depart Rome in a
sport coupe on a trip south to Naples,
Capri, and the Amalfi Coast.
Ingrid and Roberto behind the wheel
of his Cisitalia 202. The photo is not
reversed; the steering wheel actually
was on the right-hand side.

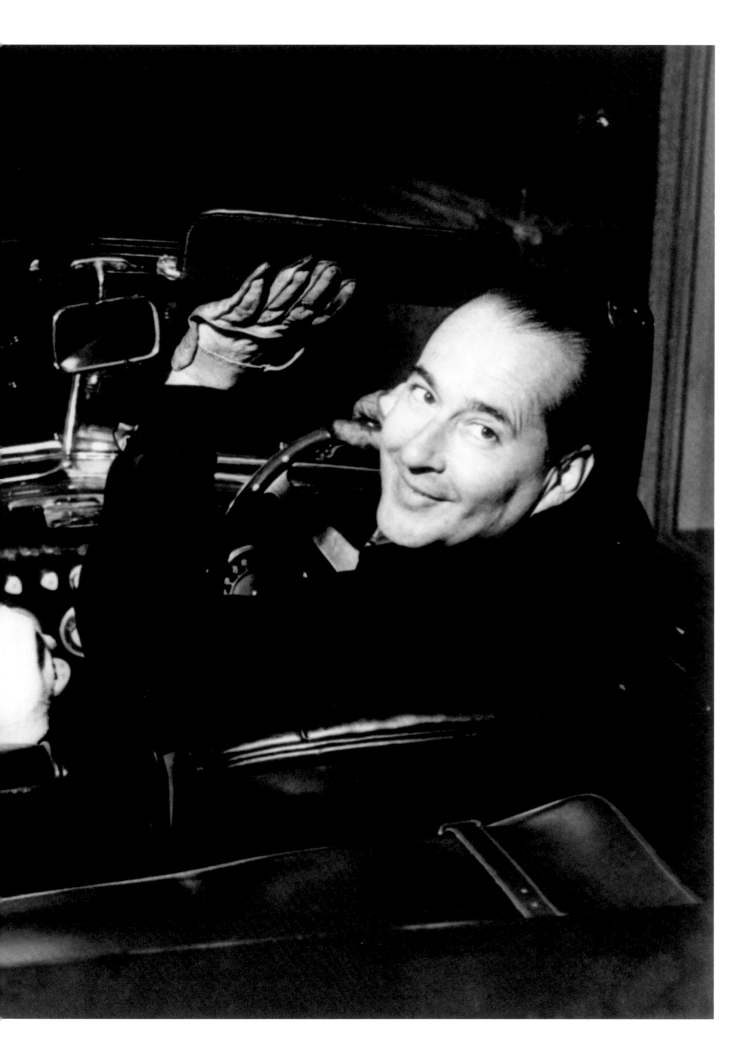

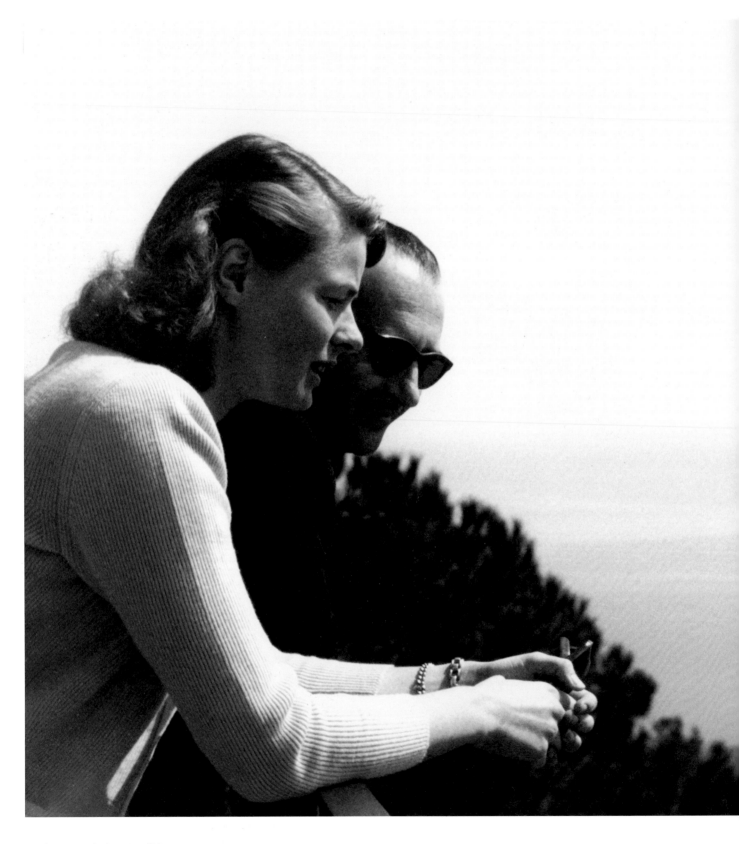

Ingrid Bergman and Roberto Rossellini
on Capri, March/April 1949. A picture
from Ingrid's private photo album.
Photo: D'Elia, Capri

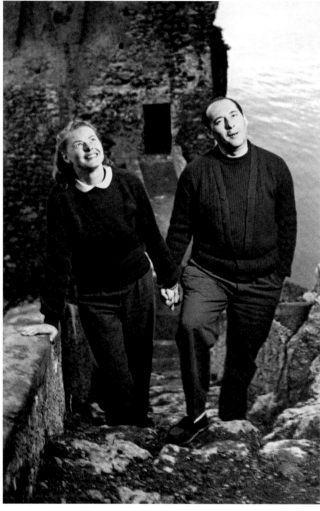

Top

The photo that unleashed a worldwide scandal. Ingrid Bergman recalls: "As we walked around, the photographers followed us everywhere And then came that famous photo—which *Life* magazine printed—on the Amalfi coast as we climbed the steps toward one of those round towers. We were hand in hand, and that went all over the world showing what a loose woman I was."[4] Amalfi, 1949. Photographer unknown

Following pages

Stromboli looms into view. The volcanic island in the Tyrrhenian Sea will provide the location and name for the film they plan to make together. Ingrid notes in her photo album: "Robert talked about the picture and points to ... Stromboli." On 4 April, a film crew and equipment will arrive here by ship. Tyrrhenian Sea, 1949. Photographer unknown

Stromboli

Roberto Rossellini succeeded in winning Ingrid Bergman for his film project *Terra di Dio*. Bergman had seen his films *Rome, Open City* and *Paisà* in New York, and she is as equally taken by the man as she is by his aesthetic. She sees in him a kindred spirit:

"I am a migratory bird. Ever since I was a little girl, I have looked for new things … I tried to change the roles, change my type, move from studio to studio … Then I met Rossellini, and in him I found another migratory bird. He grew up like a wildcat, and is never completely satisfied with anything. And with him I have the world I wanted to see …"[5]

Ingrid Bergman is to portray Karin, a Lithuanian in a refugee camp who marries an Italian soldier in order to get out. She accompanies him to his native village on a volcanic island, where she is viewed with suspicion by the local women and finds herself unable to fit into the archaic fishing community. After she becomes pregnant, she attempts to transverse the volcano in order to flee by boat, but then has a vision that induces her to remain on the island.

Before things can get underway, Bergman has to find a financially potent producer for her notoriously cash-strapped director. A consternated David Goldwyn begs off after viewing Rossellini's *Germany, Year Zero*, but Howard Hughes, who had just purchased RKO, agrees.

During shooting on the volcanic island of Stromboli, it becomes all too clear that the new aesthetic entails different working conditions as well. These include: no proper script; amateur actors like her partner Mario Vitale, a fisherman Rossellini hires locally; Spartan accommodations without electricity or running water; a primitive bill of fare; dust, dirt, and no connection to the outer world. And an erratic director: "His violence, if something goes wrong, can only be compared to the volcano in the background. His tenderness and humor come like a surprise immediately after. I understand well that people call him crazy. But so are all people called, if they dare to be different …"[6]

Before shooting is completed, Bergman's affair with Rossellini becomes known, and reporters begin arriving on the "island of ill repute." Howard Hughes wants to capitalize on the publicity and pushes for rapid completion of the film, announcing that he intends to release the film under the title *Stromboli*.

The volcano expresses its thanks by erupting on 6 June 1949. That same day, Ingrid learns that she is pregnant.

When *Stromboli* hits the US cinemas in February, the Bergman-Rossellini affair is making new waves following the birth of Robertino. The film is banned or boycotted in some states on "moral grounds."

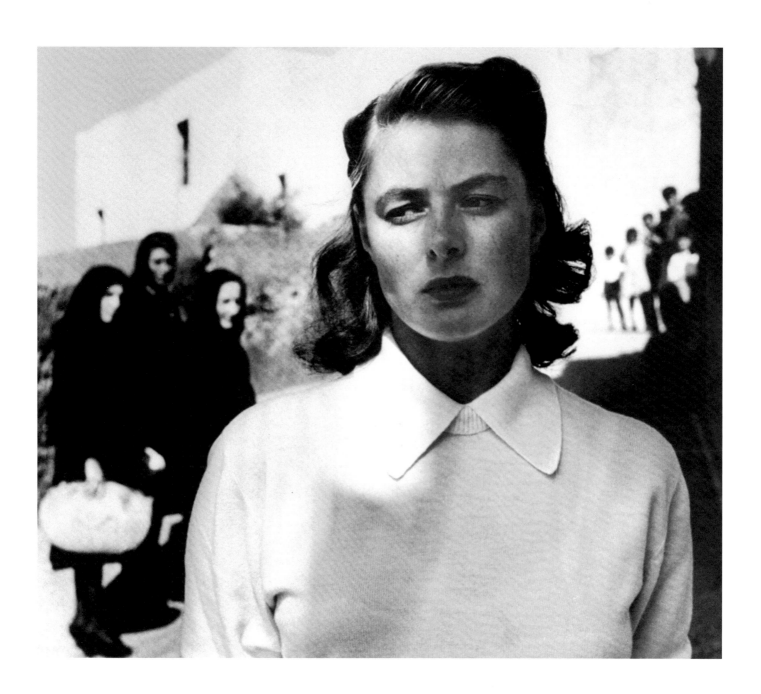

Photographer Gordon Parks, who was working for
Life in Paris at the time, is on hand for the shooting on
Stromboli. In view of the love affair and divorce *in re*
Bergman-Lindström/Rossellini, the American magazine
considers the story a top priority. The caption reads:
"Swedish actress Ingrid Bergman sadly standing in street
as village women stare curiously at her, on location for
the movie *Stromboli* directed by her lover Roberto
Rossellini on Stromboli Island."

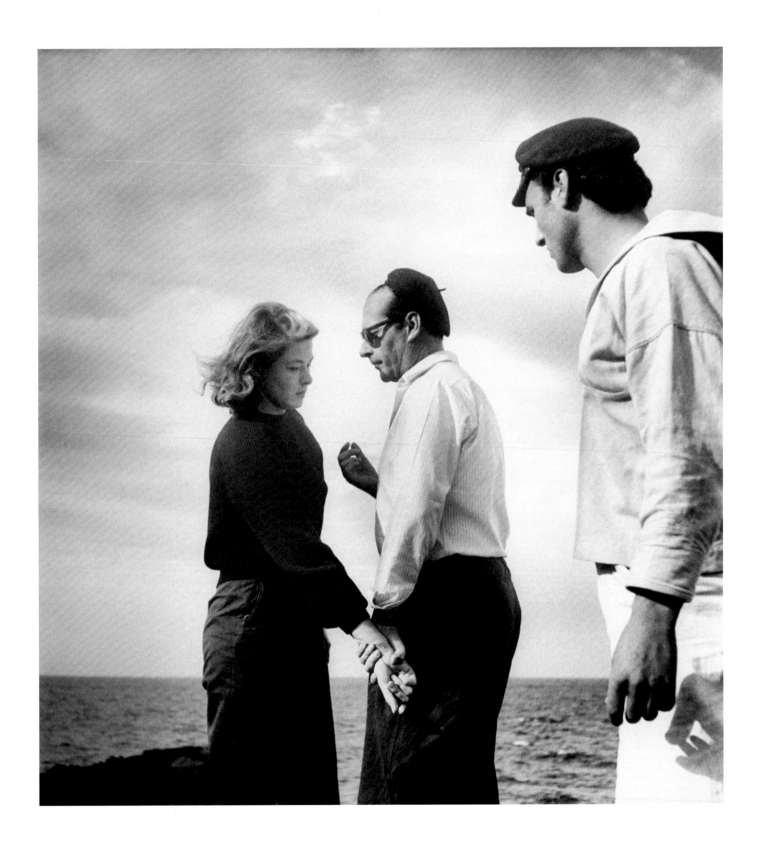

Director Rossellini gives Ingrid Bergman
instructions while standing in a boat. On
the right, fisherman Mario Vitale, who plays
Ingrid's husband in *Stromboli*. Stromboli, 1949.
Photo: Gordon Parks

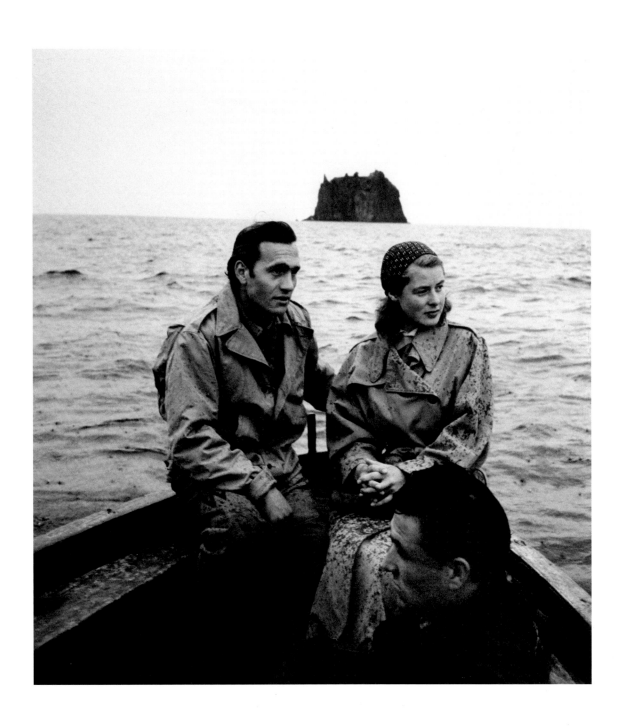

Mario Vitale and Ingrid Bergman in a boat during the shooting of
Stromboli. The tiny island of Strombolicchio is visible in the background.
Stromboli, 1949. Photo: Gordon Parks
In Salerno, "Ingrid was treated for the first time to Roberto's documen-
tary method of casting. He pulled up near a beach where a number of
fishermen were working by their boats … Now when he announced
disarmingly, 'You wait here, I just go find you a leading man,' Ingrid
took this as a joke and laughed merrily … Not until she got to the
island did she realize that he was most certainly not joking. He had
put both young men on the payroll …"[7]

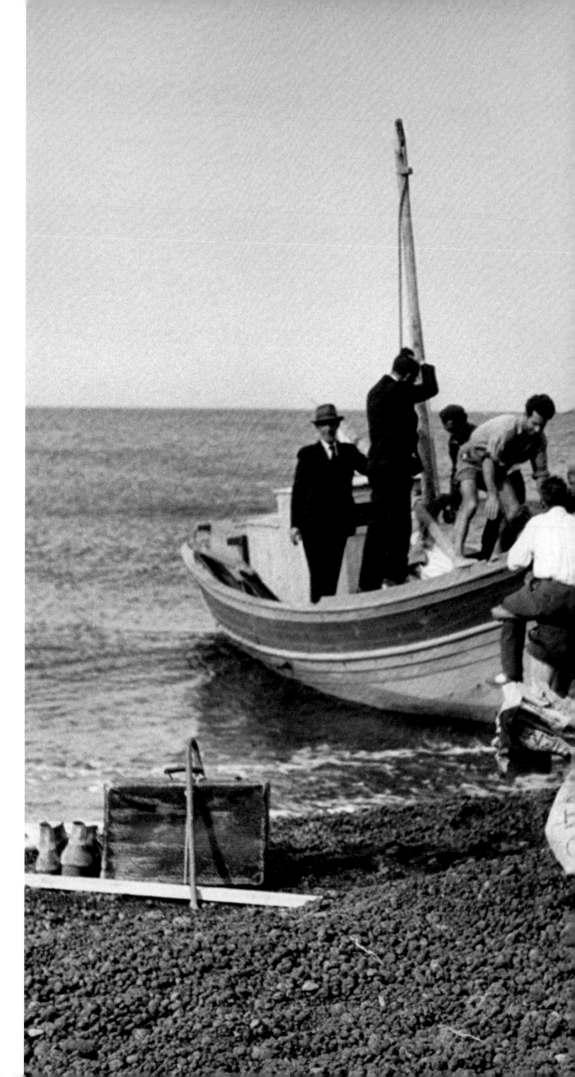

The caption reads:
"Italian visitors from Messina arriving
by fishing boat on the shore of Stromboli
Island where they are bent on seeing
the famous Swedish movie star Ingrid
Bergman who is at this location working
on the movie Stromboli."
Stromboli, 1949. Photo: Gordon Parks

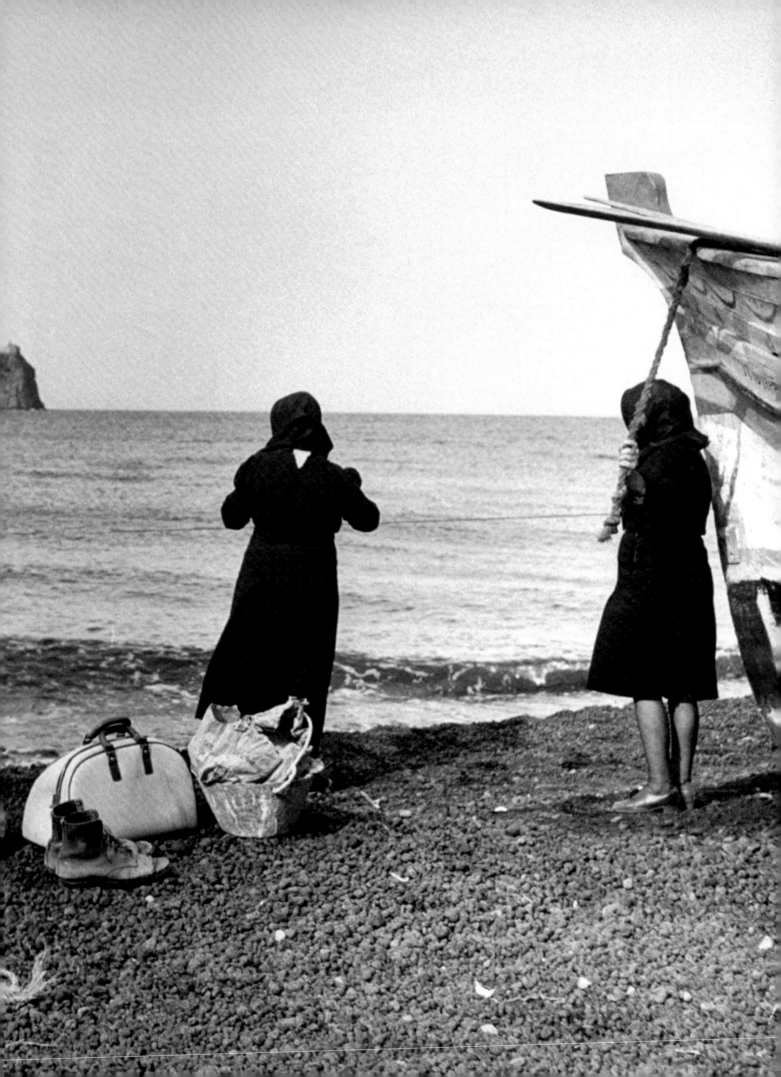

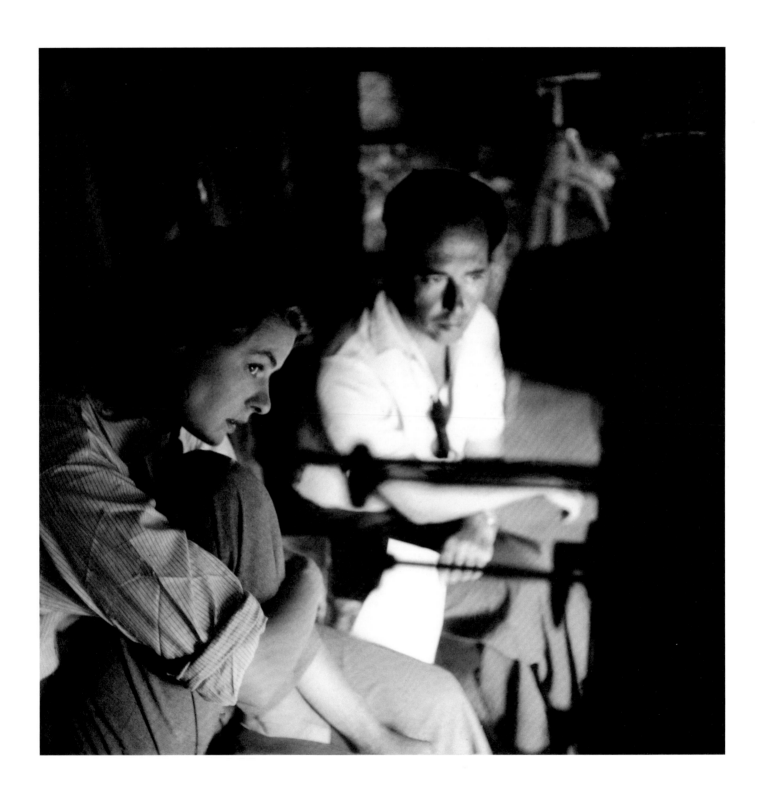

Ingrid Bergman and Roberto Rossellini
during the shooting of *Stromboli*.
Stromboli, 1949. Photo: Gordon Parks

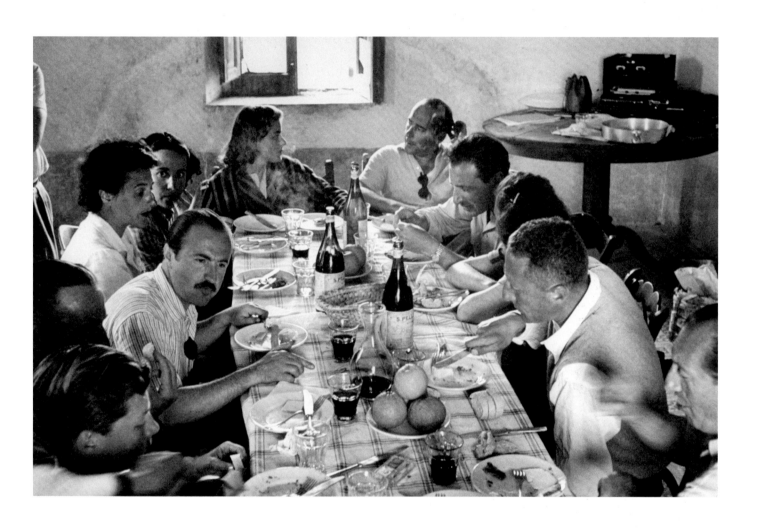

Ingrid Bergman and Roberto Rossellini during lunch with the film crew. Stromboli, 1949. Photo: Gordon Parks

On 2 August, Ingrid Bergman writes in her diary: "Left Stromboli." She now knows that she is pregnant and that the child's birth will be the culmination of the scandal her open love affair with Rossellini has unleashed.

The house by the sea: Roberto Rossellini
purchases the Villa Santa Marinella for
his future family in 1950. Located 60 km
north of Rome near Civita Vecchia, the
large estate has direct access to the sea
and a large park. Ingrid cannot move in
immediately, however: "I wasn't allowed
to go there because all the collected
generations of old Italian mammas insist
that young children should not be raised
near the sea. It was supposed to do some-
thing harmful to their ears or brains or
something. I thought it was all nonsense,
but I was a newcomer so there was no point
in starting off with arguments."[8]

The second building from the left would be-
come their home. Santa Marinella, 1950.
Panorama photo by Poletto

Right page bottom
View of the house as seen from
the sea. Probably taken by Ingrid.
Santa Marinella, 1950

On a walk near Santa Marinella, 1950.
Beneath this picture in her private
photo album, Ingrid Bergman notes:
"The first member of our family was our
dog Stromboli." Roberto gave her the
pup as a present while on the island.
Photographer unknown

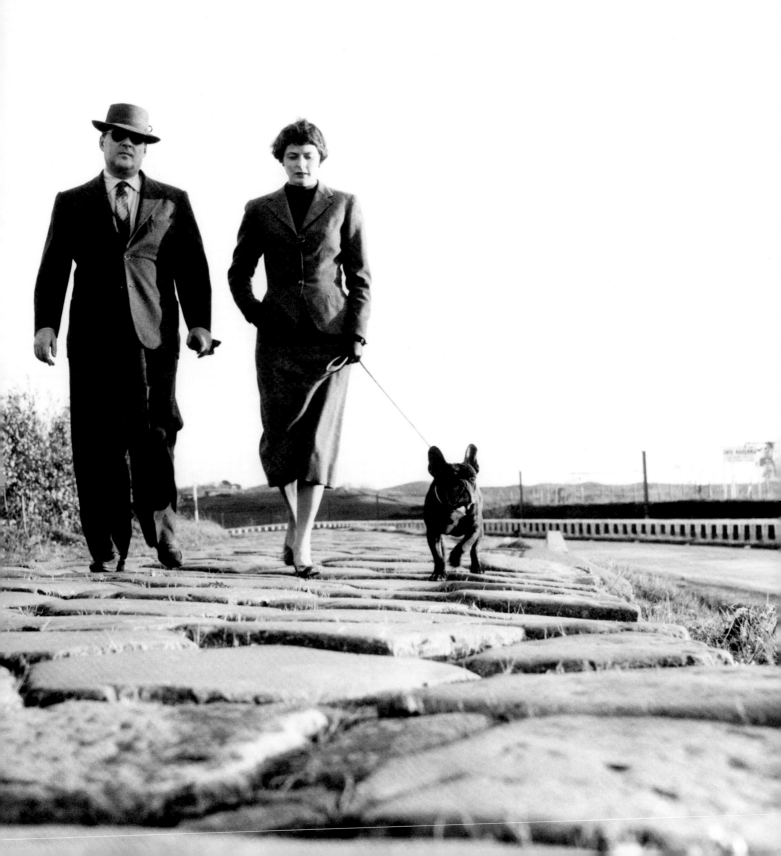

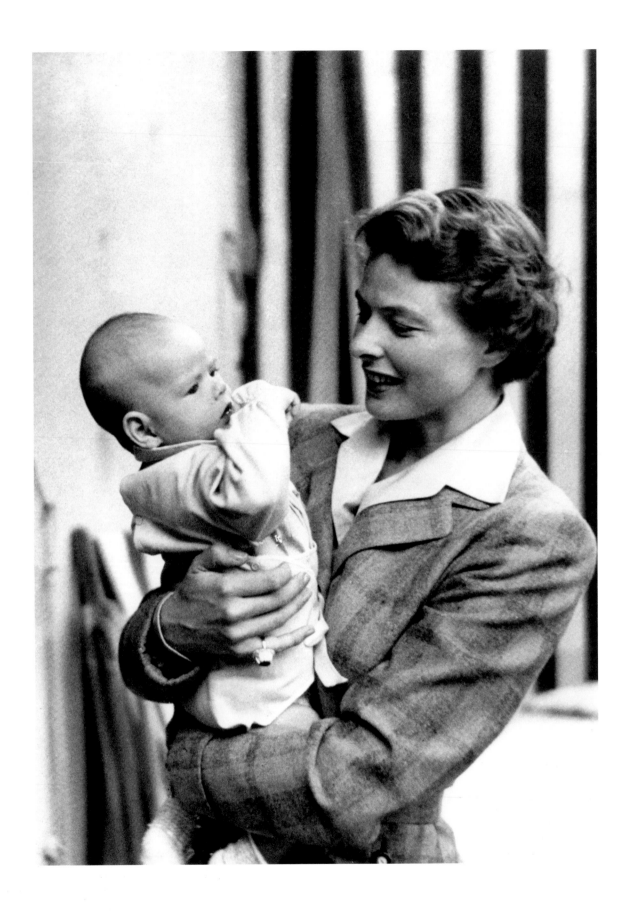

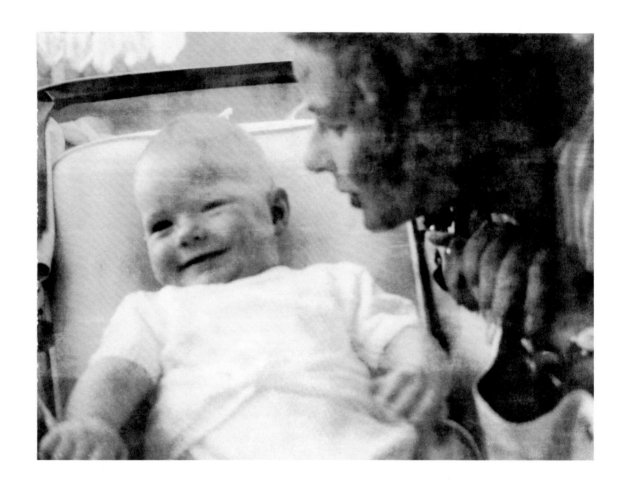

On the evening of 2 February 1950, Ingrid gives birth
to her first child born out of the union with Roberto
Rossellini. Because both parents are married to
someone else, the birth causes an even bigger
scandal than the love affair. Reporters take up the
chase for the first photo of the baby.

Left page
A press photo taken at an official press event.

This page
Robertino Rossellini and his mother, Ingrid Bergman.
May, 1950, Rome. Private photo/Polaroid, probably
taken by the proud father.

Ingrid later describes the enormous legal problems associated with
the birth in the following words: "I was a married Swedish citizen
hoping to divorce and marry an Italian who had had his marriage
annulled, and my husband was now an American citizen living in
California. I suppose lawyers were invented for such complications.
First, the birth certificate. As far as I could see, everyone in the whole
wide world knew that I'd given birth to a seven-pound baby boy and
that the father was ... Roberto Rossellini. But could we put that on the
birth certificate? No! I was still married to Petter, so if my name had
been put down, Petter would officially have been the father of the
child and Roberto would have torn the office down ...
On February 9, I got a cable saying that the divorce had been granted
and that Roberto or I could marry anyone we chose.
But February 9 was too late for the birth certificate. Roberto had had
to register himself as the father of the child and they put me down
as the mother 'whose identity will be revealed later.'"[9]

Europa '51

The Greatest Love

The success of *The Flowers of St. Francis (Francesco, giullare di Dio)* gave Rossellini the idea for a new film that concerns itself with a 20th-century woman who tries to live like St. Francis. Carlo Ponti and Dio de Laurentiis agree to produce the picture. Shooting commences in October of 1951 in Rome during a great heat wave, which means that Rossellini can only film at night.

Ingrid Bergman portrays a wealthy woman in Rome who feels responsible for her son's death and attempts to atone for it by helping all the needy people she comes into contact with. After she helps a young thief evade the police, her husband has her committed to a mental institution, where she remains for the rest of her life.

Originally titled *Europa '51*, it is a great box-office success in Italy, but it attracts little interest abroad. In 1954, four years after *Stromboli*, it begins its cinema run in the US under the title *The Greatest Love*.

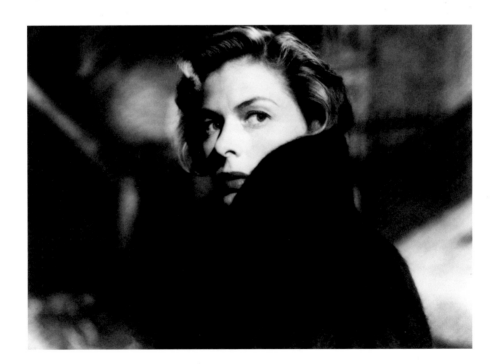

Two production stills with Ingrid Bergman from *The Greatest Love*. Rome, 1951. Photographer unknown

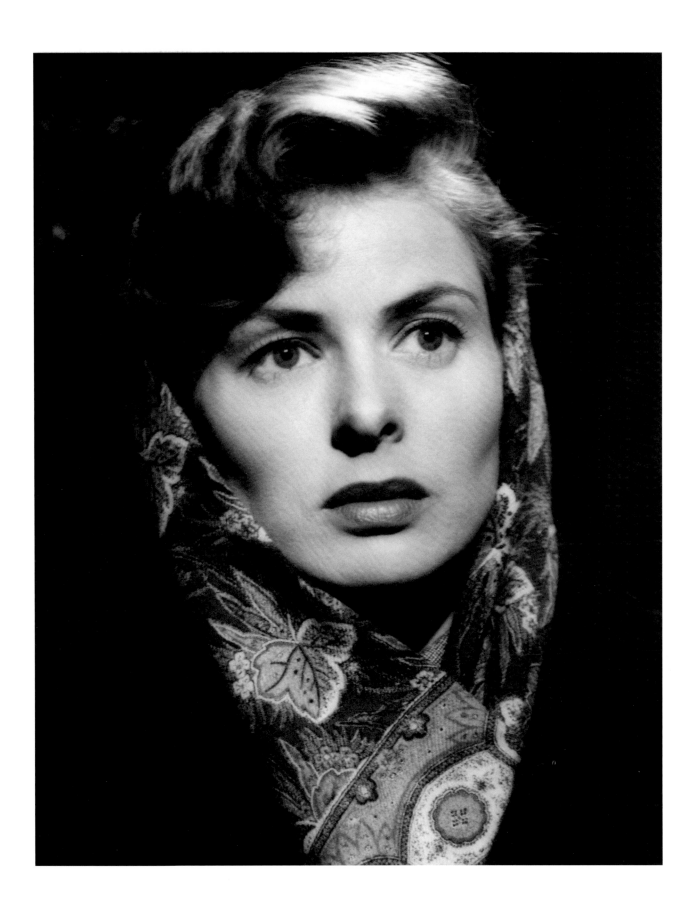

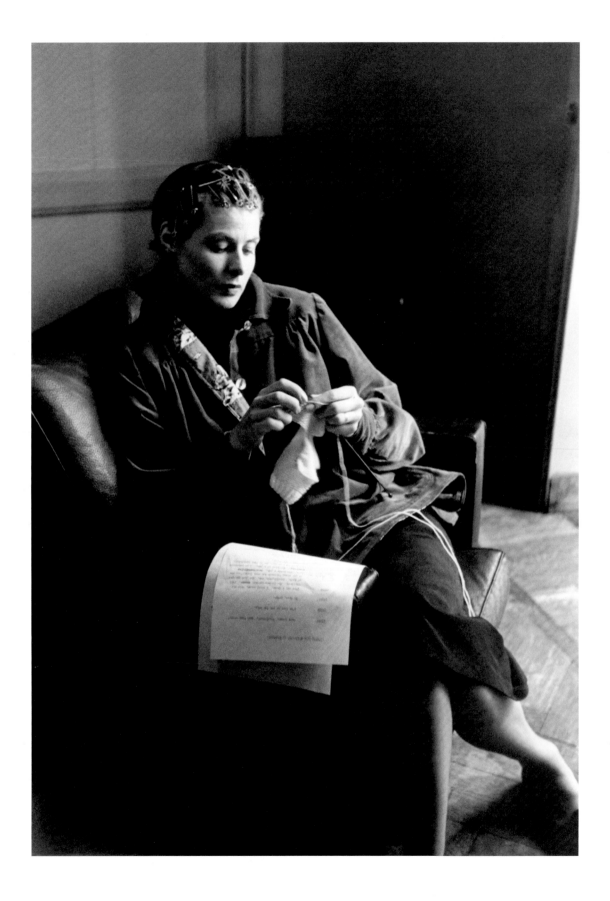

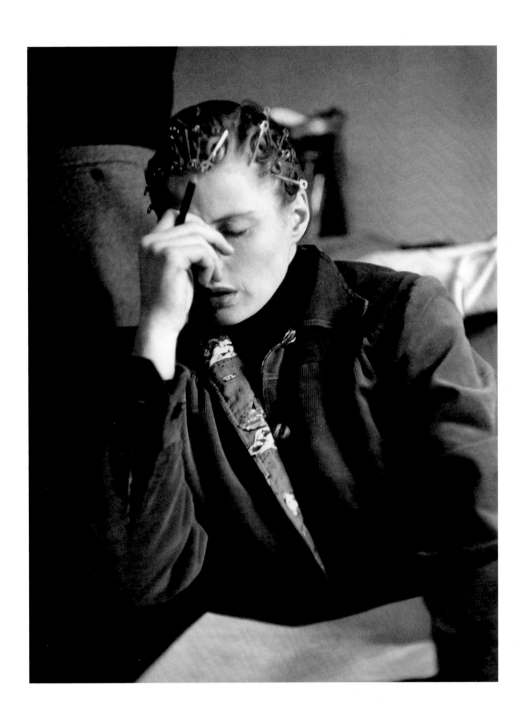

A shooting break during *The Greatest Love*. Ingrid is again pregnant:
"We were in such a hurry to get through that movie *before* it showed.
And then, of course, I grew terribly big ... I looked like an elephant."
Then the doctor tells Ingrid that she is expecting twins: "I just couldn't
wait to get home. I telephoned from the hospital and told Roberto.
And he telephoned *all Rome*, he was so proud of what he had done—
two at a time. My first reaction was worry: how in the world did you
take care of two babies at the same time?"[10]
Two striking pictures of a contemplative, introspective Ingrid Bergman
taken by no one less than David "Chim" Seymour. Rome, 1951

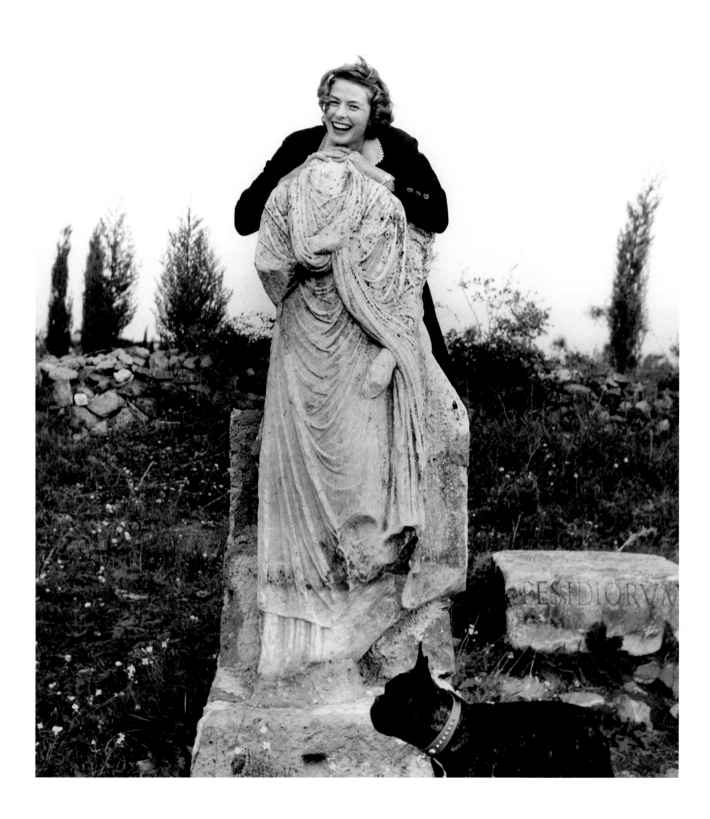

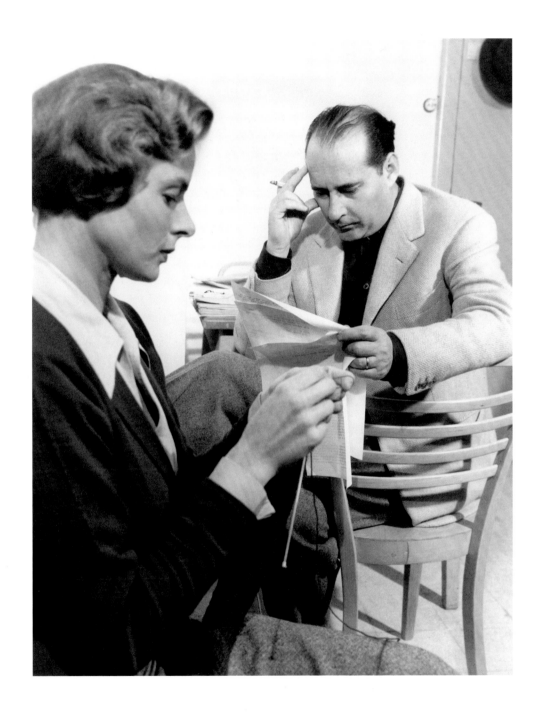

Ingrid Bergman, a Roman statue, and Lennart
Nilsson on the Appian Way. Stromboli joins in
the fun. Rome, 1951. Photo: Lennart Nilsson

The Greatest Love. Both parents quietly await
forthcoming events during a shooting break.
Rome, 1951. Photographer unknown

BIRTH OF THE TWINS
18 June 1952

The twins arrive on 18 June 1952. The elated mother recalls:

"I got so big I couldn't sleep at all, and I couldn't get into any clothes. Finally I couldn't eat, so eventually I spent the last month in the hospital. … The doctors began to get very worried because twins should come ahead of time. Mine were now *beyond* the time that they were supposed to come. So they wanted to induce the birth. I called Roberto … and I said, 'How can we allow this? We choose their birthday. That is not right. All the stars, the astrological signs, the moon, and the constellations will be confused … Roberto agreed with me, but then the doctors got on to Roberto and convinced him … It was just getting too dangerous. So he talked to me and I saw the sense in that. Came the morning, the doctor arrived with his injection, and I said, 'Let me ring Roberto.'

'It's the eighteenth of June,' I said. 'Do you think that's a good day?' 'Eighteenth of June? Sure that's a good day. Go ahead.'[11]

I wanted a girl very much because Roberto had had two sons previously with his first wife and one with me. So this had to be a little girl and the name I had chosen was Isabella. But now there was going to be a second baby and that name was not chosen because it might be a boy. So I was rolled into the delivery room and eventually Isabella arrived, and I told the doctor, 'Go at once and tell Roberto he has a daughter.' … And then they said, 'One more girl.' Two baby girls! How wonderful! It was Roberto who chose her name: Isotta Ingrid. But from the beginning we called her Ingrid."[12]

"A Woman's Burden" by John Updike (1998)

This photograph, taken by David Seymour in 1952, pricked my conscience because it showed such loveliness—a beautiful woman in her prime, sturdy and sandaled, cheerfully bearing the burden of womanhood the world over, babies. The photograph, so innocent and even comic, made seem shameful the outcry in my country two years before, when Ingrid Bergman, still married to her Swedish husband Petter Lindstrom, bore a child to the Italian director Roberto Rossellini. America was not yet used to open adultery and out-of-wedlock pregnancy from its film actresses, especially from this actress, who had played a nun and Saint Joan as well as the heroically virtuous wife of *Casablanca* and the innocent victim of Charles Boyer's cruelty in *Gaslight*. Stars are by definition beloved, but few have been loved as Bergman was by the American public in the 1940s. She betrayed us, it was felt, and with a greasy Italian at that. *Quel scancale!* Her banishment from Hollywood and our hearts was complete, and the facts that Rossellini married her and made her an "honest woman," that she had had a number of not especially secret affairs before, that Lind-

Right page top
The twins' debut at a press event on 9 July 1952 in the Villa Santa Marinella. Photo: Mario Torrisi

Right page bottom
Roberto Jr., just 2 years old, greets his sisters. 9 July 1952, Villa Santa Marinella. Photographer unknown

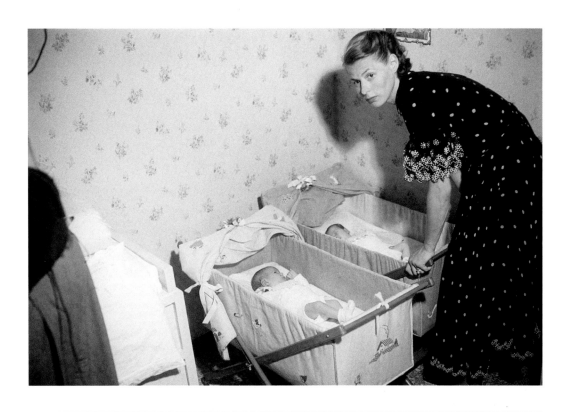

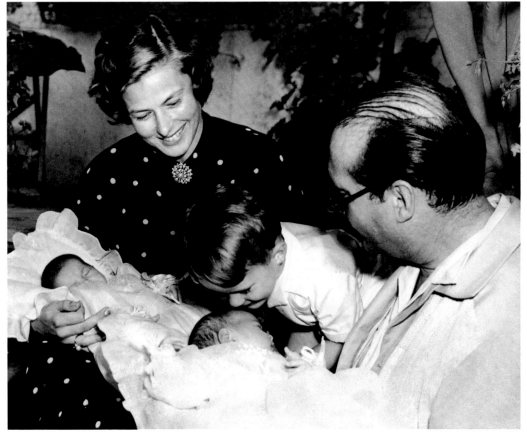

strom was a (presumably cold-blooded) Swede, and that even in her film roles she had shown some relish in playing "bad girls"—none o this sufficiently softened the national indignation. If ever there was a thoroughly fallen woman, Bergman was it, and it didn't help that Rossellini had her tramping around bare-legged in the muddy rice fields of *Stromboli*.

Well, here she is in 1952, standing proud. Two little twins, Isabella and Ingrid, peep from their carry cots as if wondering what the fuss was about. Now Isabella is a middle-aged model, her mother is sixteen years dead, and 1950 does seem a very long time ago, in terms of morality and celebrity culture. Bergman lived through it with the same quiet dignity of her screen presence. She seemed to wear no make-up and had a comfortable thickness to her waist; no wonder we all loved her, back then—a "natural woman" who was also a movie queen. A little too natural, it turned out. Nature is hard to contain, whether by religious morality or the derived hypocrisies of public relations. Bergman was a European—with a German mother, and almost a German film career—who failed to play by American rules. The rules have long changed, and, seeing this picture now, we want to go down on our knees to it.

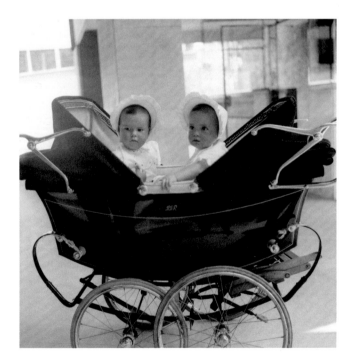

The twin stroller with Isabella and Isotta Ingrid. It bears the inscription IIR.

Right page
American writer John Updike's favorite photo of Ingrid. Rome, 1952.
Photo: "Chim" Seymour

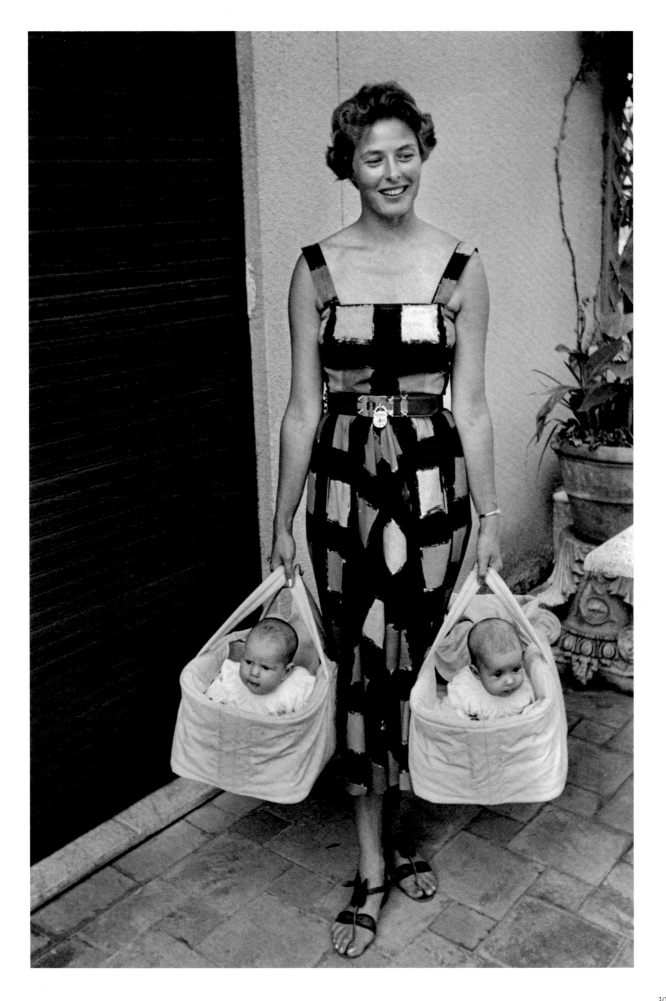

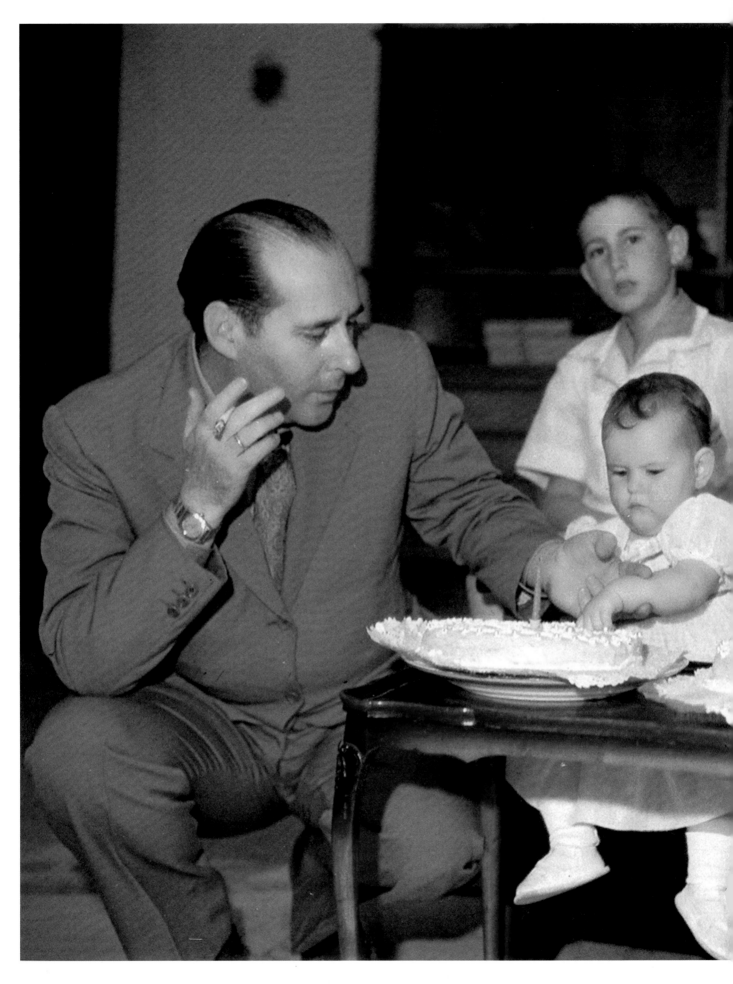

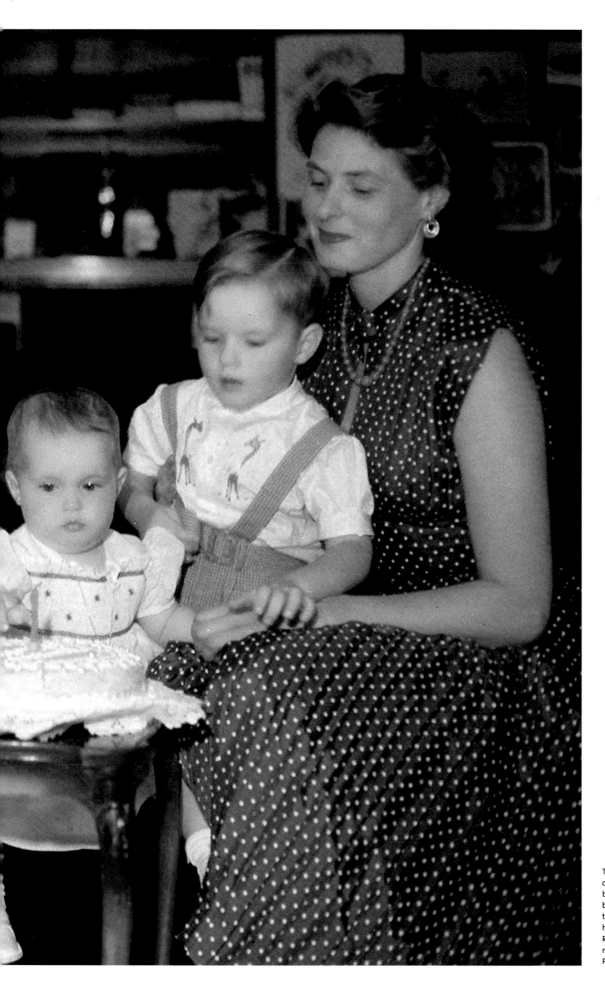

The Bergman-Rossellini family celebrating the twins' first birthday on 18 June 1953 with birthday cakes. The boy in the background is their half-brother Renzo, Roberto Rossellini's son from his first marriage. Santa Marinella, 1953. Photographer unknown

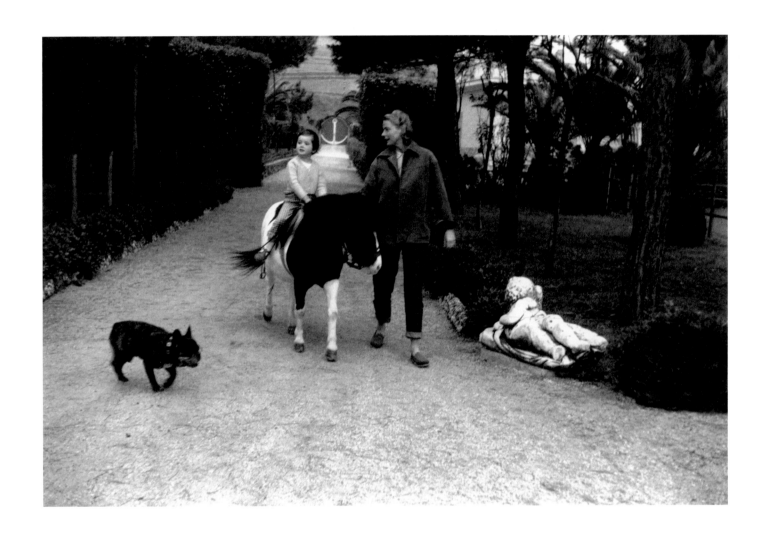

Ingrid Bergman with daughter
Isabella on a pony and Stromboli
on the grounds of Villa Marinella,
around 1955. Photo: "Chim" Seymour

Right page
Roberto Rossellini, seen here
during a trip to Stockholm in 1953,
was crazy about his children.
Photographer unknown

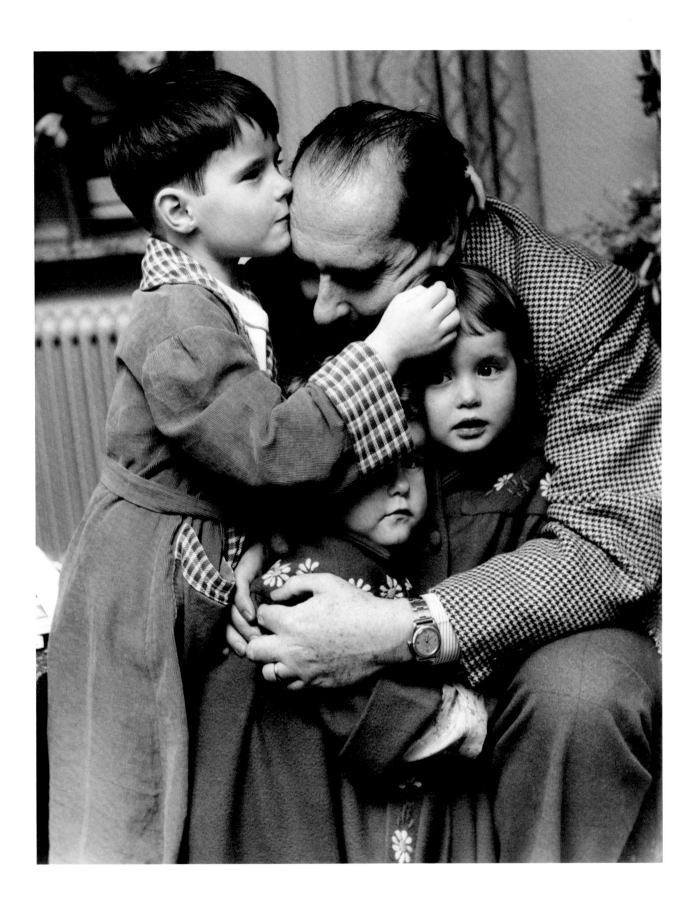

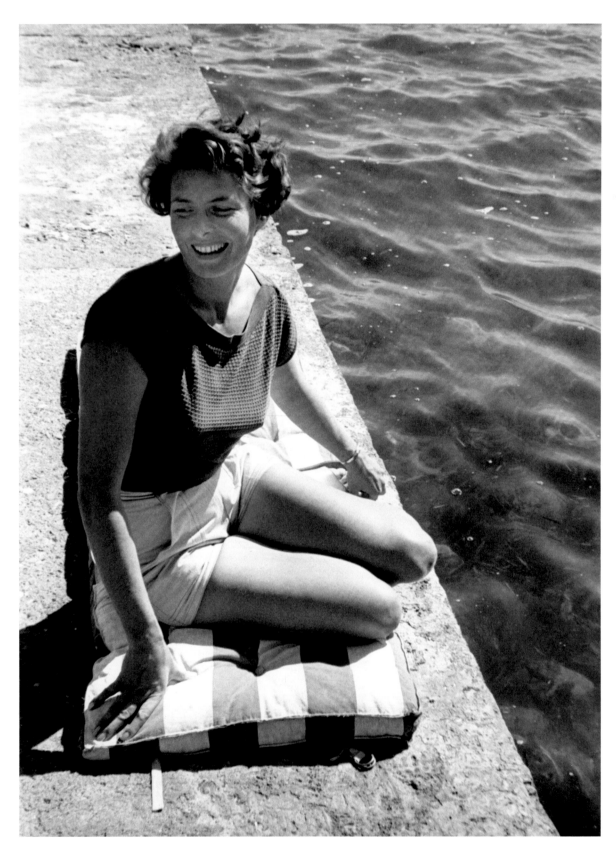

Rare photographs: Ingrid displaying her shapely legs.
Taken in 1952 on the stone jetty which extended from
Villa Santa Marinella into the sea. Photo: "Chim" Seymour

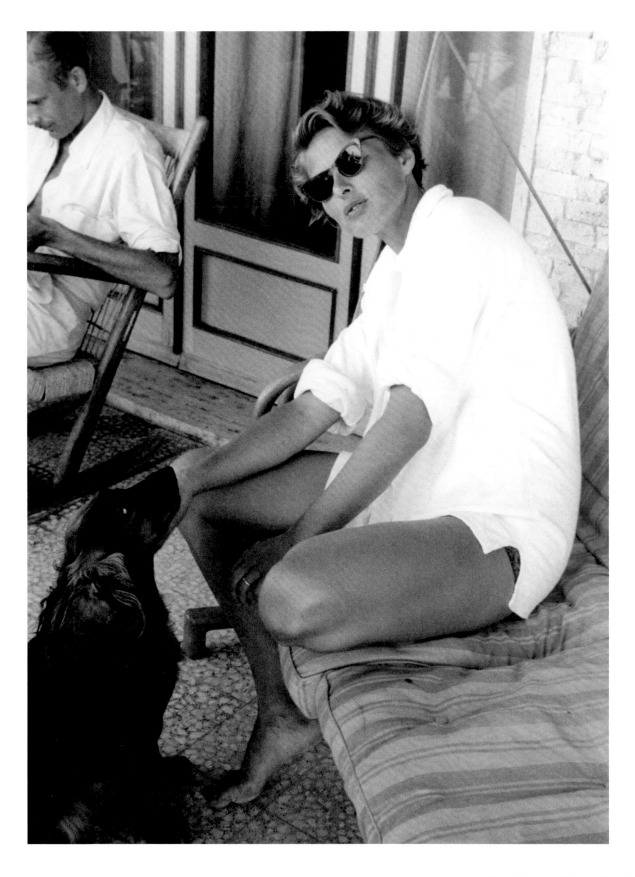

... and on the terrace of Villa Santa Marinella, 1952.
Photo: "Chim" Seymour

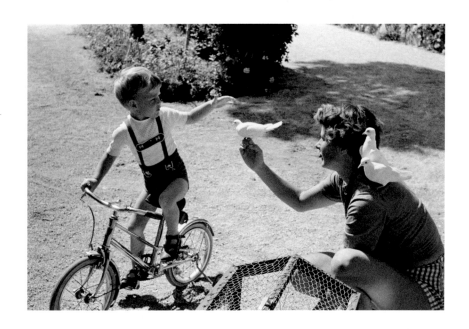

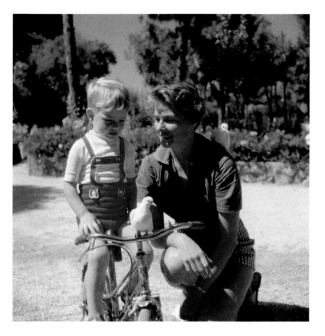

Ingrid and Robertino with doves. In
her photo album, Ingrid captions this:
"With our peace doves, Stalina, Truman,
Eisenhower and several more." Probably
taken in Santa Marinella in 1954.
Photo: "Chim" Seymour

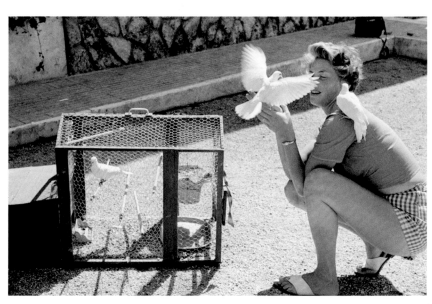

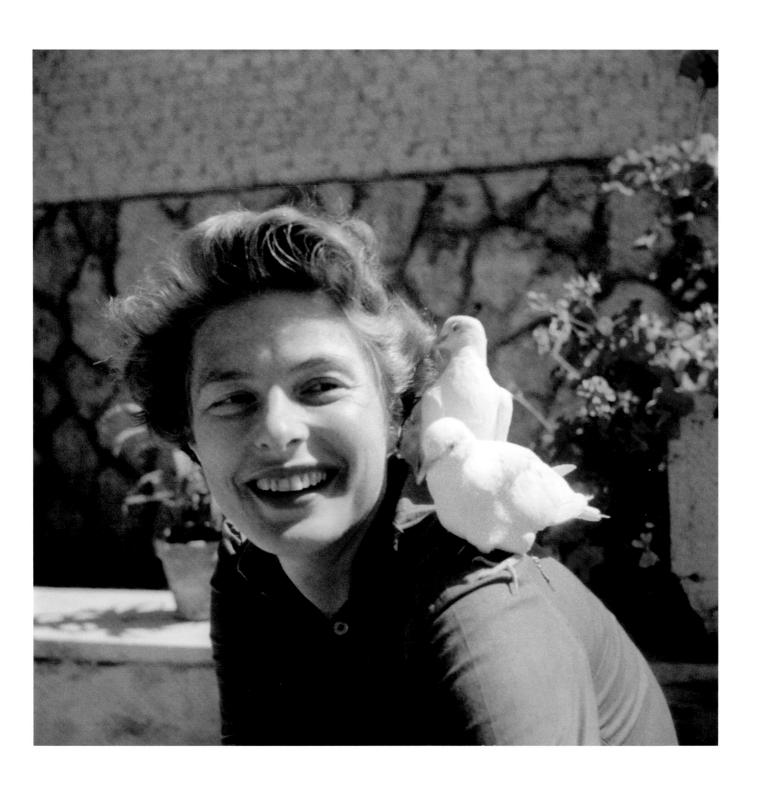

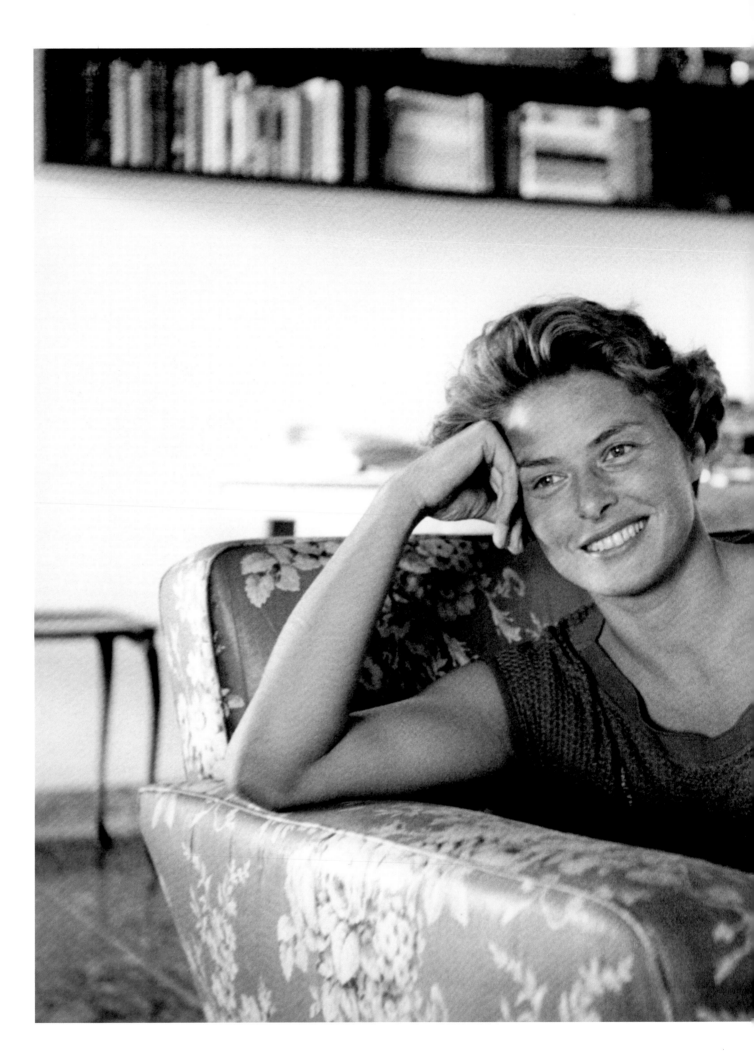

Portrait of Ingrid Bergman
taken in Santa Marinella by
"Chim" Seymour, ca. 1954.

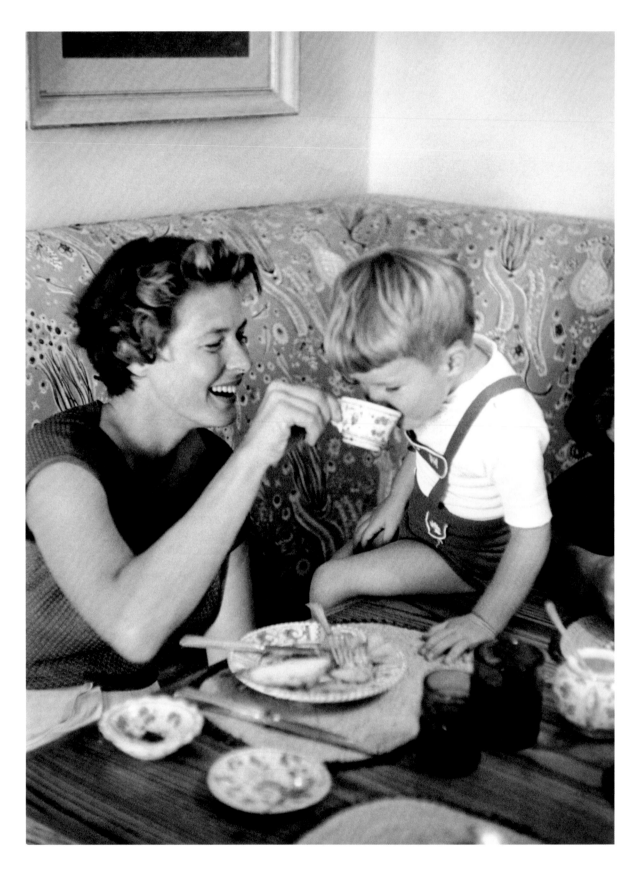

Domestic scene: Ingrid with Robertino. Santa Marinella,
ca. 1954. Photo: "Chim" Seymour

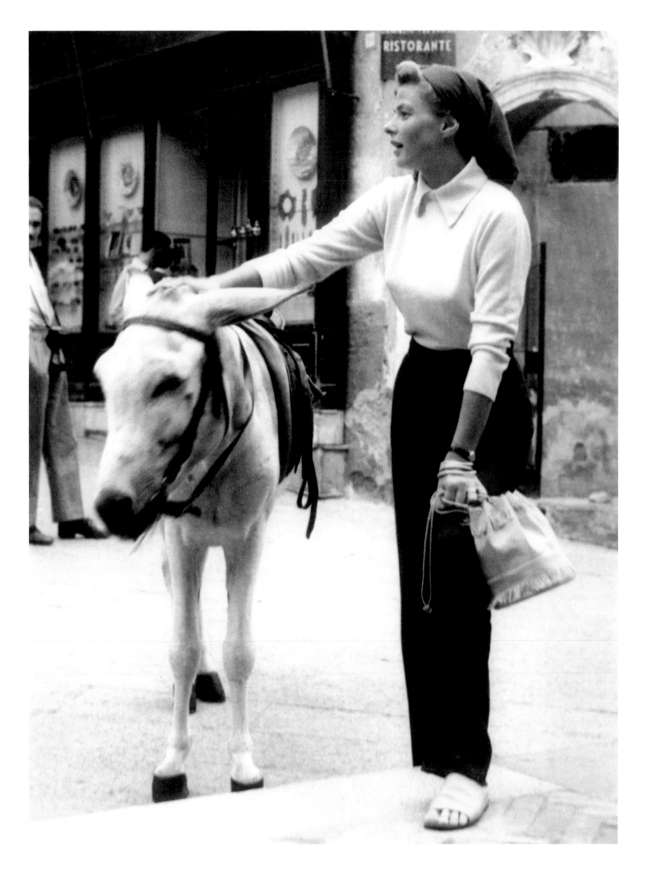

Ingrid with donkey in Capri, ca 1954.
Unknown press photographer

Viaggio in Italia

Journey to Italy

In February 1953 Rossellini begins work on *Journey to Italy*. Once again he set out "without a script, not even an outline, just an idea with no ending!"[13] He brings in George Sanders as his leading man. Sanders had starred with Ingrid in *Rage in Heaven* years before and had since made a career portraying "charming men of questionable character,"[14] and had meanwhile married Zsa Zsa Gabor. Ingrid looks forward to once again working with a fellow Hollywood actor, but Sanders too is soon at wit's end thanks to Rossellini's unorthodox way of directing, which includes a non-existent screenplay, no clear-cut instructions, long delays in shooting, and Rossellini's joyriding in his Ferrari for days on end.

Journey to Italy tells the story of an English couple who travel to Naples in order to sell the house of a deceased uncle. In the course of the trip it becomes apparent that they have nothing left to say to one another. He longs to be back at work in London and amuses himself at parties on Capri while she seeks the poesy of antiquity in the museums of Naples. They agree to divorce, but when they become separated from one another during a religious procession, they decide to try to start anew.

Although the critics pan *Journey to Italy*, it influences an entire generation of young film-makers, including French New Wave, so strongly that it is now considered a turning point in modern film. In 1958, *Cahiers du cinema* lists *Journey to Italy* as one of the twelve best films of all time.

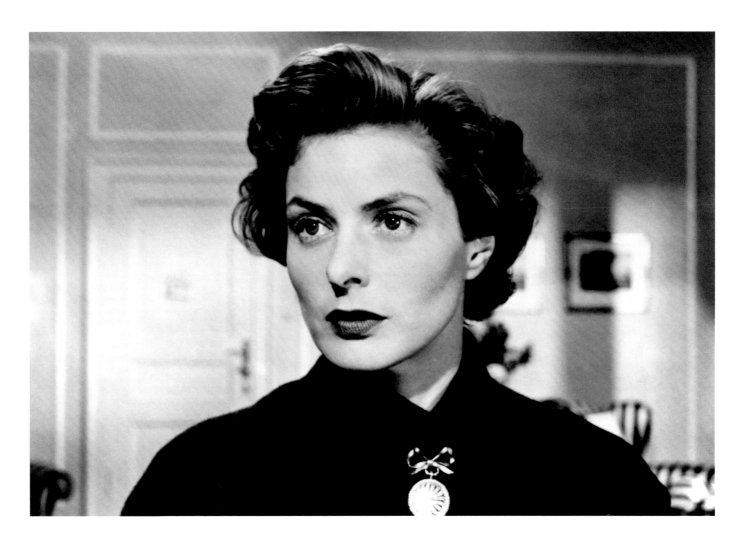

Top
Ingrid Bergman, production still from *Journey to Italy*, 1953. Photographer unknown

Bottom
Originally intended as a screen adaptation of Colette's novella *Duo*, *Journey to Italy* is shot in the second half of 1953. Rossellini brings in George Sanders as his leading man. The three are seen here during shooting in a recently found color photograph taken by Robert Capa. It was probably the last time Ingrid Bergman and Capa ever met.

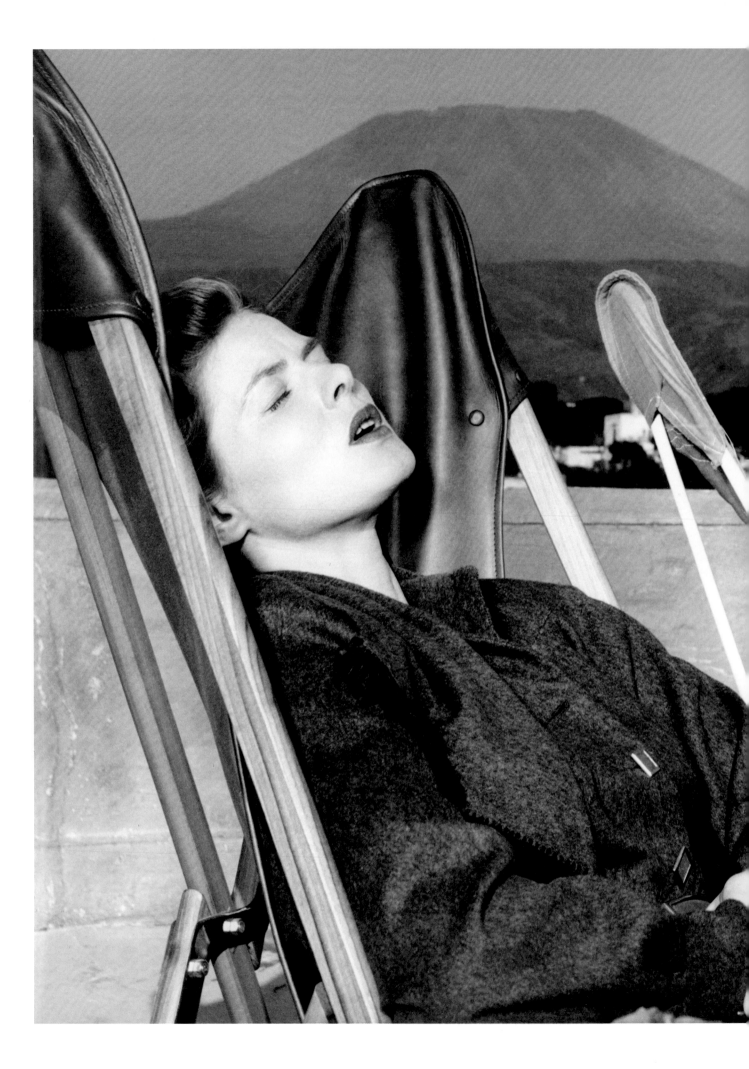

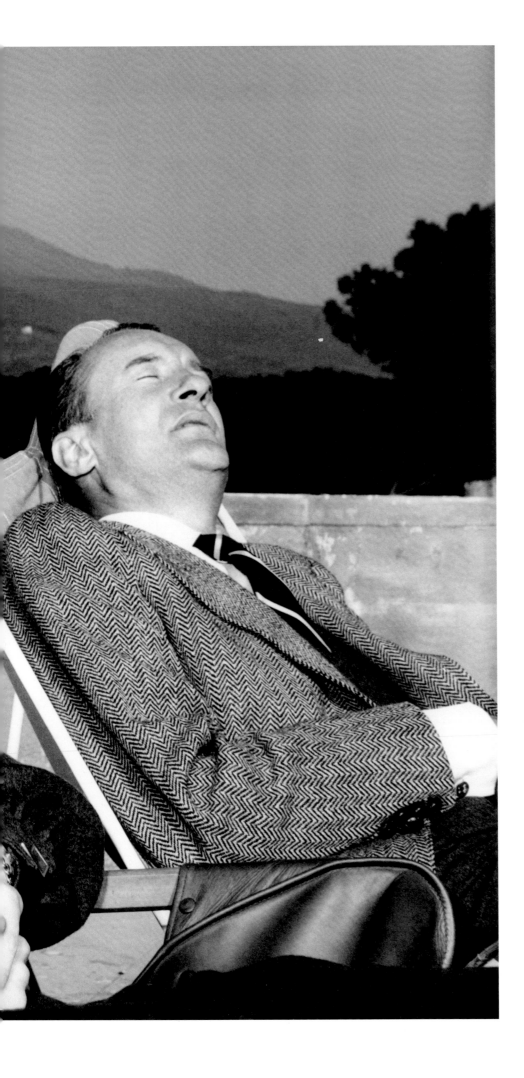

Visualized estrangement. The couple portrayed by Ingrid Bergman and George Sanders resting in deck chairs. The silhouette of Vesuvius looms menacingly in background. Production still from *Journey to Italy*. Naples, 1953. Photographer unknown

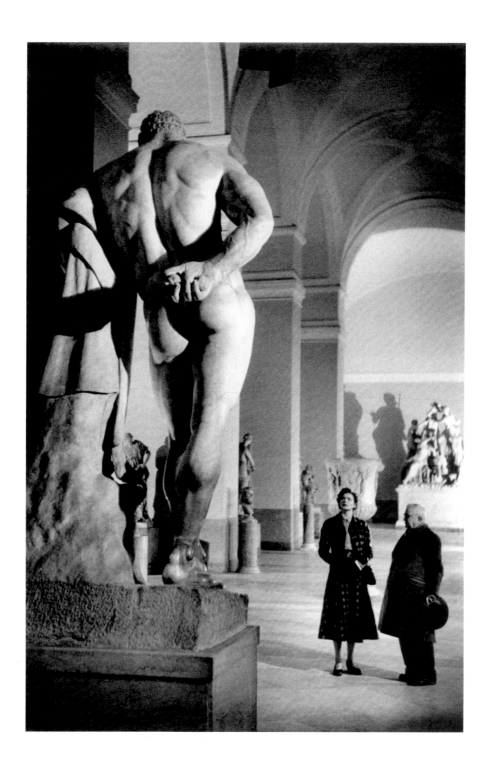

Long walks through the Naples National
Archeological Museum and the excavations
at Herculaneum and Pompeii abound in
Journey to Italy. Naples, 1953.
Production stills: left, Bert Hardy; right, Ugo Sarto

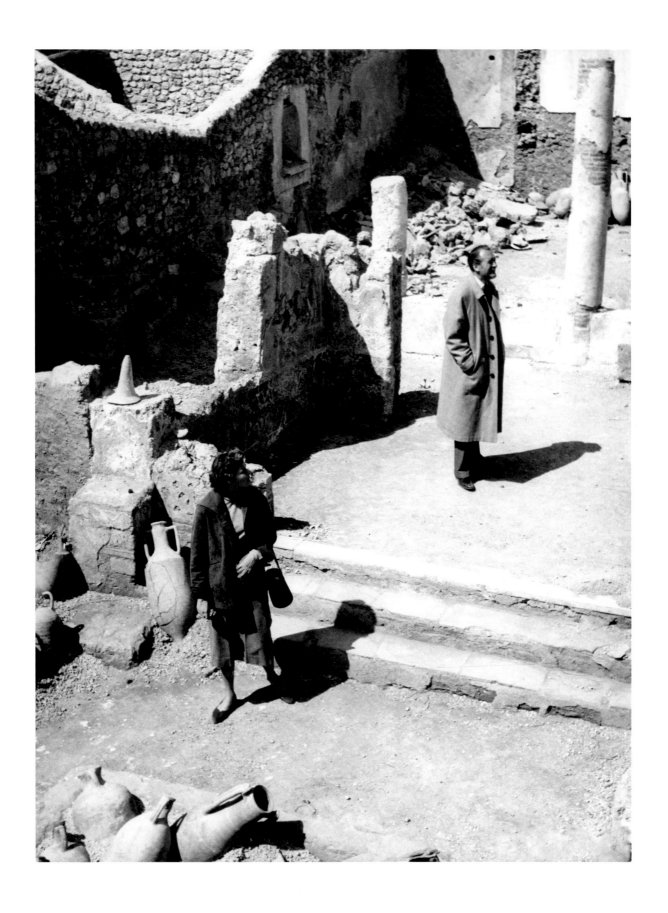

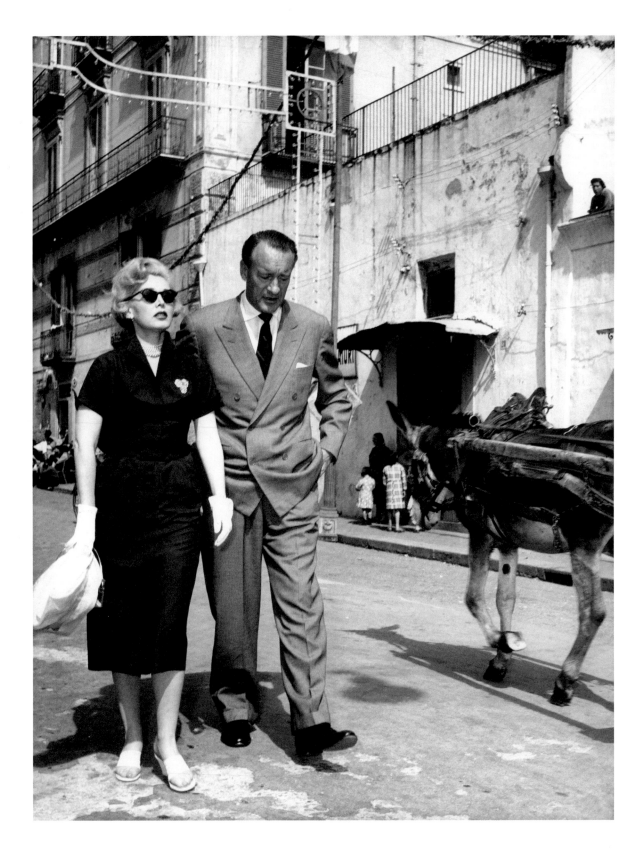

When an exasperated George Sanders threatens to leave
the film, Roberto Rossellini has Sanders' wife, Zsa Zsa
Gabor, flown in. The couple is seen here during a walk
through Naples in 1953. Photographer unknown

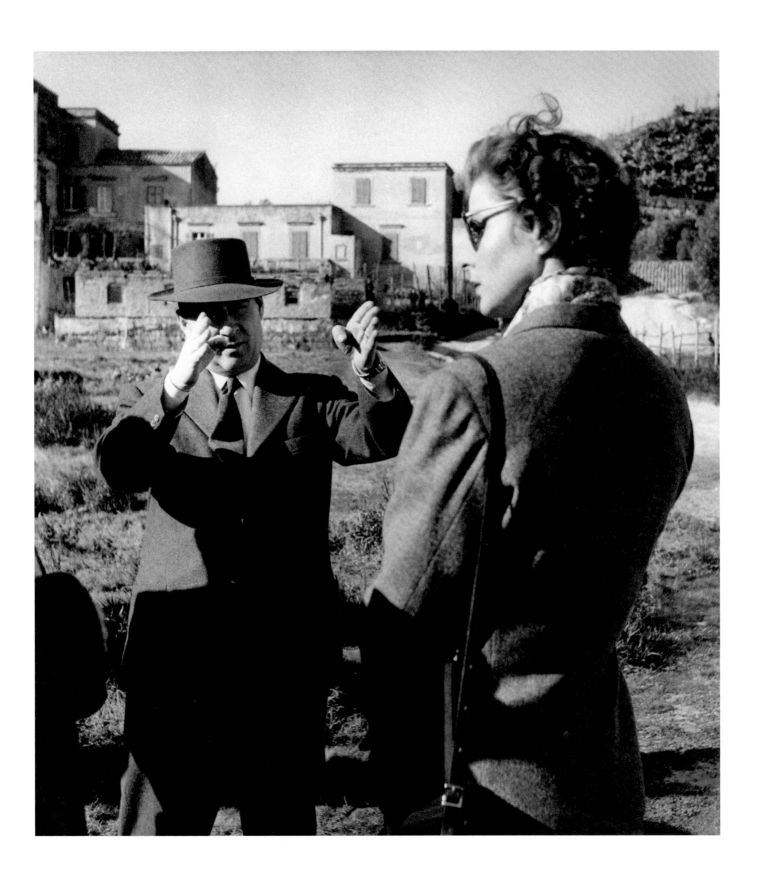

Roberto directing his wife during the
filming of *Journey to Italy*. Naples, 1953.
Photographer unknown

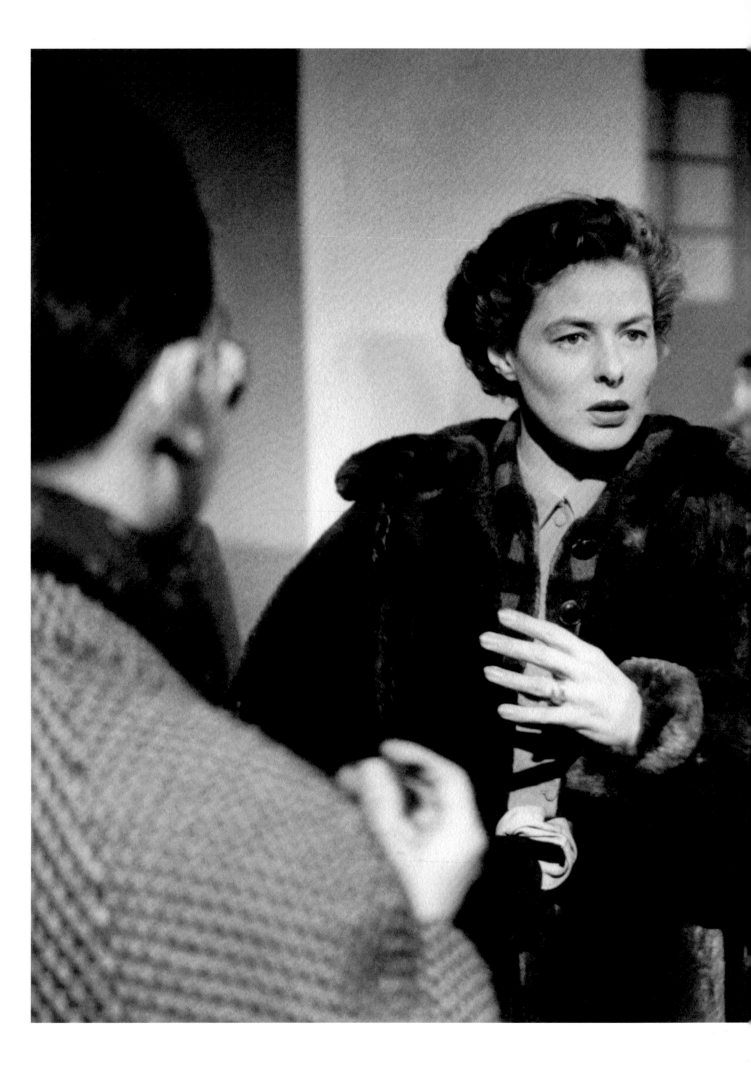

Ingrid and Roberto during the
filming of *Journey to Italy*, ca. 1953.
Photo: Bert Hardy

Giovanna d'Arco al rogo
Joan of Arc at the Stake

In the autumn following the birth of the twins, Roberto Rossellini directs a stage production of Verdi's *Othello* at the Teatro di San Carlo in Naples. At the premiere, the Rossellinis meet Paul Claudel and Arthur Honegger, the creators of the dramatic oratorio *Jeanne d'Arc au bûcher*, which premiered in 1938. They spontaneously make plans to take the oratorio based on Ingrid's "favorite saint"[15] on tour. A choir and orchestra provide the music, while Joan reflects on her life and trial in verse form.

One year later, in November 1953, *Giovanna D'Arco al rogo* premieres, again at the Teatro di San Carlo and under the direction of Roberto Rossellini. The evening is a great success. Honegger and Claudel—two aged gentlemen who are both destined to die in 1955—consider the performance the "highlight of their lives."[16]

The subsequent tour, including breaks, runs for over two years in places such as Palermo, Milan, Paris, London (29 performances), and Stockholm. The Swedish press gives Ingrid Bergman a frosty reception; she counters by addressing the audience while standing before the closed curtain.

In 1954 the Rossellinis film the production at their own expense: "No one wants to invest money in it because it is opera. But we are stubborn and will do it anyway."[17]

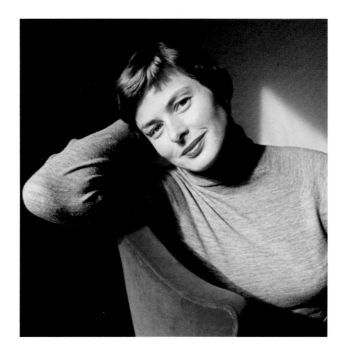

This page
The return of Joan of Arc. Ingrid must bob her hair again for her part in the oratorio written by Arthur Honegger and Paul Claudel. The drama has its much-celebrated premiere in Naples at the Teatro di San Carlo in November 1953. Naples, 1954. Photo: "Chim" Seymour

Right page
Photo with theater poster from *Giovanna D'Arco al rogo (Joan of Arc at the Stake)*. Naples, 1954. Photo: "Chim" Seymour

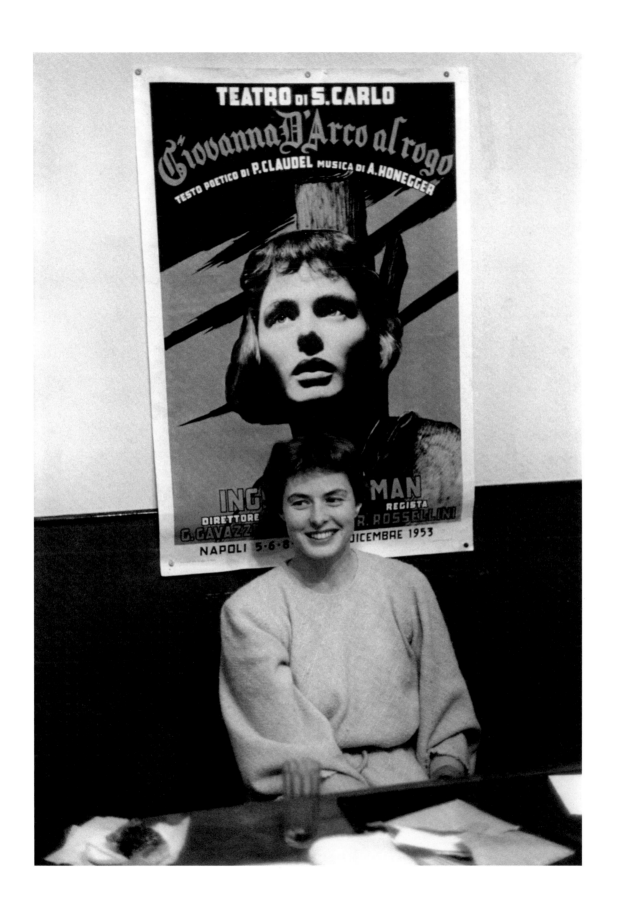

Roberto giving Ingrid stage instructions.
Naples, 1953. Photographer unknown

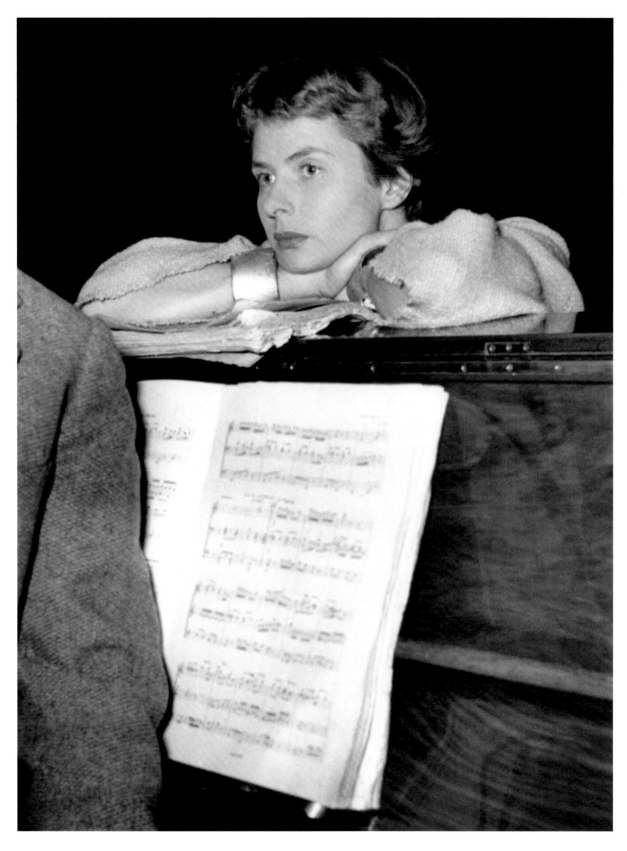

Ingrid Bergman during a rehearsal
for *Giovanna D'Arco al rogo*.
Naples, 1953. Photo: Foto Vespasiani

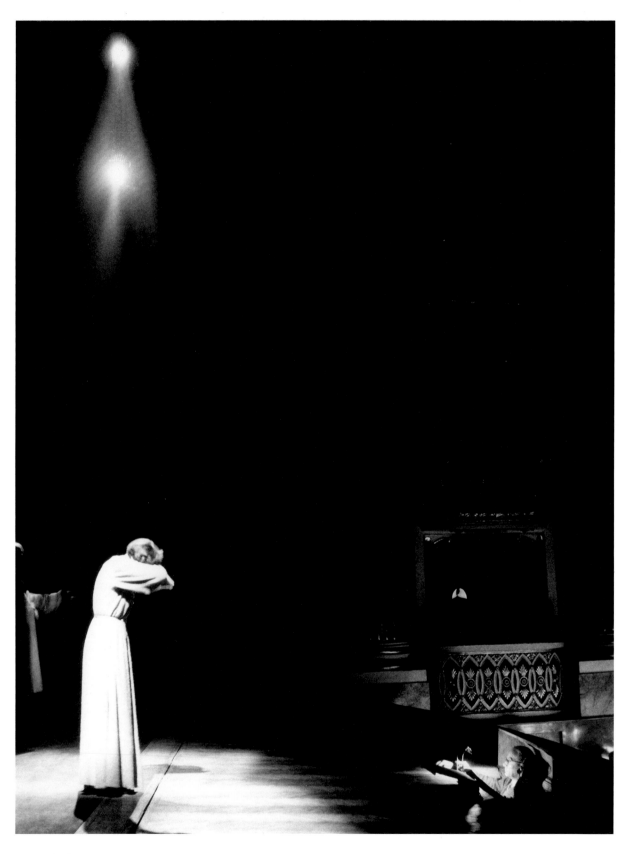

Ingrid onstage as Joan in *Giovanna
D'Arco al rogo*. Naples, 1953.
Photo: Scrimali, Rome

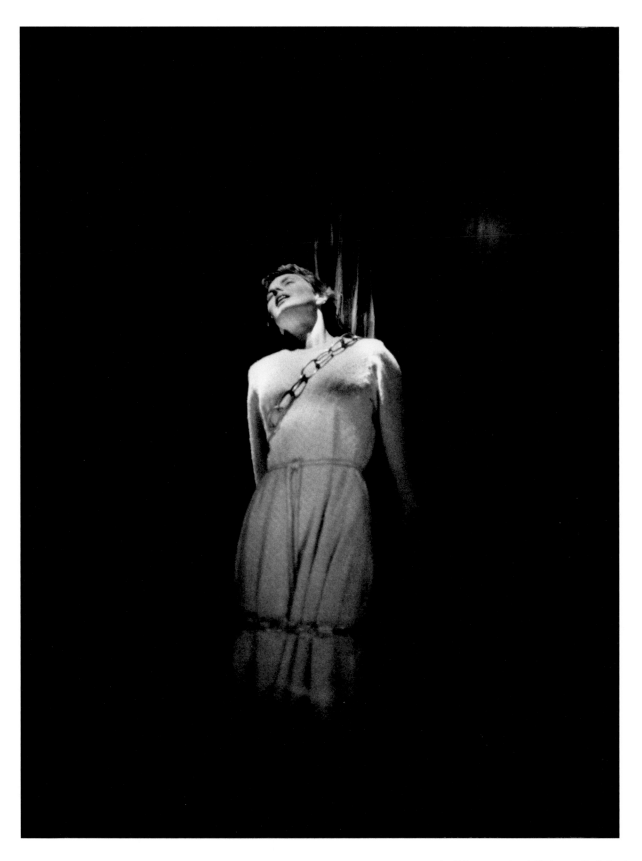

Ingrid Bergman onstage in Naples, 1954. The first reviews
appear in conjunction with headlines announcing Capa's tragic
death in Vietnam on 25 Mai 1954. Photo: "Chim" Seymour

Ingrid und Roberto take the production on
a successful European tour lasting almost two
years. All's well that ends well. Group photo
with author and composer during a guest
performance in Paris. From left to right:
Paul Claudel, Serge Lifar, Arthur Honegger,
Ingrid Bergman, and Roberto Rossellini.
Paris, ca. 1954. Photo: Trasnay

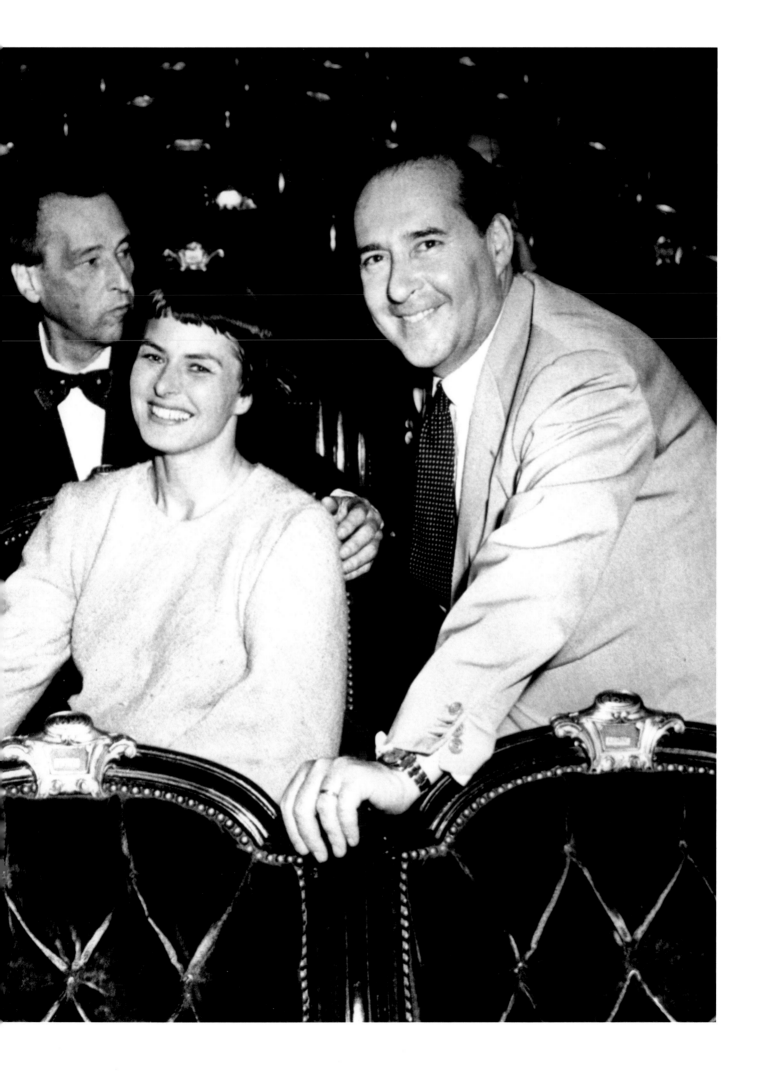

La paura

Fear

In 1954, during a touring break in the Joan of Arc oratorio, Rossellini films Stefan Zweig's novella *Angst (Fear)*. Ingrid Bergman portrays Irene, the wife of a scientist. She is blackmailed by her lover's former girlfriend—only to learn that her husband is behind the plot. She then attempts suicide using the poison her husband utilizes for his laboratory animals.

Critics also pan *Fear* and come to a crushing conclusion:

"[Miss Bergman and Mr. Rossellini] will either have to change their style of work radically— or retire into dignified silence … This is not because this film is any worse than their other recent motion pictures together, but because … it proves the inability of the couple to create anything accepted by the public or the critics. Once the world's unquestioned number one star … Miss Bergman in her latest pictures has only been a shadow of herself."[18]

Fear is, in fact, their last joint cinematic effort. Federico Fellini describes the collaboration of the two with a poetic parable:

" … it seemed like the same kind of relationship that Pinocchio had with the blue-haired fairy. Through Ingrid, Rossellini could be transformed into a good boy, though perhaps it was the blue-haired fairy who risked becoming a female Pinocchio. But before Pinocchio could become a good boy, the fairy left. The miracle never happened."[19]

The European tour of the Claudel/Honegger oratorio is interrupted by the shooting of *Fear*. Filming takes place in Munich, and the Rossellini's bring their children along. Our photo shows the family's arrival at Munich's central train station, ca. 1954. Photo: Jenö Kovacs

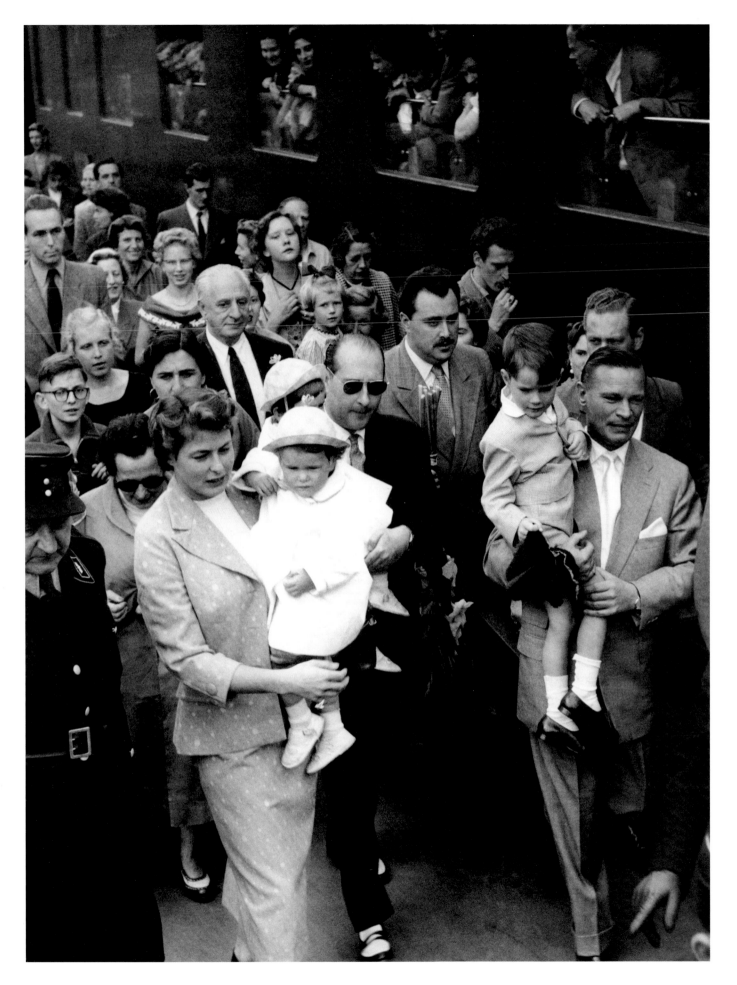

Ingrid Bergman in a production
still from *Fear*. Munich, 1954.
Photographer unknown

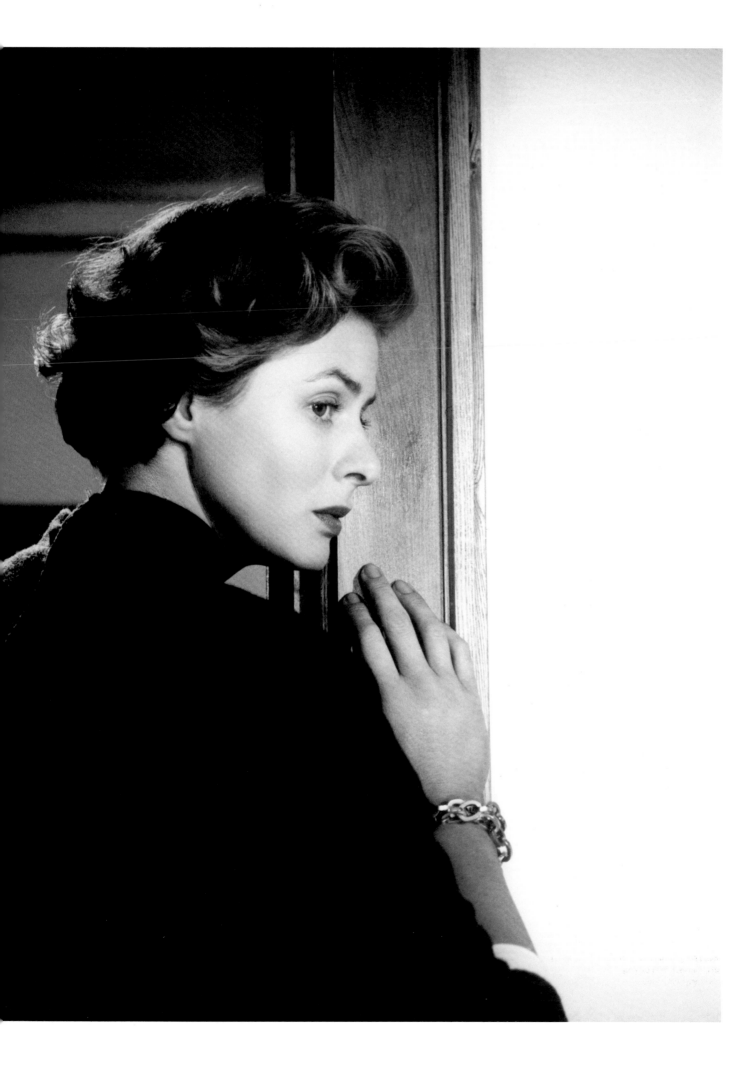

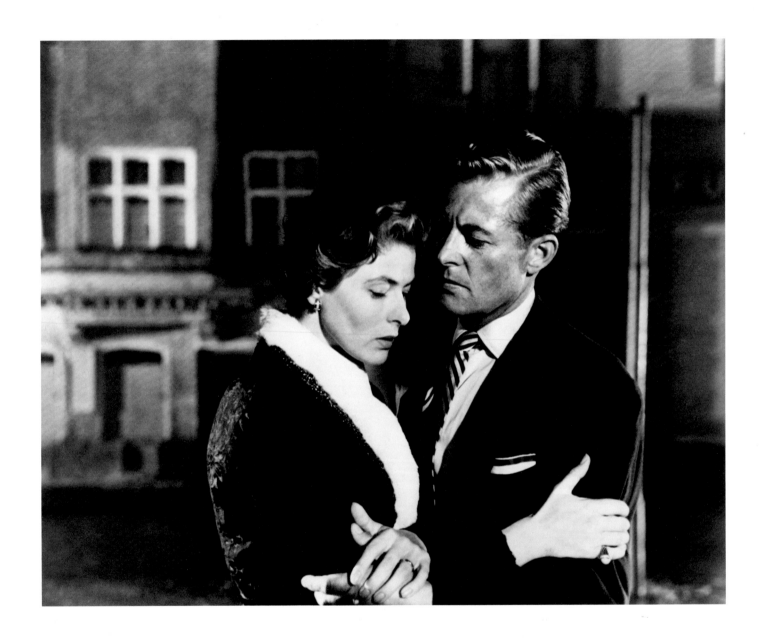

Production still: Ingrid Bergman with Kurt Kreuger in *Fear*. The film's title may be
viewed as a symptom of the couple's fear regarding the end of their relationship.
"I remember that *Angst (Fear)* was quite difficult because we had the children with
us, and we were doing two language versions, one German, one English, and I
suppose my emotions were showing through a bit. I always felt a little resentful
that Roberto wouldn't let me work with any other director. There were all these
wonderful Italian directors: Zeffirelli, Fellini, Visconti, de Sica; all wanted to work
with me and I wanted to work with them; and they were furious with Roberto that
he wouldn't let me work for them ... but in Roberto's terms, I was his property ...
Mathias Wieman, the German actor who was playing my husband in *Fear* felt this
unhappiness in me, and one day he said very quietly, 'You are being torn to pieces.
You'll go insane if you continue like this. Why don't you leave Roberto?' I stared
at him with a terrible sense of shock. Leave Roberto? 'How can I do that?' I said.
'It's impossible!' And it was impossible."[20]

Right page
Ingrid Bergman with Mathias Wieman
in a production still from *Fear*.
Munich, 1954. Photo: Lars Looschen

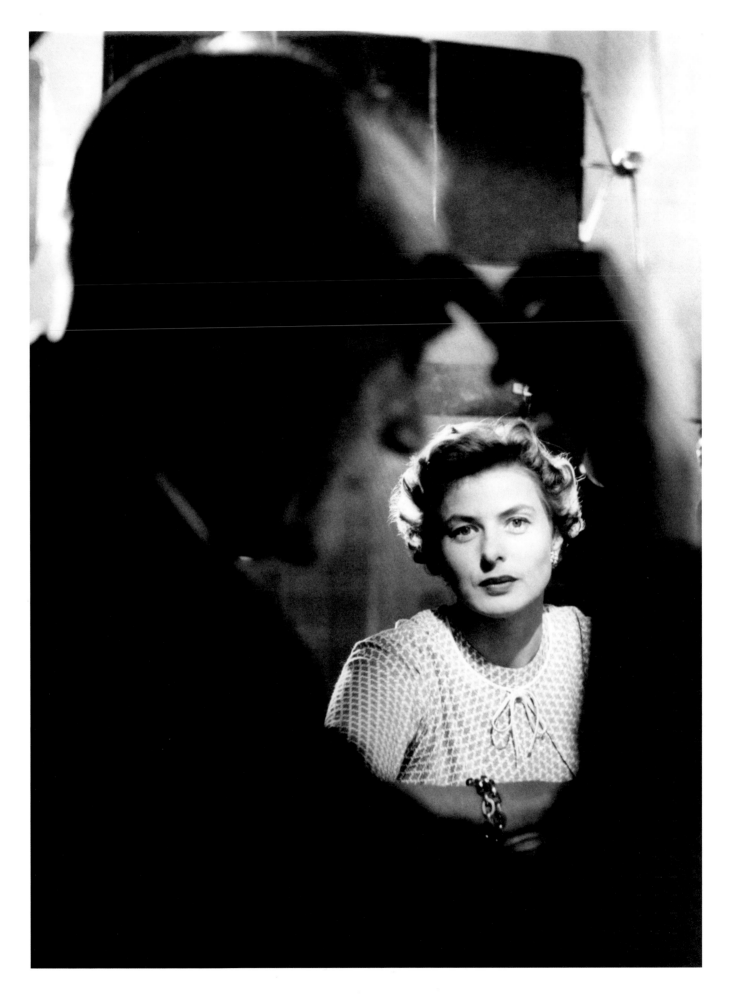

"The Holy Family." Raphael's painting in Munich's Alte Pinakothek provides the compositional scheme for Chim Seymour's famous photo of the Rossellini family on the opposite page. It was taken in 1955, the year she announces her "artistic separation" from Rossellini and her intention to make a movie with Jean Renoir in Paris in the near future.

The separation also has a financial aspect: Rossellini spends money like there is no tomorrow, while the earnings of their joint film projects remain negligible. In a letter to Selznick's former spokesman Joseph Henry Steele, Ingrid Bergman writes: "If a good picture comes up, it might be better to do that so as to buy the children new shoes."[21] The marriage seems to be nearing its end. Rome, 1955. Photo: "Chim" Seymour

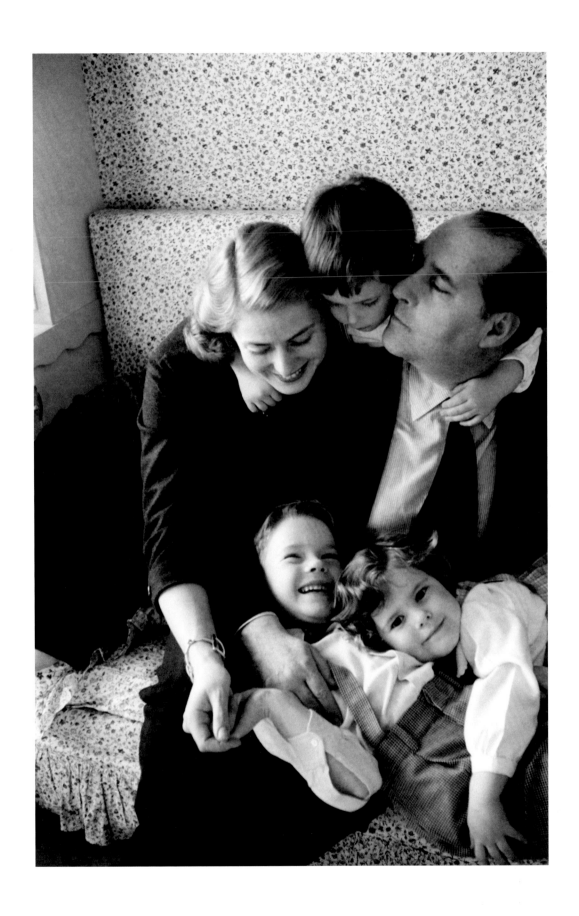

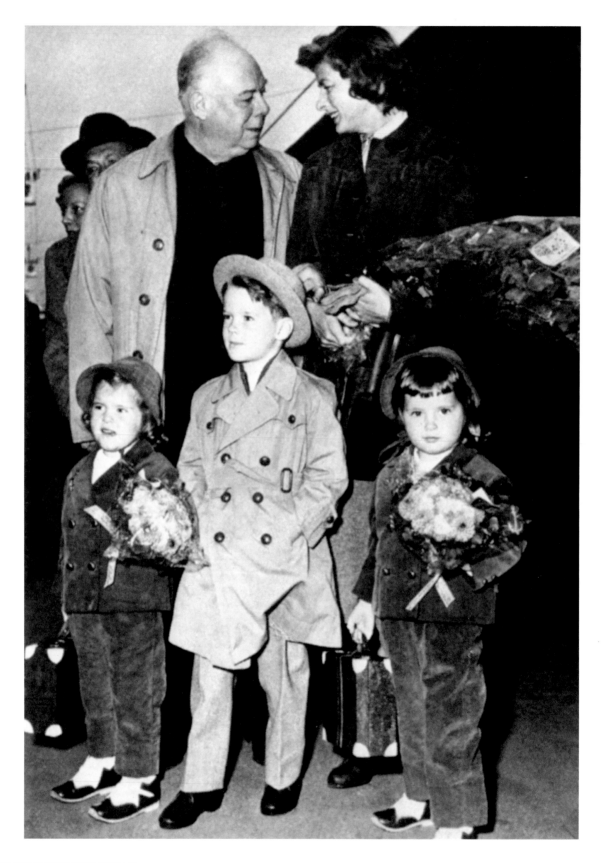

Jean Renoir meets Ingrid and her three children at
the train in Paris. The filming of *Elena and Her Men*
lasts from November 1955 until March 1956. Ingrid
moves into the Hotel Raphael. Paris, fall of 1955.
Photographer unknown

V.

ESTRANGEMENT AND SEPARATION
FROM ROSSELLINI

1956–1957

FILMING IN PARIS

Elena et les Hommes

Elena and her Men

Late in the summer of 1955, Ingrid Bergman makes a film in Paris with French director Jean Renoir. He is the son of sculptor Auguste Renoir and an old friend and neighbor from the Beverly Hills days. Rossellini held Renoir in high regard and unexpectedly consented, thereby renouncing his long-standing claim that his wife appear solely in his films.

Elena and her Men is set in Paris during the 1880s and tells the story of an impoverished Polish princess who dallies with influential men only to drop them in the end. "The story was messy, needlessly convoluted and gossamer thin—a fancy burlesque of chauvinism, French country life and shallow amours—but it had a lively affability, and the humor was exactly what she wanted at the time."[1] Consciously conceived by Renoir as a counterpoint to Ingrid Bergman's often maudlin Hollywood roles, the film is, at the same time, a counterpoint to her work with Rossellini.

Bergman's co-stars include Mel Ferrer, Jean Marais, and Juliette Greco. Ingrid rejoices in once again working with an actual screenplay under professional conditions, even though shooting takes place during the coldest Parisian winter in a hundred years. Mel Ferrer recalls having asked her: "Why are you sitting here with a shawl around you in a dressing room with no heat, waiting to be called to go on a picture that will probably never be released in the United States?" To which Ingrid replied, "Mel, I work because I like to work. I'll work until I'm an old lady and I'll play grandma parts."[2] She memorizes her lines in French and English because the film is to be synchronized for the foreign market.

The picture is well-received in France, but it is panned in the US. This does not prevent Ingrid's longtime friend and supporter Kay Brown from preparing a Hollywood comeback for her former protégée.

Pierre-Auguste Renoir: *Bal du moulin da la Galette*, 1876. Oil on canvas, 131 x 175 cm, Musée d'Orsay, Paris

Right page
Dance scene with Ingrid Bergman and Mel Ferrer during the shooting of *Elena and her Men*. Left, director Jean Renoir. Paris, 1956. Photographer unknown

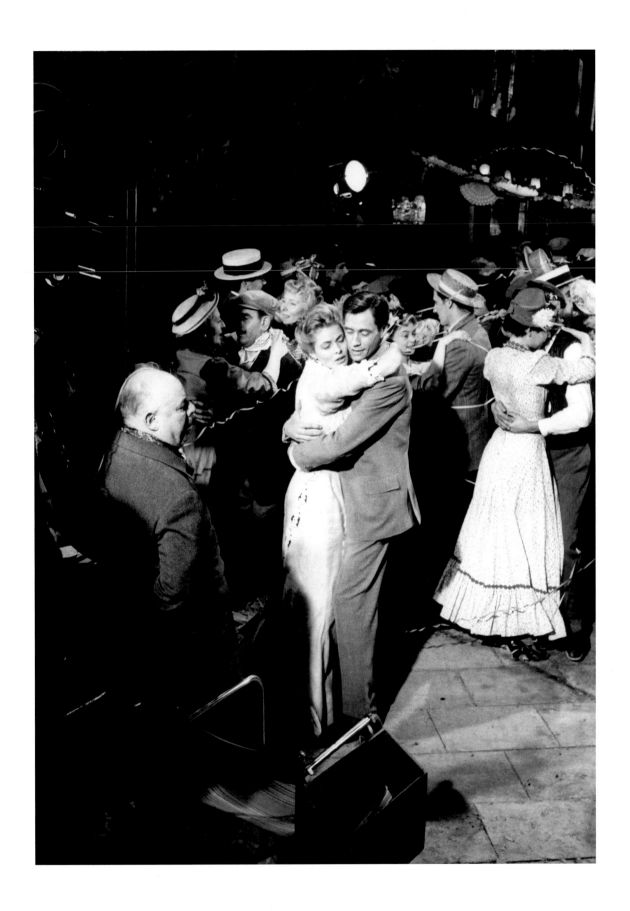

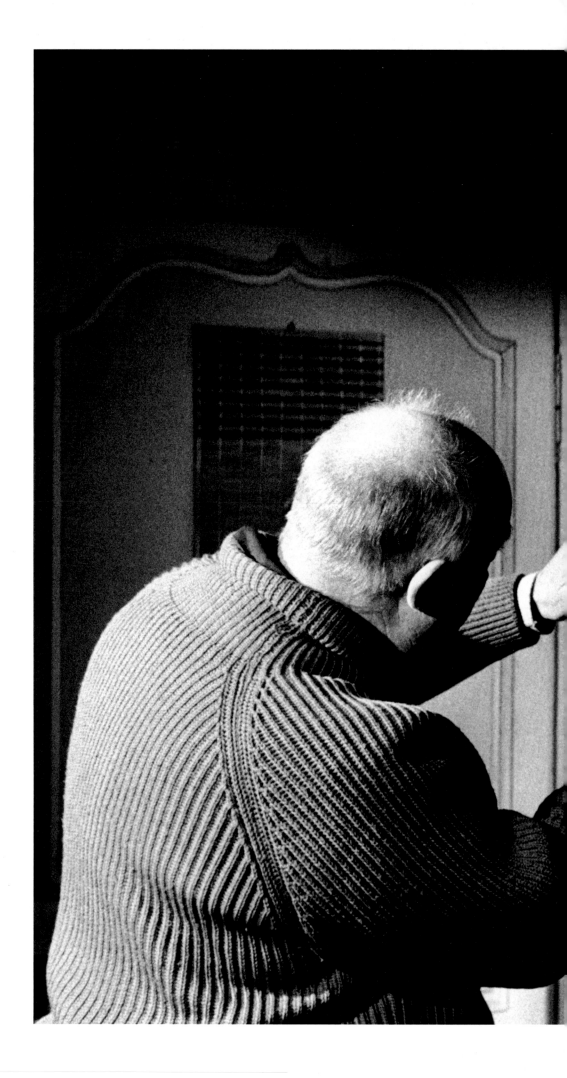

Jean Renoir gives Mel Ferrer
and Ingrid Bergman instructions
on the set. Paris, 1955/56.
Photo: René Burri

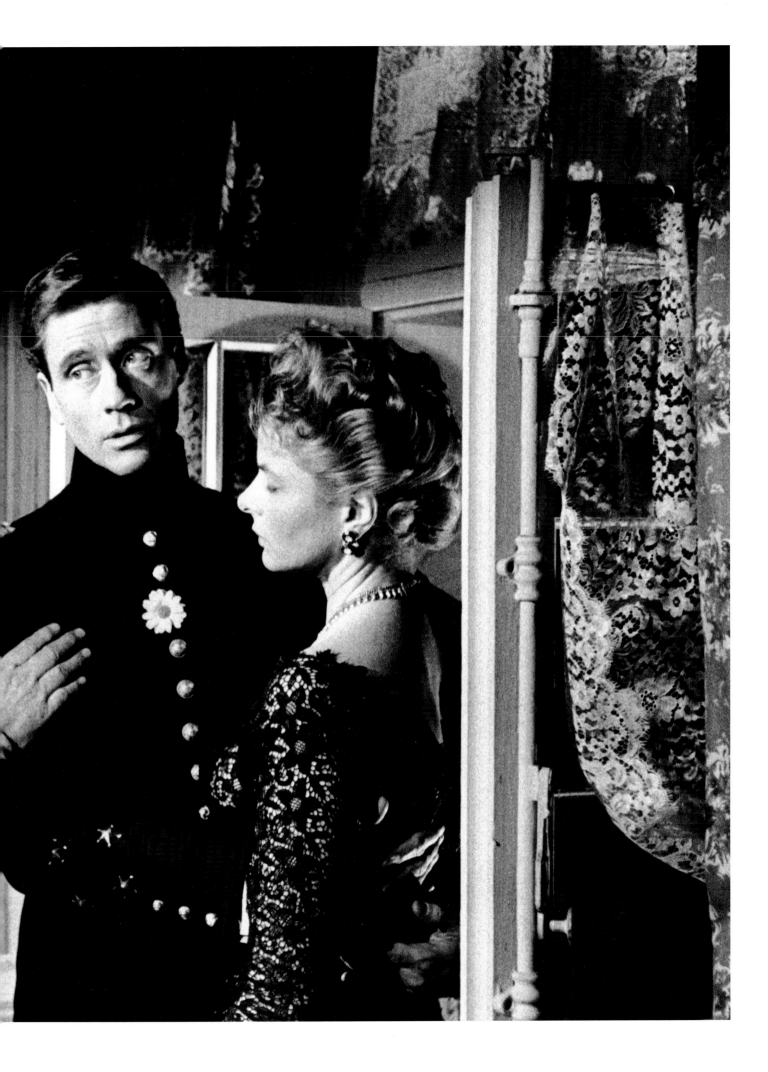

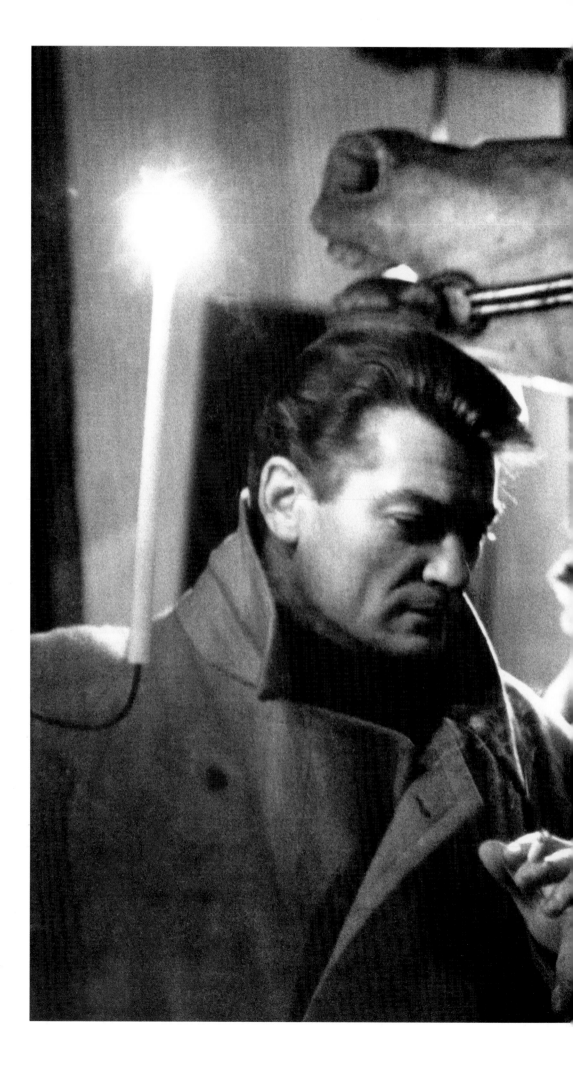

The second male co-star in
Elena and her Men is Jean Marais,
seen here with Ingrid Bergman
during a break in shooting. Paris,
1955/56. Photographer unknown

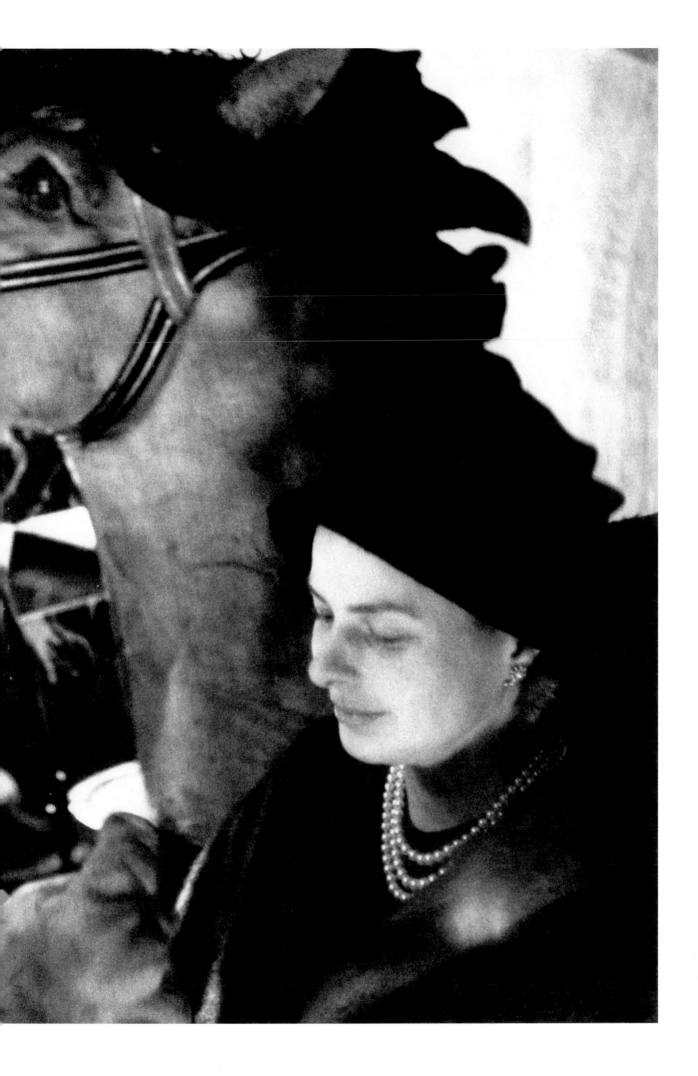

Anastasia

The news that Ingrid Bergman had worked with a director other than Rossellini spreads like wild-fire through the media. The scandal surrounding her adultery and illegitimate son was also receding into the past. Kay Brown feels the time is right to once again confront American audiences with their former superstar, even if surveys of cinema owners and television audiences still show mixed results.

20th Century Fox acquired the film rights for the English play *Anastasia* by Marcel Maurette. It tells the story of Anna Anderson, who claims to be the daughter of the last Czar, Nikolaus II, and to be the sole survivor of the murder of the Romanovs by the Bolsheviks in 1918. Anatole Litvak, a Russian immigrant, is slated to direct, and shooting of the lavish Cinemascope production is scheduled to begin in London during the summer of 1956. Against the will of the president of Twentieth Century Fox, Litvak und Kay Brown are successful in their insistence upon Ingrid Bergman for the role of Anastasia. She stars alongside Yul Brynner—who plays the general who grooms her in an attempt to get at the Romanov fortune—and Helen Hayes as the Dowager Empress, who truly believes Anna to be her granddaughter Anastasia. (Not until 2007 would it be possible to prove, through DNA analyses, that all the women who had claimed to be Anastasia Romanov were frauds.)

Ingrid Bergman's portrayal of Anastasia convinced not only her screen grandmother, but American audiences and the jury of the American Academy of Motion Picture Arts and Sciences as well. A previous recipient of the Oscar and Golden Globe for Best Actress, she is awarded her second Academy Award in that category in 1957.

At last, another Hollywood project. Anatole Litvak agreed to direct *Anastasia* on condition that Ingrid Bergman be given the leading role.

Ingrid Bergman in the title role of *Anastasia*, which was filmed in color. London, 1956. Photographer unknown

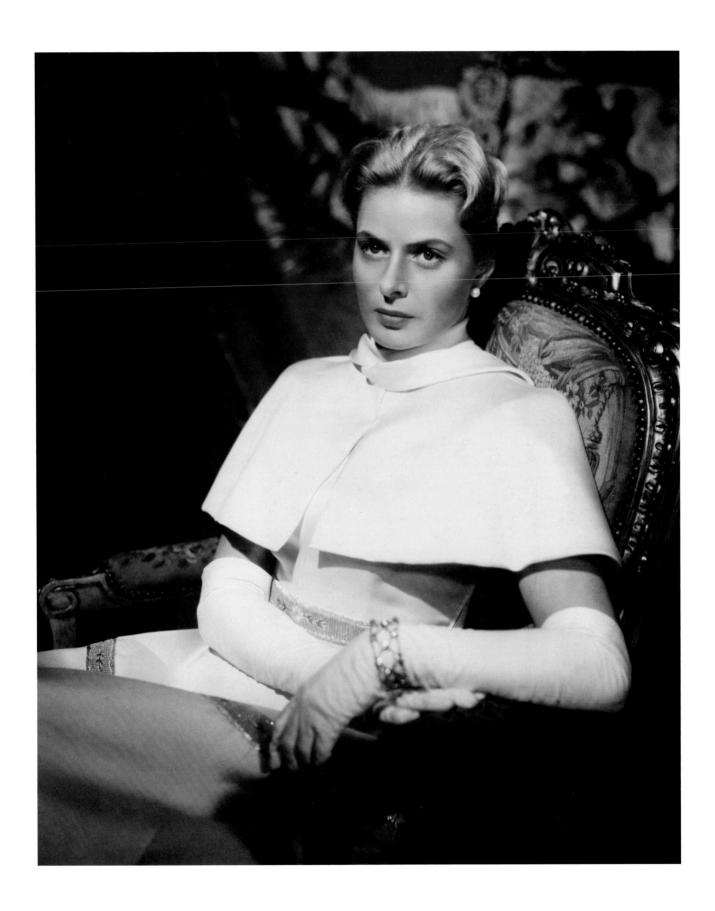

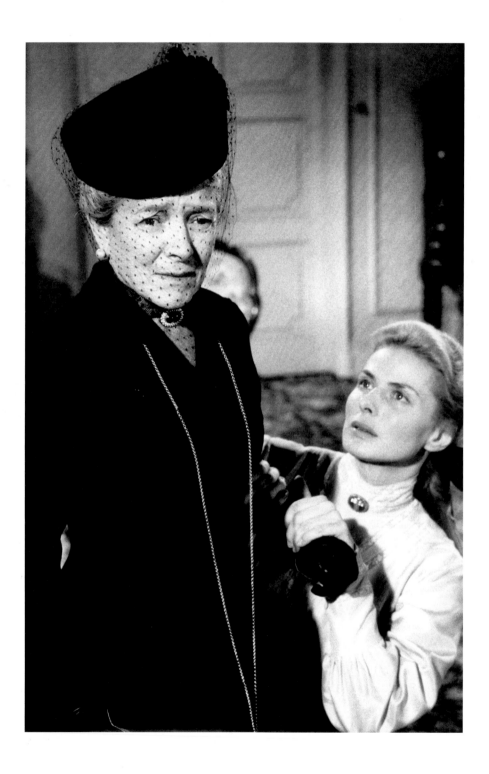

Ingrid Bergman with legendary American actress
Helen Hayes, who plays the grand duchess in *Anastasia*.
Helen Hayes will later say of Ingrid, "I think that Ingrid
was at home only in one place in the world: working."[3]
Production still from *Anastasia*. London, 1956.
Photo: Bob Landry

Right page
Ingrid Bergman with Yul Brynner in *Anastasia*. Brynner plays
ruthless General Bounine who coerces the emotionally disturbed and
mentally unstable Anna Anderson (Ingrid Bergman) into believing
she is the Czar's daughter Anastasia in order that he might gain
access to the Romanov family fortune deposited in an English bank.
Most of the film is shot in London, with some of the nighttime
outdoor takes being shot in Paris. Paris, 1956. Photographer unknown

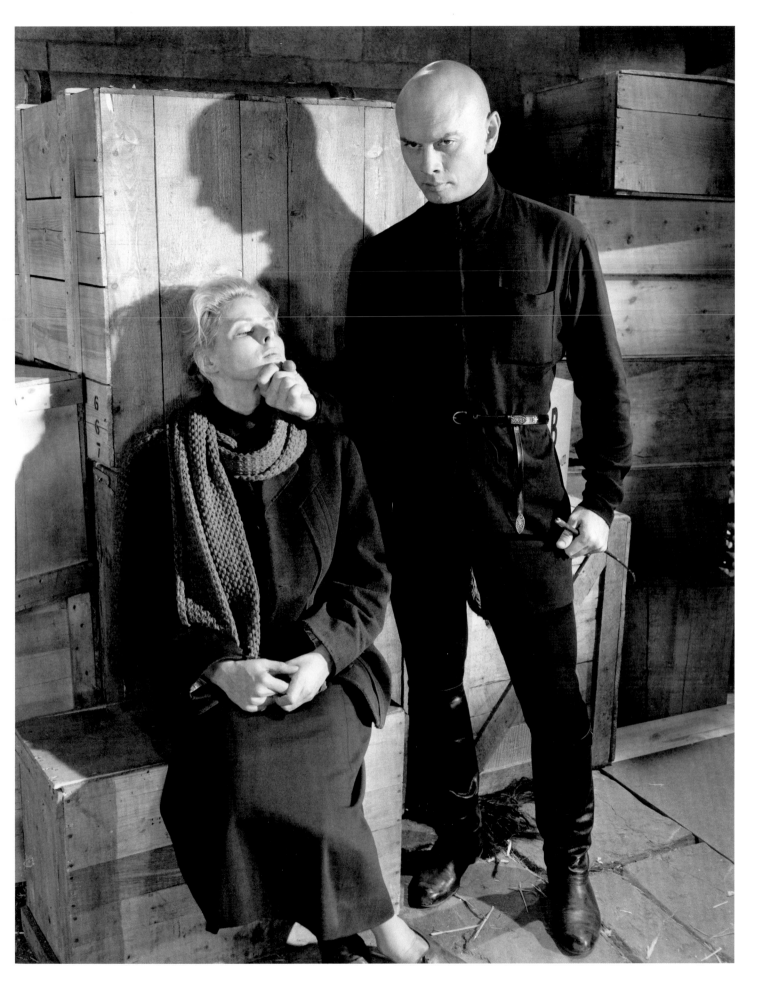

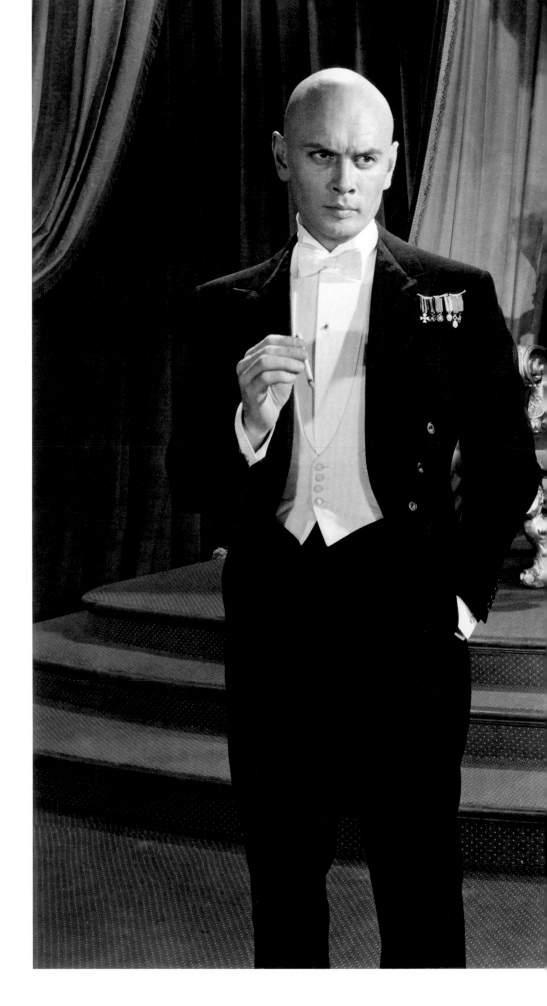

Yul Brynner and Ingrid Bergman. Production still from *Anastasia*. London, 1956.
Ingrid recalls: "It was a fine film … And Yul Brynner was really at the beginning of his career. He'd had this huge success in the *King and I*, and he was so helpful and understanding, such a wonderful friend. Roberto only came to see me once while I was making the picture. I think a lot of people sensed that the marriage was cracking.

"Anatole and I got on very well, though he was a bit worried occasionally about my slowness in learning the dialogue … Then one day he passed me in my little trailer, and there I was reading the script. 'Great! You are actually studying the dialogue,' he said. I didn't have the heart to tell him I was studying *Tea and Sympathy*. In French."[4]

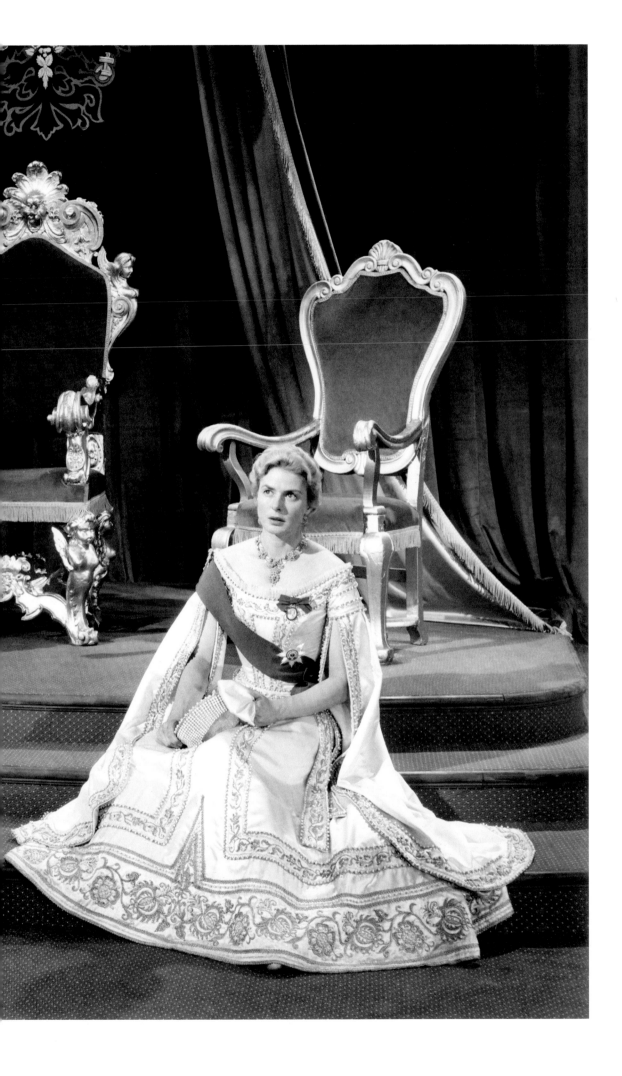

In the mirror: Ingrid Bergman and Yul Brynner.
Production still from *Anastasia*. London, 1956.
Photographer unknown

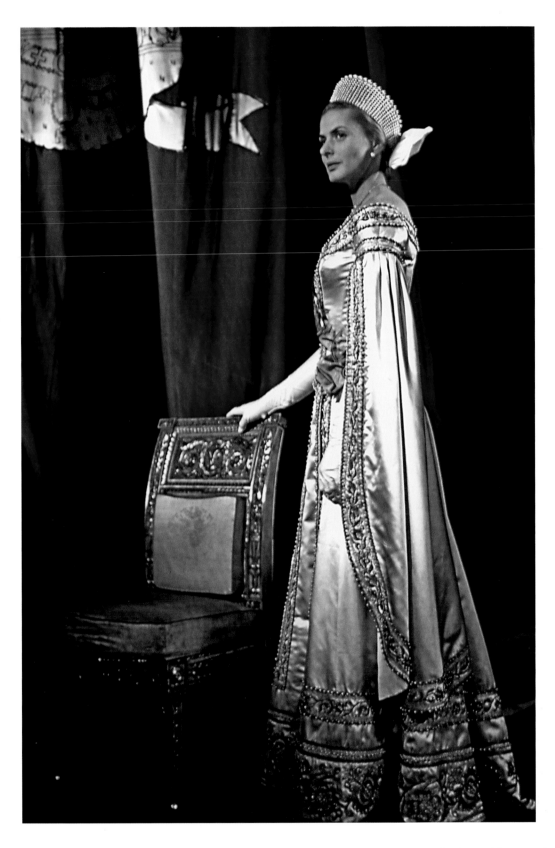

This photograph from *Anastasia* was intended as a cover photo for *Life* magazine. It was taken by Yul Brynner, a highly talented photographer in his own right. London, 1956

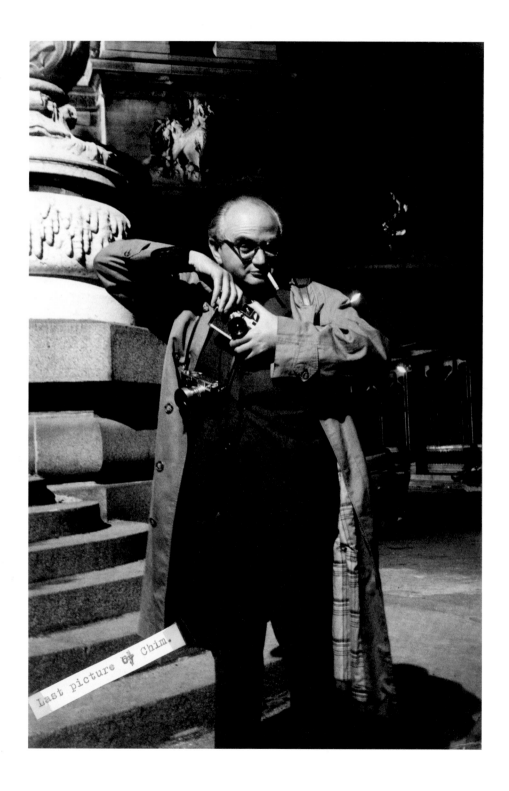

Last picture of Chim.

On hand for the shooting in nighttime Paris is Ingrid's old
friend and confidant "Chim" Seymour, seen here in a portrait
by Yul Brynner. Ingrid kept this photo in her private album, with
the annotation "Last picture of Chim." Chim was killed shortly
thereafter, on 10 November 1956, while working as a photo-
journalist during the Suez Crisis. Paris, 1956. Photo: Yul Brynner

Right page
Here, Chim seems to have turned the
tables, capturing Yul Brynner in the
act of photographing Ingrid Bergman.
Taken while on location in Paris, 1956.

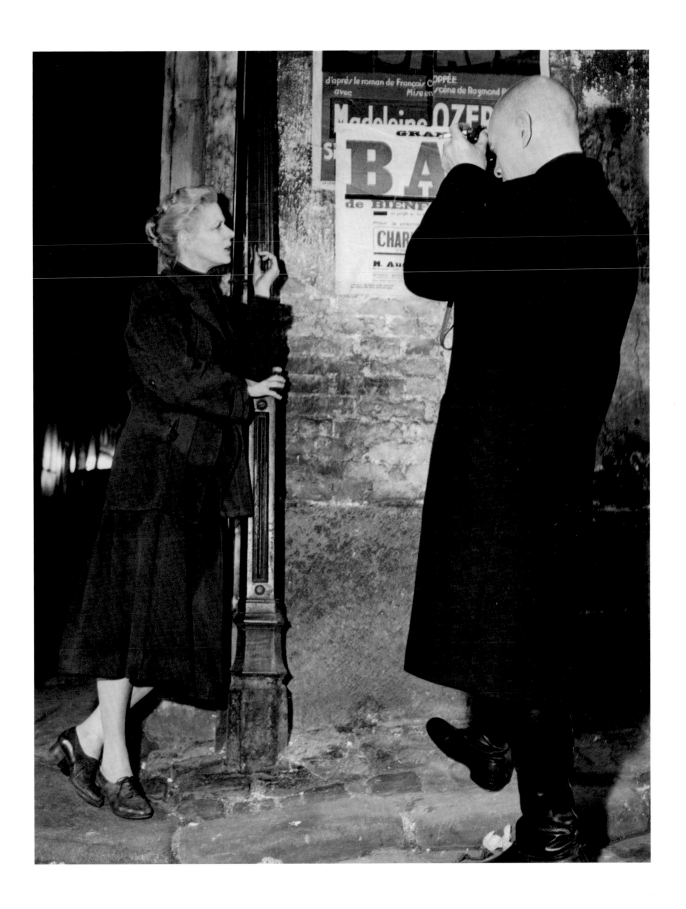

Ingrid on the set of *Anastasia*, London, 1956.
Color portrait by Yul Brynner
Ingrid is quoted as saying, "I am so excited to be back
working on a set." After the unorthodox and improvised
film work à la Rossellini, she is happy to submerge herself
in Hollywood's machinery of perfection, once again
bestowing upon it a vital and distinctive human touch.

Right page
Ingrid Bergman on the set
of *Anastasia*, London, 1956.
Portraits by Yul Brynner

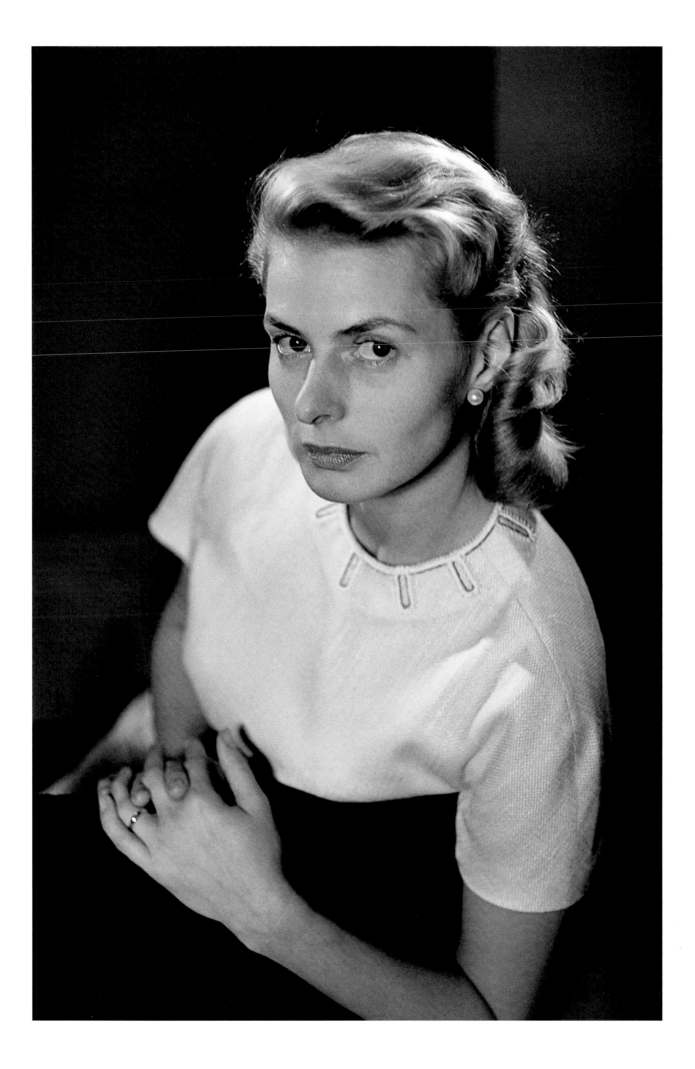

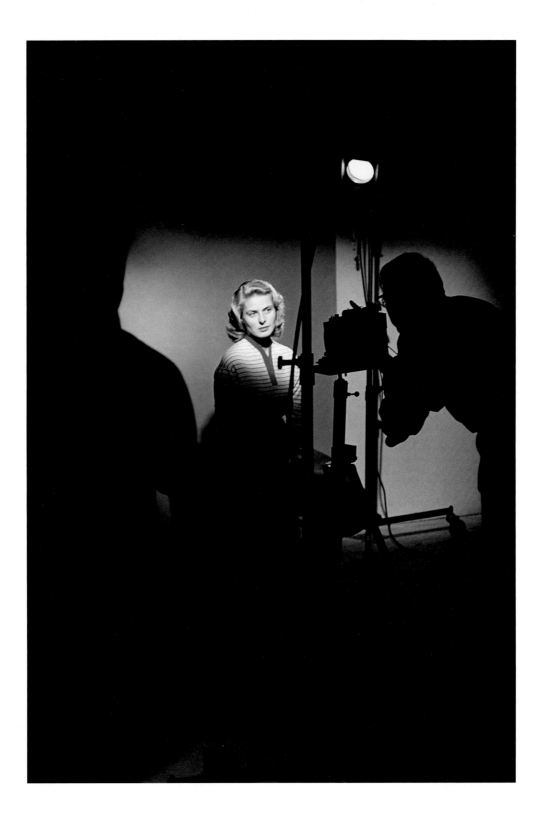

Ingrid Bergman on the set
of *Anastasia*, London, 1956.
Portraits by Yul Brynner

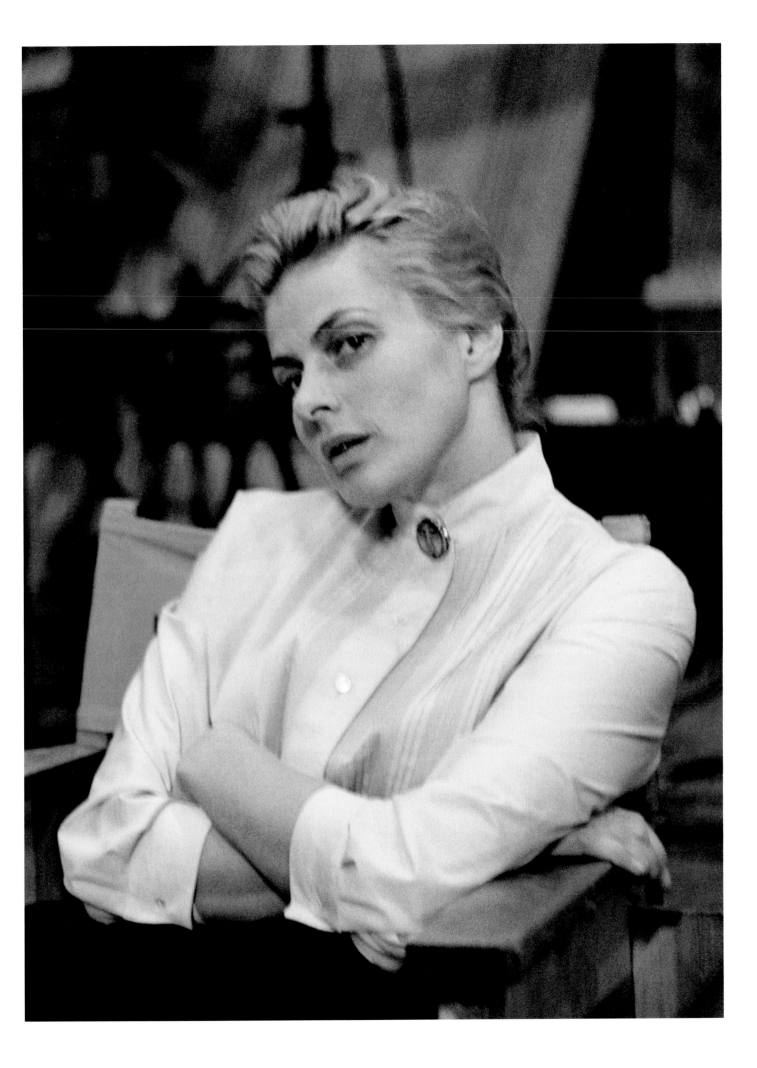

THEATER IN PARIS
Thé et sympathie

When Ingrid Bergman returns to Rome from the European tour of the Joan of Arc oratorio in the summer of 1955, an offer from the Théâtre de Paris awaits her to play the leading lady in Robert Anderson's *Tea and Sympathy*, a role Deborah Kerr had played so successfully in New York. Anderson travels to Rome in order to personally persuade the Rossellinis to join him as a team. Roberto thinks the play is tripe and immediately declines—he is planning a trip to India anyway—but Ingrid disregards her husband's refusal and commits for the autumn of 1956. As soon as the shooting of *Anastasia* is completed, she travels to Paris to begin rehearsals with director Jean Mercure for *Thé et sympathie* alongside Yves Vincent and Jean-Loup Philippe.

The play tells the story of a boarding school pupil named Tom Lee. His classmates tease him and think he is gay because he likes to play tennis and loves poetry. No one understands him except his headmaster's wife, Laura Reynolds. The two become close, and she finally introduces Tom to the joys of sex. On puritanical Broadway, Deborah Kerr had gone no further than unbuttoning the top button of her blouse; in Paris, Ingrid exposes her bra, "a black one at that."[5]

Rossellini keeps a vigilant eye on the rehearsals and is also present at the premiere on 2 December 1956, where he stands fuming backstage. Despite all his prophecies, the play is also a tremendous success for Ingrid Bergman. Although the Parisian theater was accustomed to a high degree of eloquence, the audience forgave her linguistic slips. Jean Renoir, with whom she had shot *Elena and her Men* earlier in the year, even compares her to Sarah Bernhardt —the greatest possible compliment in Paris at that time. The day after the premiere, Rossellini departs for India.

Due to the death of his wife, Phyllis, Robert Anderson is unable to attend the public premiere, but he is present two weeks later at the premiere for the press. Ingrid Bergman reserves a room for him at the Hotel Raphael, where she always stays when she is in Paris. They comfort one another in this time of personal sorrow.

Except for a brief interruption for the Oscar ceremonies in March and the obligatory summer break, *Thé et sympathie* enjoys a highly successful run at the Théâtre de Paris that lasts an entire year.

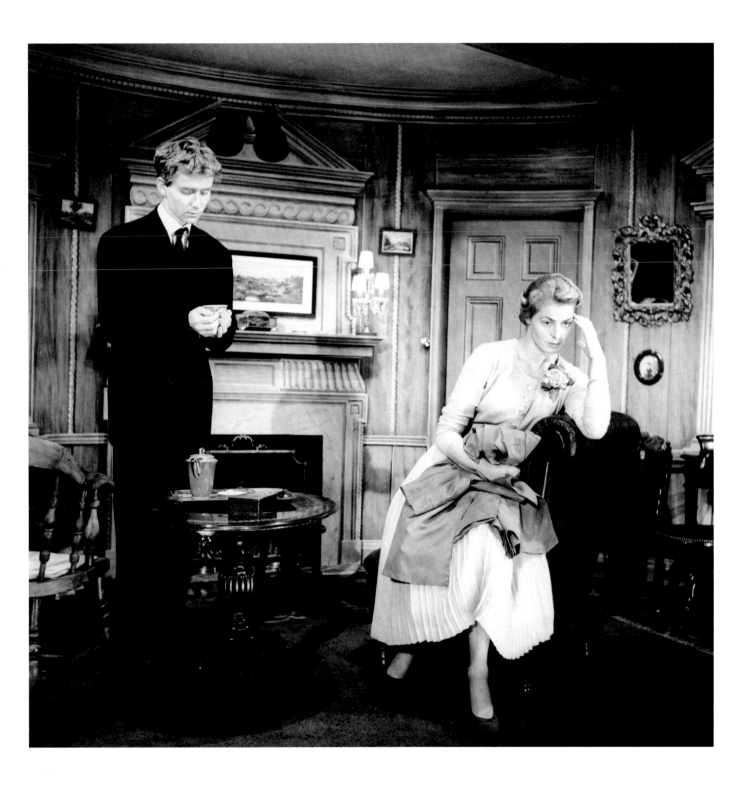

Ingrid Bergman and Jean-Loup Phillipe in the play *Thé et sympathie* by Robert Anderson at the Théâtre de Paris. The production premieres on 1 December 1956. The audience goes wild, and the applause lasts for a quarter of an hour. Only one visitor is beside himself with rage—Roberto Rossellini. Ingrid later recalls seeing him standing in the wings during the ovation: "I knew then my marriage was over …"[6]

"The following day Roberto packed his suitcases in the Raphael Hotel and I went to the railway station to see him off."[7] Roberto hurried off to Rome and departed from there for India. After its glorious premiere, *Thé et sympathie* goes on to become a long-running success with Parisian theater audiences.
Premiere photo. 1 December 1956, Paris. Photo: Roger-Viollet

Ingrid Bergman in her suite at the Hotel Raphael,
her home while performing on the Parisian stage.
Drawings by her children adorn the mirror. Robert
Anderson, the recently widowed author of the
successful play, will also stay at the Raphael during
the month of December. Paris, December 1956.
Photo: Lennart Nilsson

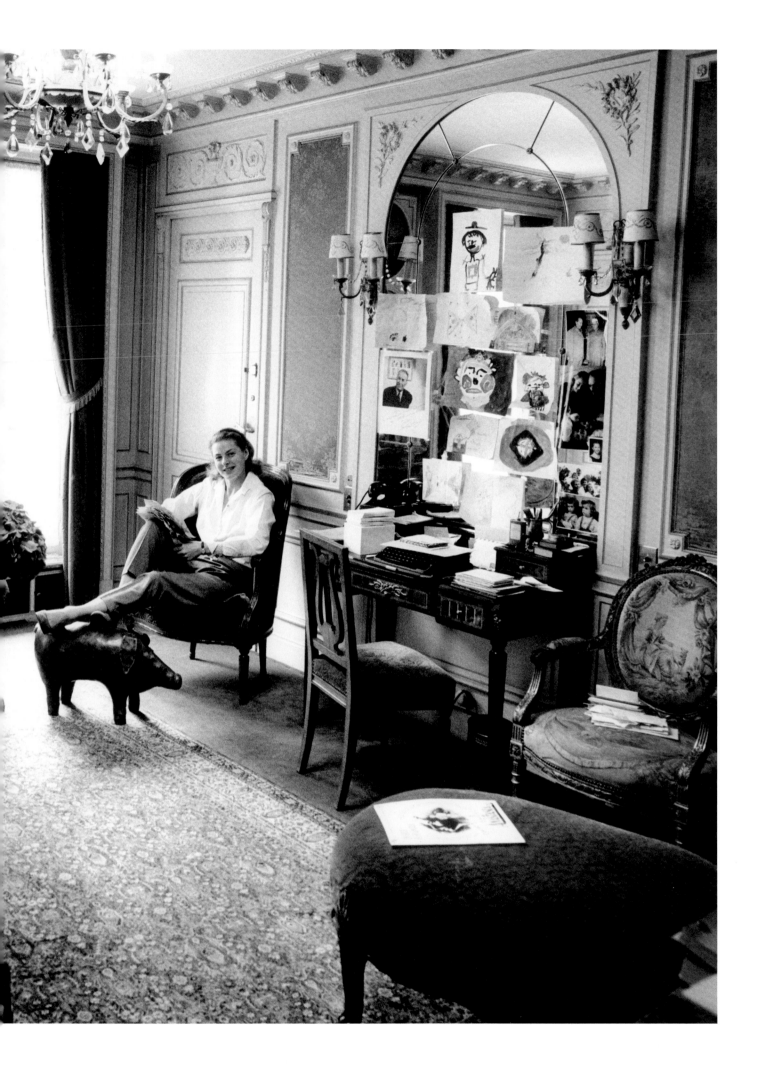

NEW YORK FROM SATURDAY MORNING
TILL SUNDAY EVENING

When Ingrid Bergman receives the New York Film Critics Circle Award for Best Actress for her performance in *Anastasia*, 20th Century Fox arranges a "flash" visit to New York. To this end, three "full-house" performances at the Théâtre de Paris are bought out. Taking into account the time differences involved, this enables Ingrid to arrive in New York by air on the morning of 19 January (a Saturday), fly back to Paris on Sunday evening, and appear onstage again on Monday evening. Barring any unforeseen events, the tight and minutely organized itinerary is as follows:

Saturday a.m.: arrival at the airport, press conference, transportation to the city; Saturday p.m.: attend a performance of *My Fair Lady* at the Mark Hellinger Theatre; subsequent transportation to the Roxy Theatre, where Joan Crawford will present her with an award from *Look* magazine, also in conjunction with *Anastasia*; prior to the gala dinner at which she will receive the Film Critics Award, a private meeting with Irene Selznick, to which Robert Anderson is also invited. Following the award ceremony and gala dinner, a television interview with Steve Allen. This pace is kept up on Sunday and culminates in a farewell press conference prior to departure from Idlewild Airport. Then Ingrid boards the night flight to Paris.

It is a triumphant return. After all the rejection and ridicule she had been subjected to, America gladly welcomes home its lost daughter with open arms. The trip leaves behind a trace of bitterness in Pia Lindström's heart, however. The itinerary does not provide time for a meeting with her mother, and the physical and emotional strain would have been too great. A long talk on the telephone serves to lessen their pain.

The summer of that same year will see Ingrid Bergman reunited with Pia.

Jean Seberg, who will later attain international stardom in Godard's cinema classic *Breathless*, attends the performance on 23 December 1956 and visits Ingrid in her dressing room after the show. Both women are fascinated by Joan of Arc and both undergo difficult phases with the American audience at certain points in their careers. Just two weeks later, Ingrid Bergman will triumphantly bury the hatchet. Paris, 1956. Photographer unknown

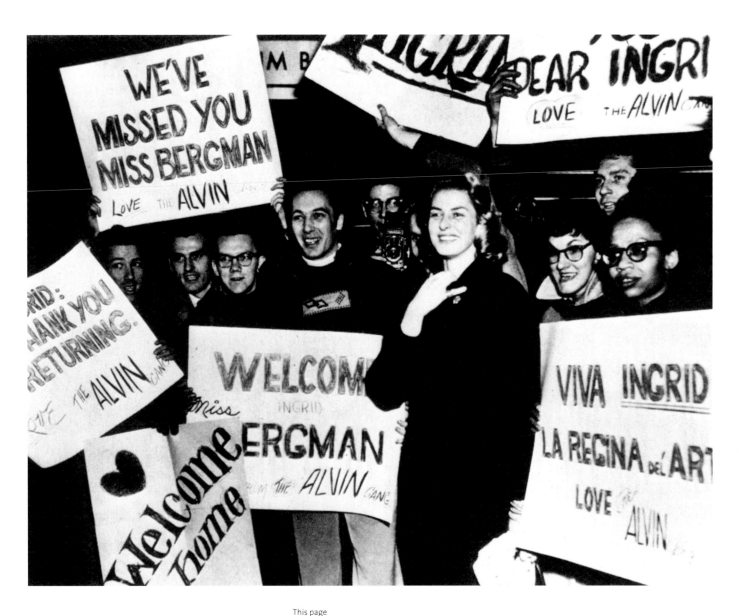

Left page
Ingrid descending the stairs. It is Saturday
morning, 19 January 1956. The weather in
New York is cool and cloudy; the plane
arrives two hours late. Ingrid is the last
to depart and waves to a crowd of around
one hundred waiting journalists.
Idlewild Airport, New York, 1957.
Photo: Jacob Harris

This page
Ingrid Bergman's fan club greets her at the airport. Named after the Alvin Theatre, the "Alvin Gang" was formed in
the course of her engagement there as Joan of Arc in 1946. While the journalists take it for a PR gag staged by the film
company, Ingrid's fans view the journalists as image slayers and character assassins.
Warren Thomas, the fan club's spokesman, describes how the Alvin Gang came into being: "I was twelve years old
when I first knew about Ingrid Bergman. As a Christmas present, my sister was taking me to the Radio City Music Hall
where she was playing in *The Bells of St. Mary's* ... there were lines a mile long, no hope of getting in. I remember being
so bitterly disappointed ...So just after missing *The Bells of St. Mary's*, we heard that Ingrid Bergman was opening in
Joan of Lorraine at the Alvin Theatre. She was already in town, staying at the Hampshire House ... and there we were
waiting outside ... when Ingrid Bergman came out to go for a walk. We followed her for about twelve blocks, and she
knew we were behind her ... So eventually she stopped and said, 'Why are you following me?' I said, very quickly, the
first thing that came into my head, 'Because we love you.' 'Well,' she said, 'I don't like being followed. It annoys me. So
don't follow me anymore.' ... But, of course, it did not stop me at all ... The best time was Wednesday afternoon when
she had her matinee. I could see her at two o'clock when she went in and at five o'clock when she came out, and that
was all I wanted out of life ... Of course we followed Ingrid every time she came to New York ... So, anyway, she went off
to Rome. Then it all started ... all of a sudden there was this big explosion ... And then ... came the day she was
coming back. I got the Alvin Gang in a flash ... I drummed up ten of them and got them to come along to the airport ...
... Ingrid came out and stood with us, and that was a great morning. Of course, I'd still never met her. It took another
seven years for a chance to talk to her and eventually become a friend."[8]

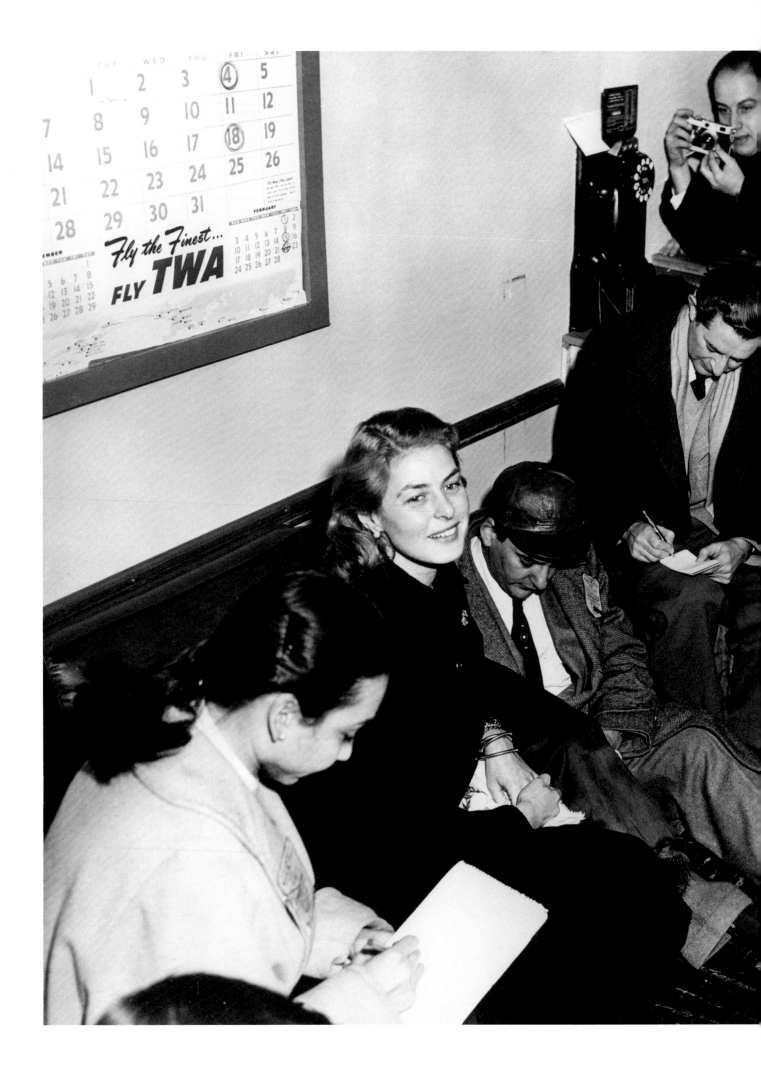

Visibly at ease and in good spirits, Ingrid Bergman meets with the journalists assembled at the airport on 19 January 1957. New York. Unknown press photographer

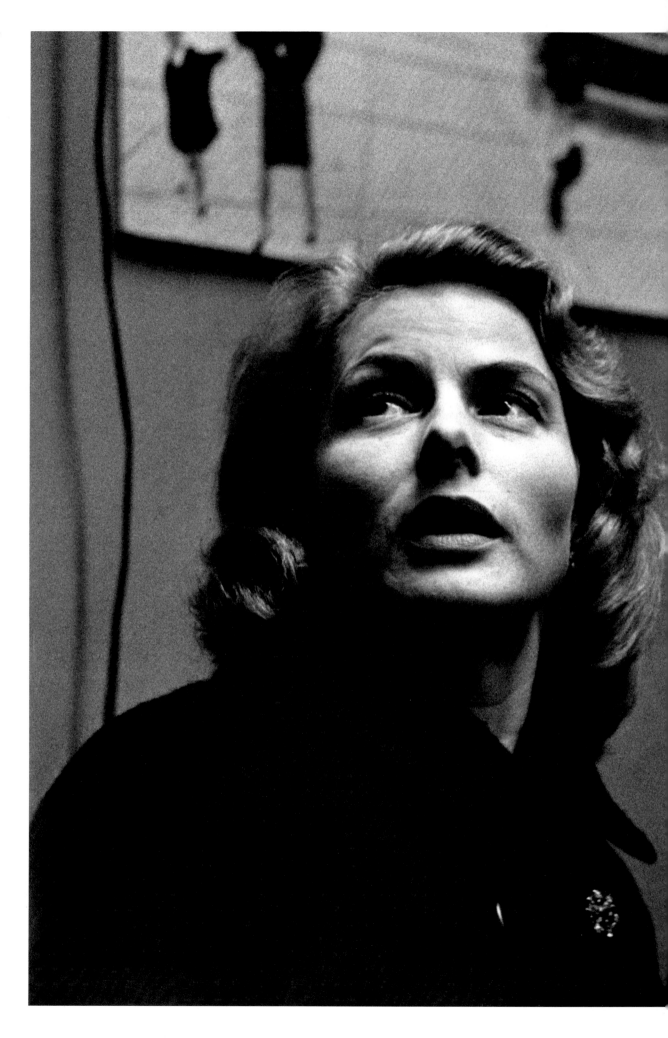

Ingrid on the Steve Allen Show,
which was broadcast live on
television from the award
ceremony at Sardi's Restaurant.
New York, 19 January 1957.
Photo: Gene Cook

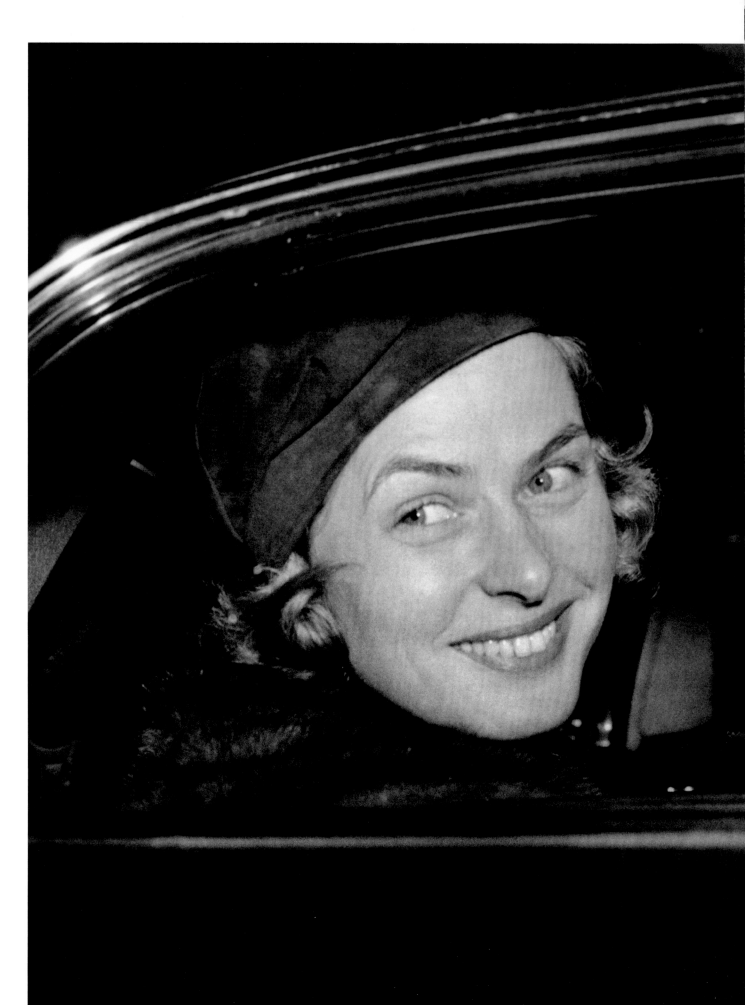

A last smile and a brief wave as she departs for
the airport on 20 January. Her face showing obvious
signs of emotion and strain, Ingrid is captured here,
as so often, through the window of a limousine.
At the airport she will again meet the press prior
to her departure. New York, 1957.
Unknown press photographer

Sporting a white tuxedo, Ingrid Bergman
performs a magic number at the artists'
gala held at the Cirque d'Hiver in Paris on
4 March 1957. Photo: Manuel Litran

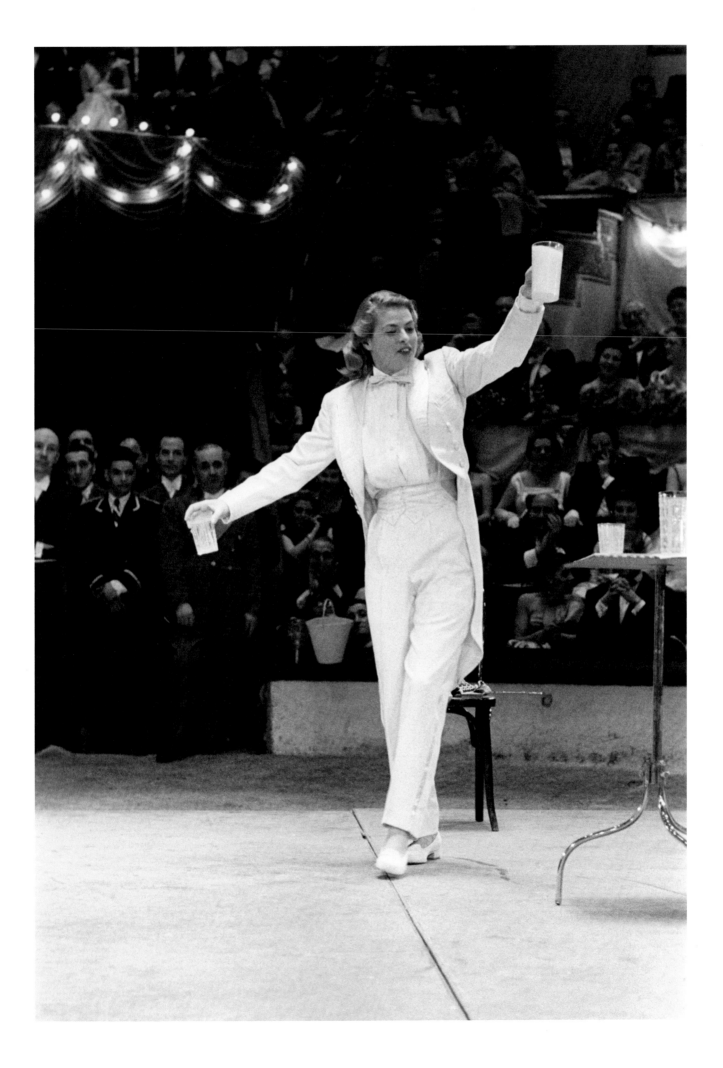

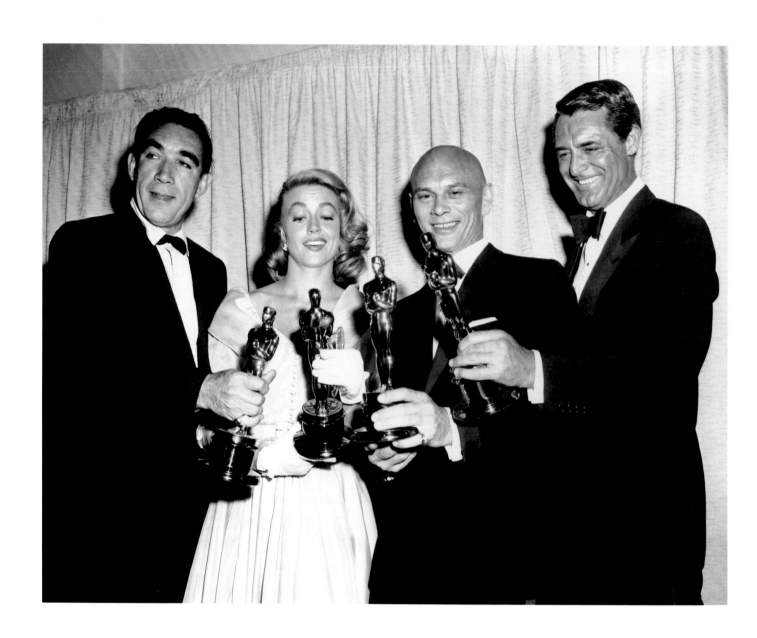

Photo taken at the Oscar ceremonies on 27 March 1957
in Hollywood. Cary Grant accepts Ingrid Bergman's
Oscar for Best Actress for her role in *Anastasia*.
The other recipients are, from left to right: Anthony
Quinn (Best Supporting Actor for *Lust for Life*), Dorothy
Malone (Best Supporting Actress for *Written in the
Wind*) and Yul Brynner (Best Actor for *The King and I*).
Los Angeles, 1957. Unknown press photographer

Right page
Ingrid Bergman celebrates her second Oscar with her children at the Hotel
Raphael in Paris. She is in the bathtub when the winner is announced on the
radio: "Cary Grant, who was a very good friend, had promised to stand by at
the Academy Awards just in case I got lucky, to go up and collect the prize …
I went to take my bath, and have a glass of champagne to celebrate, and
there was little Robertino carrying his radio around and saying, 'Mama,
they're talking about you!' … I could still hear the applause as he put the
radio on the bathroom floor, and then Cary began his speech: 'Dear Ingrid,
wherever you are … And I was saying, 'I'm in the bathtub!' 'Wherever you
are in the world, we, your friends, want to congratulate you, and I have your
Oscar here for your marvelous performance, and may you be as happy as
we are for you."[9]

Ingrid Bergman with her children. A clown drawn by Robertino adorns the
mirror. Paris, 28 March 1957. Photo: Burt Glinn.

For the first time since Ingrid's "escape to Italy" over eight years prior, Pia Lindström and her mother Ingrid Bergman meet at Le Bourget Airport in Paris on 8 July 1957. Ingrid describes the reunion: "I knew it would be a very emotional meeting. It was the first time we had met for six [*sic*] long years … And I really didn't want all this in front of the dozens of cameramen who were bound to be there. So I talked to Scandinavian Airlines. They were very understanding. They said, We'll keep her aboard until all the passengers have disembarked, and then you can go onto the aircraft and be alone together.

So I was on the plane and there was Pia and we fell into each other's arms, and immediately a flashbulb went off. *Paris Match* had sent a photographer all the way from New York so that he could watch Pia and get the first reunion picture. When he had realized that Pia was being kept back, he hid himself on the floor at the back of the plane. Well, they threw him off. Pia looked at me very curiously and said, 'How young you look!'"

They were alone for twelve minutes before they reappeared on the aircraft steps to face the milling photographers.

"We're happy to be together after six years; no, we don't know what we'll do together in Paris,' was Ingrid's only statement.

Pia remembers it well: 'Meeting in Paris wasn't a trauma. It's a trauma when things happen at age ten … I mean, it was really a combination of being excited and being, I suppose, a little em-barrassed and ill at ease because so many people are staring at you, and taking pictures of you. But to say I was afraid would be wrong because I wasn't. I was by then a pretty big person.'"[10]

Ingrid and Pia leaving the aircraft. Pia is now 18 years old. Paris, 1957. Photo: Philippe le Tellier

Right page
Pia spends almost two months with her mother. From Paris they travel to Rome, Santa Marinella, Capri, and Taormina in Sicily. They also visit Roberto's relatives. 1957. Photographer unknown

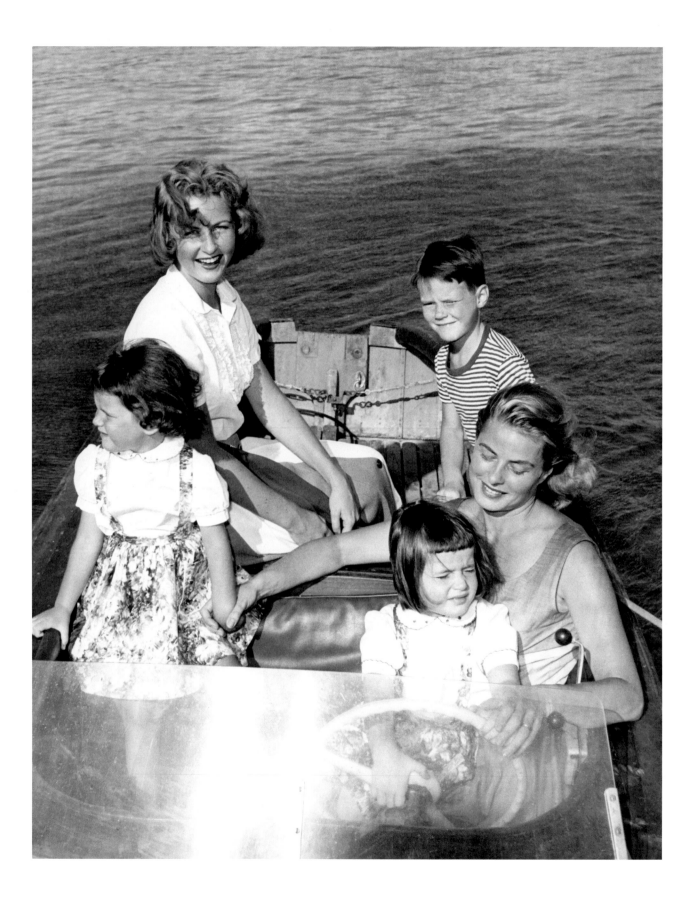

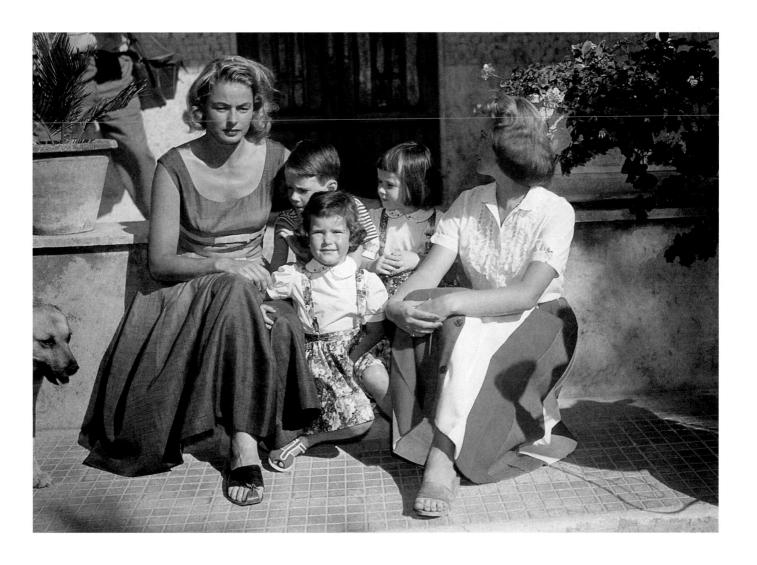

A family outing in a motor boat.
Pia, her half siblings, and Ingrid in a
lighthearted moment on the "high
seas" near Santa Marinella, 1957.
Photographer unknown

Ingrid and her four children. Santa
Marinella, 1957. Photo: Jim Pringle

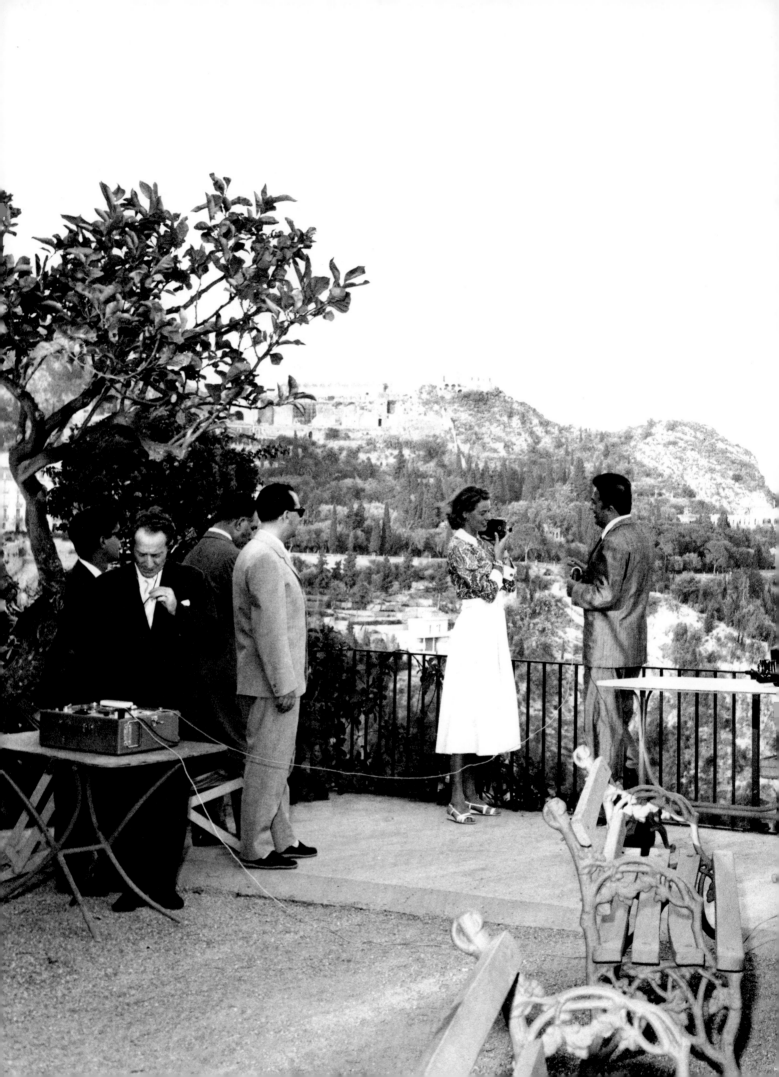

A meeting with Federico Fellini
and his film crew on the terrace of
the San Domenico Palace Hotel.
Taormina, 1957.
Photo: Michelangelo Vizzini

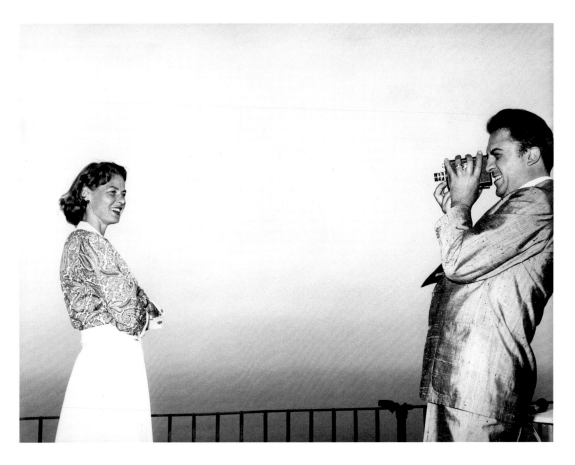

Top
Federico Fellini filming Ingrid.

Bottom
Ingrid filming Federico Fellini.
"On location" on the terrace
of the San Domenico Palace
Hotel in Taormina, 1957.
Photo: Michelangelo Vizzini

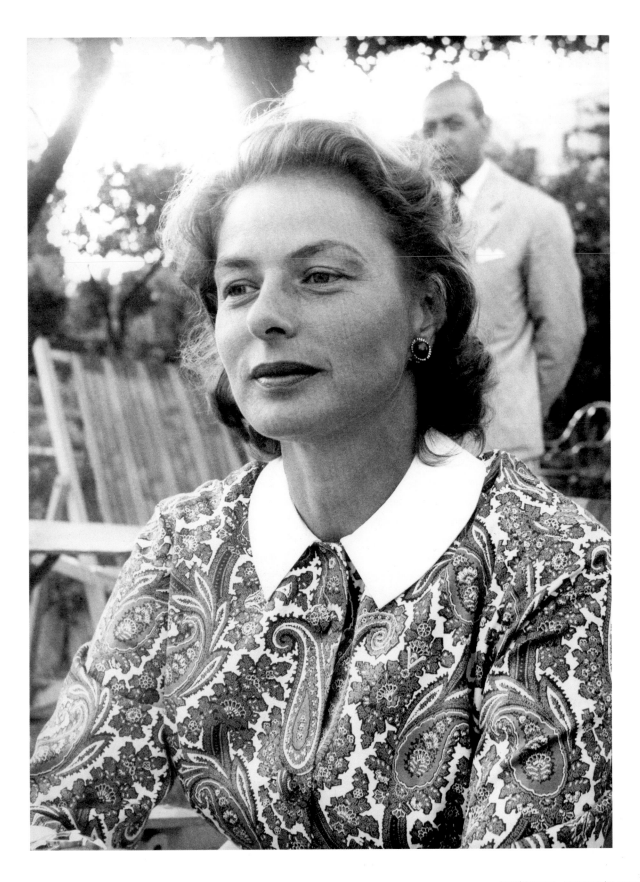

Ingrid Bergman—same occasion, same place.
1957. Photo: Michelangelo Vizzini

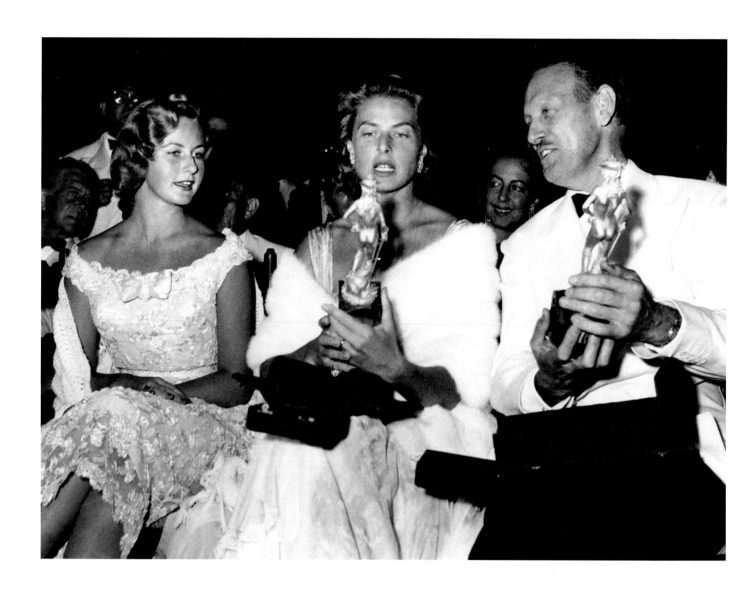

Pia Lindström and Ingrid Bergman
at the David di Donatello Award
ceremonies held in the ancient
Greek Theatre in Taormina, 1957.
Unknown press photographer

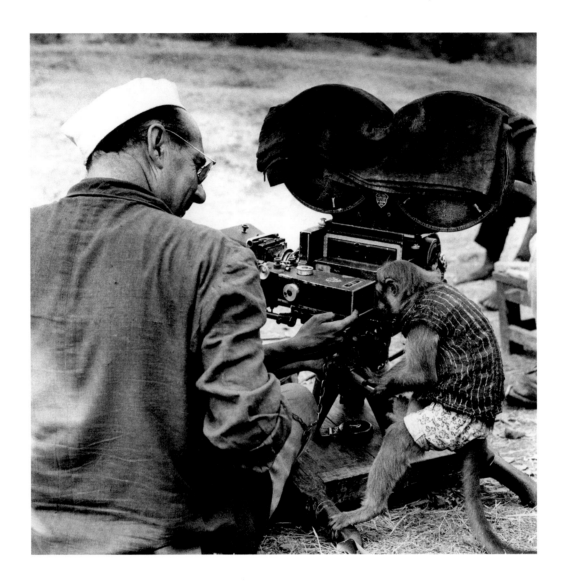

While Ingrid relaxes with her daughter in Taormina and accepts her award, Roberto is busy filming in Bombay with the assistance of a most peculiar cameraman. And, furthermore, he is in something of an amorous predicament. He is having an affair with his producer's wife, and the mother of two is expecting Rossellini's child. The story follows a familiar pattern, but he can still count on Ingrid's sympathetic understanding and assistance. "Then in the middle of one night in the spring of 1956 [1957, ed.] the phone rang in my Raphael Hotel bedroom. 'Roberto! Where are you phoning from? ... India?' ... 'How are things going along?' 'Oh, fine, fine, but there are these newspaper stories going around about this woman. If any newspaper people call you regarding some romance of mine, you will deny it. Not a word of it is true! Not a word!' ... As I put the phone down on Roberto and sat on the bed, I was thinking about all these things. And wondering what I would do. Because I knew now that things had changed forever. I knew when he rang me up to tell me a thing like that, he did have another woman. He had fallen in love again ... He had left *me*. And as I sat on the bed I could feel the smile spreading right around up to my ears. I was so pleased.

For him. And for me. We had solved it. A few nights later the phone rang again in the middle of the night. Roberto again! The husband of the woman he was not supposed to be having an affair with, who was also a very important producer, was so angry about the whole business that he'd pulled all sorts of strings. Not only had he managed to stop Roberto from filming any more, he had also managed to get the film impounded so that Roberto could not take the film out of India with him ... [Roberto said,] 'But the only man who can help me with the film is the Prime Minister of India, Nehru. He's in London. You know lots of people in London. Can you get to him and see to it that I'm allowed to bring my film out of India?'" Ingrid telephones her friend Ann Todd in London. Ann arranges a meeting with Nehru, and Ingrid flies to London the next day: "So there we were at lunch. Ann, Nehru's sister, me, and the Prime Minister Nehru himself ... We had lunch, and I thought, He [sic] must wonder why I am here. Only when we walked in the garden after lunch did I realize he already knew ... The very next day Roberto received permission to take his film out of India. And he left immediately."[11]

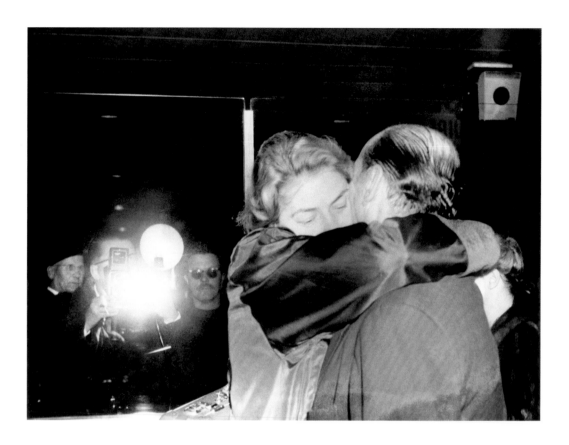

"People thought I acted strangely, for now the newspapers were full of how Roberto had pursued, fallen in love with, and run off with this Indian producer's wife ... When he arrived back at the Paris airport, I went to meet him. That confused all the newspaper reporters who were around me clamoring, 'Miss Bergman, I understand your husband has run away with an Indian girl?' ... And I said, 'Has he? I didn't know that. I'm just here to meet him.' Roberto came into the airport and I threw myself into his arms. He gave me a great big hug and we kissed; this photograph was all over the world's press, with the caption saying how silly all those rumors were. Here was Ingrid Bergman meeting Roberto Rossellini and here was their wonderful embrace."[12]

A big welcome at the airport in Paris on 21 October 1957.

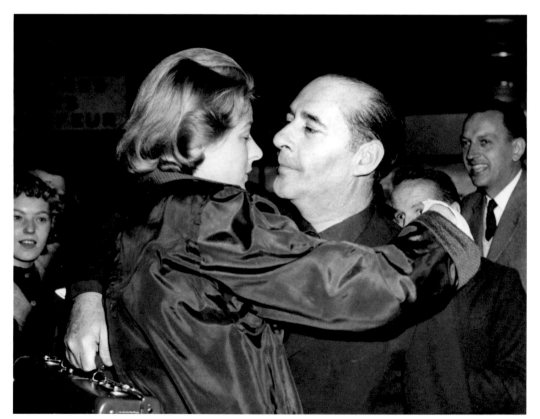

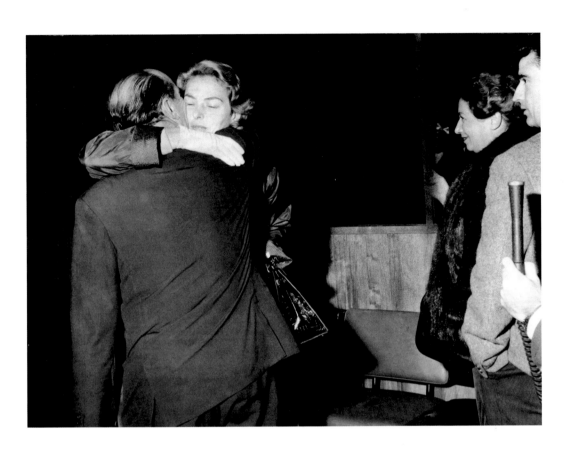

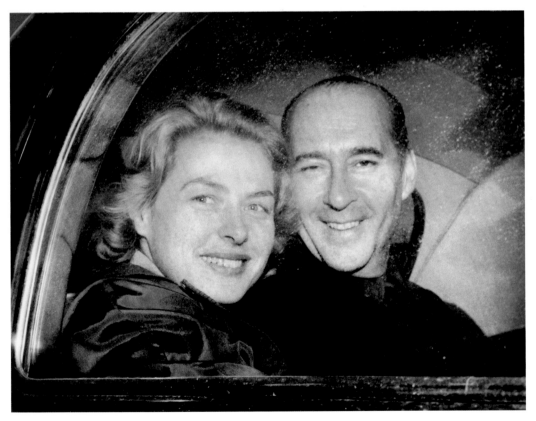

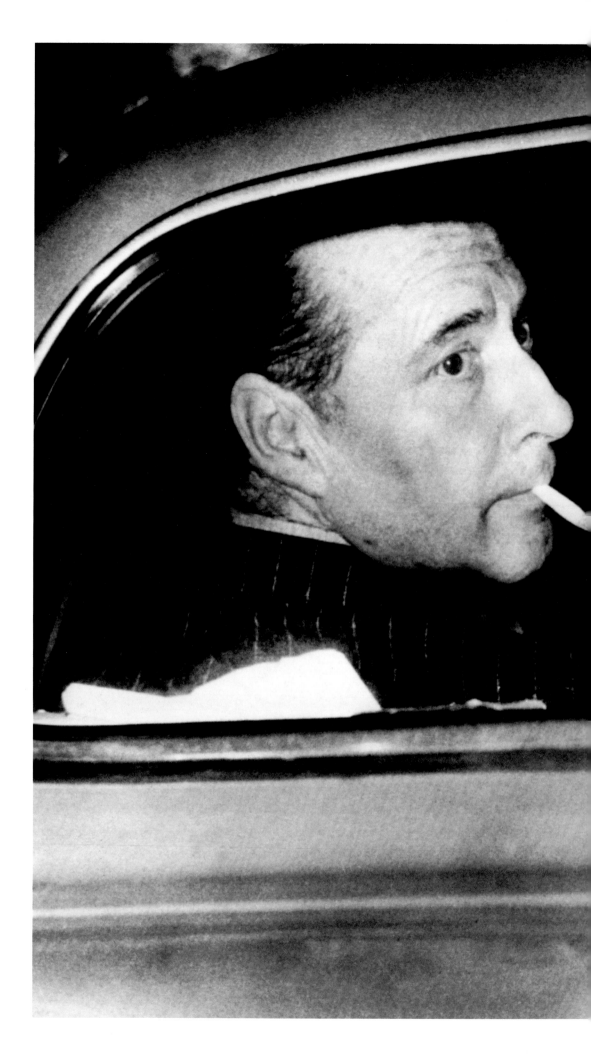

Ingrid Bergman und Roberto
Rossellini seen through the rear
window of a limousine on their
way to their divorce proceedings
on 7 November 1957. Unknown
press photographer

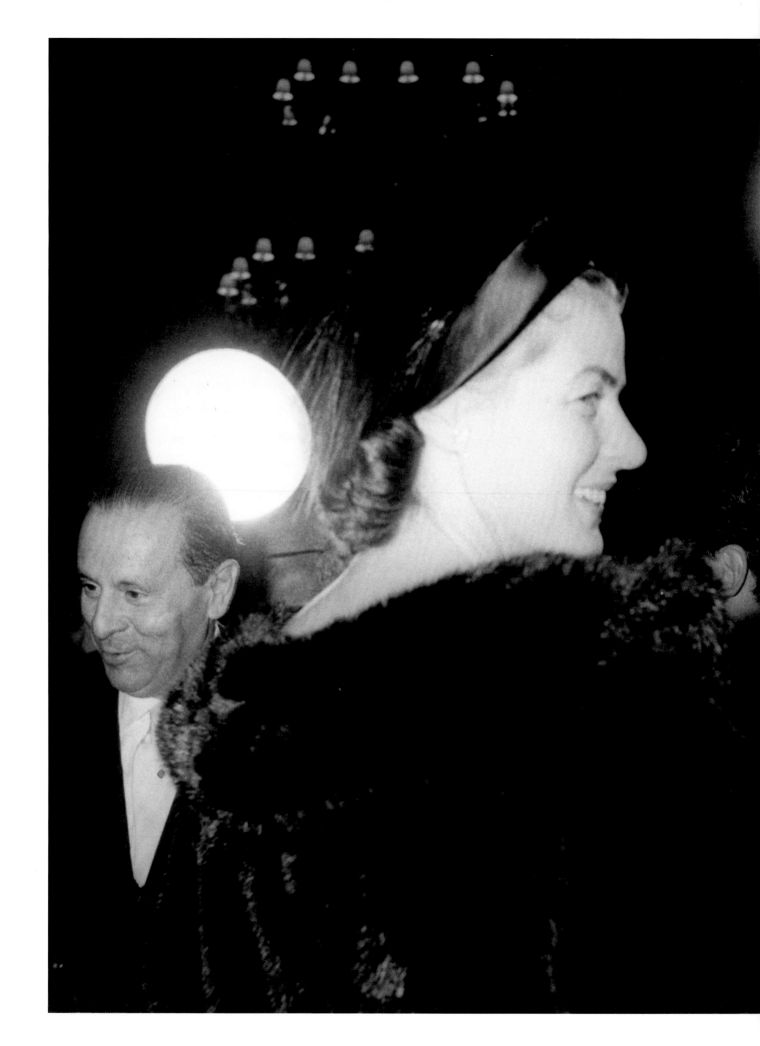

Ingrid Bergman festively attired in Rome,
fall of 1957. Photographer unknown

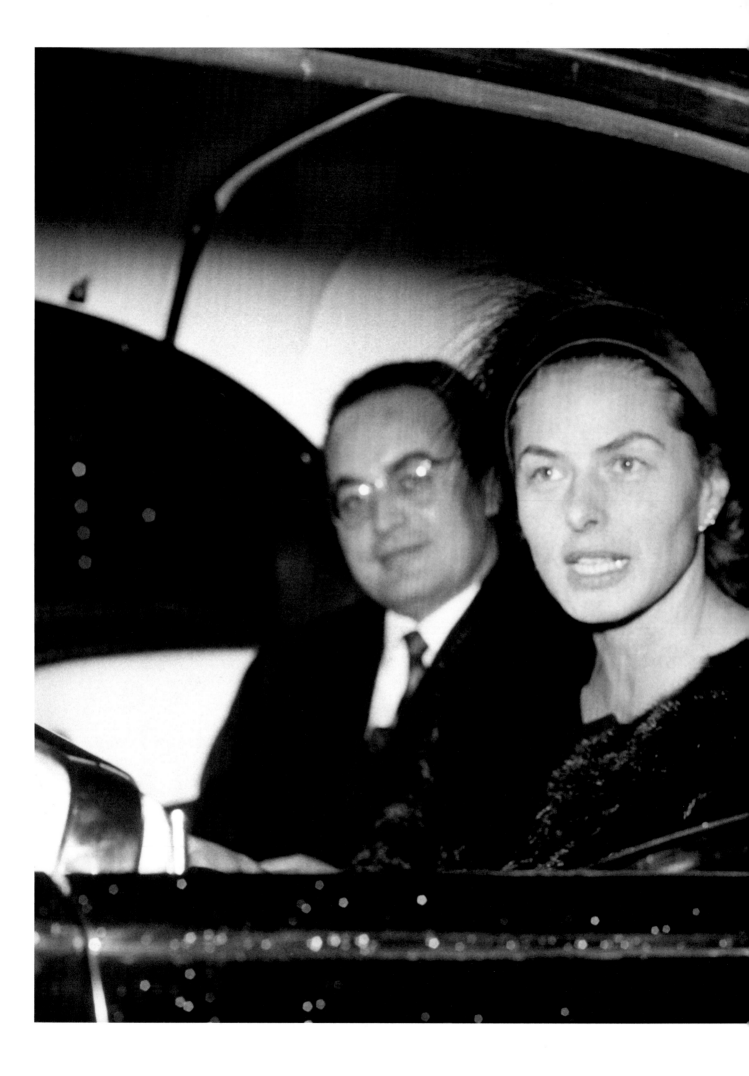

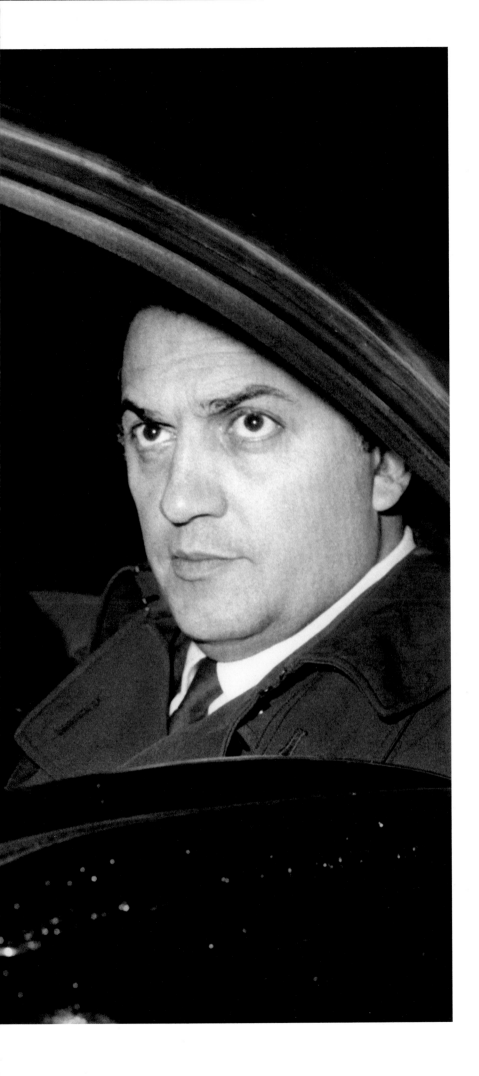

Three great Italian film celebrities on the backseat of a limousine. From the left: producer Dino de Laurentiis, Ingrid Bergman, and Federico Fellini. Rome, autumn of 1957. Unknown press photographer

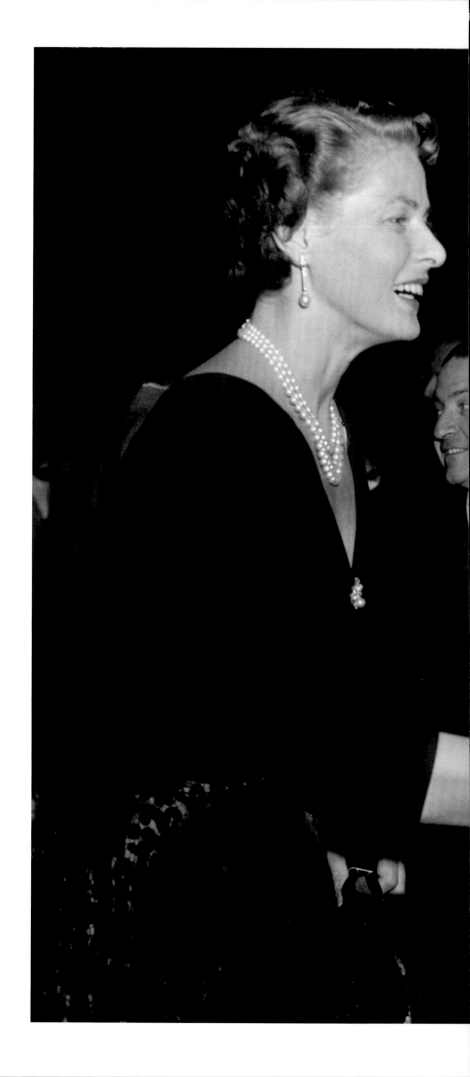

Ingrid Bergman greets Oona and Charlie Chaplin
at an evening gala, probably in Rome, 1957.
Photographer unknown

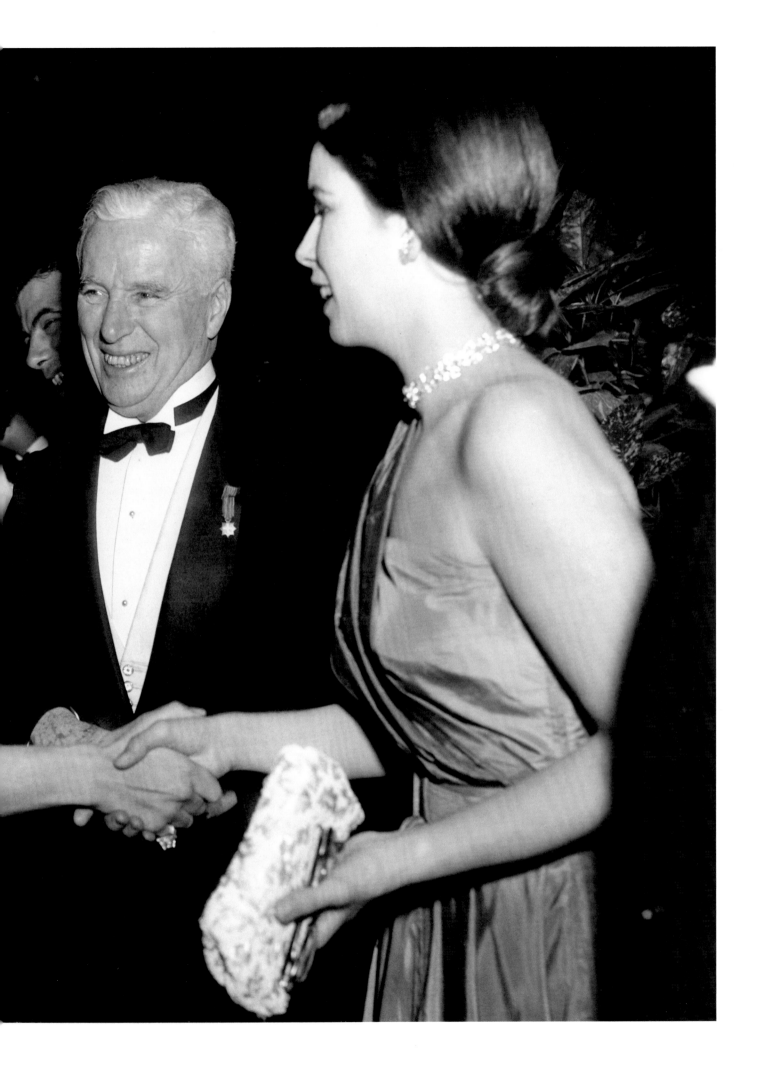

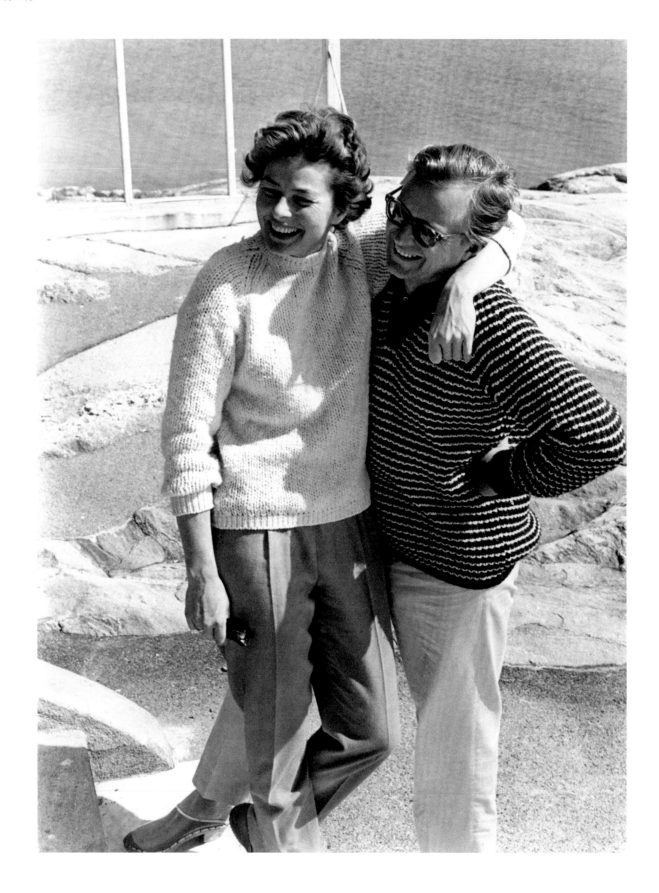

The new man at Ingrid's side is theater producer
and agent Lars Schmidt—a fellow Swede.

VI.

A NEW CAREER – NEW HAPPINESS

1958–1965

Indiscreet

In early 1957, while Ingrid Bergman is appearing nightly onstage in Thé et sympathie in Paris, she receives an inquiry from Cary Grant in Hollywood. He asks if she would like to appear in the first film he and director Stanley Donen are planning to make for their recently founded production company: a screen adaptation of the comedy Kind Sir by Norman Krasna. The play was a flop on Broadway, and Robert Anderson strongly advises Ingrid against it. When Donen travels to Rome that summer for the express purpose of gaining her for the new project with her former co-star from Notorious—and also offers her an extremely generous contract—Ingrid once again ignores the advice of a confidant and accepts. It is to be her first pure comedy role in English—a novelty for American audiences. Shooting takes place in London during the winter of 1957/58. In order to avoid any reminders of the flop on Broadway, the title is changed to Indiscreet.

It is the story of a successful but lonely actress, Anna Kalman, who falls in love with international finance expert Philip Adams. The charming and handsome Adams avoids romantic entanglements by pretending to be married, but he falls deeply in love with Anna. When Anna discovers the deception, she indignantly makes an exclamation that will go down in movie history: "How dare he make love to me when he isn't a married man!" She resolves to beat Adams at his own game, and following some commotion, things culminate in a happy end.

Shot in Technicolor and featuring two extremely attractive, not-so-young Hollywood stars, brilliant dialogue, and gorgeous costumes by Dior, Balmain, and Lanvin, this late screwball comedy is, in the words of the New York Times, "as light, airy, and weightless as a soufflé. But all concerned have made it a most palatable concoction."[1]

Upon the completion of shooting, Cary Grant throws a farewell party for his leading lady and gives her the key to the wine cellar from Notorious as a gift. The key had opened the doors to a great Hollywood career for him, and he had since kept it as a talisman. For Ingrid Bergman, Indiscreet represents her successful debut as a comedienne.

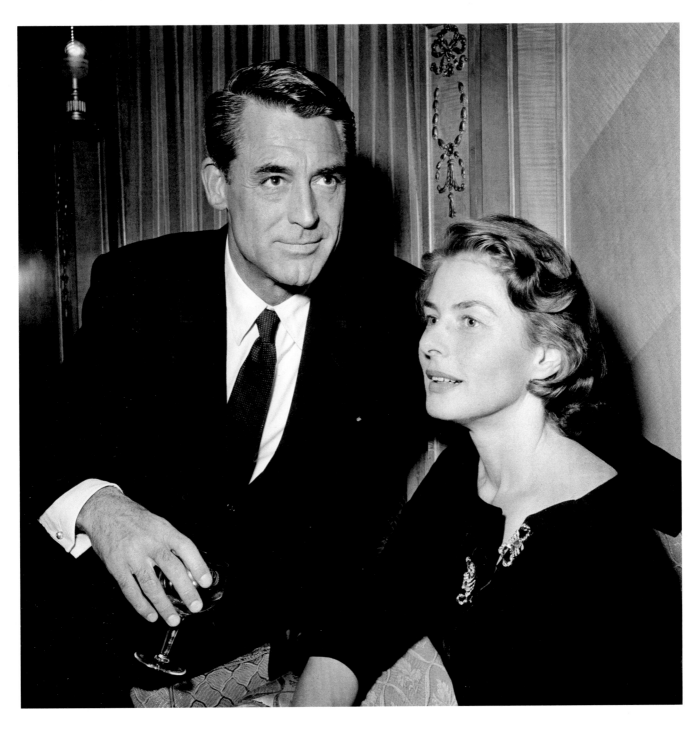

Ingrid Bergman and Cary Grant at a press conference before shooting commenced for *Indiscreet* in London, November 1957. Unknown press photographer

"I went to London to make *Indiscreet* with Cary Grant and the press was waiting at Heathrow for a statement. I'd ruined my career by marrying Roberto Rossellini, they said, and now was I going to ruin it again by leaving Roberto Rossellini? ... Cary Grant was sitting up on the table. He shouted across the heads of the journalists, 'Ingrid, wait till you hear my problems!'
That broke the ice. Everybody burst into laughter. He held them at bay in such a nice way. 'Come on, fellas, you can't ask a lady that! Ask me the same question and I'll give you an answer. So, you're not interested in my life? It's twice as colorful as Ingrid's.' "[2]

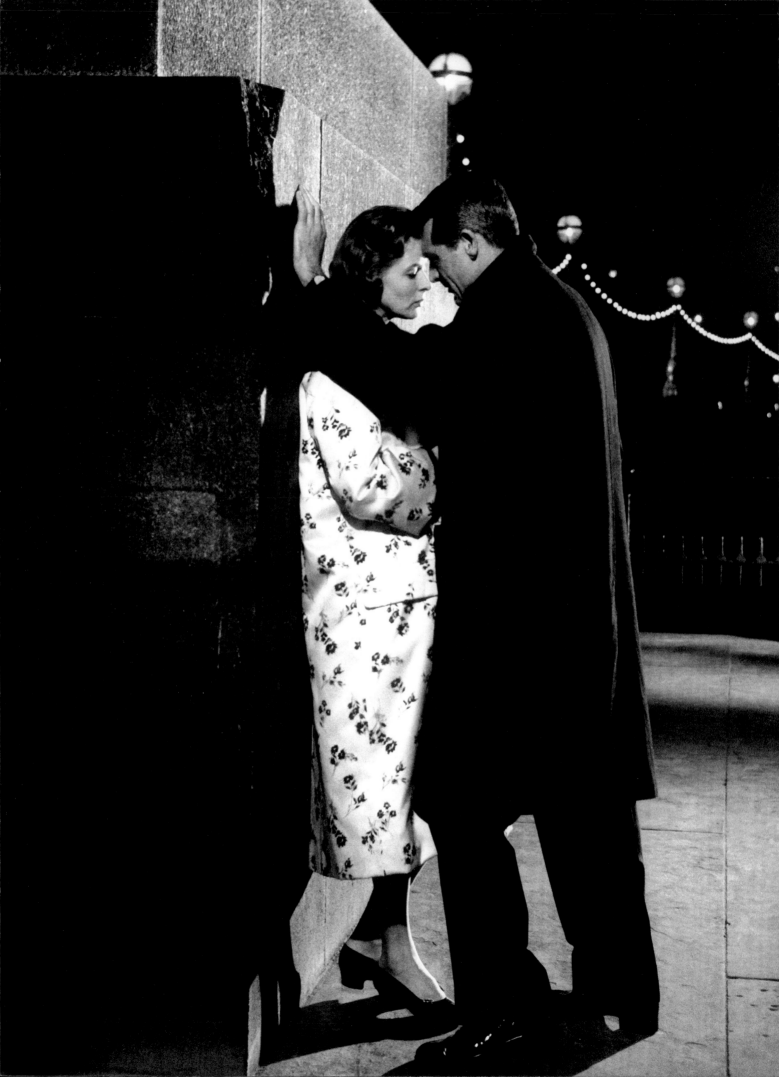

Ingrid Bergman as Anna Kalman and
Cary Grant as Philip Adams, a bachelor who
avoids the unwanted long-term effects of
his love affairs by (falsely) claiming to be
already married—to a wife who won't
agree to a divorce. Production still from
Indiscreet, London, 1957/58

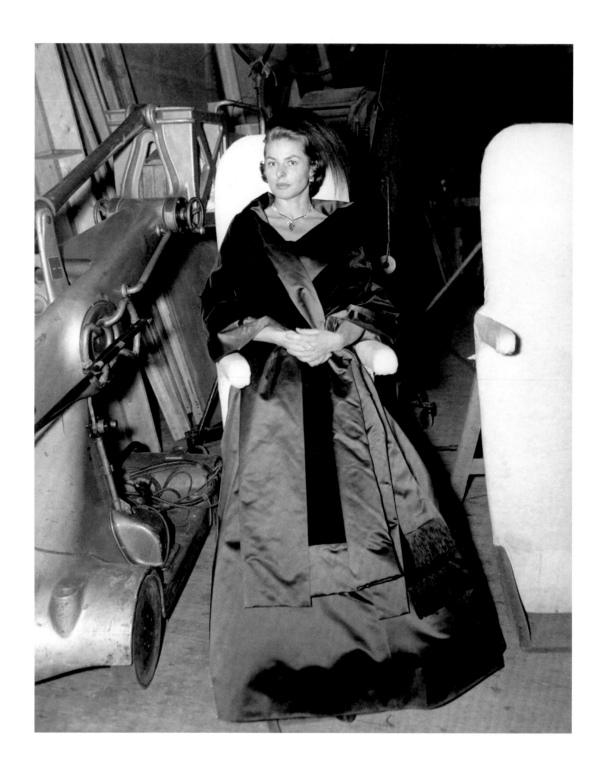

In *Indiscreet*, top billing is also given to the wonderful dresses of French couture. Dior, Balmain, and Lanvin are on hand with their best to ensure that Ingrid is dressed in the best contemporary fashion has to offer.

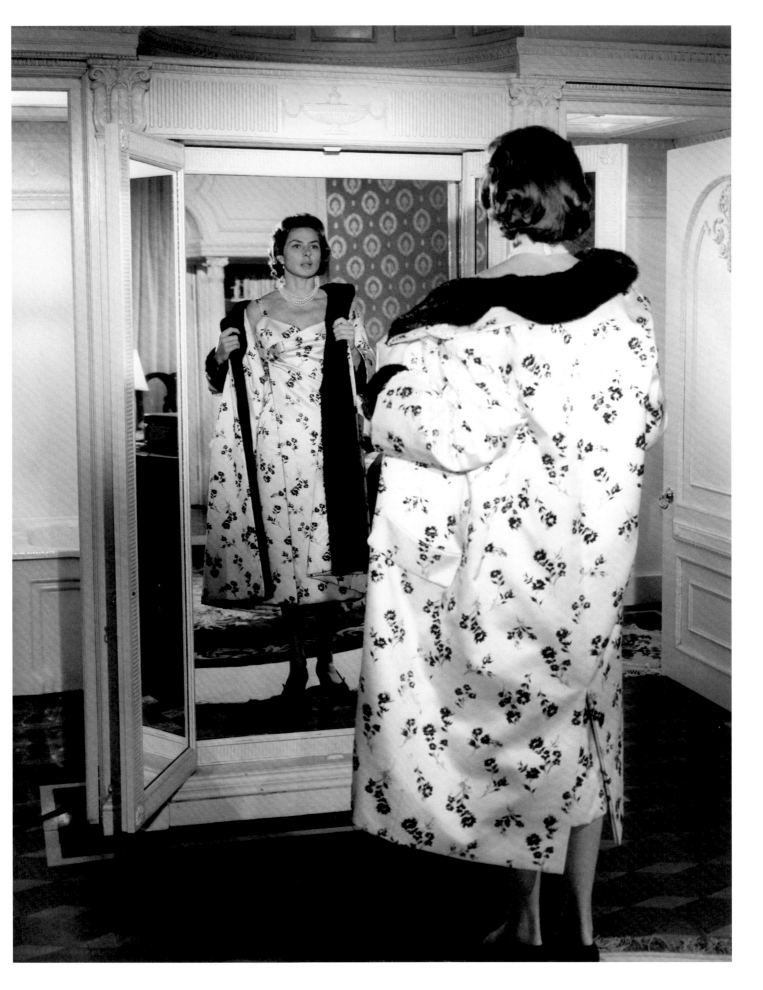

413

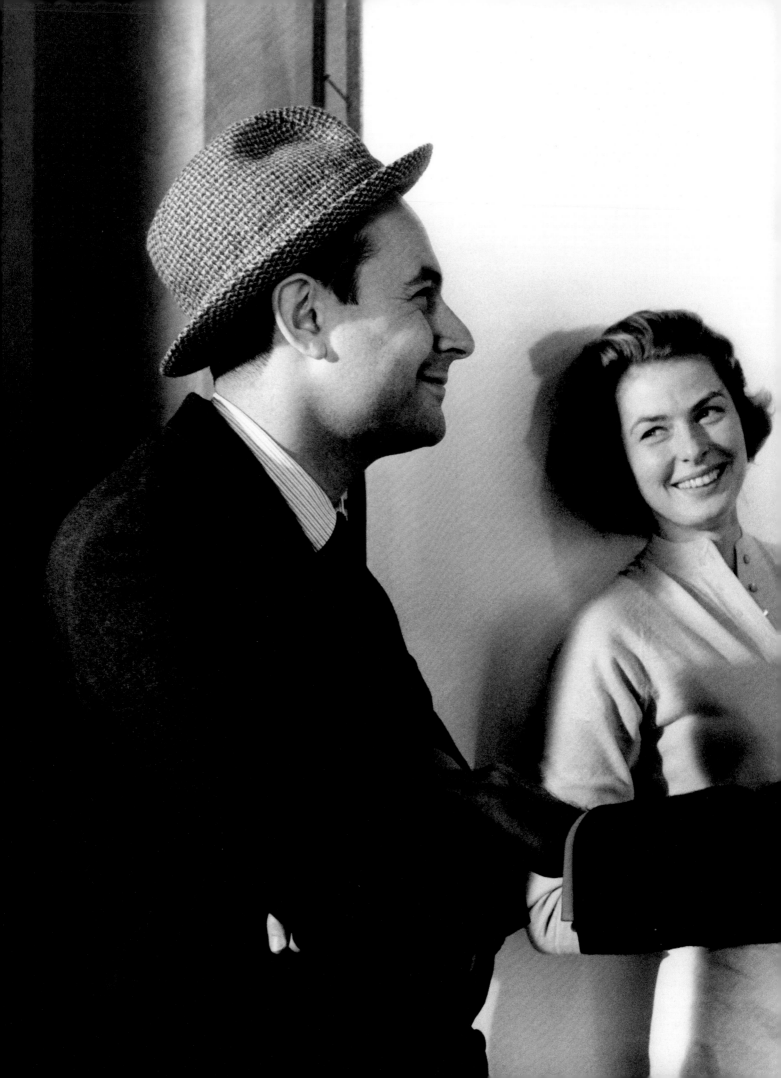

Group portrait with director Stanley
Donen (left), Ingrid, and Cary Grant.
Thirty-three-year-old Donen and Cary
Grant are the movie's co-producers.
London, 1958. Photographer unknown

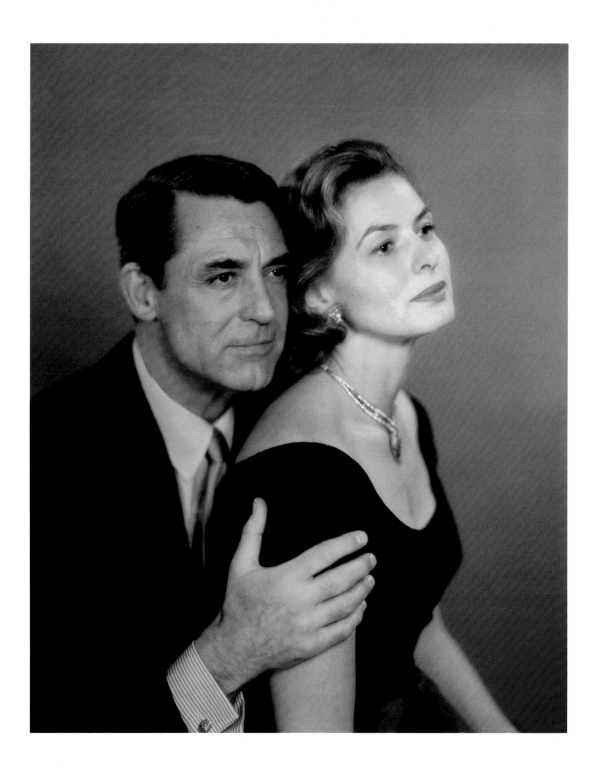

Color portrait of the main characters
in *Indiscreet*, which was filmed in color.
London, 1958. Photographer unknown

Right page
Ingrid and Cary Grant on the set of *Indiscreet*. Ingrid recalls: "*Indiscreet*
was a light comedy ... Cary Grant was an American diplomat protecting
his bachelor status by pretending he was already married. I found out
and asked how dare he make love to me when he wasn't even a married
man! It ended happily ever after. And that's what I wanted to be."[3]
London, 1958. Photographer unknown

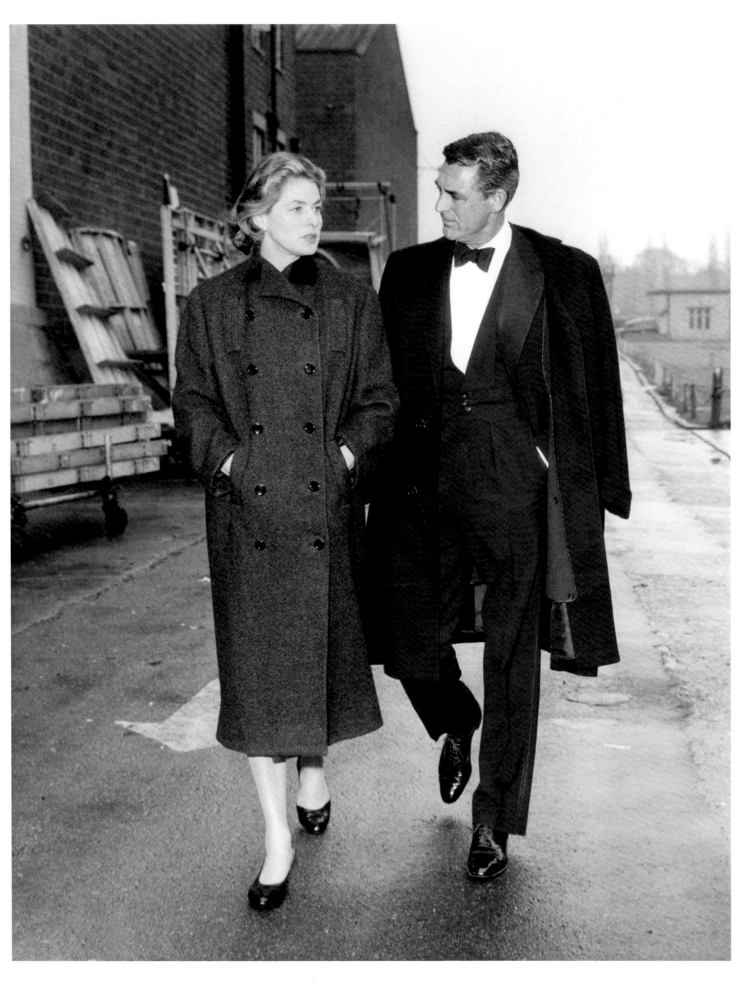

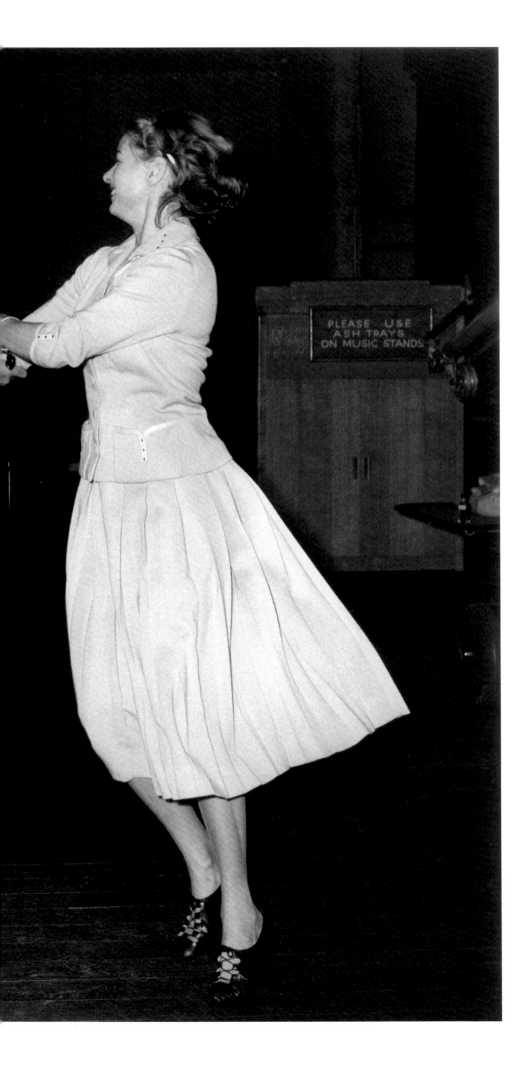

Ingrid Bergman and Cary Grant engage in a rollicksome dance. The movie is completed in early February of 1958. London, 1958. Photographer unknown

This portrait study by Cecil Beaton
probably dates back to Ingrid's stay
in London while she was doing
Indiscreet. London, 1957/58

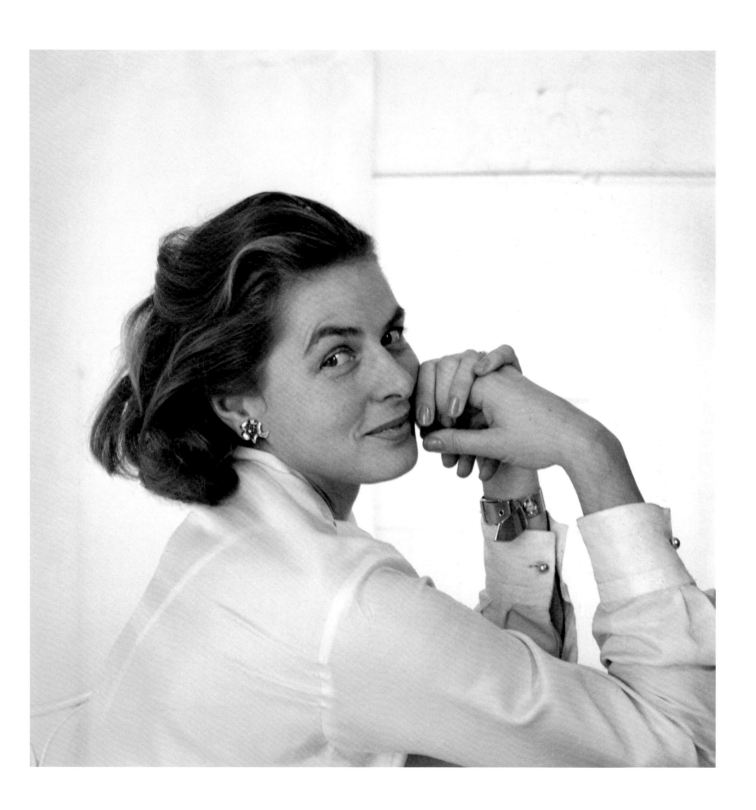

NEW LOVE WITH OWN ISLAND – MARRIAGE WITH LARS SCHMIDT

Ingrid Bergman and Lars Schmidt met briefly during a theater visit in late 1956. A handsome fellow Swede and the son of a family of ship owners from Gothenburg, he had gained financial independence as an international theater agent. Ingrid recalls the conversations that sealed their marriage plans:

"There was one thing that was very important to Lars: Danholmen, his island. If I wanted to spend summers in St. Tropez, Capri, or Monte Carlo, then the marriage was off. If I liked his island, we would get married. So in the middle of a Swedish winter we set off to see the island … I loved every minute of the journey and the island itself. So lonely … And such a feeling of isolation."[4]

One evening, she informs the children of the upcoming marriage … "I said to the six-year olds, Ingrid and Isabella, 'What do you think? How would you like it, if Mama got married again?' … 'Have you found somebody?' I said, 'Yes, you remember that nice person, Lars, who came to visit us here in Wales?' 'Oh, yes, we liked him; when can you marry him?' …

Robertino was less enthused: 'Yes, I don't mind Lars, I like Lars, but that doesn't mean you have to marry him.'[5]

Following the annulment of Ingrid's marriage to Rossellini, she and Lars are married on 21 December 1958. Lars Schmidt purchases an estate in Choisel, about an hour's drive from Paris, to serve as their family home.

The marriage between Ingrid Bergman and Lars Schmidt lasts for nearly twenty years, and it ends amicably—as did the marriage with Rossellini. For the first two years, however, it is fueled by the legal contest between Bergman and Rossellini for the custody of their mutual children.

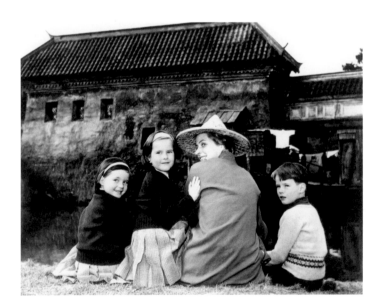

Ingrid Bergman informs her children of her marriage plans during the filming of *The Inn of the Sixth Happiness*. Ingrid is seen here with the Rossellini children. Wales, 1958. Photographer unknown

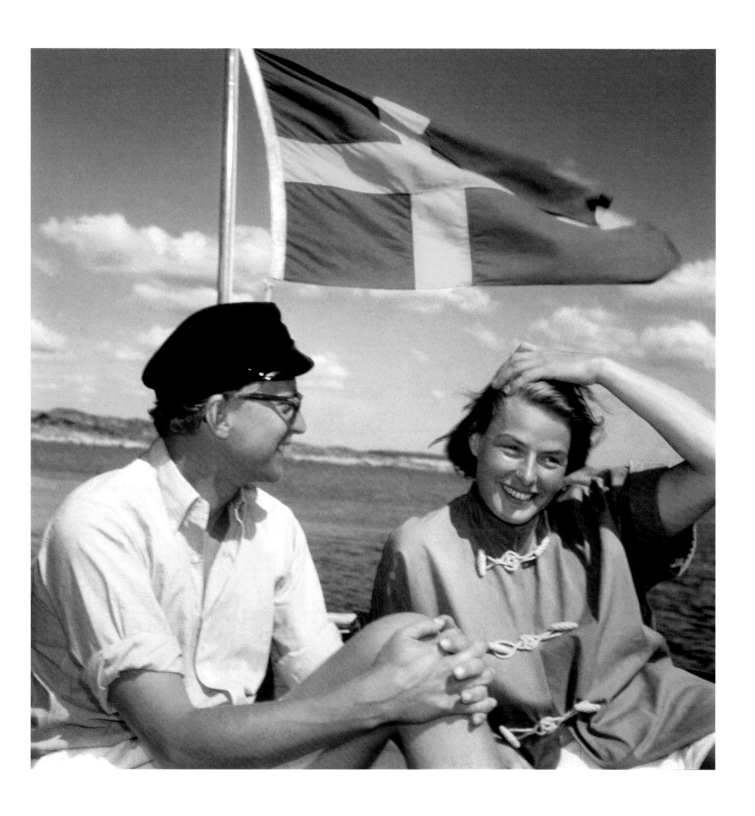

With the Swedish coast in the background, this photo shows Ingrid Bergman and Lars Schmidt on their way to Danholmen on 21 July 1958. Lars Schmidt bought the island as a summer residence. In future, Ingrid and he will spend the summer months here. Sweden, 21 July 1958.
Photo: Olle Seijbold

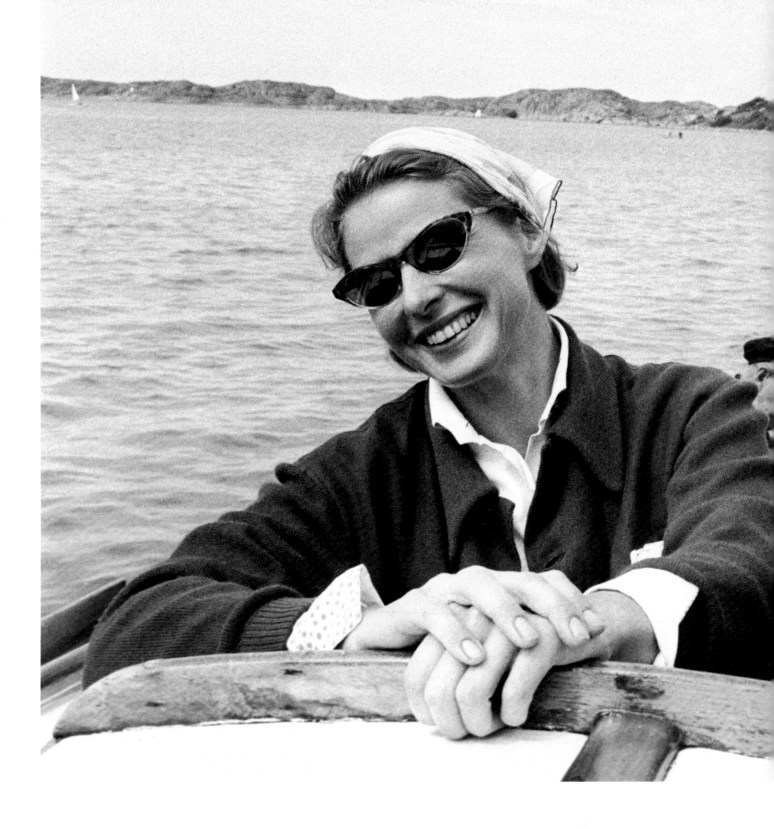

Two days later: once again on
the boat to Danholmen.
Sweden, 23 July 1958.
Photo: Georges Ménager

Following pages:
Ingrid Bergman hugs her dachs-
hund during a summer stay on
Danholmen. She is obviously
glad to be back in Sweden. The
photo calls to mind the carefree
holidays of her youth at Lake
Mälaren in 1932. Danholmen, 1959.
Unknown press photographer

The Inn of the Sixth Happiness

Following the Oscar-crowned success of Anastasia, 20th Century Fox offers Ingrid Bergman a multi-million dollar five-year contract. She declines. No more exclusive contracts; she wants to be free to choose her projects. She agrees, however, to do a screen adaptation of Alan Burgess's book A Small Woman directed by Mark Robson. It is based on the true story of Gladys Aylward, an Englishwoman who travelled to China at her own expense during the thirties in order to work there as a missionary. When the Japanese invaded China at the outbreak of the Second Sino-Japanese War, she led a hundred orphan children on a long march across a treacherous mountain region to safety. In view of her previous roles, Ingrid dryly comments: "I swore that I wouldn't play any more saints or nuns, so now I'm playing a missionary!"[6]

Fox wants to shoot the scenes set in China on Formosa (modern Taiwan), but when the Chinese Nationalist government insists that all criticism of conditions in pre-communist China be deleted, outdoor shooting is moved to Snowdonia in Wales. Ingrid subsequently writes to the real Gladys Aylward on Taiwan, where she was then living, and expresses her regrets at the change of location, as well as her admiration, and ensures her that "we are always trying to be throughout honest, and that the picture is made with great affection and respect for you." Still Ingrid feels compelled to add the disclaimer, "But after all it is a movie, and to become entertainment certain liberties must be taken."[7]

The principal male roles—the local mandarin of the town in which Gladys runs her "Inn of the Sixth Happiness," and a captain in the Chinese Army who falls in love with Gladys— are cast in accordance with the conventions of the day: "In Hollywood of the 1950s everything was possible, however, everything except casting Chinese as Chinese. Better, by far, to have a dying Robert Donat play the cynical mandarin, with a cynical mandarin's beard and eyebrows, and to have Curd Jurgens [sic] play the nationalist general [sic]—after all, a German was exotic enough."[8] Real Chinese are recruited locally as extras, however.

The two-and-a-half hour long movie with its crude exoticism and a cast of over two thousand doesn't gain intensity until near the end, however, when Gladys leads the group of orphans over the mountains, "a long sequence given enormous power by Ingrid's refusal to substitute pathos for tenderness."[9] This sets The Inn of the Sixth Happiness apart from the other saber-rattling Holly-wood war movies of the day.

Ingrid Bergman and Robert Donat in *The Inn of the Sixth Happiness*, Wales, 1958. Photographer unknown

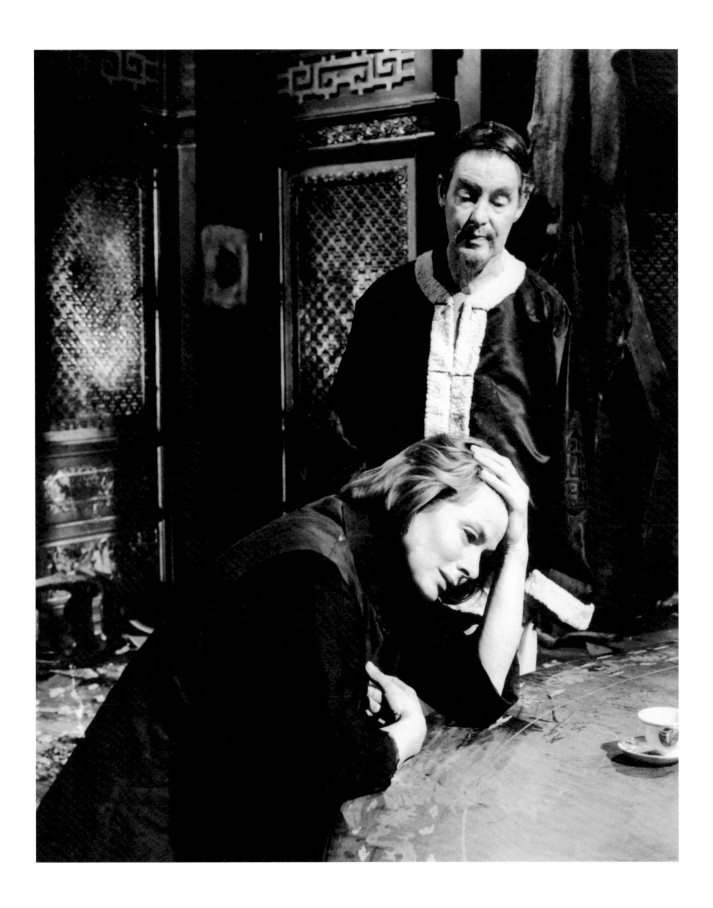

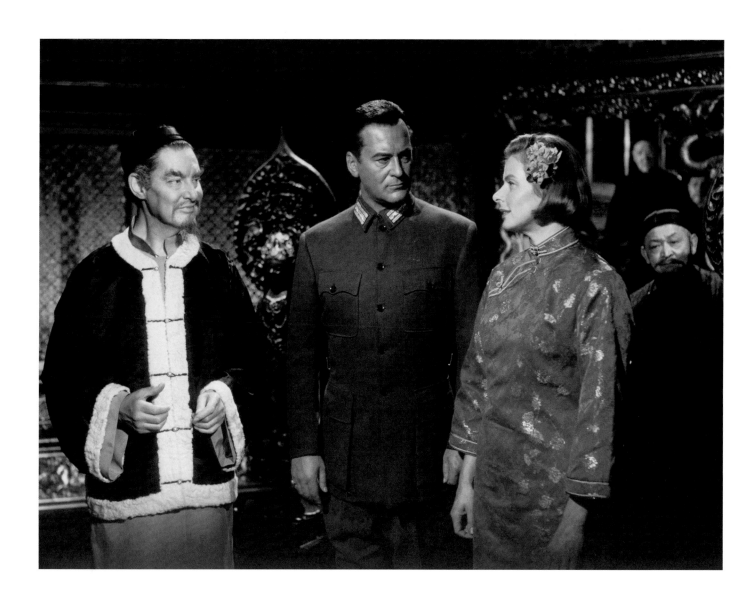

Ingrid Bergman's co-star is German actor
Curd Jürgens, who plays a Chinese Nationalist,
Captain Lin Nan. From a Hollywood stand-
point, Jürgens is at least a "Hun" and thus
close enough. Production still from *The Inn
of the Sixth Happiness* with Robert Donat,
Curd Jürgens, and Ingrid Bergman.
Wales, 1958. Photographer unknown

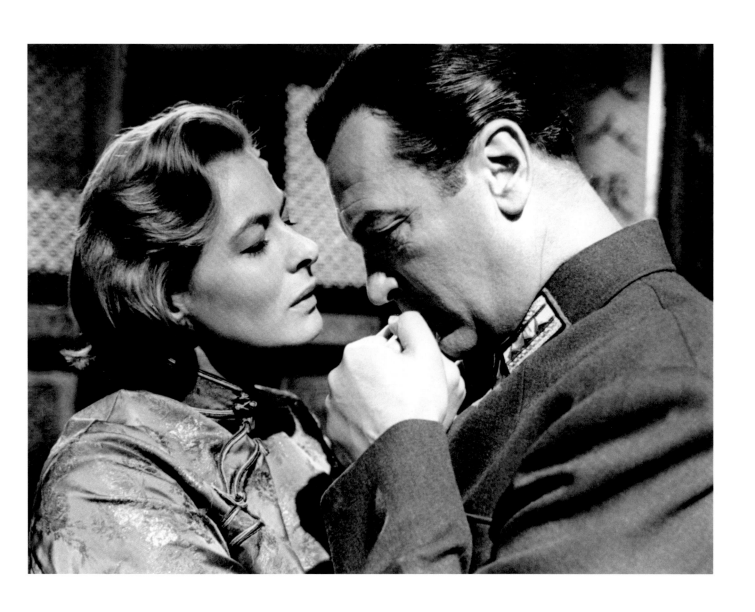

Ingrid with Curd Jürgens in *The Inn of the Sixth Happiness*. Wales, 1958. Photographer unknown

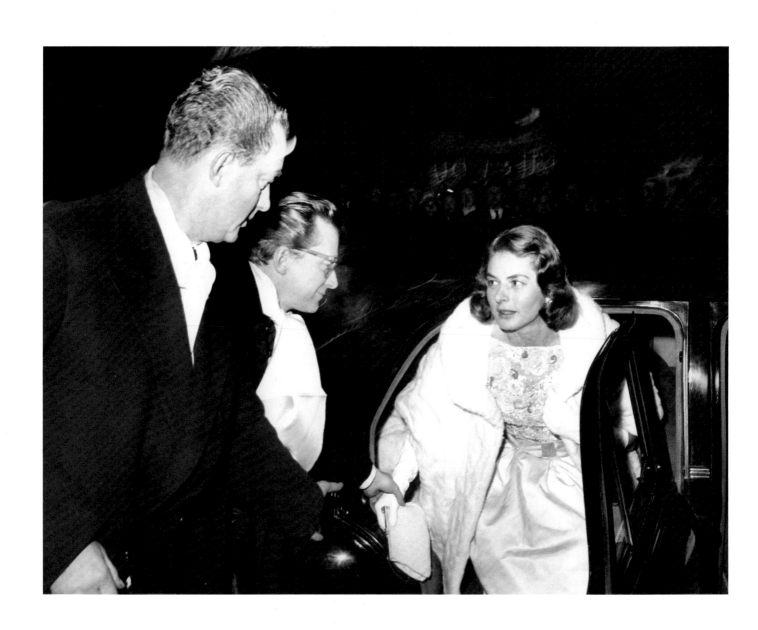

Lars Schmidt and Ingrid emerging from
a limousine. Possibly taken in Hollywood
where both attended the Oscar ceremonies
on 6 April 1959. Ingrid Bergman presents
the Oscar for Best Picture to Arthur Freed
for *Gigi*. April 1959. Photo: Arne Schweitz

Right page
Obviously the same occasion: Ingrid and
Lars Schmidt in a tender moment. After the
legal formalities have been clarified, Lars
Schmidt and Ingrid Bergman are married on
21 December 1958 in London. The heart-shaped
photo was cut out by Ingrid.

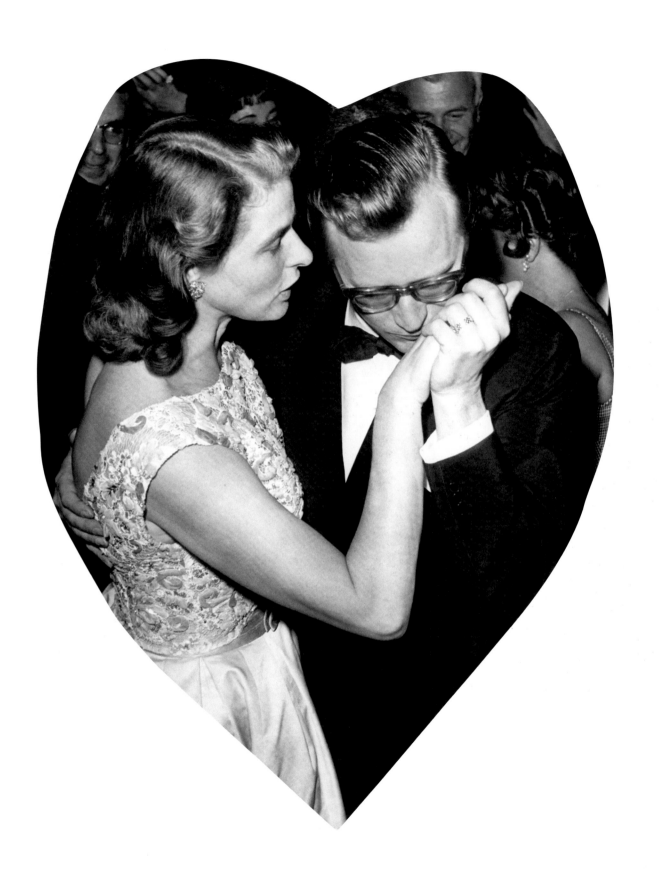

The pending marriage to Lars Schmidt casts a dark cloud: Roberto Rossellini commences the struggle for the children, once again focusing the attention of the international press on them in the fourth and final act of the Bergman/Rossellini marital drama. In what could be a scene from a Hitchcock film, the paparazzi catch Ingrid (cut off on the left), Robertino, Isotta Ingrid, and Isabella in a maelstrom of flashbulbs upon their arrival at the Paris Airport on 16 or 17 November 1959. Unknown press photographer

The twins are growing up. Isabella and
Isotta Ingrid with two donkeys hitched
to a cart. Ca. 1958 in Rome.
Photo: Roma's Press Photo

Right page
Fashion photographer Horst P. Horst
photographs Ingrid in Paris. 1958

Goodbye Again

After The Inn of the Sixth Happiness, more than two years will pass before Ingrid makes another film (she appears in her first television role during this time, however—The Turn of the Screw directed by John Frankenheimer and based on the novel of the same name by Henry James—a role that swiftly earns her an Emmy). During the fall of 1960 in Paris, she once again works with Anatole Litvak, her director in Anastasia, appearing in Goodbye Again, based on the novel Aimez-vous Brahms by the young French bestseller author Françoise Sagan.

Ingrid Bergman plays Paula, a forty-year-old interior designer and unhappy mistress of faithless businessman Roger (Yves Montand). When Philip (Anthony Perkins), the son of a client, falls in love with her, Paula begins an affair with the much younger man. Driven by jealousy, Roger proposes marriage, and she accepts. When Philip learns of this, he is deeply distraught and ends the relationship. Soon after their marriage, Roger resumes his infidelity, and Paula is left a twice-abandoned, middle-aged woman.

At age 45, Ingrid Bergman is simply too attractive for the role of Paula. The make-up artists "had to put shadows under her eyes and wrinkles on her neck to give her the required maturity!"[10]

With his hauntingly brilliant portrayal of Philip, Anthony Perkins is an even match for Ingrid Bergman, who is hard put to keep him from upstaging her. (Hitchcock's Psycho had begun its run several months earlier, and Perkin's performance as Norman Bates would gain him everlasting international fame). Yves Montand, known primarily as a singer in his native France, struggles with the English language, however.

The shooting attracts many celebrities to the set, as Ingrid relates in a letter to Liana Ferri: "… they have copied exactly the most popular nightclub in Paris at the present time—Epic Club—and we have "famous people" sitting around like Marcel Achard. Yul Brynner is playing an extra, and Sagan is playing herself sitting at a table too. As they are not getting paid, they get drinks!"[11]

Ingrid Bergman as Paula Tessier with 28-year-old Anthony Perkins as Philip van der Besh in *Goodbye Again*, directed by Anatole Litvak. Paris, 1960. Photo: Philippe Halsman

Ingrid Bergman in the night-club scene
with Anthony Perkins. Yves Montand
watches them in the background.
Set still from *Goodbye Again* taken
by Philippe Halsman. Paris, 1960

Photo taken during the filming
of *Goodbye Again*. Paris, 1960.
Photo: Raymond Voinquel

Photographer Yul Brynner captures Ingrid Bergman
in the mirror and himself in the background.
Yul Brynner worked as an unpaid extra in *Goodbye
Again*. Here he sneaks a peek into Ingrid's dressing
room. Paris, 1960. Photo: Yul Brynner

Right page
Ingrid smiling back. On the set
of *Goodbye Again*. Paris, 1960.
Photo: Yul Brynner

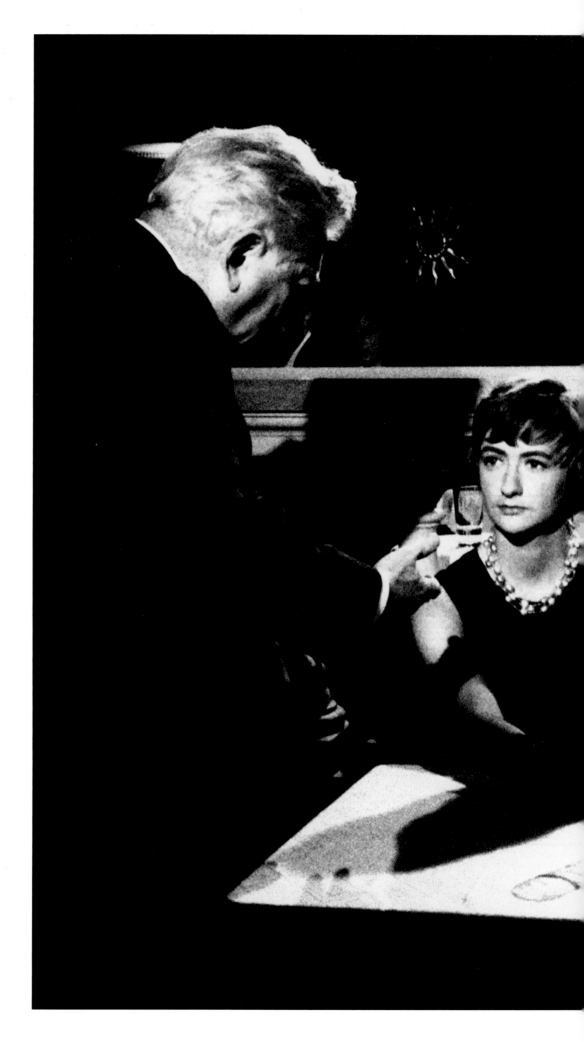

"The Magnificent Four" of *Goodbye Again*: director Anatole Litvak, author Françoise Sagan, Ingrid Bergman, and Yves Montand. Paris, 1960.
Set still: Inge Morath

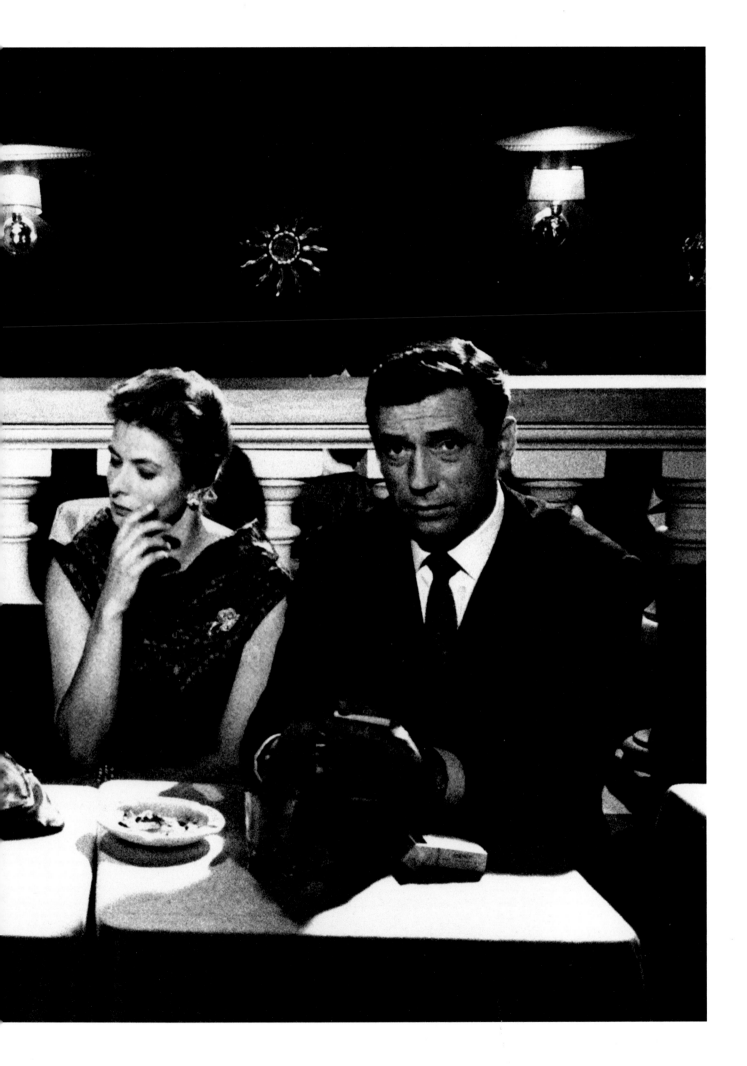

The Visit

In the fall of 1960, 20th Century Fox acquired the film rights for Friedrich Dürrenmatt's The Visit, which had run two years earlier on Broadway. The acquisition is made at the suggestion of Ingrid Bergman, who is eager to portray the "old lady" (the play's original title Der Besuch der alten Dame literally translates as The Visit of the Old Lady). The initial plan is to turn the dark tale of corruption and revenge into a sort of Western along the lines of Johnny Guitar, but the project is shelved until the summer of 1961, when Anthony Quinn acquires the rights and gives himself the roles of co-producer and leading man. The director is Bernhard Wicki, a Swiss citizen like Friedrich Dürrenmatt, and filming takes place in Rome in 1963.

The plot revolves around Claire Zachanassian, said to be the richest woman in the world, who returns to her hometown, the impoverished town of Güllen, after many years of absence. Hoping for a handout, the townspeople prepare a lavish reception. Claire makes a shocking proposal: she offers Güllen two million dollars in exchange for the killing of Serge Miller, the town's leading businessman. Claire was once Serge's lover, but when she became pregnant, he bribed some of the town's inhabitants to testify that she was a strumpet, whereupon she was driven out of town in disgrace. The townspeople initially want nothing to do with the killing of Serge, but they gradually warm to the idea.

Whereas Dürrenmatt's original play has a gruesome ending—Serge is lynched and Claire transports his body to a mausoleum in Capri in a coffin she brought along solely for that purpose, —The Visit ends with Serge being tried in court and sentenced to death. Claire stops the execution, however, and proclaims that it is a worse punishment for Serge to have to live among people who were willing to kill him for money.

"The movie is a flop, partly because of the modified ending, which turns the biting grotesque into a "run-of-the-mill morality drama."[12] Ingrid Bergman's sardonic comment:

They would have nothing to do with black comedy … and they refused to kill Anthony Quinn at the end. When Tony arrived; I told him, 'In the play you are killed,' and Tony replied, 'I expect they were hoping to get Cary Grant to play this part. If they'd known that I was going to play it, they would have killed me without hesitation.'"[13]

Nor was Dürrenmatt pleased with the film. Ingrid recalls that he "gave an interview in a newspaper saying that we had destroyed his play. He hadn't wanted me in the part; he'd wanted Bette Davis." Now in her late forties, Ingrid is in fact too young and attractive for the role of the diabolical old lady. "Well, here I am," Ingrid laments, "too old for the younger parts and too young for the older! What am I to do? One film a year is enough to keep me happy, but it must be something just right."[14]

Ingrid Bergman as Claire Zachanassian, who returns to take revenge on her former lover. Production still from *The Visit*. Rome, 1963. Photographer unknown

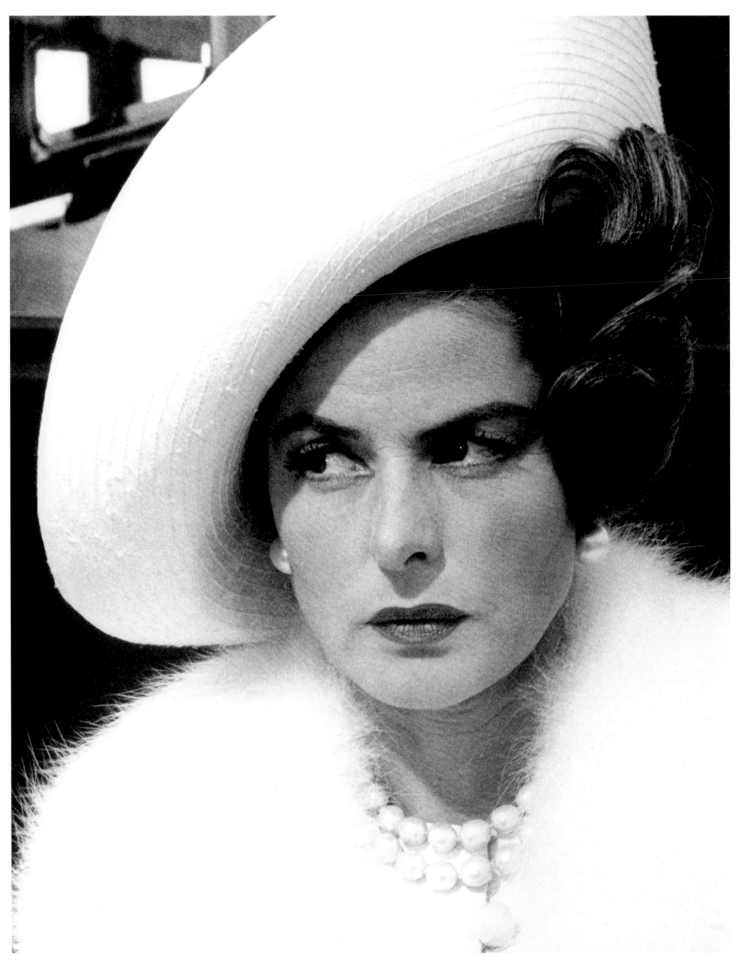

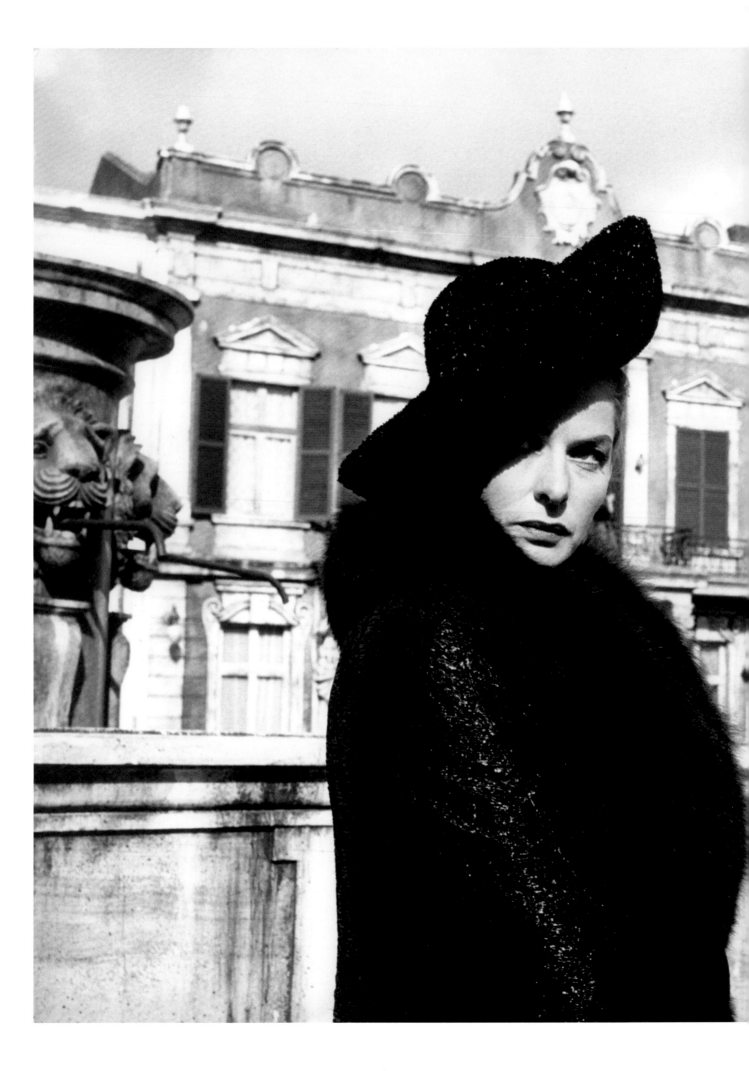

Ingrid Bergman as Claire Zachanassian.
Production still from *The Visit*. Rome,
1963. Photographer unknown

Following pages
Güllen, the fictitious town in Central
Europe in which the drama is set. All
the inhabitants have turned out to hear
what Claire has to say. Production
still from *The Visit*. Rome, 1963.
Photographer unknown

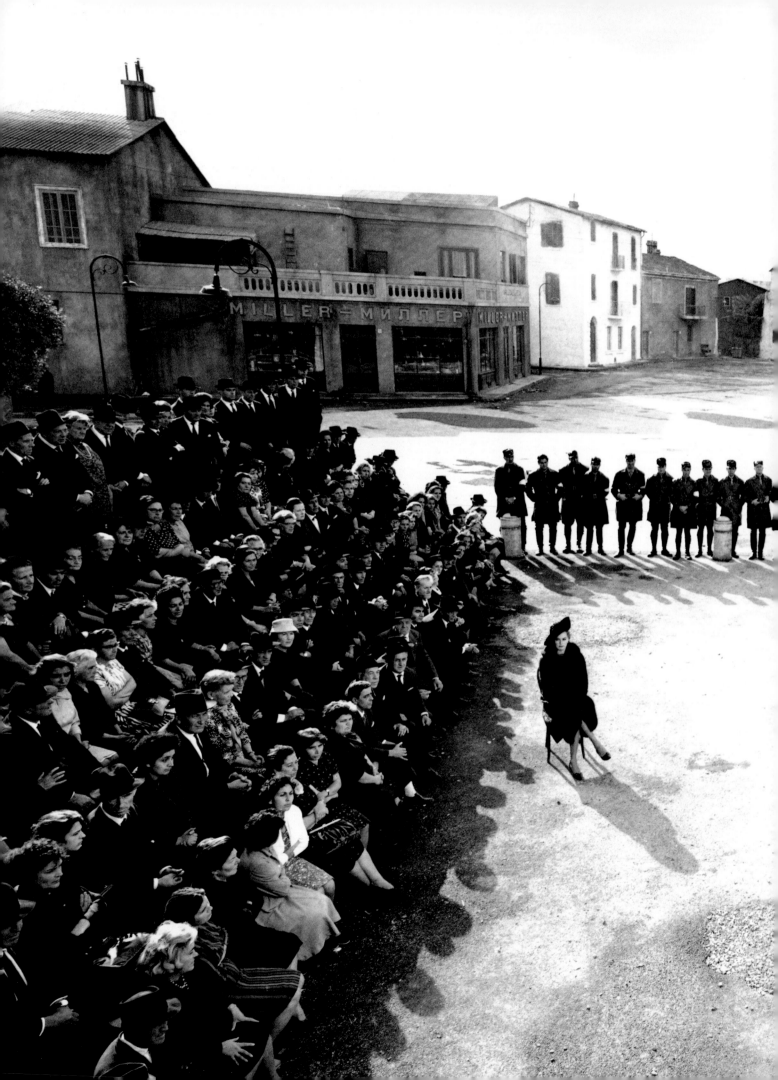

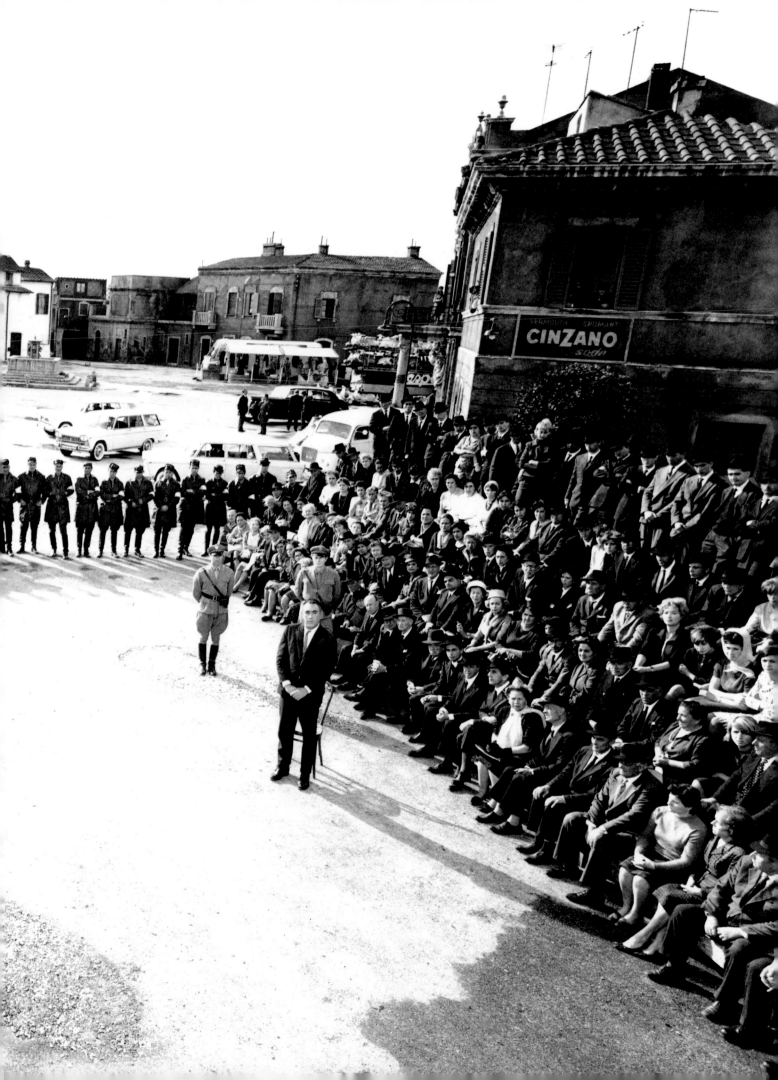

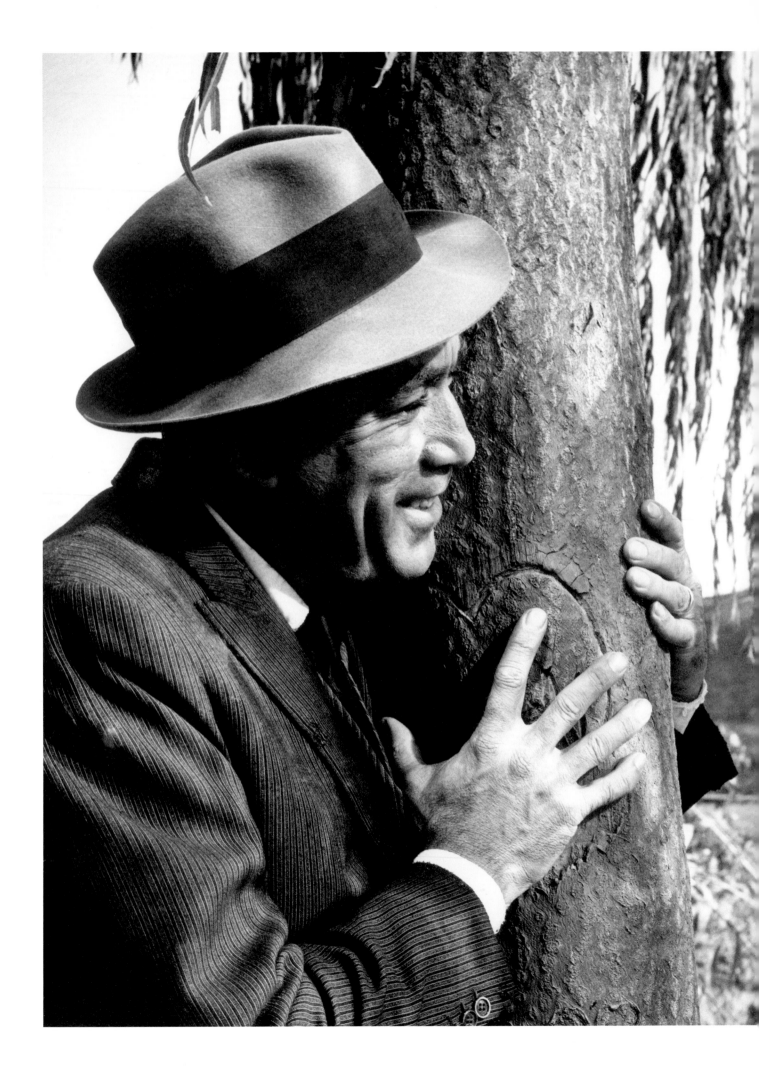

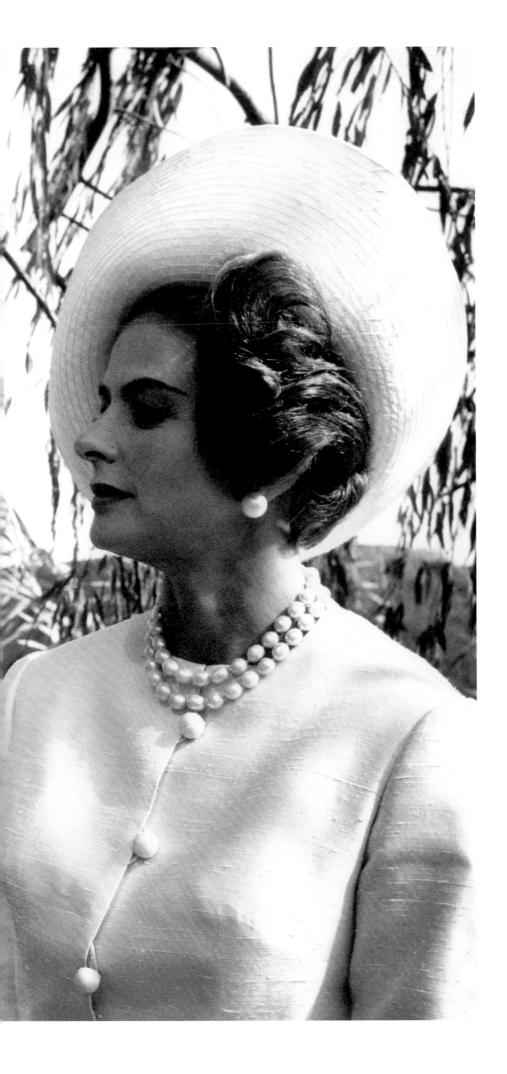

Ingrid Bergman and Anthony Quinn.
Quinn plays her former lover, Serge Miller.
Rome, 1963. Photographer unknown

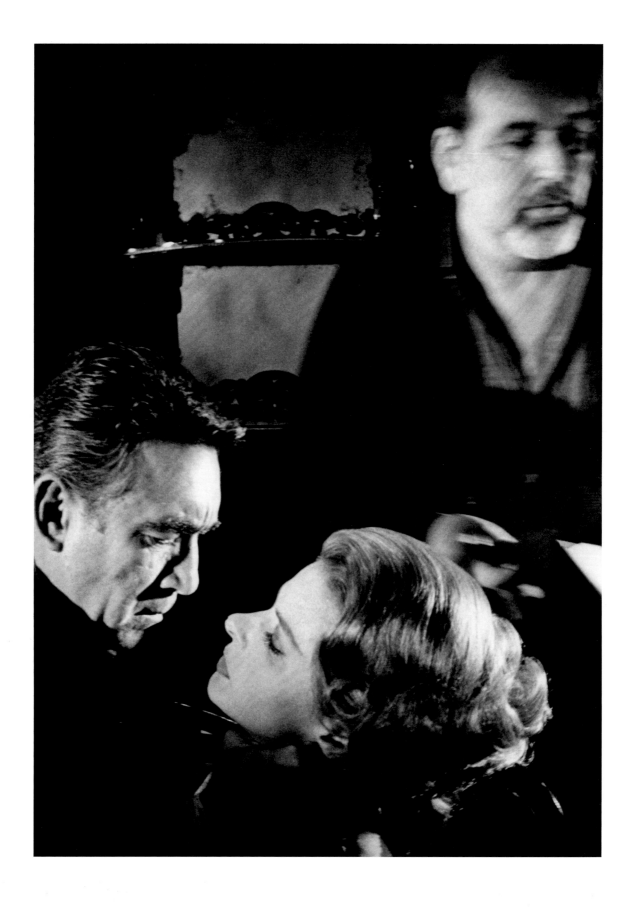

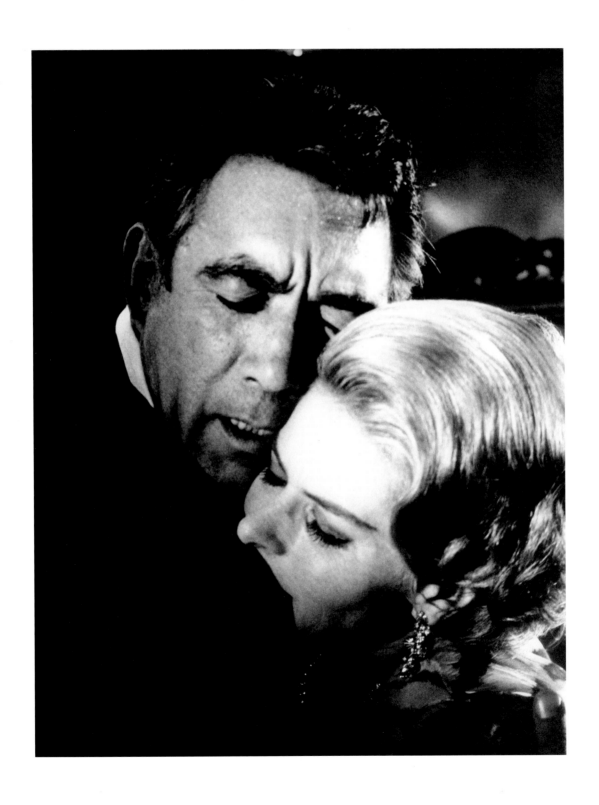

Left page
Ingrid Bergman and Anthony Quinn in *The Visit*.
In the background, Swiss director Bernhard Wicki.
On the set in Rome, 1963. Photographer unknown

This page
Ingrid Bergman and Anthony Quinn in *The Visit*. Rome, 1963. Photographer unknown

The Yellow Rolls-Royce

In May of 1964, before The Visit begins its run, Ingrid Bergman travels to London in order to shoot the final sequence of the anthology film The Yellow Rolls-Royce with Omar Sharif. The director of this star-studded round dance (the other episodes feature, among others, Jeanne Moreau and Rex Harrison, as well as Shirley MacLaine and Alain Delon) is Anthony Aquith, who became famous for his screen adaptations of George Bernard Shaw's Pygmalion und Oscar Wilde's The Importance of Being Earnest.

Ingrid Bergman later describes the project in these words: "The picture consisted of three sequences, and the yellow Rolls-Royce had the star part in each. I was a wealthy American widow who on her travels through Europe bumps into Omar Sharif who played a Yugoslav partisan. In the Rolls-Royce we rescue the wounded, get involved in the war, and have a very quick love affair. Then I go on my way with a lovely memory of 'Better to have loved and lost than never to have loved at all' – the theme of so many films in those days …"[15]

The Yellow Rolls-Royce is a lucrative undertaking for Ingrid Bergman: she earns $275,000 for four weeks of work, but the movie is a flop with audiences and reviewers, just like The Visit before it.

Ingrid Bergman as the rich American widow Mrs. Gerda Millett, the main character in Episode III of *The Yellow Rolls-Royce*. London, 1964.

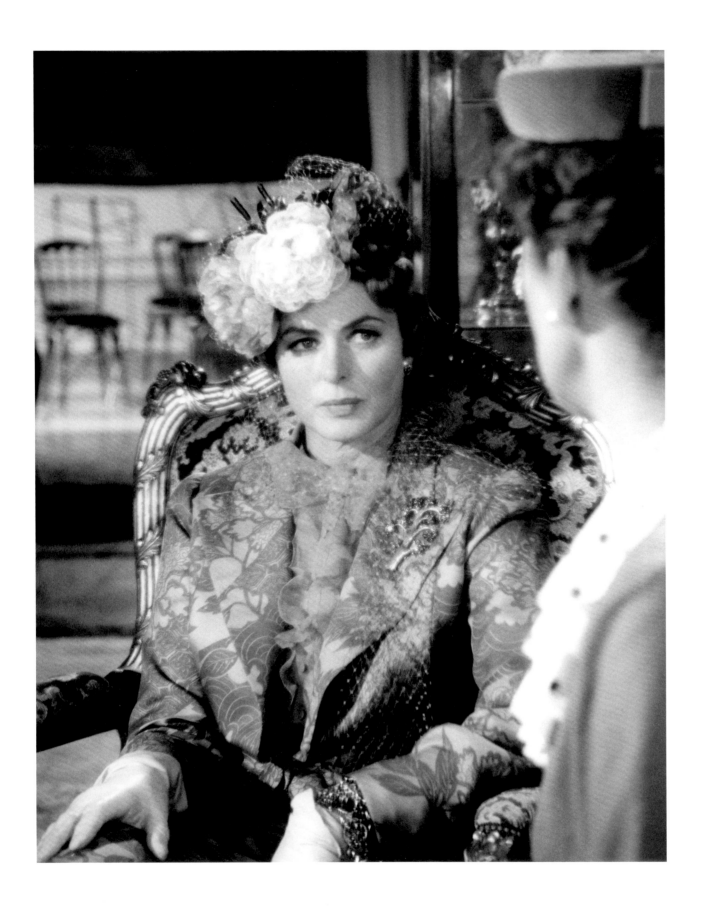

Group photo with the main protagonists on
the set of *The Yellow Rolls-Royce*: Omar Sharif
(left), the visiting Lars Schmidt (center), and
Ingrid Bergman (right). Behind them, the
true star of the movie: the yellow Rolls-Royce.
London, 1964. Photographer unknown

Stimulantia

Gustaf Molander, the man who discovered Ingrid Bergman while she was attending drama school in the early thirties and with whom she made her first movies, fetches her back to Sweden in 1967 for the anthology film Stimulantia. Molander is seventy-six at the time and almost deaf.

It is Ingrid's first Swedish picture in over twenty-five years:

"The film was to be made up of seven different episodes, each done by a different, famous director. Ingmar Bergman was going to direct one episode, and they had approached Gustaf Molander to do another.

… eventually he relented and said, 'All right, but I'll only do it on one condition: that you get Ingrid to work with me again.' As soon as they told me that, I said, 'I'm coming, I'm on my way.' They asked, 'Don't you want to know anything about the story?' I said, 'No, just tell Gustaf I'm coming.'

It was so wonderful to be directed by him again … with Gunnar Björnstrand, my old friend from the Royal Dramatic School, playing opposite me."[16]

In his segment titled Smycket, Molander films a screen adaptation of Guy de Maupassant's The Necklace. It is the story of a woman married to a poorly paid civil servant. Acting out of vanity, she borrows a diamond necklace from a friend so that she might attend a ball. The necklace goes missing, the couple borrows money to buy a deceptively similar piece from a jeweler, and returns the replacement to the owner as the original. For many years, they are forced to lead a dreary, meager life in order to repay the debt thus incurred—until the haggard wife learns from the owner that the lost necklace had only been a cheap imitation.

The Necklace is the longest and most conventional, yet in its old-fashioned way quite pleasant, episode in Stimulantia. The Swedish press writes: "Gustaf Molander has Maupassant and Ingrid Bergman, and, with the right that age commands, the largest slice of the cake. Accordingly, this slice appears to be baked in a different world. Ingrid Bergman is beautiful and the crystals ring when she speaks."[17]

Ingrid Bergman in the Swedish anthology film *Stimulantia*. Working with Gustaf Molander, the director who discovered her, she plays the leading role in the screen adaptation of Guy de Maupassant's novel *The Necklace*. Production still from *Stimulantia*. Stockholm, 1964.

Ingrid Bergman and Dirk Bogarde, with whom she
stayed while appearing in *A Month in the Country* in
Guildford. As she later recounts: "The entire stay in
Guildford was one of the happiest times of my life."[18]
Guildford, summer of 1965. Photo: Eve Arnold

VII.

THEATER AND LATER FILMS – ILLNESS, FAREWELL, AND DEATH
1965–1982

THEATER IN LONDON

Ingrid Bergman's extraordinary and commercially successful theater career began with a telephone call from London in 1965:

"The next thing I knew Michael Redgrave was ringing from London. A new theater was opening in Guildford and he wanted the first production to be Ivan Turgenev's *A Month in the Country*. Would I play Natalya Petrovna with him as Mikhail Rakitin? I said 'no' immediately … Then Lars came into the room and overheard what I was saying. He took the phone out of my hand and said, 'Michael, send her the play because it fits her like a glove. It's a marvelous part for her.'

I looked at him and said, 'But we promised each other we'd have these three months in the summer without work. Now you want me to go to England and work in this play?'

'Yes, I don't want to be accused of having been an obstacle in your life. This is a marvelous play and after Guildford you might well go to London.'" [1]

A Month in the Country premieres in Guildford, near Oxford, and due to its rousing success, it does indeed move to London in the fall.

Numerous stage roles follow in the years to come, such as Deborah Harford in *More Stately Mansions* by Eugene O'Neill in New York (1967); in London she portrays Lady Cecily in *Captain Brassbound's Conversion* by George Bernard Shaw (1972), Constance in *The Constant Wife* by Somerset Maugham (1975), and Helen Lancaster in *Waters of the Moon* (1979).

Bad news awaits when *A Month in the Country* completes its run in early March 1966: Isabella, who will turn 14 that summer, displays obvious signs of scoliosis. The ensuing treatment of this insidious spine disease will last nearly two years, during which Isabella is bedridden much of the time. She must also endure major surgery lasting seven hours and vigorous physical therapy. From the spring of 1966 until the summer of 1967, Ingrid dedicates herself solely to caring for Isabella. It is one of the few times in her professional life that she doesn't work. The only break in this hiatus is a two-week stay in London where Ingrid records Jean Cocteau's play *The Human Voice* for television in December of 1966.

Her daughter's scoliosis is cured, but the struggle with her own illness begins just a few years later: Ingrid Bergman is diagnosed with breast cancer in 1974. For eight years she fights back with her characteristic zeal, undergoing numerous operations and nevertheless starring in four major films. But it is all in vain: on 29 August 1982, her 67th birthday, Ingrid Bergman dies in London.

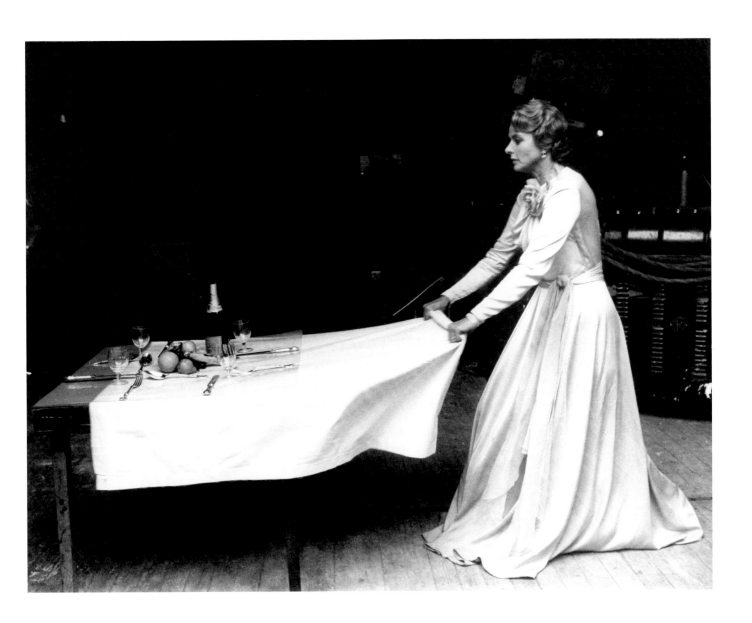

Ingrid Bergman as Natalya Petrovna in Michael Redgrave's production of Turgenev's *A Month in the Country*. The play enjoys great success in Guildford before moving to London, where it has an eight-month run. "It was during the London run that we had a surprising happening. One night there were a couple of empty seats left at the end of a row, and just as all the lights went down a couple walked in and occupied them. Immediately the ushers began to whisper: 'Isn't that the Queen? Yes, it must be.' ...The manager rang up Emile Littler who owned the theater ...In the intermission he went down and escorted the Queen and her Lady-in-Waiting to a small private room. The Queen said very graciously, 'Tell the cast that I'm not coming backstage because I'm not working. It's my night off. But also tell them I enjoyed the play very much.' She stayed until the final curtain, and we all felt so very pleased that she'd spent her one night off with us."[2]
Production still. London, 1965. Photographer unknown

Lars Schmidt and Pia Lindström; Ingrid
is visible on the television monitor.
Photo: George Konig
Possibly taken during a television
recording of *The Human Voice*. London,
December 1966.

More Stately Mansions

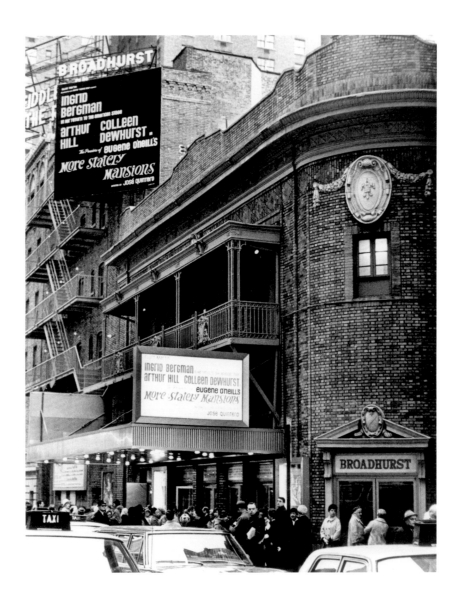

The Broadhurst Theatre on Broadway announces the guest performance by the Ahmanson Theatre from Los Angeles of Eugene O'Neill's *More Stately Mansions*, in which Ingrid Bergman plays the role of Deborah Harford. Ingrid recalls working with José Quintero: "We got on, and I liked him very much, though there were arguments during the rehearsals. In my first entrance I have a meeting in the forest with my son. José said, 'You come running in and you stop—dead still—and stand there transfixed.' I insisted, 'But I'm a mother who hasn't seen her son for four long years. She's going to meet him at this little deserted cottage in the forest. Surely she'll creep in hesitating and worried, frightened to see him, fearful that she's aged.' José said, 'I see her flying in ... So I said, 'Well, I don't want to stop rehearsals, but perhaps we can discuss it later ... Now, what's next?' " 'Next you come right down stage to the footlights. Right down to the steps there, and you sit on the steps there.'

"I looked at the front of the stage in horror. 'You mean I dash in, stand transfixed, then walk right down to the audience and sit in their laps?' ... 'Yes, do that.' 'But they'll hear my heart going bang-bang-bang. I can't do that ... In those very first moments I'm *frightened* of the audience ... I'm terrified of the audience.' ... From then on, José Quintero was a bit terse, and didn't say anything much to me except 'Well, what do you suggest?' So I said, 'Well if I could sit back there where the cottage is, get my breath, and let my heart calm down, and then begin the monologue—when I've found my voice then I'll come down front and sit with the audience.' ... We became such good friends. José is a marvelous director. We worked very well; we both compromised. I did his run onto the stage, and then he let me sit down to catch my breath; then I came and sat down next to the audience. And, of course, on opening night I found myself staring straight into the eyes of Sam Goldwyn who was in the front row. That helped my performance no end!"[3]

New York, 1967. Photographer unknown

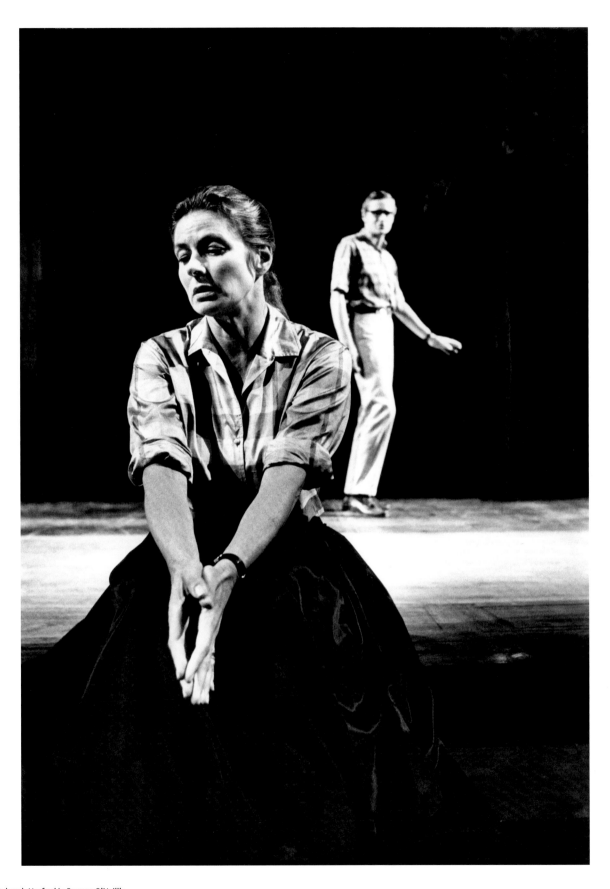

Ingrid as Deborah Harford in Eugene O'Neill's
More Stately Mansions. Fall of 1967, Los Angeles
or New York. Photo: Bill Ray for *Life*

Cactus Flower

Cactus Flower is the first movie Ingrid Bergman had shot in Hollywood in over twenty years. It provides her with an opportunity to once again prove her talent as a comedienne. Her co-stars are Walter Matthau, the American film comedian *par excellence*, and 23-year-old Goldie Hawn in her first screen role.

Ingrid Bergman plays Stephanie Dickinson, the self-sacrificing but demure receptionist of dentist Julian Winston (Walter Matthau). Julian is having an affair with Toni (Goldie Hawn), a little blonde he deceives into believing he is married. When lovesick Toni turns on the gas only to be saved in the nick of time by her neighbor, Julian proposes marriage, claiming that his wife has agreed to a divorce. Toni insists upon meeting his wife. Julian is now in desperate need of a surrogate wife and asks Stephanie to stand in. In the role of the dentist's wife, plain, farouche Stephanie is transformed into a temperamental, glamorous, and seductive woman.

At 54, Ingrid Bergman is not initially sure if she is right for the role of 35-year-old Stephanie. She insists that Mike Frankovich, who is producing the movie for Columbia, take some test shots:

"Mike and his director, Gene Saks, arrived in Paris and came to see me. When they arrived, I stood under a very bright light, and Mike walked around me grinning broadly, examining me from every angle like you do if you're looking over a head of cattle for sale. Then he announced his verdict:

'Ingrid. You're fine! And you'll also be pleased to know that we have a very good cameraman!'[4]

The press agrees: 'Miss Bergman lets her inhibitions down and becomes the swingiest swinger of a swinging set … Goldie Hawn is so funny for awhile, you think she will steal the show, but you change your mind when Bergman puts her mind to the comedy in her role.'"[5]

Ingrid Bergman as the receptionist of dentist Julian Winston (Walter Matthau) in the comedy *Cactus Flower*. Production still from *Cactus Flower*. Hollywood, 1969. Photographer unknown

Ingrid Bergman with Goldie Hawn (left) in *Cactus Flower*. Ingrid is mindful not to let the young television star steal her fire. Scene from *Cactus Flower*. Hollywood, 1969. Photographer unknown

A Walk in the Spring Rain

The news that Ingrid Bergman is again working in Hollywood spreads like wildfire through the film industry and immediately whets the appetite of other producers. The shooting of *Cactus Flower* had not even begun when producer Stirling Silliphant offered Ingrid the leading role in *A Walk in the Spring Rain,* a screen adaptation of Rachel Maddux's novel of the same name. Silliphant intends to write the screenplay and direct the picture himself, and he tells Ingrid that: " … if she was going to be in America for *Cactus Flower,* he could arrange an equally expeditious schedule for *A Walk in the Spring Rain* later that spring. Two films in succession with high salaries, a triumphant return to Hollywood, and she would be back in Europe with Lars by summertime."[6]

Ingrid Bergman describes the plot of *A Walk in the Spring Rain* in the following words: "I'm just the ordinary wife of a college professor … He decides to take a year's vacation, a sabbatical, to write the book he's always wanted to write. We go down to Tennessee to live in an old cottage. I meet the local handyman, a man steeped in the countryside, uneducated but very male … We fall in love. His teenage son hears about it. In a fight with his father, the boy is accidentally killed. Anthony Quinn and I realize it's all over. We say goodbye. My husband decides he's a failure as a novelist. We go back to New York."[7]

Ingrid Bergman agrees to make the picture on the following conditions: she wants Anthony Quinn for the role of the lover—an unusual choice because Quinn is normally typecast as a Latin American or Mediterranean character; she wants Charles Lang, the cameraman for *Cactus Flower*; and she gets involved in the screenplay. She knows and likes the literary source, which Kay Brown had recommended to her some time before.

The movie's premiere is a gala occasion. Nevertheless, there is widespread disappointment. Comforting a weeping Rachel Maddux, Ingrid shares the feeling of most of those present: the picture simply didn't work although no one really understood why:

"The book had been so well written, full of the country and the true feelings of a woman in this situation …

The film had been a good try. We'd started off with such high hopes … We'd worked hard. We'd done our best and at the end of it we'd made Rachel Maddux cry."[8]

With Anthony Quinn in *Walk in the Spring Rain*. Production still. Tennessee, 1969

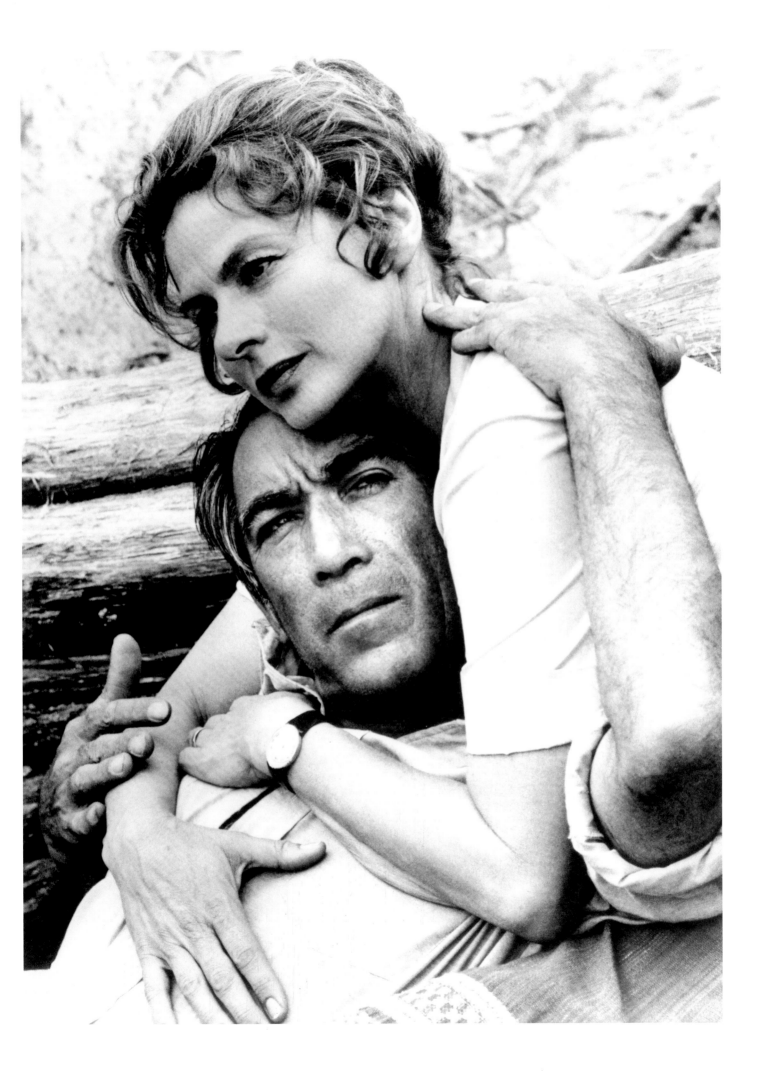

Royalty visits the dressing room during
a performance of *Captain Brassbound's
Conversion*. From left to right: a youthful
Princess Caroline of Monaco; Her Serene
Highness Princess Grace of Monaco (alias
Grace Kelly); and Ingrid Bergman, Probably
taken in London, 1971/72. Photographer
unknown

Left
With son Roberto Jr. during the film festival
in Cannes, 1973. Photographer unknown

Right
A smile from the president of the jury.
Cannes, 1973. Photographer unknown

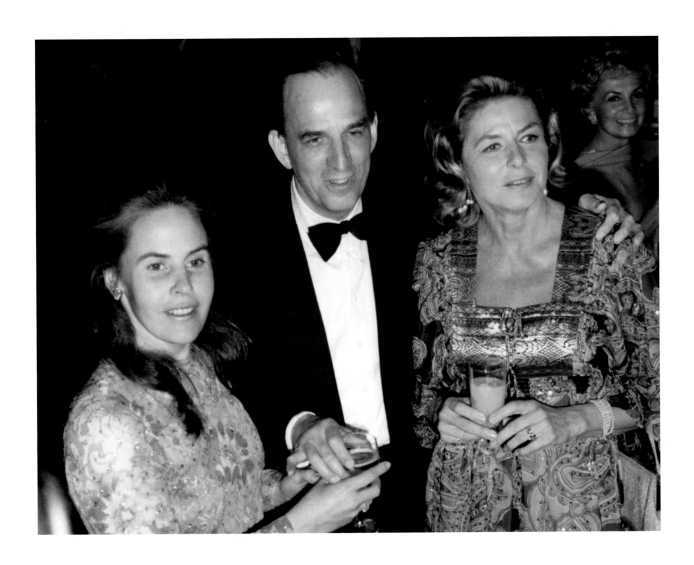

Ingrid and her compatriot, the great Swedish director Ingmar Bergman, meet for the first time in Cannes. They agree to collaborate, but an opportunity doesn't present itself until five years later. From left to right: Ingrid van Rosen (Ingmar Bergman's wife since 1971), Ingmar Bergman, and Ingrid Bergman. Cannes, 1973. Photographer unknown

From 1973 to 1975 Ingrid Bergman is a triumphant suc-
cess onstage in Somerset Maugham's *The Constant Wife*.
Directed by Sir John Gielgud, the troupe's tour includes
performances in Brighton, London, and finally the US.
Just as the play begins its run, Ingrid learns that she
has breast cancer. She postpones surgery until late 1974,
however, when the play's London engagement is over
and the filming of *Murder on the Orient Express* is
completed.

Ingrid in the back seat of a limousine, surrounded by
photographers and fans, following a performance,
probably in New York, ca. 1975. Photographer unknown

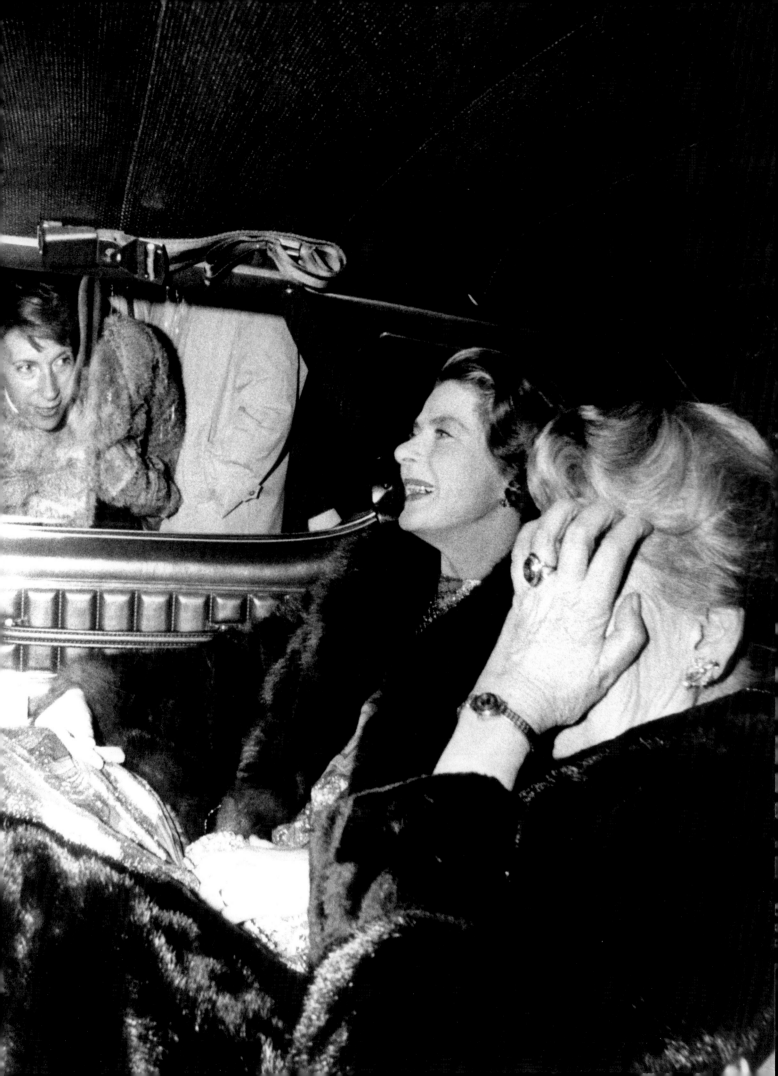

Murder on the Orient Express

Ingrid Bergman is in London appearing in Sir John Gielgud's production of Somerset Maugham's *The Constant Wife*, the box-office hit of the season, when Sidney Lumet offers her a part in the screen adaptation of Agatha Christie's *Murder on the Orient Express*. Boasting an illustrious cast, the picture is shot during daylight hours in London because almost everyone involved has prior theater commitments in the evenings.

The distinguished ensemble consists of, among others, Lauren Bacall, Vanessa Redgrave, Wendy Hiller, Jacqueline Bisset, Richard Widmark, Sean Connery, Anthony Perkins, Sir John Gielgud, with Albert Finney playing Belgian detective Hercule Poirot. With the exception of Poirot, whose task it is to solve the murder on the Orient Express, the roles carry about the same weight. Lumet foresaw Ingrid for the role of the aged Russian Princess Dragomiroff, but she is keen on another role: "Why in the world should I wear a make-up mask and play the Russian princess when you have a very good Swedish missionary part just made for me. I mean, I can put on a very good Swedish accent."[9]

Lumet acquiesces. As Greta Ohlsson, Ingrid Bergman has a couple of short appearances with almost no lines and a four-and-a-half minute scene in which she must portray an entire scale of emotions which "ran the gamut from annoyance to sorrow to fear to the kind of nervy sweetness of a maiden lady missionary."[10] Sidney Lumet films the scene as a single continuous shot—a challenge to Ingrid's acting skills that she masters brilliantly. It is also a masterstroke of comedy destined to earn her a third Oscar, this time as Best Supporting Actress. The award takes her completely by surprise—she only attended the Academy Awards in order to accept an honorary Oscar for Jean Renoir, her friend since the days of *Elena and her Men*, who is mortally ill.

On the set of *Murder on the Orient Express*. From the left: Michael York (as Count Rudolf Andrenyi), Jacqueline Bisset, Lauren Bacall, and Ingrid Bergman (as Swedish missionary Greta Ohlsson). Shooting commences in the spring of 1974 in London where Ingrid Bergman is appearing evenings onstage in *The Constant Wife*. Although her role is very small and her longest scene lasts only four-and-a-half minutes—filmed by Sidney Lumet as a single continuous shot—it will nevertheless secure her a third Oscar.

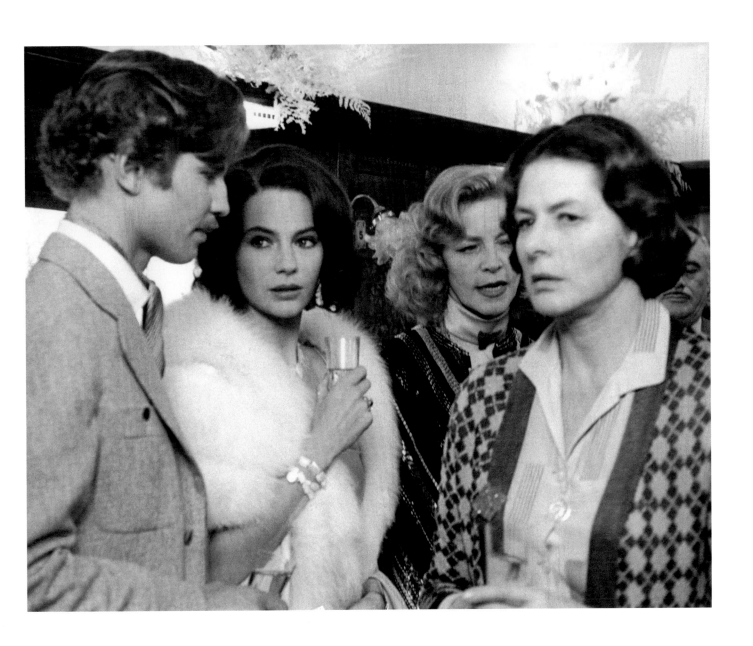

Ingrid as a Swedish missionary in
Murder on the Orient Express. London,
1974. Photographer unknown

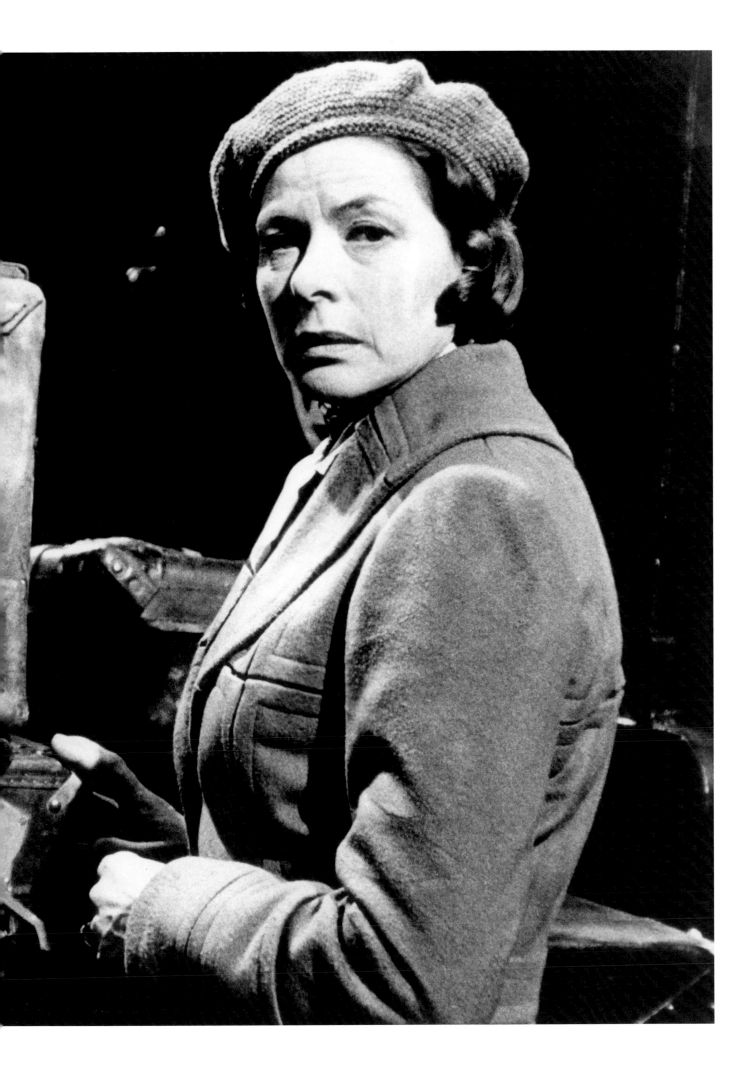

Ingrid Bergman with Lauren Bacall in *Murder on the Orient Express*. London, 1974.

Following pages
Following pages: Group portrait of the cast of *Murder on the Orient Express*. Rarely before and rarely thereafter has such a high-caliber cast of international stars been assembled together in one movie. From left to right, rear row: Colin Blakely, Michael York, Sir John Gielgud, Albert Finney, George Coulouris, Sean Connery, Martin Balsam, Jean-Pierre Cassel, Anthony Perkins, Dennis Quilley
front row: Vanessa Redgrave, Rachel Roberts, Lauren Bacall, Jacqueline Bisset, Ingrid Bergman, Wendy Hiller
center front: director Sidney Lumet
London, 1974. Photographer unknown

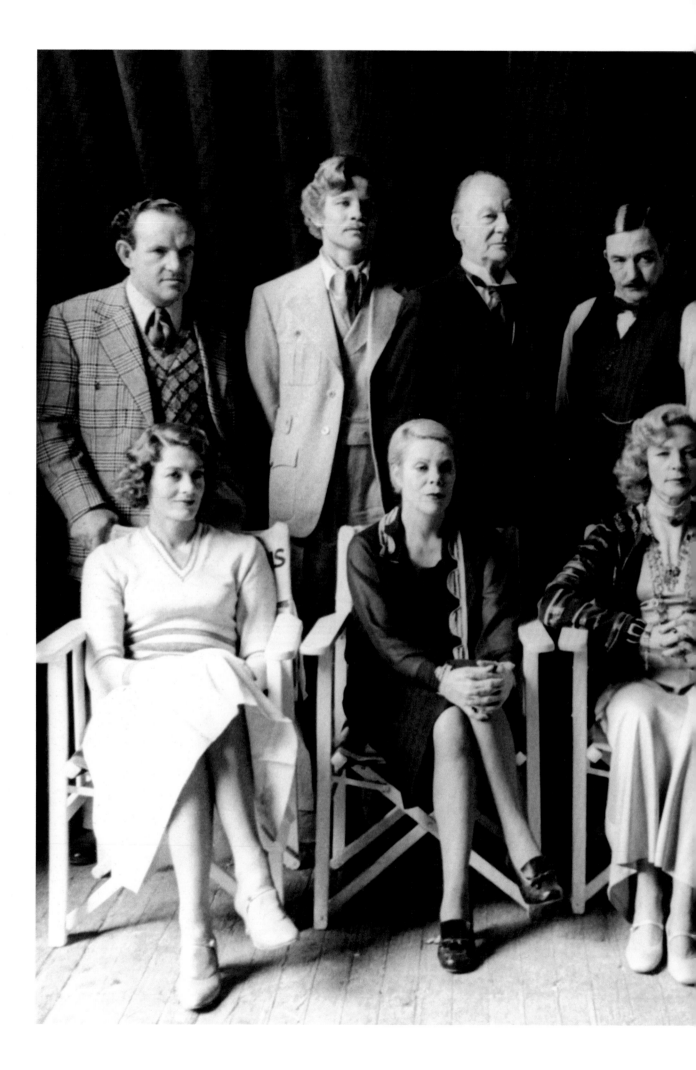

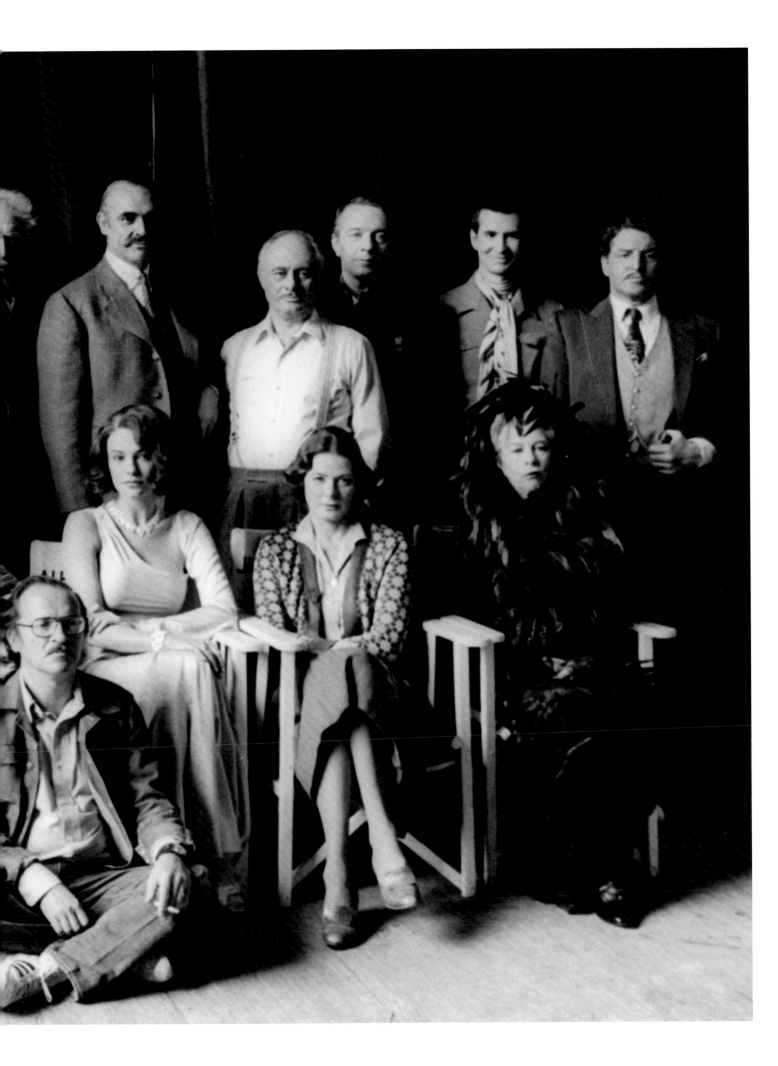

A Matter of Time

One could say that *A Matter of Time* is a family and intergenerational project: it is director Vincente Minnelli's last picture and the first time he has worked with his daughter Liza Minnelli; and Ingrid Bergman is working together for the first and only time with her daughters. Isotta assists the make-up artists, and Isabella has a minor role as a nun. It is Isabella's first film and it will be the last for Charles Boyer, who is working with Ingrid for the first time since they appeared together in the screen adaptation of Remarque's *Arch of Triumph* thirty years earlier.

The plot also revolves around reminiscence and the present. It is based on the true story of the Italian eccentric, the Marchesa Casati. Youthful Nina (Liza Minnelli) works as a chambermaid in a dilapidated hotel in Rome, where she meets one of the hotel's long-time residents, the aged Contessa Sanziani (Ingrid Bergman), whom everyone considers crazy. Knee deep in debt and abandoned by her husband and friends, she lives in the memories of her past as a courtesan. Nina and the Contessa become friends. The Contessa dies, and Nina is discovered by a movie director. The chambermaid is transformed into a movie star; on the way to a press conference, thoughts of the aged Contessa fill her head.

The Italo-American co-production is filmed in the original locations in Rome and Venice in 1975. Minnelli doesn't sentimentalize the story, and Ingrid plays an "irrational, cantankerous, foolish old woman whose inclinations are annoying."[11]

Despite the all-star cast, the response of American movie audiences is so disappointing that *A Matter of Time* is not distributed internationally.

Ingrid Bergman as the aged Contessa in *A Matter of Time*. Rome, 1975. Photographer unknown

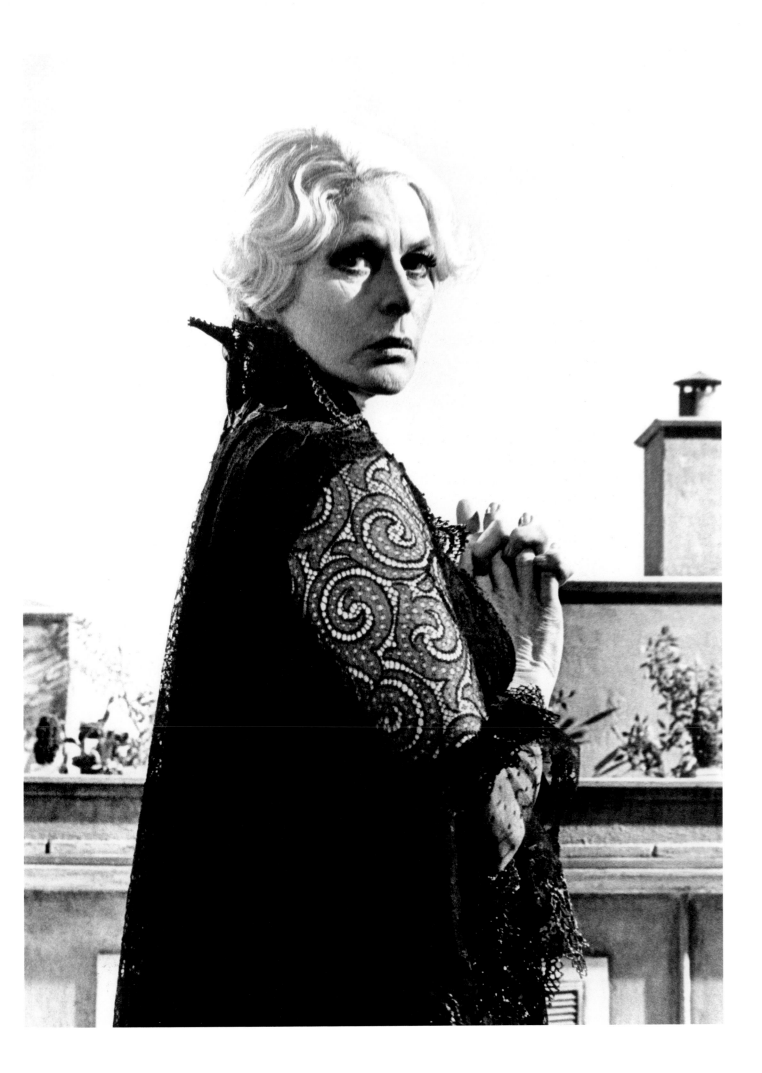

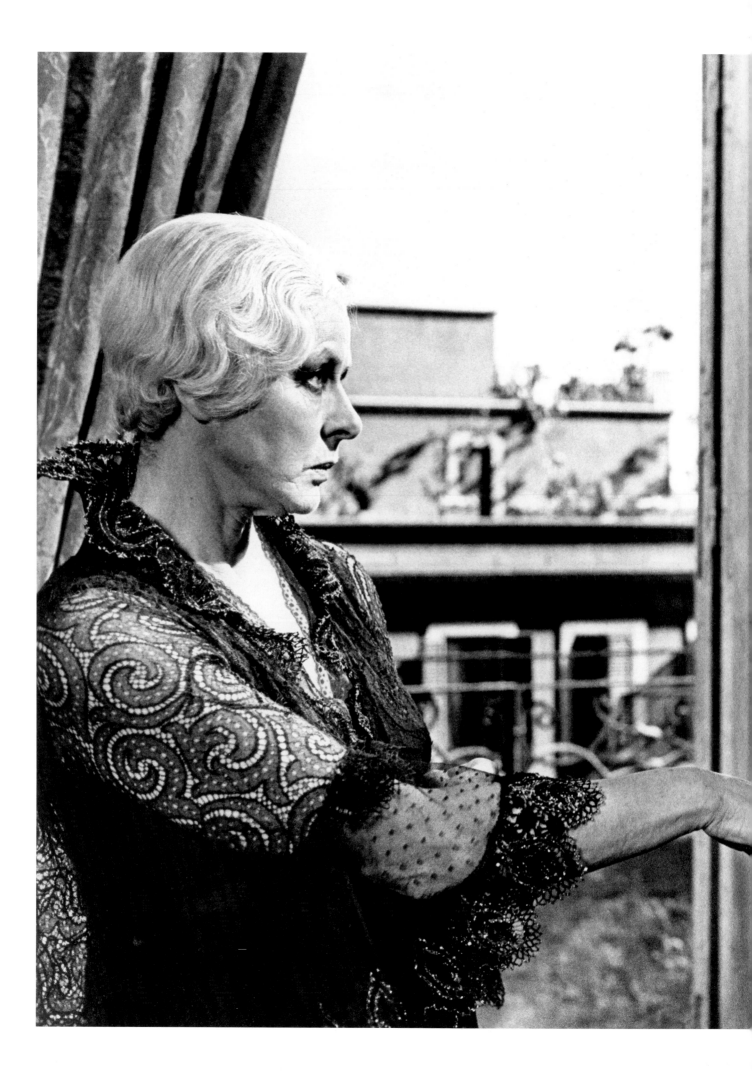

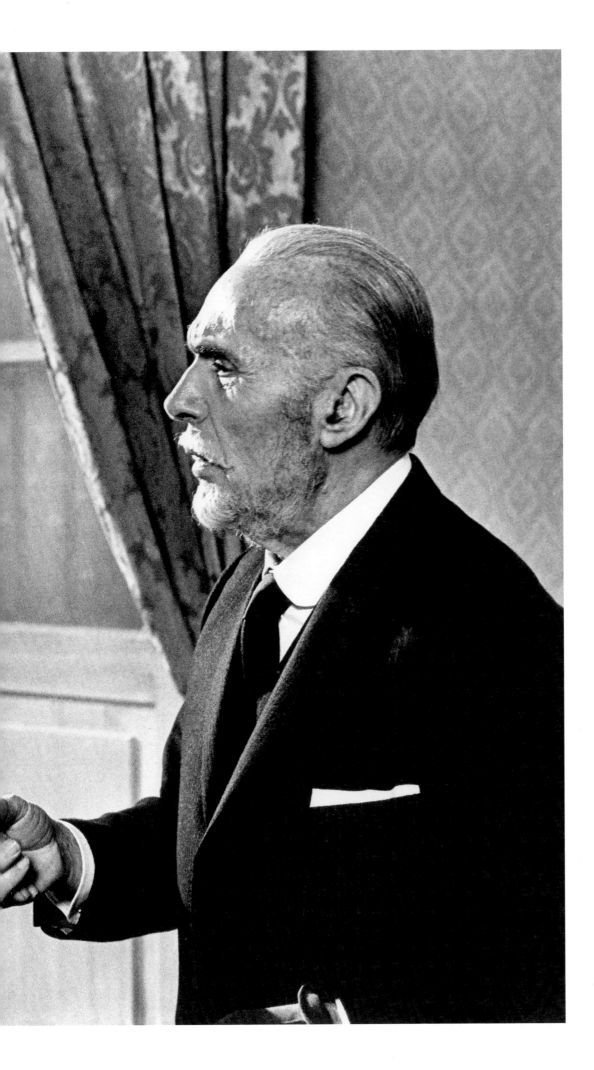

A Matter of Time sees her reunited with Charles Boyer. Rome, 1975. Photographer unknown

Following pages
On the set of *A Matter of Time*. From the left: director Vincente Minnelli, his daughter Liza Minnelli, and Ingrid Bergman. Rome, 1975. Photographer unknown

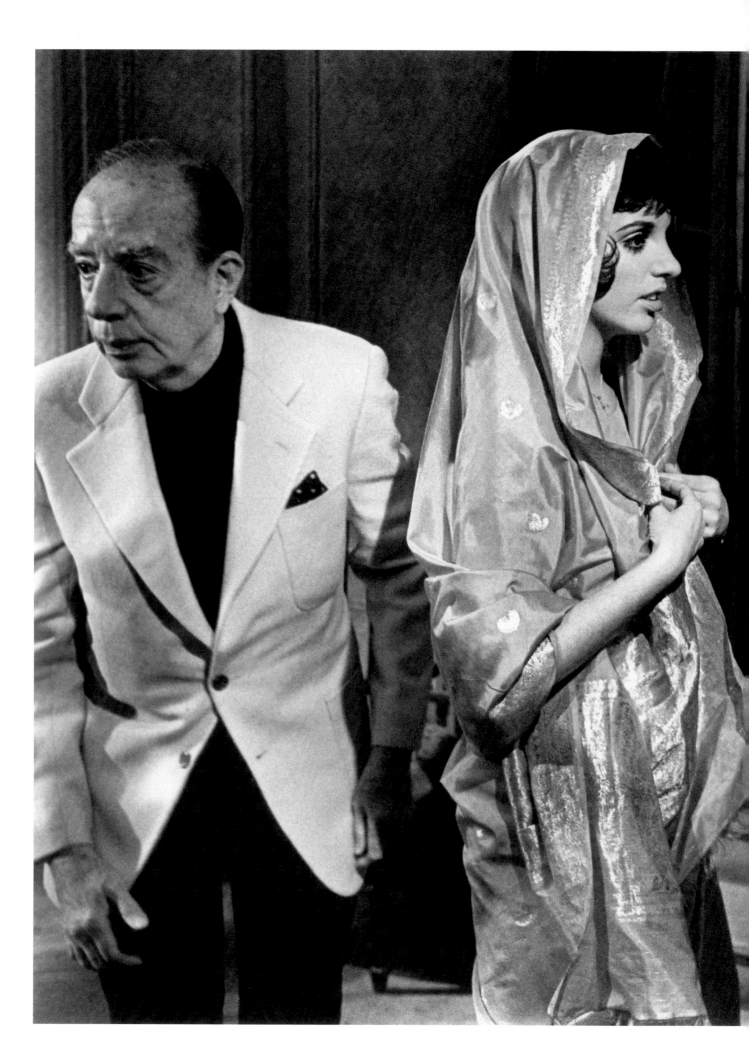

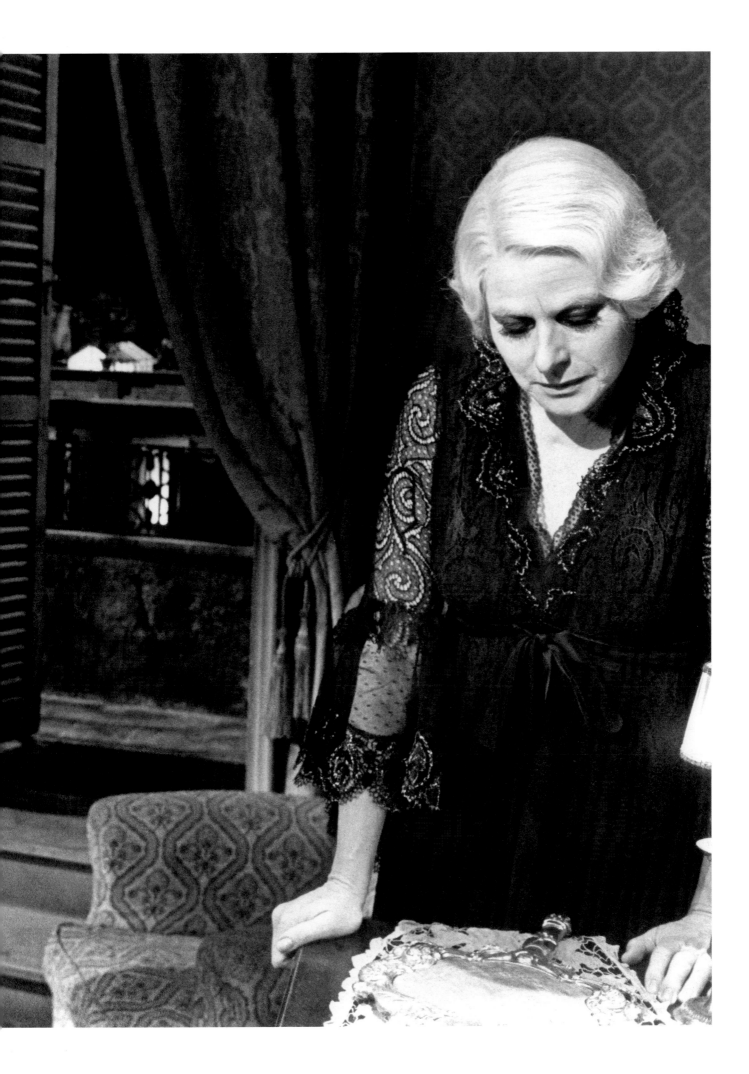

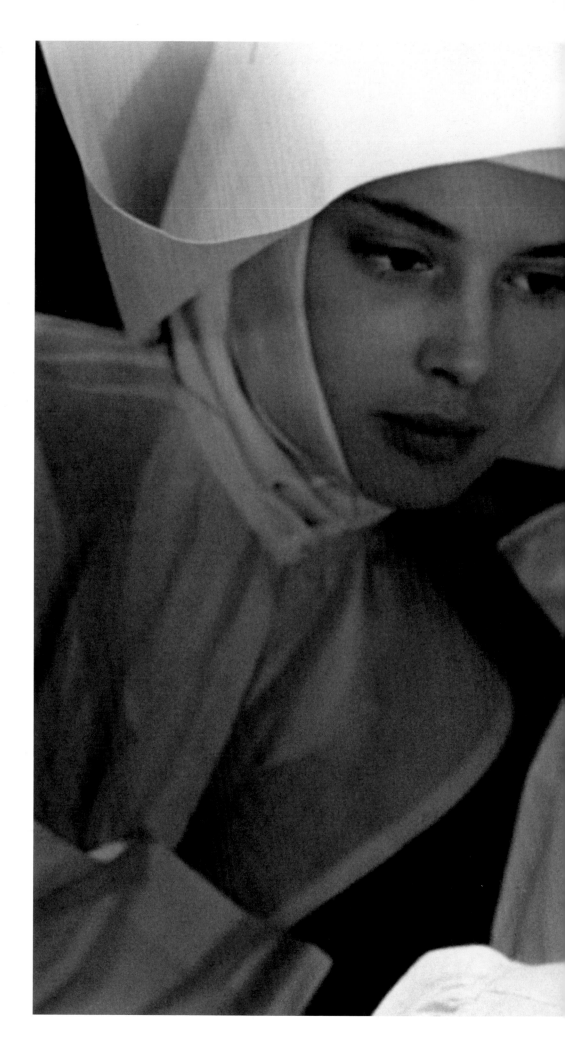

A small role was reserved for Ingrid's daughter Isabella Rossellini. She makes her film debut as a nun at her mother's side. Ingrid's other daughter, Isotta Ingrid, works on the set, gathering her first film experience as a make-up artist. Production still from *A Matter of Time*. Rome, 1975. Photographer unknown

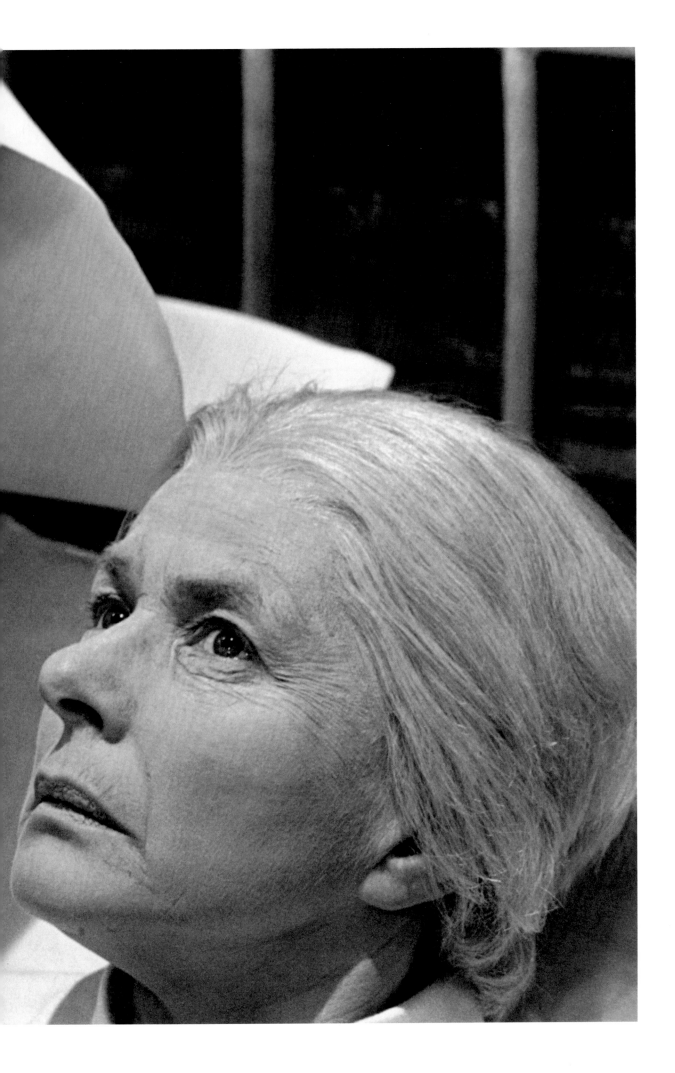

Höstsonaten

Autumn Sonata

For years people had talked about Ingmar Bergman directing his compatriot in a film; they were the best-known Swedish artists in the world; they were of the same generation, from a country so small that it sometimes seemed like one great village. Indeed, Ingmar's father, Erik Bergman, a prominent Lutheran minister, had confirmed Ingrid when she was a little girl, and baptized Pia …

As a young director Ingmar had known all about the legendary Ingrid Bergman, Hollywood's greatest star … In the years since he met Ingrid in Stockholm, he saw her only once in a play. "She was not very good," he says. "She performed like an enthusiastic amateur."

This was the Ingrid Bergman whom Ingmar asked to be in his film *Autumn Sonata*, playing Charlotte, a world-famous pianist, returning to visit her daughter after a long absence.[12]

Ingmar Bergman relates:

"Of course, some of Ingrid's pictures in those early American years were not masterpieces, but I remember very clearly that whatever she did I was always fascinated by her face. In her face—the skin, the eyes, the mouth—especially the mouth—there was this very strange radiance and an enormous erotic attraction."[13]

When the collaboration begins, Ingrid is already mortally ill and Ingmar Bergman knows it. Leamer writes: "'I live on borrowed time,' she said … Lars had called and said that it was very bad, and asked him [Ingmar Bergman] to please hurry; Ingrid needed another operation."

"Ingrid was an anarchist," says Ingmar. "When she took away any make-up and showed her naked face in the midnight scene, that was the anarchist. That was the anarchist who doesn't think of seeing her past face."[14]

After completion of her work with Ingmar, she calmly faces the end of her acting career: "I felt that my life had been rounded out with *Autumn Sonata* and *Waters of the Moon*. Yes, I might make more movies and more plays, but if I didn't I was satisfied with this finale."[15]

Ingrid Bergman and Liv Ullmann receive the New York Film Critics Circle Award as well as the David di Donatello Award for *Autumn Sonata*.

On the set of *Autumn Sonata*.
Ingmar Bergman and Ingrid discuss
the field of view. Stockholm, 1977.
Photo: Arne Carlsson.

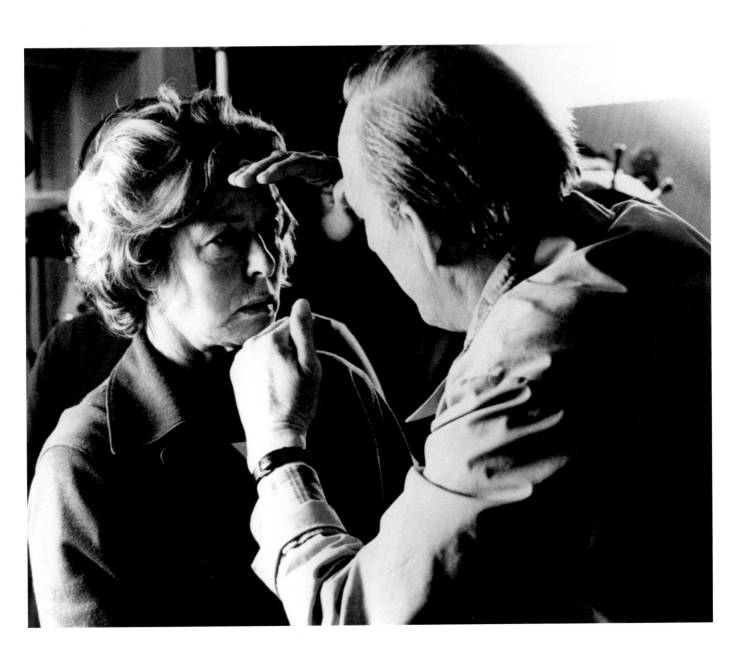

Following pages

Ingmar Bergman and Ingrid Bergman have a tête-à-tête concerning the concept of her role in *Autumn Sonata*. She finds it bleak and tells him so:" 'Look, the script is terribly depressing. In life I have three real daughters, and we do have our little *discussions* from time to time—but this! Can't we have a little joke here and there?'

" 'No,' said Ingmar, 'no jokes. We're not doing *your* story ...'

" 'But seven years without seeing her daughters? I mean! And one of them is paralyzed and almost dying. It's unbelievable.'

So Liv and I, both mothers, teased him. I said, 'Ingmar, the people you know must be monsters.' But no, we couldn't budge him."[16]

Only in retrospect does Ingrid recognize the parallels between her own biography and *Autumn Sonata*.

Stockholm, 1977. Set photo: Arne Carlsson

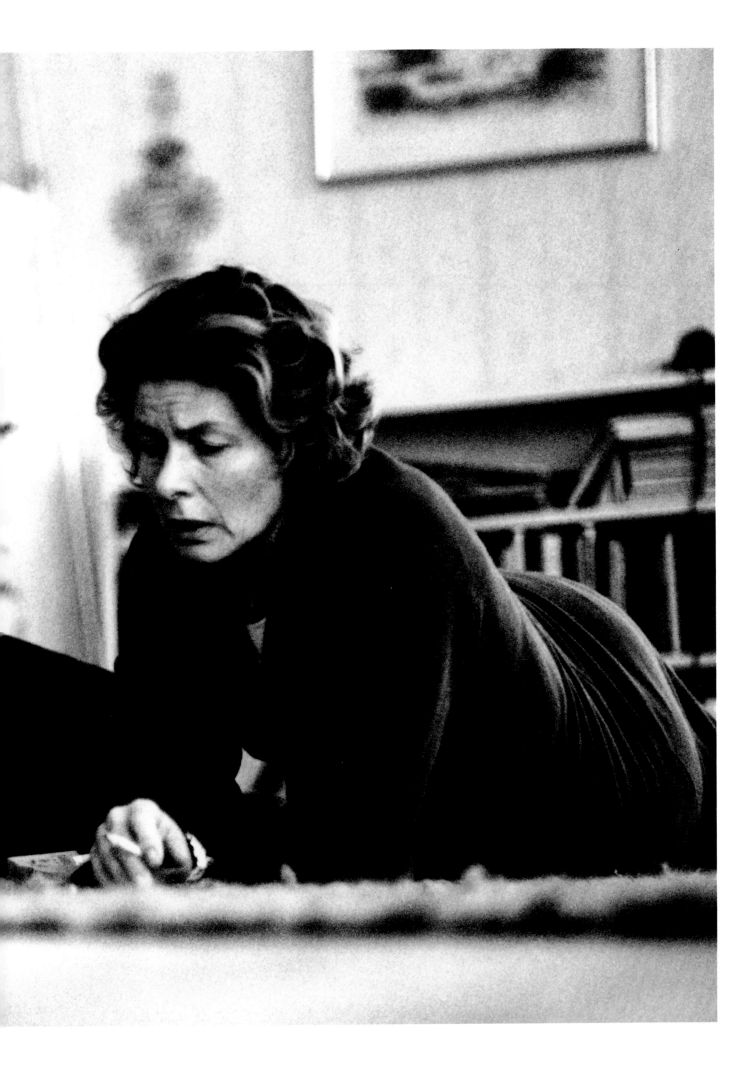

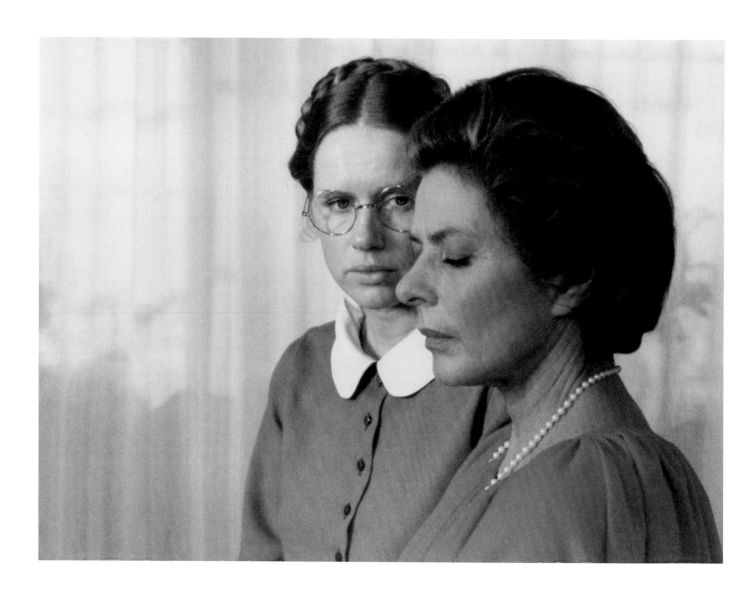

Ingrid Bergman and Liv Ullmann:
mother and daughter in *Autumn
Sonata*. Stockholm, 1977.
Set photo: Arne Carlsson

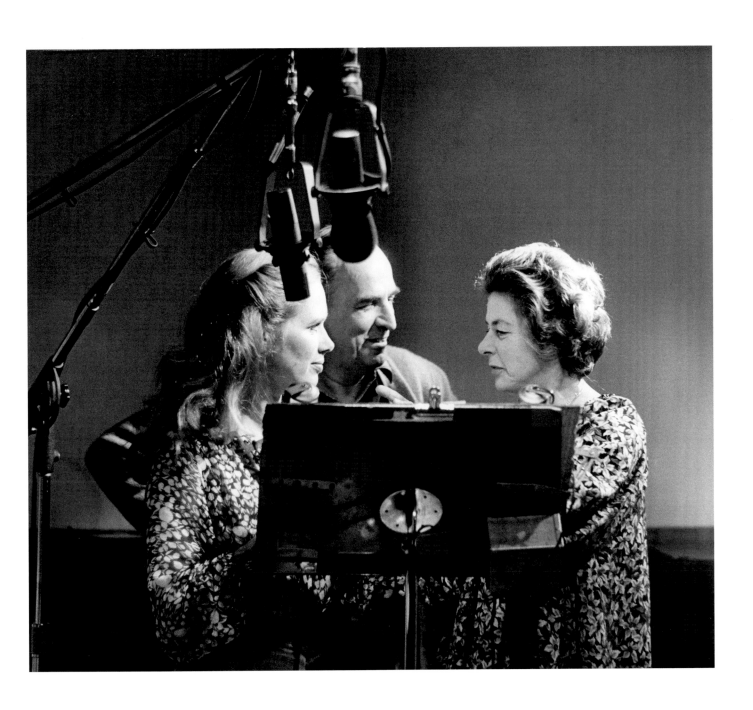

During the shooting of *Autumn Sonata*, Ingmar Bergman also does a "making of" documentary. When Ingrid views it for the first time, she is deeply shaken.

"Two years later, in the summer of 1979, I went back to see Ingmar again on his island and he showed me the long documentary he'd shot about the making of *Autumn Sonata*. I was completely unaware most of the time that they were shooting it ...
I saw myself as I've never seen myself before. It was a most revealing experience ... Because I couldn't believe I was so difficult ... I hope I was nicer when I was younger. I doubt it ...
You know, even though I was in the film, looking at that documentary was a wonderful experience, almost like a thriller. Would it all work? Would it all come together? It was exciting. It really is the best documentary on the making of a movie I've ever seen, even though my part in it is a bit—er—abrasive."[7]

A Woman Called Golda

Paramount producer Gene Corman had made many films in Israel prior to 1980 when he began making plans to do a four-hour television play about Golda Meir, provided he could find the right actress. Ingrid Bergman categorically rejects his offer at first, but not because of her fragile health. She feels she is too blond, too tall, too pretty, a Swedish Protestant with a German mother, she worked for UFA in 1938, and she was never interested in politics.

When the publicity campaign for her autobiography is completed, Ingrid takes a brief vacation in Jerusalem, where Corman immediately looks her up and tells her more about the woman he wants her to portray:

"Here was a Golda Meir who had left her husband and children to pursue her career; who had lovers while she was married; who had struggled not only for Israel but for herself, for her own recognition and success. Yet here was a Golda Meir who when she was prime minister might be found in the kitchen cooking dinner. Here, finally, was a Golda Meir who died after a long struggle with leukemia."[18]

Ingrid Bergman recognizes the parallels in their biographies and changes her mind, but once again insists on a screen test because of the heavy make-up she would be required to wear. She does not want to make a mockery of Golda or of herself. "I have never played underneath a mask in my life. I want to see if I can do it."[19] She obtains everything about Golda Meir she can get her hands on: books, film documentaries, tape recordings, and interviews. She even meets with Abba Eban, who was Israel's foreign minister under Golda Meir, and with Meir's former secretary.

In one last exertion of artistic and physical might, Ingrid puts her back into the role of Golda Meir. The budget and the schedule are tight. Against the advice of her doctors, she works in near 100° heat in Israel, with a wig, and padded clothes and stockings, while the cancer relentlessly spreads through her body. She wants to surprise her audience one last time; she wants to look different and sound different than the Ingrid Bergman the audience is expecting—and she succeeds:

"Her Golda was a feisty combination of charm and bravado, of dignity and insecurity. Like the prime minister, she chain-smoked her way through Israel's kitchens and back rooms, and her mind's wheels spun constantly. Her voice, as one viewer said, was like 'gravel grounded in authority.'"[20]

Ingrid Bergman passes away on 29 August 1982, four months after the broadcast of *A Woman Called Golda*. Three weeks after her death, the Academy of Television Arts and Science awards her a Primetime Emmy for Outstanding Lead Actress in a Miniseries or a Movie. She also receives a Golden Globe Award for Best Performance by an Actress in a Mini-Series or Motion Picture Made for Television.

Ingrid Bergman as Golda Meir in *A Woman Called Golda*. Taken on the set in Tel Aviv, 1981. Photographer unknown

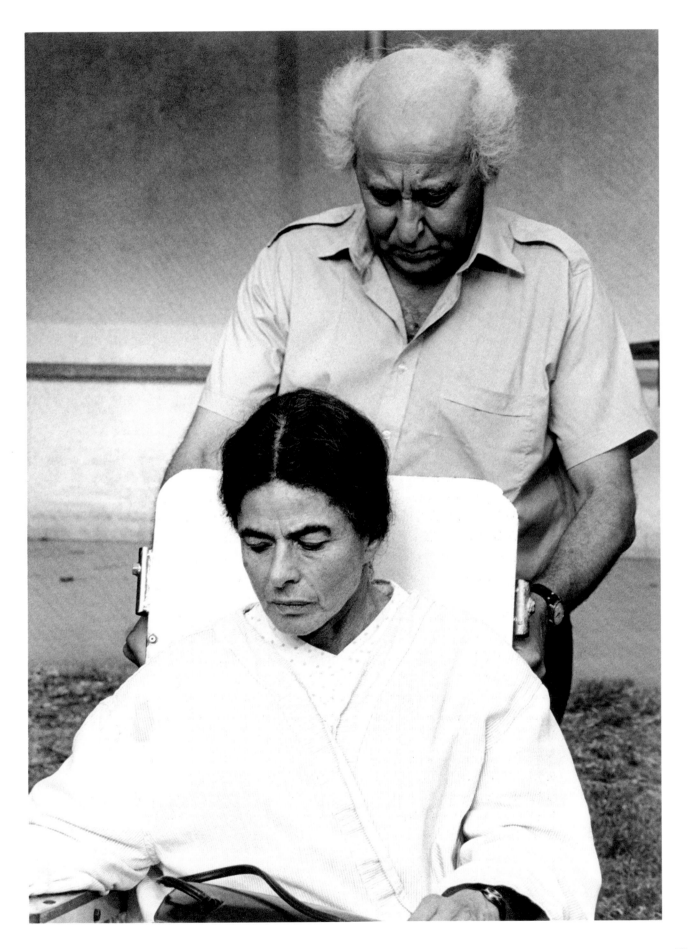

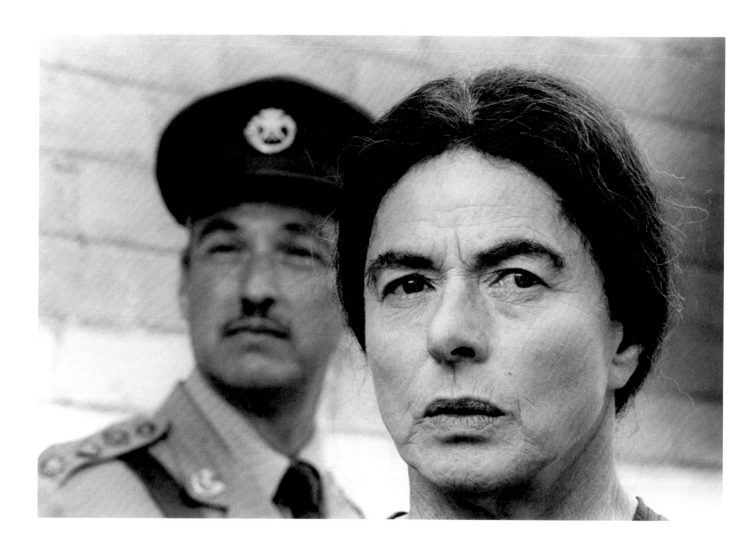

The transformation into the small, stocky
Golda Meir is of utmost perfection, but it
involves physical pain and emotional anguish.
Taken on the set of *A Woman Called Golda*.
Tel Aviv, 1981. Photographer unknown

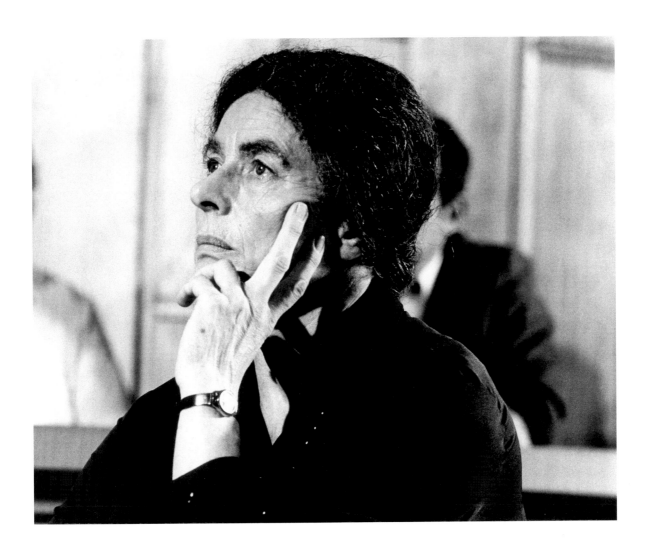

John Kobal paid tribute to the actress with these words:
"Bergman, a heroine who gave herself no airs, never stopped growing and learning in her craft, for, more than anything and I think anyone, her passionate love was reserved for her work. Before she died of cancer, she made a film with her Swedish compatriot Ingmar Bergman, *Autumn Sonata*, in which she played a career-obsessed concert pianist who had little time for her daughter. Had this been her last film, it would have been a memorable farewell; but, with only a short time left to live, she tackled probably the most demanding role of her career when she played Israel's first woman prime minister, a woman as formidable and down-to-earth as herself, Golda Meir, in the made-for-TV movie *A Woman Called Golda*. Those who knew she was dying may have wept secretly as they watched her work."[21]

Executive producer Harve Bennett recalls the cast's reaction when Ingrid emerged from the make-up room: "When Ingrid walked back into the studio, there was a momentary hush. It was no longer Ingrid Bergman but a woman who had the feel and walk and look of Golda Meir ... and what was most amazing was that Ingrid didn't even seem big any longer, but appeared to be a tiny, dumpy old lady."[22] Production still from *A Woman Named Golda*. Tel Aviv, 1981. Photographer unknown

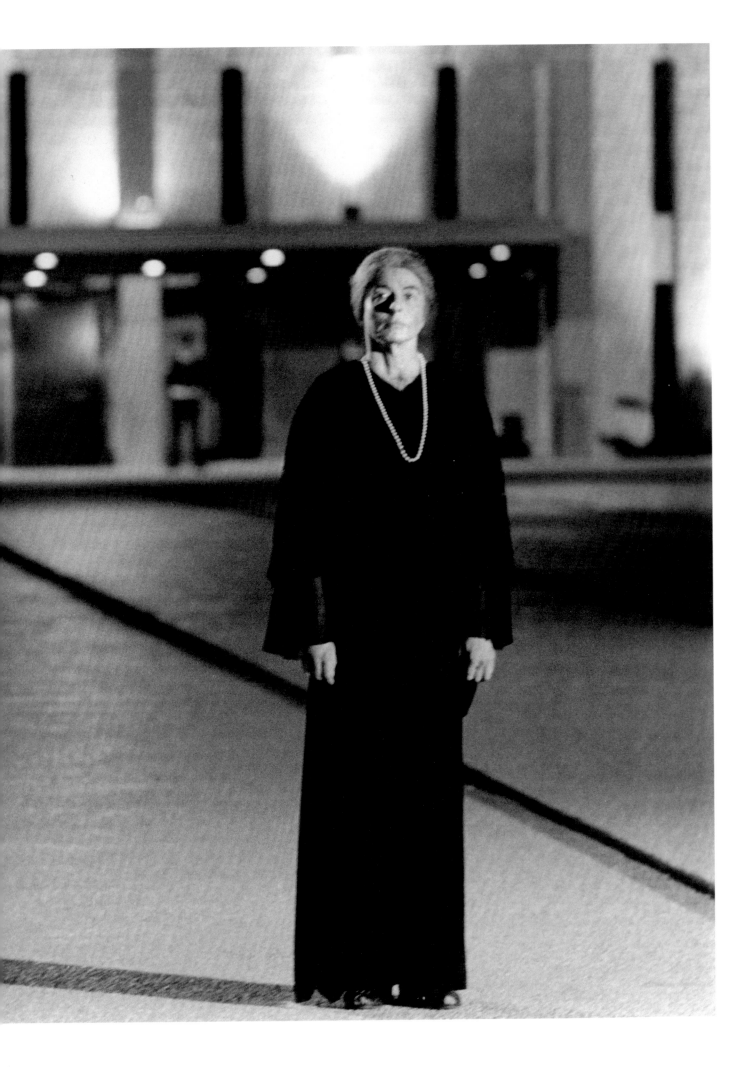

EPILOGUE

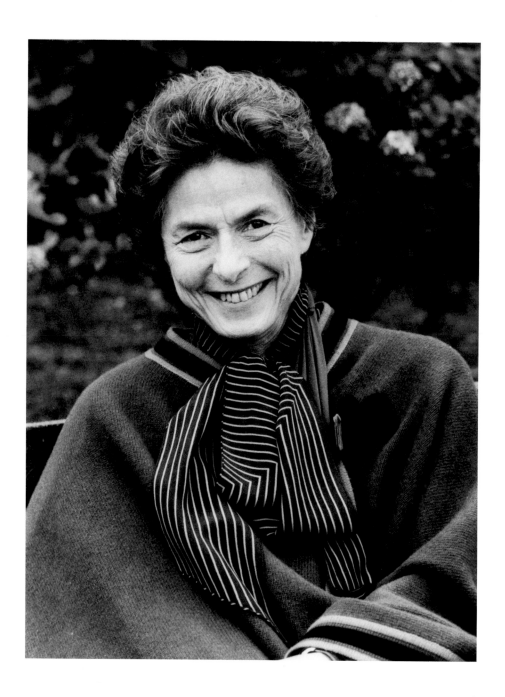

A last, impromptu photo session for the press.
" ... she sat there on a bench near the Thames
and let the photographers have their way."[23]
London, 1982. Photo: Dave Hogan

Right page
Ingrid Bergman with her arm in a sling and clad in a shawl.
These were necessary to stabilize and hide her left arm,
which was deformed as a result of deregulated lymphatic
drainage and cancer. She writes about her arm to Oriana
Fallaci: "I call him my dog, I joke with him: 'You're a dog,
a nasty sick dog. Come on, let's go walking.'"[24]
A scene that could have been taken from Antonioni's *Blow
up*: Ingrid with her arm in a sling and an unknown pa-
parazzo. London, 1982. Photographer unknown

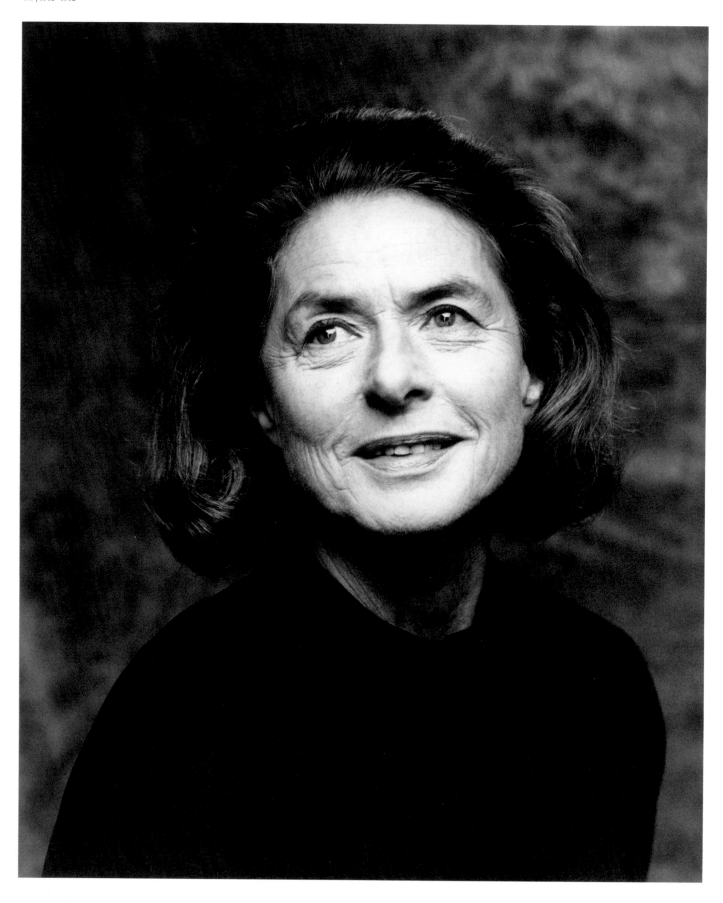

A last official portrait, taken
by Lord Snowdon. London, 1982.

Top
On Sunday 29 August 1982, Ingrid Bergman passes away on her 67th birthday. Flowers are arranged around the casket and on top of the hearse following the private memorial ceremony on 1 September. London. Photographer unknown

Bottom
Photo taken at the official memorial ceremony for Ingrid Bergman held on 14 October 1982 at St. Martin's-in-the-Fields, London.
First row from left to right: Pia Lindström, her husband Joe, and their two children. Second row from the left: Lars Schmidt, Isabella, Isotta Ingrid, and Roberto Jr. Lawrence Leamer writes, "There was nothing that was as touching as the moment when, from a distant corner of the church, a violin played the strains of 'As Time Goes By'."[25]

The sea is her grave: view from the cliffs of Danholmen where Ingrid's ashes were cast into the water. Her name and the dates of her birth and death have been inscribed in the rocks.

Following pages
Everlasting in the media. Bruno Barbey took this photo in Tokyo's Shinjuku ward in 1985.

BIBLIOGRAPHY

Bergman, Ingrid and Alan Burgess. *Ingrid Bergman. My Story*. New York: Delacorte Press, 1980.

Gellhorn, Martha. *Selected Letters of Martha Gellhorn*. Edited by Caroline Moorehead. New York: Henry Holt and Company, 2006.

Jürgens, Curd. *… und kein bisschen weise*. Locarno: Droemer Knaur Verlag, 1976.

"Die junge Ingrid Bergman." *Kinemathek*, Vol. 18, issue 59, November 1981, Berlin, Lübeck 1981.

Kobal, John. *People Will Talk*. New York: Knopf, 1986.

Leamer, Laurence. *As Time Goes By. The Life of Ingrid Bergman*. London: Sphere Books, 1987.

Mayer Selznick, Irene. *A Private View*. New York, 1983.

Quirk, Lawrence J. *The Complete Films of Ingrid Bergman*. New York: A Citadel Press Book, Carol Publishing Group, 1991.

Quirk, Lawrence J. *Ingrid Bergman und ihre Filme*. Munich: Wilhelm Goldmann Verlag, 1982.

Reinhardt, Gottfried. *Der Apfel fiel vom Stamm. Anekdoten und andere Wahrheiten aus meinem Leben*. Munich: Langen Müller, 1992.

Rossellini, Isabella. *In the Name of the Father, the Daughter and the Holy Spirits. Remembering Roberto Rossellini*. Munich: Schirmer/Mosel, 2006.

Rossellini, Isabella. *Some of Me*. New York: Random House, 1997.

Ruegsegger, Hans Peter. *Ingrid – tu als ob! Ingrid Bergman*. E-book, Bottmingen, 2009. www.ingridbergman.ch/files/INGRID_tu-alsob_2010_12_27.pdf

Spoto, Donald. *Notorious. The Life of Ingrid Bergman*. New York: HarperCollins, 1997.

Steele, Joseph Henry. *Ingrid Bergman. An Intimate Portrait*. New York: Popular Library, 1960.

Updike, John. "A Woman's Burden." in John Updike: *More Matter. Essays and Criticism*, New York: Random House, 1999/2012.

NOTES

Introduction by Liv Ullmann

pp. 11–14

1 Ingrid Bergman, *My Story*. By Ingrid Bergman and Alan Burgess. New York: Delacorte Press, 1980, p. 456.
2 Bergman, *My Story*, p. 455.

I. Sweden 1915–1939

pp. 35–102

1 Bergman, *My Story*, p. 19.
2 Bergman, *My Story*, pp. 28f.
3 Bergman, *My Story*, p. 26.
4 Bergman, *My Story*, p. 15.
5 Laurence Leamer, *As Time Goes By: The Life of Ingrid Bergman*. London: Sphere Books, 1987, p. 23.
6 Bergman, *My Story*, p. 31.
7 Bergman, *My Story*, p. 47.
8 Bergman, *My Story*, p. 16.
9 Bergman, *My Story*, p. 24.
10 Bergman, *My Story*, p. 32.
11 Bergman, *My Story*, p. 40.
12 ibid.
13 Bergman, *My Story*, p. 43.
14 Bergman, *My Story*, p. 48.
15 Bergman, *My Story*, pp. 49f.
16 ibid.
17 Bergman, *My Story*, p. 50.
18 Bergman, *My Story*, p. 52.
19 ibid.
20 Curd Jürgens,… *und kein bisschen weise*, Locarno 1976, p. 194f. Translated by Roger Benner for this publication.
21 "Die junge Ingrid Bergman". *Kinemathek*, issue 59 (November 1981), Berlin/Lübeck, p. 41. Translated by Roger Benner for this publication.

II. Hollywood 1939–1945

pp. 103–206

1 Leamer, p. 50.
2 Leamer, p. 52.
3 Bergman, *My Story*, pp. 59f.
4 John Kobal, "Ingrid Bergman", in *People Will Talk*, New York 1986, p. 459.
5 Selznick in a letter dated 22 June 1939, quoted in Bergman, *My Story*, pp. 72f.
6 Bergman, *My Story*, p. 77.
7 Bergman, *My Story*, p. 78.
8 Donald Spoto, *Notorious: The Life of Ingrid Bergman*. New York: HarperCollins, 1997, p. 77.
9 Spoto, p. 80
10 Hans Peter Ruegsegger, *Ingrid – tu als ob! Ingrid Bergman*, eBook, Bottmingen 2009, p. 123, 124. www.ingrid-bergman.ch/files/

INGRID_tualsob_2010_12_27.pdf Translated by Roger Benner for this publication.
11 Leamer, p. 90.
12 Bergman, *My Story*, p. 81.
13 Bergman, *My Story*, p. 86.
14 Bergman, *My Story*, p. 87.
15 Spoto, p. 95.
16 Bergman, *My Story*, p. 91.
17 Leamer, p. 86.
18 Bergman, *My Story*, p. 94.
19 Bergman, *My Story*, p. 98.
20 ibid.
21 Bergman, *My Story*, p. 106.
22 Bergman, *My Story*, p. 108f.
23 Bergman, *My Story*, p. 109.
24 Leamer, p. 106.
25 Bergman, *My Story*, p. 110.
26 ibid.
27 Leamer, p. 112.
28 Bergman, *My Story*, p. 114.
29 Leamer, p. 122.
30 Bergman, *My Story*, p. 116.
31 see Leamer, p. 90.
32 Bergman, *My Story*, p. 113.
33 Bergman, *My Story*, p. 116.
34 Leamer, p. 131.
35 Bergman, *My Story*, p. 114.
36 see Bergman, *My Story*, p. 125.
37 Bergman, *My Story*, p. 126.
38 Bergman, *My Story*, p. 127.
39 Bergman, *My Story*, p. 121.
40 Spoto, p. 168f.
41 Spoto, p. 165.
42 Leamer, p. 146.
43 ibid.
44 Bergman, *My Story*, p. 140.
45 Spoto, p. 181.

III. End of the War in Europe – New Horizons 1945–1949

pp. 207–265

1 Bergman, *My Story*, p. 141.
2 Bergman, *My Story*, p. 142.
3 ibid.
4 see Spoto, p. 183.
5 Martha Gellhorn, *Selected Letters*. Edited by Caroline Moorehead. New York: Henry Holt and Company, 2006, p. 504.
6 Spoto, p. 202.
7 ibid.
8 Bergman, *My Story*, pp. 141f.
9 Bergman, *My Story*, p. 142.
10 ibid.
11 Spoto, p. 167.
12 Bergman, *My Story*, p. 152.
13 Bergman, *My Story*, p. 153.
14 Spoto, p. 209.

15 Bergman, *My Story*, p. 153.
16 Spoto, p. 217.
17 Bergman, *My Story*, pp. 156f.
18 Spoto, p. 231.
19 ibid.
20 Spoto, pp. 231f.
21 Bergman, *My Story*, p. 169.
22 Bergman, *My Story*, p. 171.
23 ibid.
24 Spoto, p. 246.
25 Bergman, *My Story*, pp. 185f.

IV. The Scandal: The Relationship with Rossellini 1949–1955

p. 267–345

1 Bergman, *My Story*, p. 202.
2 Bergman, *My Story*, p. 199.
3 Irene Mayer Selznick, *A Private View*, New York 1983, p. 374.
4 Bergman, *My Story*, p. 204.
5 Spoto, pp. 266f.
6 Spoto, p. 272.
7 Bergman, *My Story*, p. 206.
8 Bergman, *My Story*, p. 265.
9 Bergman, *My Story*, pp. 265f.
10 Bergman, *My Story*, p. 283.
11 Bergman, *My Story*, pp. 283f.
12 Bergman, *My Story*, p. 287.
13 Spoto, p. 313.
14 Leamer, p. 290.
15 Spoto, p. 313.
16 Spoto, p. 315.
17 Lawrence J. Quirk, *The Complete Films of Ingrid Bergman*. New York: A Citadel Press Book, Carol Publishing Group, 1991, p. 142.
18 Leamer, p. 298.
19 Leamer, p. 300.
20 Bergman, *My Story*, pp. 313f.
21 Leamer, p. 298.

V. Estrangement and Separation from Rossellini 1956–1957

pp. 347–405

1 Spoto, p. 320.
2 Leamer, p. 301.
3 Leamer, p. 304.
4 Bergman, *My Story*, p. 320.
5 Leamer, p. 305.
6 Bergman, *My Story*, p. 322.
7 ibid.
8 Bergman, *My Story*, pp. 326ff.
9 Bergman, *My Story*, p. 337.
10 Bergman, *My Story*, pp. 332f.
11 Bergman, *My Story*, pp. 338ff.
12 Bergman, *My Story*, p. 340.

VI. New Career – New Happiness 1958–1965

pp. 407–463

1 Quirk, p. 157.
2 Bergman, *My Story*, p. 344.
3 Bergman, *My Story*, p. 345.
4 Bergman, *My Story*, p. 346.
5 Bergman, *My Story*, pp. 349f.
6 Spoto, p. 345.
7 Bergman, *My Story*, p. 347.
8 Leamer, p. 327.
9 Spoto, p. 346.
10 Spoto, p. 351.
11 Bergman, *My Story*, p. 373.
12 Quirk, p. 168.
13 Bergman, *My Story*, p. 380.
14 Spoto, p. 355.
15 Bergman, *My Story*, p. 385.
16 Bergman, *My Story*, pp. 380f.
17 Quirk, pp. 175f.
18 Bergman, *My Story*, p. 386.

VII. Theater and Later Films – Illness, Farewell and Death 1965–1982 and Epilogue

pp. 465–516

1 Bergman, *My Story*, p. 386.
2 Bergman, *My Story*, p. 388.
3 Bergman, *My Story*, pp. 404ff.
4 Bergman, *My Story*, p. 411.
5 Quirk, p. 180.
6 Spoto, p. 377.
7 Bergman, *My Story*, p. 414.
8 Bergman, *My Story*, pp. 416.
9 Bergman, *My Story*, p. 429.
10 Spoto, p. 393.
11 George Morris, *Film Comment*, quoted in Lawrence J. Quirk, *Ingrid Bergman und ihre Filme*. Edited by Joe Hembus. Munich: Wilhelm Goldmann Verlag, 1982, p. 164. Translated by Roger Benner for this publication.
12 Leamer, pp. 393f.
13 Bergman, *My Story*, p. 450.
14 Leamer, pp. 399 ff.
15 Bergman, *My Story*, p. 464.
16 Bergman, *My Story*, p. 452.
17 Bergman, *My Story*, pp. 458f.
18 Leamer, p. 420.
19 Leamer, p. 422.
20 Spoto, p. 427.
21 Kobal, p. 482.
22 Leamer, p. 423.
23 Leamer, p. 435.
24 Leamer, p. 433.
25 Leamer, p. 444.

PICTURE CREDITS

APPENDIX

INGRID BERGMAN – BIOGRAPHY

1915
29 August: Ingrid Bergman is born in Stockholm to Hamburg-native Friedel Bergman, née Adler, and Justus Bergman, painter and photographer.

1918
Death of her mother.

1928
Death of her father. Ingrid goes to live with the family of Justus Bergman's sister, Hulda Engström, where she is brought up with five cousins.

1933
Autumn: Ingrid is accepted to the Royal Dramatic School in Stockholm. She meets Dr. Petter Aron Lindström.

1934
Summer: First motion picture role in *The Count of the Monk's Bridge (Munkbrogreven)* and termination of drama school.

1934 – 1939
Ingrid Bergman rises to become Sweden's most sought-after star.

1936
7 July: Engagement to Petter Lindström in Hamburg.

1937
10 July: Marriage to Petter Lindström in his native village of Stöde.

1938
Stars in *The Four Companions (Die vier Gesellen)* for UFA in Nazi Germany.

20 September: Birth of daughter Friedel Pia in Stockholm.

1939
May – August: First trip to the US at the invitation of American film producer David O. Selznick. Ingrid Bergman's first Hollywood picture is a remake of *Intermezzo*.

1940
January: Departure on second trip to the US; Lindström remains behind in Sweden; Pia accompanies her mother.

April: Five-year contract with Selznick takes effect, but there are no roles for Ingrid Bergman.

May: Appearance in Franz Molnár's stage production *Liliom* on Broadway.

Autumn: Selznick puts Ingrid Bergman on loan to other film companies, for whom she takes on various roles.

December: Petter Lindström takes a position in Rochester, New York, and moves to the US.

1940 – 1945
While under contract with Selznick, Ingrid is loaned out for numerous pictures with other film companies. Following the success of *Casablanca* and *For Whom the Bell Tolls*, she now ranks among the world's top stars. Affairs with co-stars and directors.

1943
End of the year: Ingrid entertains troops in Alaska.

1944
Ingrid Bergman and Petter Lindström, who has now taken a position in San Francisco, purchase a house on Benedict Canyon Drive in Beverly Hills. In October, Ingrid departs on a tour of the US promoting the purchase of war bonds.

1945
March: Oscar for Best Actress in *Gaslight*.

June: Travel to war-torn Europe with the USO. Ingrid meets war photographer Robert Capa in Paris. They fall in love and an affair ensues.

1946
The contract with Selznick expires. Ingrid makes her first film as an independent artist, *Arch of Triumph*, for The Enterprise Studios. The movie is a financial disaster, however.

1948
September: First encounter with Roberto Rossellini during a meeting in Paris at which Petter Lindström is also present. They discuss the possibility of working together.

1949
20 March: Ingrid Bergman lands in Rome.

May – August: Filming of *Stromboli*, her first picture with Roberto Rossellini. The love affair between Ingrid Bergman and Rossellini causes a scandal. Rossellini acquires the Villa Santa Marinella near Rome as their family home.

1950

2 February: Birth of Robertino in Rome.

Autumn: Ingrid Bergman ends her previously announced "retirement" and stars in Rossellini's *The Greatest Love (Europa '51)*.

1952

18 June: Birth of the twins, Isabella and Isotta Ingrid.

1953–1955

European tour of *Giovanna d'Arco al rogo (Joan of Arc at the Stake)*, an oratorio by Claudel/Honegger, directed by Rossellini. Breaks in the tour are used to shoot *Journey to Italy (Viaggio in Italia)* and *Fear (La Paura)*.

June 1955: Ingrid Bergman announces her artistic separation from Rossellini in Santa Marinella and lets it be known that she plans to work with Jean Renoir in Paris in the fall.

1956

Filming of *Anastasia* in London. The picture paves the way for her Hollywood comeback.

December: Against the will of Rossellini, Ingrid Bergman appears in *Thé et sympathie* in Paris. Rossellini departs for India to work on a film project. Ingrid begins an affair with writer Robert Anderson and meets Swedish theater producer Lars Schmidt, who will later become her third husband.

1957

19 January: First return to the US following the scandal: Ingrid Bergman receives the New York Film Critics Circle Award for Best Actress for her performance in *Anastasia*.

27 March: Cary Grant accepts Ingrid Bergman's Oscar for Best Actress for her role in *Anastasia*.

8 July: Following a separation of eight years, Ingrid is reunited with her daughter Pia in Paris.

21 October: Rossellini returns from India; in a move geared toward the media, Ingrid Bergman awaits him at the airport.

7 November: Ingrid Bergman and Roberto Rossellini sign a separation agreement.

1958

June: The marriage with Roberto Rossellini is annulled by an Italian court.

21 December: Marriage to Lars Schmidt in Paris. They purchase a home in Choisel, near Paris.

1963

Ingrid Bergman cedes custody of the Rossellini children to their father. She begins an affair with Anthony Quinn during the

shooting of *The Visit*, which is based on Friedrich Dürrenmatt's novel of the same name.

1965

Summer: Ingrid appears onstage in Guildford and London in Turgenev's *A Month in the Country*.

1967

Autumn: Ingrid appears onstage in Eugene O'Neill's *More Stately Mansions* in Los Angeles and New York.

1973

June: Ingrid Bergman is president of the jury during the International Film Festival in Cannes.

Autumn: Ingrid Bergman learns that she has breast cancer. She postpones surgery so as not to interfere with the run of *The Constant Wife* in Brighton and London.

1974

During the day, Ingrid Bergman stars in Sidney Lumet's screen adaptation of Agatha Christie's *Murder on the Orient Express*; in the evenings, she performs onstage. She undergoes surgery towards the end of the year.

1975

March: She receives her third Oscar for Best Supporting Actress in *Murder on the Orient Express*.
Divorce from Lars Schmidt..

1977

During the shooting of *Autumn Sonata*, directed by Ingmar Bergman, Ingrid learns that further surgery will be necessary.

3 June: Roberto Rossellini dies at the age of 71 in Rome.

1978

Ingrid undergoes second surgery.

1979

November: A gala is held in Los Angeles in Ingrid Bergman's honor. Frank Sinatra is in attendance to sign "As Time Goes By."

1981

Last role in the television production *A Woman Called Golda* about the life of Golda Meir.

1982

June: Ingrid Bergman flies to New York to celebrate the twin's 30th birthday.

29 August: Ingrid Bergman passes away in London on her 67th birthday.

FILMOGRAPHY

Editorial Note
The following index of motion pictures in which Ingrid Bergman appeared lists the pictures according to their original titles and in the chronological order in which they were made. Since some of the films premiered significantly later, the dates may thus sometimes be at variance with other sources. Alternative titles are also listed, where applicable. For further information, please refer to the filmographies provided in Quirk and Leamer (see bibliography).

1. **Munkbrogreven**
 The Count of the Monk's Bridge.
 Sweden, 1934
 Directors: Edvin Adolphson and Sigurd Wallén

2. **Bränningar**
 Ocean Breakers. Sweden, 1935
 Director: Ivar Johansson

3. **Swedenhielms**
 Swedenhielms Family. Sweden, 1935
 Director: Gustaf Molander

4. **Valborgsmässoafton**
 Walpurgis Night. Sweden, 1935
 Director: Gustav Edgren

5. **På solsidan**
 On the Sunny Side. Sweden, 1936
 Director: Gustaf Molander

6. **Intermezzo**
 Sweden, 1936
 Director: Gustaf Molander

7. **Dollar**
 Sweden, 1938
 Director: Gustaf Molander

8. **En kvinnas ansikte**
 A Woman's Face. Sweden, 1938
 Director: Gustaf Molander

9. **Die vier Gesellen**
 The Four Companions. Germany, 1938
 Director: Carl Froelich

10. **En enda natt**
 Only One Night. Sweden, 1939
 Director: Gustaf Molander

11. **Intermezzo: A Love Story**
 USA, 1939
 Director: Gregory Ratoff

12. **Juninatten**
 June Night / aka A Night in June. Sweden, 1940
 Director: Per Lindberg

13. **Adam Had Four Sons**
 USA, 1941
 Director: Gregory Ratoff

14. **Rage in Heaven**
 USA, 1941
 Director: W. S. Van Dyke II

15. **Dr. Jekyll and Mr. Hyde**
 USA, 1941
 Director: Victor Fleming

16. **Casablanca**
 USA, 1942
 Director: Michael Curtiz

17. **Swedes in America**
 USA, 1943
 Director: Irving Lerner

18. **For Whom the Bell Tolls**
 USA, 1943
 Director: Sam Wood

19. **Saratoga Trunk**
 USA, 1943
 Director: Sam Wood

20. **Gaslight**
 USA, 1944
 Director: George Cukor

21. **The Bells of St. Mary's**
 USA, 1945
 Director: Leo McCarey

22. **Spellbound**
 USA, 1945
 Director: Alfred Hitchcock

23. **Notorious**
 USA, 1946
 Director: Alfred Hitchcock

24. **Arch of Triumph**
 USA, 1948
 Director: Lewis Milestone

25. **Joan of Arc**
 USA, 1948
 Director: Victor Fleming

26. **Under Capricorn**
 Great Britain, 1949
 Director: Alfred Hitchcock

27. **Stromboli**
 Italy, 1950
 Director: Roberto Rossellini

28. **Europa '51**
 The Greatest Love. Italy, 1951
 Director: Roberto Rossellini

29. **Siamo Donne**
 We, the Women. Italy, 1953
 Director: Roberto Rossellini

30. **Viaggio in Italia**
 Journey to Italy. Italy, 1954
 Director: Roberto Rossellini

31. **Giovanna d'Arco al rogo**
 Joan of Arc at the Stake. Italy, 1954
 Director: Roberto Rossellini

32. **La paura**
 Fear / aka Angst. Germany, 1955
 Director: Roberto Rossellini

33. **Elena et les Hommes**
 Elena and her Men / aka Paris Does Strange Things.
 France, 1956
 Director: Jean Renoir

34. **Anastasia**
 Great Britain, 1956
 Director: Anatole Litvak

35. **Indiscreet**
Great Britain, 1958
Director: Stanley Donen

36. **The Inn of the Sixth Happiness**
Great Britain, 1958
Director: Mark Robson

37. **Goodbye Again**
France, 1961
Director: Anatole Litvak

38. **The Visit**
Italy, 1964
Director: Bernhard Wicki

39. **The Yellow Rolls-Royce**
Great Britain, 1965
Director: Anthony Asquith

40. **Stimulantia**
Sweden, 1967
Director: Gustaf Molander

41. **Cactus Flower**
USA, 1969
Director: Gene Saks

42. **A Walk in the Spring Rain**
USA, 1970
Director: Guy Green

43. **From the Mixed-up Files of Mrs Basil E. Frankweiler**
USA, 1973
Director: Fielder Cook

44. **Murder on the Orient Express**
Great Britain, 1974
Director: Sidney Lumet

45. **A Matter of Time**
Italy, 1976
Director: Vincente Minnelli

46. **Höstsonaten**
Autumn Sonata. Norway, 1978
Director: Ingmar Bergman

47. **A Woman Called Golda**
USA, 1982
Director: Alan Gibson

REGISTER

First published in the United States and Canada in 2015 by
Chronicle Books, LLC.

First published in Europe by Schirmer/Mosel Verlag in 2013.

© 2013 for the foreword by Liv Ullmann
© 2013 for the interview between John Kobal and
Ingrid Bergman by Light Industry Ltd., London,
with kind permission of Simon Crocker
© 2013 for the photographs by the photographers or their legal
successors mentioned below the pictures or in the photo credits
© 2013 for this edition by Schirmer/Mosel Munich

The quotes taken from Ingrid Bergman/Alan Burgess,
Ingrid Bergman. My Story (New York, 1980) are reprinted with
kind permission of Pia Lindström, Roberto Rossellini Jr.,
Isabella and Isotta-Ingrid Rossellini.

The text by John Updike is reprinted with kind permission
of The Wylie Agency (UK) Ltd.

The quotes from Irene Mayer Selznick are taken from the
book Irene Mayer, *A Private View* (New York, 1980) and
reprinted with kind permission of Alfred A. Knopf, a division
of Random House Inc., USA.

Chapter texts/picture captions chapters I-VII:
Michaela Angermair, Marion Kagerer, Lothar Schirmer
English translation by Roger Benner

Design: Schirmer/Mosel Studio, Munich,
Klaus E. Göltz, Halle
Lithography: NovaConcept, Berlin
Printing and binding: Printer Trento srl

Library of Congress Cataloging-in-Publication Data is available.
ISBN 978-1-4521-4955-4

Printed in Italy

10 9 8 7 6 5 4 3 2 1

Chronicle Books LLC
680 Second Street
San Francisco, CA 94107
www.chroniclebooks.com

Chronicle books and gifts are available at special quantity
discounts to corporations, professional associations, literacy
programs, and other organizations. For details and discount
information, please contact our premiums department at
corporatesales@chroniclebooks.com or at 1-800-759-0190.

Ingrid Bergman – our Web Guide for you

If you want to know more about Ingrid Bergman, the book, her life, her films and her family,
we recommend a visit to the website which has specially been developed to accompany this
book.

Please visit **www.ingridbergman-thebook.com** or use the following code with your
smartphone or tablet computer.

There you will find

– a video message from Isabella Rossellini for you
– a press archive with selected international reviews
– a new recording of the *Casablanca* theme song "As Time Goes By"
 with star cellist Anja Lechner and pianist François Couturier
– News about the book and the many exhibition preparations
 in honor of Ingrid Bergman's 100th birthday on 29 August 2015
– In addition we have prepared for you a selection of the best Ingrid Bergman
 film clips in a little clip library on the website. You can also access it directly
 with the following code on your smartphone or tablet computer.

www.ingridbergman-thebook.com/en/filmclips

This is what we have selected for you:

– Ingrid Bergman speaks German – in the movie *Die vier Gesellen* (1938)
– From the movie classic *Casablanca* (1942): "Play It, Sam" and "We'll Always Have
 Paris" the famous scenes with Dooley Wilson and Humphrey Bogart
– Recordings of the three presentations of the *Oscar* award for Ingrid Bergman in 1945,
 1957 and 1975
– "Alfred Hitchcock is an adorable genius!" – Ingrid Bergman's big speech honoring
 Alfred Hitchcock on the occasion of the presentation of the Life Achievement Award
 of the American Film Institute to the director in 1979

THE END